Abstract Expressionism:
Creators and Critics

Abstract
Expressionism:

Creators and Critics

An Anthology

Edited and with an Introduction by Clifford Ross

Harry N. Abrams, Inc., Publishers, New York

Project Manager: Mark Greenberg
Assistant Editor: Ellen Rosefsky
Photograph and Permissions Researcher: Uta Hoffmann
Designer: Judith Michael

Library of Congress Cataloging-in-Publication Data

Abstract expressionism: creators and critics/edited by Clifford
Ross.
p. cm.
Includes bibliographical references.
ISBN 0-8109-1908-7
1. Abstract expressionism—United States. 2. Art, Modern—20th
century—United States. I. Ross, Clifford, 1952-
N6512.5.A25A24 1990
709'.73'09045—dc20 89-39710
 CIP

Printed and bound in Japan

To Helen Frankenthaler, my painterly link,
who got the message and passed it on

Contents

Part II: Critics

Preface

The purpose of this book is to present the most informative writings by and about the Abstract Expressionists. It should serve to heighten and intensify the experience of looking at the works of art themselves, including works by artists who are not represented in this anthology. As such, it is not designed as an historical survey but aims to gather those writings that would best illuminate the art itself.

These writings, which include transcribed interviews and speeches, fall into four categories: criticism, history, process, and politics. This last category involves cheerleading, in-fighting, and occasional slander. Artists and critics alike indulge in this inevitably vigorous pursuit, and it is curiously illuminating. It is part of the process by which any art movement arrives before the public.

The core of this book consists of writings by the artists themselves. Their texts include private notations, letters, speeches, essays, and interviews by individual artists, as well as statements and dialogues published by groups of two or more. They range from carefully constructed art-historical arguments to hastily written notes of admiration.

Because certain artists were much less inclined than others to commit their ideas to paper or reveal their ideas in dialogue, it was

both impossible and inappropriate to give equal space to each artist.
The goal was simply to represent each artist's views and concerns as
completely as possible while keeping an eye on how they themselves
proportioned their thoughts between the various topics. Some, for
example, focused more on the nuts and bolts of making art than on
philosophy.

I have included some texts that were group efforts, for even
though the Abstract Expressionists were strongly individualistic,
there was a common pool of artistic issues with which they were all
struggling. These texts also provide an opportunity to include artists
who were not leading figures but were nonetheless an integral part
of the Abstract Expressionist movement. They all shared a feeling of
being misunderstood and explored their difficulties through formal
and informal discussions, periodically issuing statements that were
published in a variety of ways.

The artists and their circle maintained a certain community
through their friendships and met informally at bars and restaurants
such as the Cedar Tavern and the Waldorf Cafeteria. They
exchanged ideas at such places as The Subjects of the Artist school,
founded by William Baziotes, David Hare, Robert Motherwell, and
Mark Rothko in 1948; Studio 35, an arts club that sponsored public
lectures by many of the Abstract Expressionists and other abstract
artists such as Fritz Glarner and Hans Arp; and The Club, a private
organization for artists founded by Philip Pavia. The Club was
located at 37 East 8th Street, next door to the building that housed
The Subjects of the Artist school and Studio 35. The more literary
of the artists grouped together to publish magazines or pamphlets
such as *Modern Artists in America, Tiger's Eye,* and *Possibilities.*

Many of the artists were represented by a handful of art dealers
who exhibited Abstract Expressionist work from the 1940s through
the 1960s. These dealers, along with supportive critics, collectors,
and museum curators, were also part of the artists' community.

The most interesting and difficult aspect of editing this book
came in deciding which artists to include. In order for this
anthology to have a focus and structure consistent with Abstract
Expressionism itself, it became clear that it had to concentrate on
those artists whose work was decisive in formulating the aesthetic
core and far-flung stylistic boundaries of the movement. Eleven
painters and one sculptor were critical to this definition.

Willem de Kooning, Adolph Gottlieb, Philip Guston, Hans
Hofmann, Franz Kline, Robert Motherwell, Barnett Newman,
Jackson Pollock, Ad Reinhardt, Mark Rothko, David Smith, and
Clyfford Still established the basic direction of the movement and
account for all its significant stylistic innovations. Other artists of

quality were active and involved, but none can lay claim to a leadership role.

This list excludes certain artists who are sometimes included in surveys of Abstract Expressionism. Foremost among them is Arshile Gorky.

Gorky was an original and important artist, but he was closer in spirit to the Surrealists than to the Abstract Expressionists. His central objective was to depict the dream world of his subconscious. Although a number of Abstract Expressionists were involved with a similar pursuit early in their development, they ultimately achieved their artistic objectives by confronting the subconscious, not depicting it. Their images did not picture the subconscious; rather they invoked certain feelings and sensations connected with it. Gorky's work stands as a brilliant and poignant summation of much of twentieth-century art up to the mid-1940s, a summation that laid the final groundwork for Abstract Expressionism. He broke important ground, but unlike the best work by the Abstract Expressionists, his greatest paintings are visions of a world into which the viewer is invited to enter. With Abstract Expressionism, the reverse is generally true. Abstract Expressionist paintings enter our world.

William Baziotes, a generally underrated artist, was also basically a Surrealist, with a greater sense of whimsy than any of the Abstract Expressionists. In his mature work, he shared Paul Klee's affinity for eccentric drawing and illustration. Baziotes's reputation has suffered from comparison with the Abstract Expressionists precisely because he was grappling with different artistic imperatives.

Mark Tobey's work rests outside the confines of Abstract Expressionism, as well. He was not an intimate of the New York scene and his central concerns and stylistic development were markedly different as a result. Tobey has always existed in a sort of art-historical limbo, but it does his work no credit to place it in a movement where it does not belong. Although he shared with the Abstract Expressionists an interest in gestural paint handling evenly accented across the surface of the canvas, his works are always well-mannered and imbued with a quality of Eastern mysticism quite different from the confrontational and heroic aspects of the movement.

A number of interesting sculptors were part of the Abstract Expressionist scene, including Herbert Ferber, David Hare, Ibram Lassaw, Seymour Lipton, and Theodore Roszak, but they had a different aesthetic agenda than the Abstract Expressionists. One is tempted to label them "Primevalists," for their best work was often

based on vegetable, animal, or mineral configurations that relate to early life forms. In this way, their sculpture was connected to the mythic style of early Abstract Expressionism, but it did not unfold along the same aesthetically progressive path. As metal workers, they were indebted to Julio Gonzales and Picasso, but they seemed more intent on exploring Surrealist imagery and keeping in touch with the modeling tradition of Rodin than in struggling with Cubism, a central issue to the Abstract Expressionists.

There are certain other artists who produced significant work in the Abstract Expressionist mode, although they did not affect the basic thrust or stylistic range of the movement to the same extent as the artists who are the focus of this book. In particular, I would single out Richard Pousette-Dart and Bradley Walker Tomlin, who vigorously explored many of the issues with which Abstract Expressionism was preoccupied. They made strong, deeply felt paintings without the obvious stylistic debt to others that guided the work of many artists. If their paintings lack the powerful emotional and pictorial counterpoint that we look for in major work, they are captivating nonetheless.

The section devoted to art critics focuses on essays written during the crucial first two decades of the movement. A certain freshness and urgency exists in writings of the period which later writings on the movement rarely have. Within the constraints of limited space my goal has been to compile a balanced selection of those texts that had the strongest and most illuminating viewpoints, including essays which were highly critical of the movement, for some of these are both insightful about the art and clearly indicative of the public temper that confronted Abstract Expressionism.

The European reviews that tracked "The New American Painting" exhibit through Europe during 1958 and 1959 make a critical sub-section. The show consisted largely of Abstract Expressionist work, and the mixed reviews help to re-create the historical moment.

I hope this anthology will lead the reader back to Abstract Expressionist art with both greater insight and greater curiosity. As David Smith said: "Words can be used to place art historically, to set it in social context, to describe the movements, to relate it to other works, to state individual preferences, and to set the scene all around it. But the actual understanding of a work of art only comes through the process by which it was created—and that was by perception."

CLIFFORD ROSS
May 1990
New York City

Acknowledgments

A project of this scope required the support of many people. It was undertaken with the initial encouragement of Robert Motherwell, whose *Dada Painters and Poets* provided the inspiration for this book. The late Bernard Karpel, librarian of The Museum of Modern Art, New York, and documentary editor for Motherwell's *The Documents of Twentieth Century Art*, was particularly helpful early on in my efforts.

The book could not have been published without the consent of numerous owners and custodians of copyright, some of whom lent valuable insight that improved the final shape of the book. I extend my gratitude to all of them. In particular I would like to thank: André Emmerich, Milton Esterow, Sanford Hirsch, Fred McDarrah, David McKee, Robert Motherwell, Hans Namuth, Kate Rothko Prizel, Rita Reinhardt, John Silberman, Rebecca and Candida Smith, Arthur Swoger, and Eugene Thaw.

I would also like to thank the following individuals for their help during the course of many years work: Linda Shearer, who provided the basis for the chronology; Arnold Glimcher for his support; Connie Rogers Tilton, for research assistance; and Henry Geldzahler, Barbara Rose, and Robert Rosenblum, who believed enough in my efforts to recommend the book for publication. Thanks to Patricia Crown and Amy Budinger for their assistance; Ellen Rosefsky for her careful copy editing; Uta Hoffmann for organizing the complex job of securing permissions; Judith Michael, who worked my myriad design requirements into a beautiful book; Mark Greenberg, my editor, for his insight and much appreciated guidance; and Paul Gottlieb, who gave me the opportunity to publish this book and allowed himself to get more involved than he wanted. Finally, I would like to thank my wife, Bonnie, who always tries to give me a healthy perspective on all things, and sometimes even succeeds.

C.R.

Our day of dependence, our long apprenticeship to the learning of other lands, draws to a close.

The American Scholar, 1837
RALPH WALDO EMERSON

The union is only perfect when all the uniters are isolated. It is the union of friends who live in different streets or towns. Each man, if he attempts to join himself to others, is on all sides cramped and diminished of his proportion; and the stricter the union the smaller and the more pitiful he is. But leave him alone, to recognize in every hour and place the secret soul; he will go up and down doing the works of a true member.

New England Reformers, 1844
RALPH WALDO EMERSON

Introduction by Clifford Ross

Abstract Expressionism is a "moniker," a label created by Robert Coates in 1946 during the early stages of the movement to grasp at the most obvious qualities of the work in question. He was reviewing a show by Hans Hofmann and used the term to replace "what some people call the spatter-and-daub school of painting." Not a very complimentary introduction to his newly coined term, but in the tradition of "Impressionism," "Fauve," and "Cubism," the term stuck. It quickly lassoed other artists working in a similar vein.

In the years 1945 to 1947, clear stylistic similarities existed in the work of Ad Reinhardt and Jackson Pollock, Mark Rothko and Adolph Gottlieb, artists whose later styles differed so markedly. At the time, their art was both abstract and expressionist. For however brief a period, these artists shared certain stylistic affinities as they were building a major collective aesthetic. It is this new aesthetic, their common ground, that interests us here.

The present point is simply that Abstract Expressionism became the encompassing label, in spite of the fact that the movement ultimately included certain styles that relied on explosive, multicolored brushwork and others that relied on monochromatic fields of smoothly applied paint. Not one major critic or artist staunchly defended the term's continued use, but the public needed a name for what it saw—and continues to see—as a connected effort. Abstract Expressionism has taken its place in the lexicon of art history.

By 1940 virtually all the major Abstract Expressionists had settled in New York City, or, in the cases of Clyfford Still and David Smith, had made lasting connections with those who were settled there. They had been born in the Netherlands, Russia, Germany, Canada, North Dakota, Wyoming, Washington, Indiana, Pennsylvania, and upstate New York. Only Adolph Gottlieb and Barnett Newman were native New Yorkers. Between 1942 and 1950, they consolidated their individual artistic struggles and forged a new aesthetic. What was their common experience?

The primary events leading up to and into this period were the Great Depression and Roosevelt's New Deal; World War II and the Allied victory over the Axis powers; and the harnessing of atomic power, which resulted in the creation of the atomic bomb. The two great calamities of the era had been dealt with successfully, while the most significant scientific achievement had culminated in the

creation of a weapon that, for the first time in human history, would be capable of destroying all life. The scale of events was astonishing and the United States was at the forefront of activity. At no time had greater power resided in one culture. This highly charged setting was the background in which the Abstract Expressionists were working.

Even though they were themselves on the outside edges of society, mostly clustered around Greenwich Village, the Village itself had become the world's cultural center, for in addition to the Abstract Expressionists, many European exiles had arrived in New York to escape the war in Europe, including André Breton, Marc Chagall, Marcel Duchamp, Max Ernst, John Graham, Fernand Léger, Jacques Lipchitz, André Masson, Roberto Matta, Piet Mondrian, and Yves Tanguy.

Between 1930 and 1940, the cultural mix was further enriched by exhibits of Dada, Surrealism, and Cubism; primitive art from Africa, South America, and Mexico; retrospectives of Picasso, Matisse, Klee, and Rivera; and shows including works by Kandinsky, Mondrian, Miró, Siqueiros, and Orozco. The Abstract Expressionist movement coincided with a continuing transfusion of modern European and Mexican art into American cultural life that had started with the Armory show of 1913.

The embrace of foreign cultures was not really a new experience for America, which had been so thoroughly dependent on Europe from its earliest stages, that in the 1850s Ralph Waldo Emerson was crisscrossing the country demanding the development of a specifically American culture, free from foreign influence and based on the unique qualities of the American individual.

His call was heeded by Hawthorne, Thoreau, Whitman, and Melville, whose novel *Moby Dick* was arguably America's first cultural masterpiece. But the visual arts lagged behind. Even such major artists as Frederick Church and Thomas Cole, leaders of the Hudson River School, were deeply indebted to the style of the German Romantics like Caspar David Friedrich and the classical landscapes of Claude Lorraine.

It was left to Albert Pinkham Ryder and Ralph Blakelock three decades later to create the first American paintings that relied primarily on a native sensibility and only secondarily on European aesthetics and style. Their obsessed, impastoed surfaces and particular use of organic, interlocking shapes propel their paintings toward the viewer in a way that had not been seen before in European art. One is struck by the physical presence of the work as much as by the mystical world it depicts.

In the early part of the twentieth century, a number of artists, including Stuart Davis, Charles Demuth, Arthur Dove, Marsden Hartley, and Georgia O'Keeffe, developed original styles connected to peculiarly American subject matter. A particular mysticism or simple emotional power pervades their best work, but one would still be hard pressed to define a central American aesthetic to which these artists were connected that transcended their indebtedness to Europe.

Of the period, Arthur Dove and post-1918 Marsden Hartley stand apart from the rest. There is a physical insistence to their work that is reminiscent of the quality we find in Ryder and Blakelock. Hartley, after 1918, relied on a heavily worked surface and an almost clumsy sense of design and color. Shapes and hues tend to push aggressively against each other in order to fill the surface of the painting. Dove, on the other hand, began to nestle his shapes and colors more and more intimately with each other, muting the individual elements and the surface in such a way as to create a unified, pulsating whole.

The work of both artists, regardless of differing degrees of abstraction, pushes toward the viewer from its frame, Hartley's with the quality of a restrained riot, and Dove's with the warm effulgence of a religious chant. The aesthetic impulse first glimpsed in Ryder and Blakelock had begun to find focus in two different styles, and it is not hard to see these styles as the precursors of what blossomed thirty years later in the work of de Kooning and Rothko.

The Abstract Expressionists continued to explore art from other cultures as their predecessors had done. Intuitively, and in differing proportions, they bore down on the lessons of Cubist drawing, Fauve color, the iconic qualities of primitive art, and the attitudes of Surrealism.

The importance of Surrealism cannot be underestimated. The key to it was a deep philosophical belief in the importance of the individual subconscious, particularly as it might relate to a larger collective one. In a sense, Surrealism gave powerful license to the Abstract Expressionists to explore their own personalities and stylistic impulses to the fullest as they developed a central, collective aesthetic. It allowed them unbridled individuality, yet—despite strong denials by some of the artists—gave their work a shared focus.

As Abstract Expressionism matured, the artists shared fewer and fewer stylistic traits, but they all developed styles of extraordinary force. And while all of the aesthetics and styles to which the Abstract Expressionists had turned were forceful, they were forceful

without totally abandoning certain traditional notions of depiction, composition, or the sense that art should reside at some remove from the viewer.

Mondrian and Malevich, the two artists who had previously come closest to producing a pure, abstract art, were ultimately bound to both a strict Cubist flatness and an innate European elegance which prevented their work from projecting toward the viewer as objects in their own right. When looking at their work, one feels that they are still describing "something else," a piece of exterior reality, however abstractly.

If one compares Reinhardt's rectangles of color to Mondrian's, a difference is clear. As radical as Mondrian's images are, his color planes reside comfortably on the wall. We contemplate the exquisite balance of his rectangles and can sense the relation of his images to the flat landscape of his native Holland. With Reinhardt's black paintings, we are thrown back on ourselves, and not out to any aspect of the exterior world. The slight variations in the darkly colored rectangles are constantly subsumed under our forced contemplation of the whole. It is a subtle yet ultimately aggressive assault, totally different from the experience of viewing Mondrian's work.

And if we compare Mondrian to Hofmann, the difference is even more striking. With Hofmann the viewer is required to reckon with planes of color that have become forces of nature in themselves.

By 1950, the shared early styles of Abstract Expressionism had completely dissolved, giving way to twelve distinct styles which supported a single, new aesthetic. With their mature works, the Abstract Expressionists created highly charged images which force the viewer to recall and experience a range of powerful emotions and feelings, in effect giving the public an opportunity to experience the same confrontation with the subconscious that attended the artists during creation.

Abstract Expressionist images invoke; they do not depict. They confront; they do not describe. Even de Kooning's *Women*, although focused around a recognizable image, present themselves more as the aesthetic detritus of a collision with the subconscious than a depiction of it. Reinhardt's unified symmetrical structures, Newman's commanding fields of color, Pollock's skeins of flung paint, and Motherwell's iconic shapes all serve the same end. The Abstract Expressionists, through various stylistic methods, had turned art into a heroic, one-on-one confrontation with the subconscious. Abstract Expressionism fulfilled Emerson's dream of a great, indigenous art based on the individual.

Willem de Kooning
Woman I, 1950–52
Oil on canvas, 75⅞ × 58″
Collection, The Museum of Modern Art, New York, Purchase

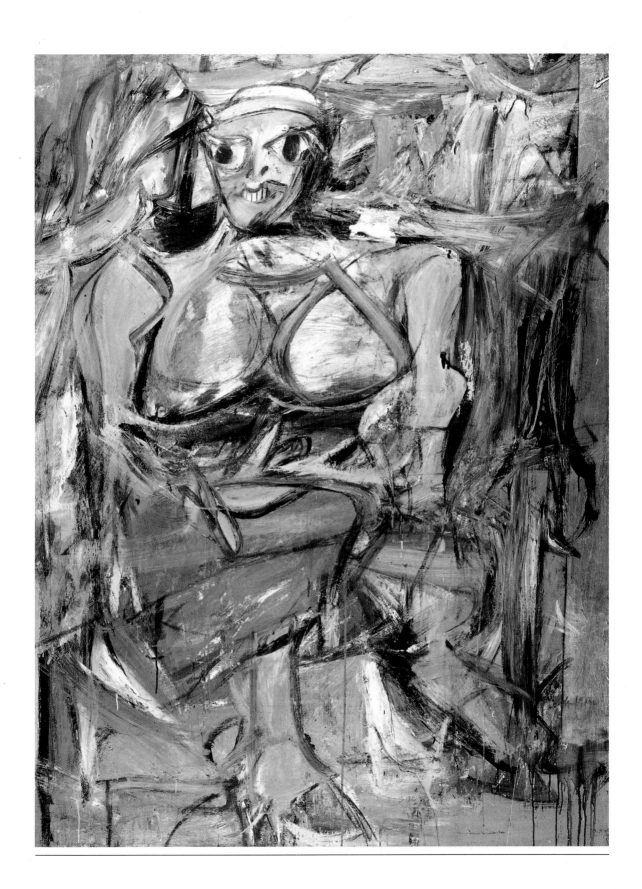

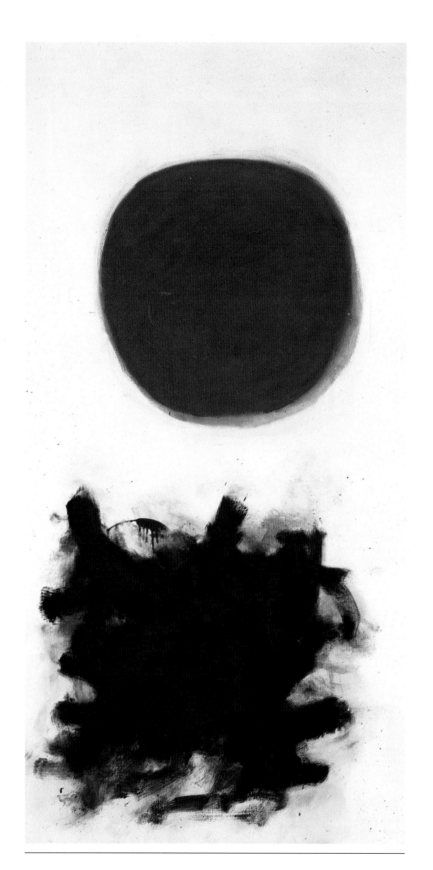

Adolph Gottlieb
Blast I, 1957
Oil on canvas, 90 × 45⅛″
Collection, The Museum
of Modern Art, New York.
Philip Johnson Fund

OPPOSITE:
Philip Guston
The Room, 1954–55
Oil on canvas, 60 × 71⅞″
The Los Angeles County
Museum of Art

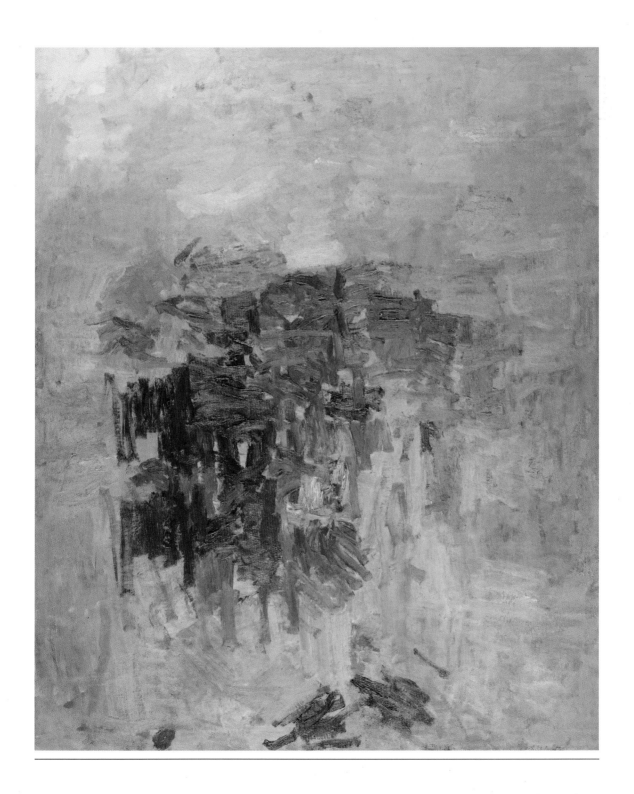

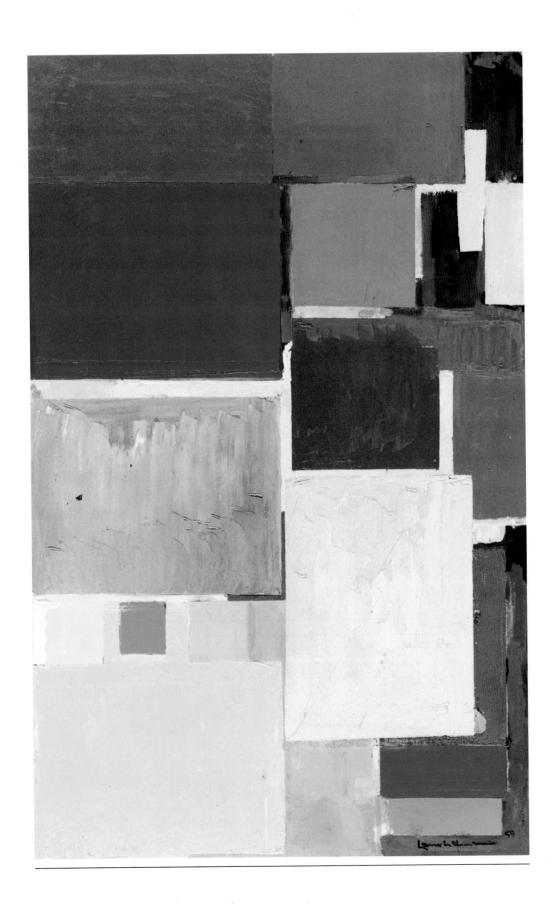

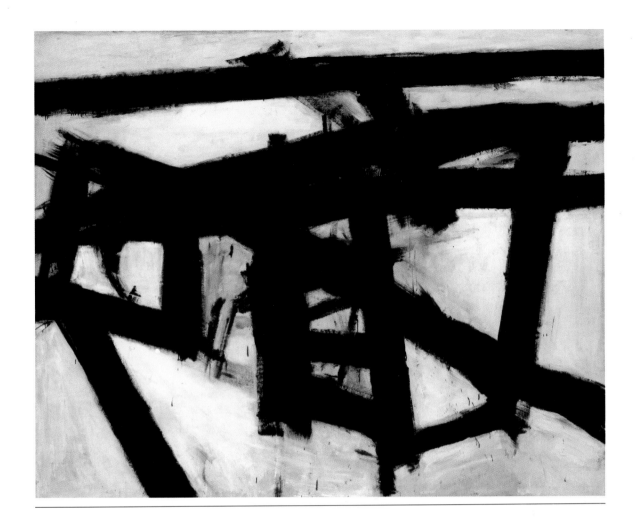

Franz Kline
Mahoning, 1956
Oil on canvas, 80 × 100″
Collection of Whitney Museum
of American Art. Purchase,
with funds from the Friends
of the Whitney
Museum of Art 57.10

OPPOSITE:
Hans Hofmann
Cathedral, 1959
Oil on canvas, 74¼ × 48¼″
Promised gift to The Museum
of Modern Art

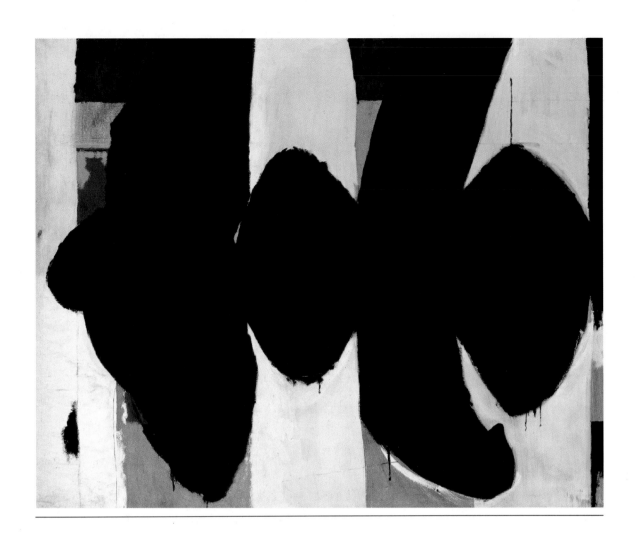

Robert Motherwell
*Elegy to the Spanish Republic
No. 34*, 1953–54
Oil on canvas, 80 × 100″
Albright-Knox Gallery Buffalo,
New York
Gift of Seymour H. Knox, 1957

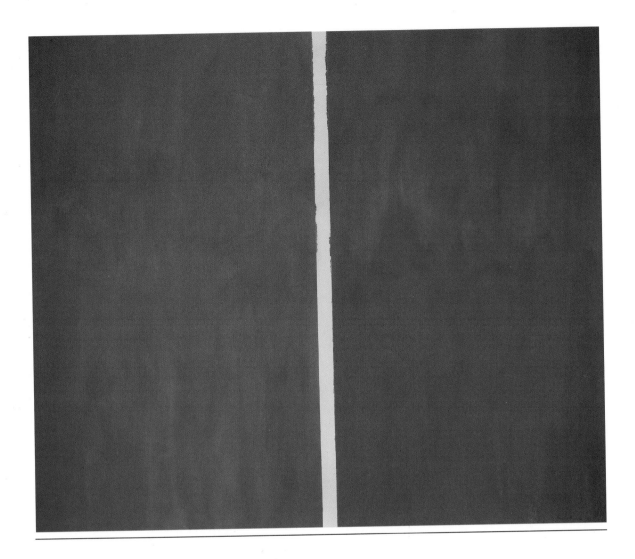

Barnett Newman
Onement VI, 1953
Oil on canvas, 102 × 120″
Collection Mr. and
Mrs. Peter Brandt

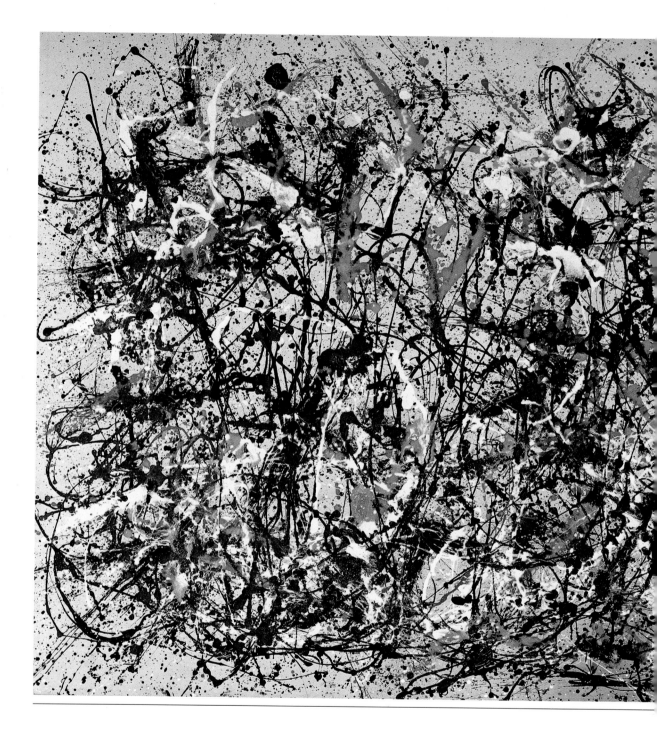

Jackson Pollock
Autumn Rhythm (Number 30),
1950
Oil on canvas, 105×207″
The Metropolitan Museum
of Art, George A. Hearn
Fund, 1957 (57.92)

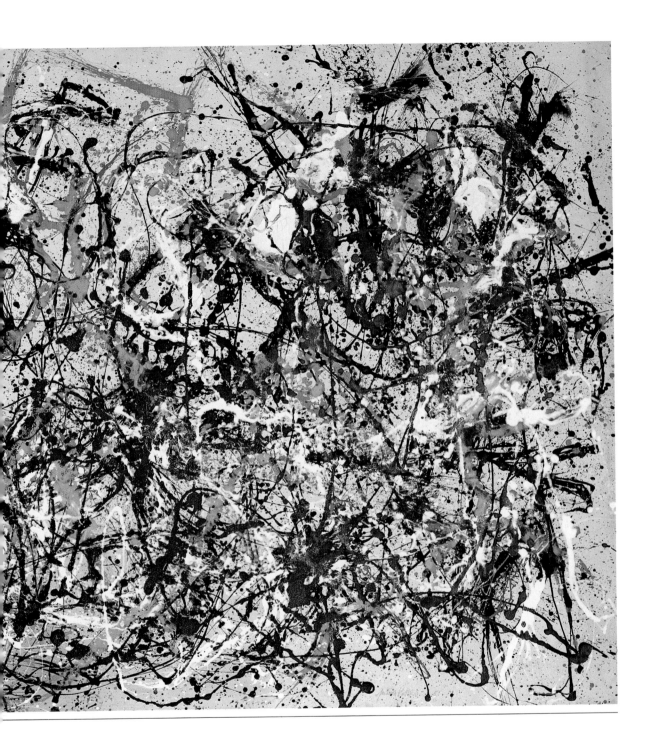

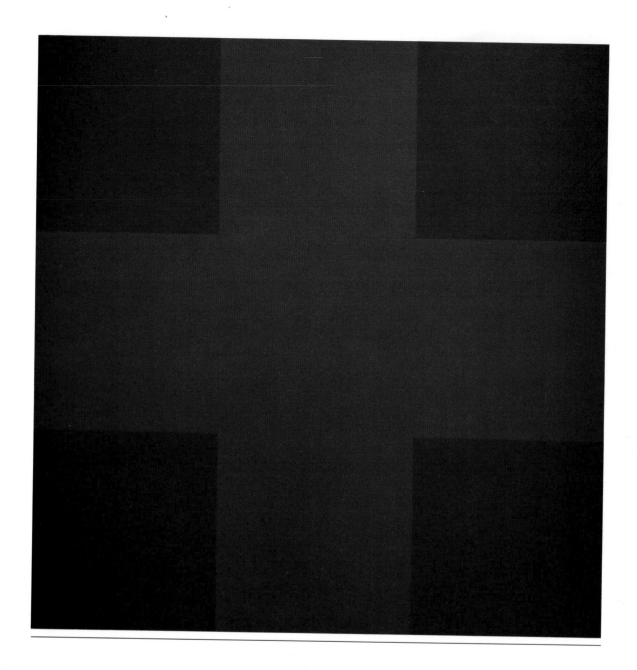

Ad Reinhardt
Abstract Painting, 1960–61
Oil on canvas, 60 × 60″
Collection, The Museum of
Modern Art, New York
Purchase (by exchange)

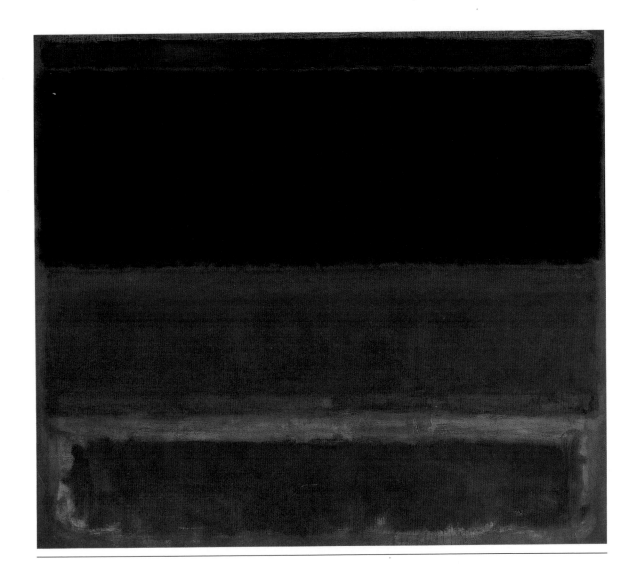

Mark Rothko
Four Darks in Red, 1958
Oil on canvas, 102 × 116″
Collection of Whitney Museum
of American Art.
Purchase, with funds of the
Friends of the Whitney
Museum of American Art. 68.9

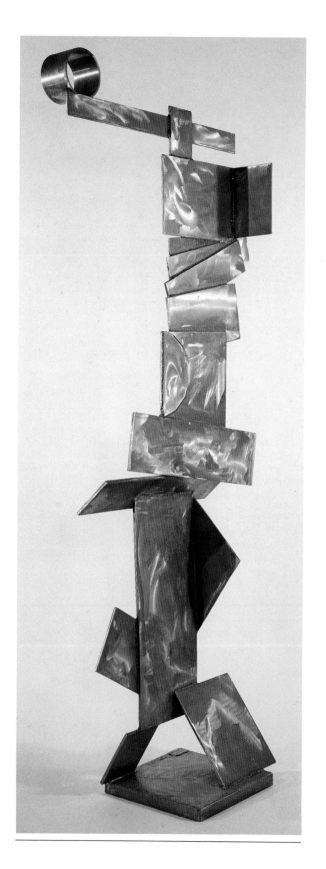

David Smith
Lectern Sentinel, 1961
Stainless steel,
101¾ × 33 × 20½″
Collection Whitney Museum
of American Art. Purchase,
with funds of the Friends of the
Whitney Museum of American
Art. 62.15

Clyfford Still
1957–D No. 1, 1957
Oil on canvas, 113 × 159″
Collection Albright-Knox Art
Gallery Buffalo, New York,
Gift of Seymour H. Knox, 1959

Part I: Creators

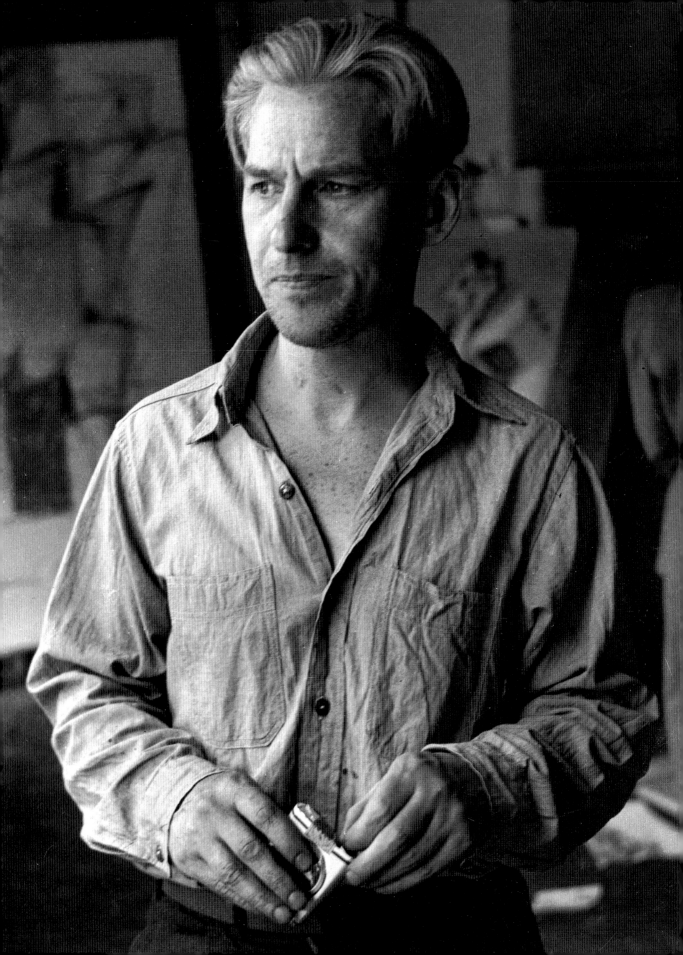

Willem de Kooning

Letter to the editor of *ARTnews*, 1949

Sir:

In a piece on Arshile Gorky's memorial show—and it was a very
little piece indeed—it was mentioned that I was one of his
influences. Now that is plain silly. When, about fifteen years ago, I
walked into Arshile's studio for the first time, the atmosphere was so
beautiful that I got a little dizzy and when I came to, I was bright
enough to take the hint immediately. If the bookkeepers think it
necessary continuously to make sure of where things and people
come from, well then, I come from 36 Union Square. It is
incredible to me that other people live there now. I am glad that it
is about impossible to get away from his powerful influence. As long
as I keep it with myself I'll be doing all right. Sweet Arshile, bless
your dear heart.

Yours, etc.
Willem de Kooning
New York, N.Y.

from *ARTnews*, vol. 47, no. 9, January 1949 © *ARTnews*, XLVII, No. 9, January 1949.
Reprinted with permission.

"The Renaissance and Order," 1950

There is a train track in the history of art that goes way back to
Mesopotamia. It skips the whole Orient, the Mayas, and American
Indians. Duchamp is on it. Cézanne is on it. Picasso and the
Cubists are on it; Giacometti, Mondrian and so many, many more—
whole civilizations. Like I say, it goes way in and back to
Mesopotamia for maybe five thousand years, so there is no sense in
calling out names. The reason I mention Duchamp is because he
was one of the artists in *Life*'s half-century number. But I have some
feeling about all these people—millions of them—on this enormous
track: way into history. They had a peculiar way of measuring. They
seemed to measure with a length similar to their own height. For
that reason they could imagine themselves in almost any

Willem de Kooning, c. 1950
Photograph by Rudolph
Burkhardt

proportions. That is why I think Giacometti's figures are like real people. The idea that the thing that the artist is making can come to know for itself, how high it is, how wide and how deep it is, is a historical one—a traditional one I think. It comes from man's own image.

I admit I know little of Oriental art. But that is because I cannot find in it what I am looking for, or what I am talking about. To me the Oriental idea of beauty is that "it isn't here." It is in a state of not being here. It is absent. That is why it is so good. It is the same thing I don't like in Suprematism, Purism and non-objectivity.

And, although I, myself, don't care for all the pots and pans in the paintings of the burghers—the genre scenes of goodly living which developed into the kind sun of Impressionism later on—I do like the idea that they—the pots and pans, I mean—are always in relation to man. They have no soul of their own, like they seem to have in the Orient. For us, they have no character; we can do anything we please with them. There is this perpetual irritability. Nature, then, is just nature. I admit I am very impressed with it.

The attitude that nature is chaotic and that the artist puts order into it is a very absurd point of view, I think. All that we can hope for is to put some order into ourselves. When a man ploughs his field at the right time, it means just that.

Insofar as we understand the universe—if it can be understood—our doings must have some desire for order in them; but from the point of view of the universe, they must be very grotesque. . . .

excerpted from *trans/formation*, vol. 1, no. 2, 1951, pp. 85–87 © Willem de Kooning

This was written for a lecture given at Studio 35 in 1950. *trans/formation*, "a world review of arts, communication, and environment," was a publication edited by Harry Holtzman with the aid of Nicolas Calas, Stuart Davis, and Marcel Duchamp, which centered around issues involving art, science, and technology. Three issues appeared, 1950–52.

"What Abstract Art Means to Me," 1951

The first man who began to speak, whoever he was, must have intended it. For surely it is talking that has put "Art" into painting. Nothing is positive about art except that it is a word. Right from there to here all art became literary. We are not yet living in a world where everything is self-evident. It is very interesting to notice that a lot of people who want to take the talking out of painting, for instance, do nothing else but talk about it. That is no contradiction, however. The art in it is the forever mute part you can talk about forever.

For me, only one point comes into my field of vision. This narrow, biased point gets very clear sometimes. I didn't invent it. It was already here. Everything that passes me I can see only a little of, but I am always looking. And I see an awful lot sometimes.

The word "abstract" comes from the light-tower of the philosophers, and it seems to be one of their spotlights that they have particularly focused on "Art." So the artist is always lighted up by it. As soon as it—I mean the "abstract"—comes into painting, it ceases to be what it is as it is written. It changes into a feeling which could be explained by some other words, probably. But one day, some painter used "Abstraction" as a title for one of his paintings. It was a still life. And it was a very tricky title. And it wasn't really a very good one. From then on the idea of abstraction became something extra. Immediately it gave some people the idea that they could free art from itself. Until then, Art meant everything that was in it—not what you could take out of it. There was only one thing you could take out of it sometime when you were in the right mood—that abstract and indefinable sensation, the aesthetic part—and still leave it where it was. For the painter to come to the "abstract" or the "nothing" he needed many things. Those things were always things in life—a horse, a flower, a milkmaid, the light in a room through a window made of diamond shapes maybe, tables, chairs, and so forth. The painter, it is true, was not always completely free. The things were not always of his own choice, but because of that he often got some new ideas. Some painters liked to paint things already chosen by others, and after being abstract about them, were called Classicists. Others wanted to select the things themselves and, after being abstract about them, were called Romanticists. Of course, they got mixed up with one another a lot too. Anyhow, at that time, they were not abstract about something which was already abstract. They freed the shapes, the light, the color, the space, by putting them into concrete things in a given situation. They *did* think about the possibility that the things—the horse, the chair, the man—were abstractions, but they let that go, because if they kept thinking about it, they would have been led to give up painting altogether, and would probably have ended up in the philosopher's tower. When they got those strange, deep ideas, they got rid of them by painting a particular smile on one of the faces in the picture they were working on.

The aesthetics of painting were always in a state of development parallel to the development of painting itself. They influenced each other and vice versa. But all of a sudden, in that famous turn of the century, a few people thought they could take the bull by the horns and invent an aesthetic beforehand. After immediately disagreeing

with each other, they began to form all kinds of groups, each with the idea of freeing art, and each demanding that you should obey them. Most of these theories have finally dwindled away into politics or strange forms of spiritualism. The question, as they saw it, was not so much what you *could* paint but rather what you could *not* paint. You could *not* paint a house or a tree or a mountain. It was then that subject matter came into existence as something you ought *not* to have.

In the old days, when artists were very much wanted, if they got to thinking about their usefulness in the world, it could only lead them to believe that painting was too worldly an occupation and some of them went to church instead or stood in front of it and begged. So what was considered too worldly from a spiritual point of view then, became later—for those who were inventing the new aesthetics—a spiritual smoke-screen and not worldly enough. These latter-day artists were bothered by their apparent uselessness. Nobody really seemed to pay any attention to them. And they did not trust that freedom of indifference. They knew that they were relatively freer than ever before *because* of that indifference, but in spite of all their talking about freeing art, they really didn't mean it that way. Freedom to them meant to be useful in society. And that is really a wonderful idea. To achieve that, they didn't need *things* like tables and chairs or a horse. They needed ideas instead, social ideas, to make their objects with, their constructions—the "pure plastic phenomena"—which were used to illustrate their convictions. Their point was that until they came along with their theories, Man's own form in space—his body—was a private prison; and that it was because of this imprisoning misery—because he was hungry and overworked and went to a horrid place called home late at night in the rain, and his bones ached and his head was heavy—because of this very consciousness of his own body, this sense of pathos, they suggest, he was overcome by the drama of a crucifixion in a painting or the lyricism of a group of people sitting quietly around a table drinking wine. In other words, these aestheticians proposed that people had up to now understood painting in terms of their own private misery. Their own sentiment of form instead was one of comfort. The beauty of comfort. The great curve of a bridge was beautiful because people could go across the river in comfort. To compose with curves like that, and angles, and make works of art with them could only make people happy, they maintained, for the only association was one of comfort. That millions of people have died in war since then, because of that idea of comfort, is something else.

This pure form of comfort became the comfort of "pure form."

The "nothing" part in a painting until then—the part that was not painted but that was there because of the things in the picture which were painted—had a lot of descriptive labels attached to it like "beauty," "lyric," "form," "profound," "space," "expression," "classic," "feeling," "epic," "romantic," "pure," "balance," etc. Anyhow that "nothing" which was always recognized as a particular something—and as something particular—they generalized, with their book-keeping minds, into circles and squares. They had the innocent idea that the "something" existed "in spite of" and not "because of" and that this something was the only thing that truly mattered. They had hold of it, they thought, once and for all. But this idea made them go backward in spite of the fact that they wanted to go forward. That "something" which was not measurable, they lost by trying to make it measurable; and thus all the old words which, according to their ideas, ought to be done away with got into art again: pure, supreme, balance, sensitivity, etc.

Kandinsky understood "Form" as *a* form, like an object in the real world; and an object, he said, was a narrative—and so, of course, he disapproved of it. He wanted his "music without words." He wanted to be "simple as a child." He intended, with his "inner-self," to rid himself of "philosophical barricades" (he sat down and wrote something about all this). But in turn his own writing has become a philosophical barricade, even if it is a barricade full of holes. It offers a kind of Middle European idea of Buddhism or, anyhow, something too theosophic for me.

The sentiment of the Futurists was simpler. No space. Everything ought to keep on going! That's probably the reason they went themselves. Either a man was a machine or else a sacrifice to make machines with.

The moral attitude of Neo-Plasticism is very much like that of Constructivism, except that the Constructivists wanted to bring things out in the open and the Neo-Plasticists didn't want anything left over.

I have learned a lot from all of them and they have confused me plenty too. One thing is certain, they didn't give me my natural aptitude for drawing. I am completely weary of their ideas now.

The only way I still think of these ideas is in terms of the individual artists who came from them or invented them. I still think that Boccioni was a great artist and a passionate man. I like Lissitzky, Rodchenko, Tatlin and Gabo; and I admire some of Kandinsky's painting very much. But Mondrian, that great merciless artist, is the only one who had nothing left over.

The point they all had in common was to be both inside and outside at the same time. A new kind of likeness! The likeness of

the group instinct. All that it has produced is more glass and a hysteria for new materials which you can look through. A symptom of love-sickness, I guess. For me, to be inside and outside is to be in an unheated studio with broken windows in the winter, or taking a nap on somebody's porch in the summer.

Spiritually I am wherever my spirit allows me to be, and that is not necessarily in the future. I have no nostalgia, however. If I am confronted with one of those small Mesopotamian figures, I have no nostalgia for it but, instead, I may get into a state of anxiety. Art never seems to make me peaceful or pure. I always seem to be wrapped in the melodrama of vulgarity. I do not think of inside or outside—or of art in general—as a situation of comfort. I know there is a terrific idea there somewhere, but whenever I want to get into it, I get a feeling of apathy and want to lie down and go to sleep. Some painters, including myself, do not care what chair they are sitting on. It does not even have to be a comfortable one. They are too nervous to find out where they ought to sit. They do not want to "sit in style." Rather, they have found that painting—any kind of painting, any style of painting—to be painting at all, in fact—is a way of living today, a style of living, so to speak. That is where the form of it lies. It is exactly in its uselessness that it is free. Those artists do not want to conform. They only want to be inspired.

The group instinct could be a good idea, but there is always some little dictator who wants to make his instinct the group instinct. There *is* no style of painting now. There are as many naturalists among the abstract painters as there are abstract painters in the so-called subject-matter school.

The argument often used that science is really abstract, and that painting could be like music and, for this reason, that you cannot paint a man leaning against a lamp-post, is utterly ridiculous. That space of science—the space of the physicists—I am truly bored with by now. Their lenses are so thick that seen through them, the space gets more and more melancholy. There seems to be no end to the misery of the scientists' space. All that it contains is billions and billions of hunks of matter, hot or cold, floating around in darkness according to a great design of aimlessness. The stars *I* think about, if I could fly, I could reach in a few old-fashioned days. But physicists' stars I use as buttons, buttoning up curtains of emptiness. If I stretch my arms next to the rest of myself and wonder where my fingers are—that is all the space I need as a painter.

Today, some people think that the light of the atom bomb will change the concept of painting once and for all. The eyes that actually saw the light melted out of sheer ecstasy. For one instant,

Willem de Kooning, 1968
Photograph by Hans Namuth

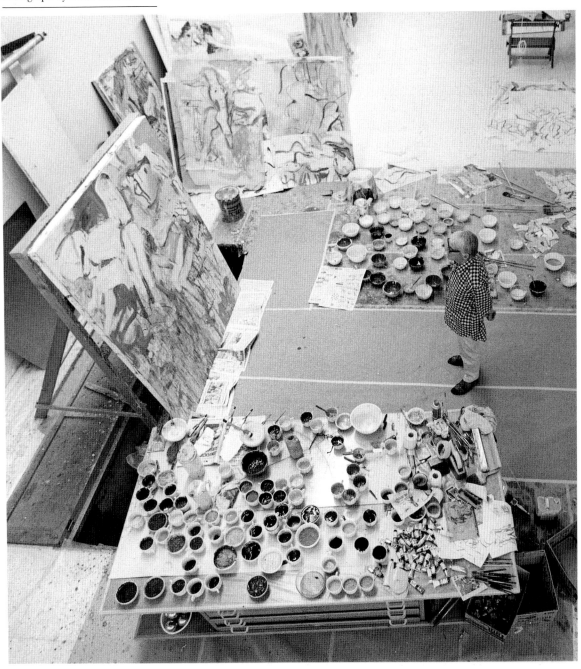

everybody was the same color. It made angels out of everybody. A truly Christian light, painful but forgiving.

Personally, I do not need a movement. What was given to me, I take for granted. Of all movements, I like Cubism most. It had that wonderful unsure atmosphere of reflection—a poetic frame where something could be possible, where an artist could practice his intuition. It didn't want to get rid of what went before. Instead it added something to it. The parts that I can appreciate in other movements came out of Cubism. Cubism *became* the movement, it didn't set out to be one. It has force in it, but it was no "force-movement." And then there is that one-man movement, Marcel Duchamp—for me a truly modern movement because it implies that each artist can do what he thinks he ought to—a movement for each person and open for everybody.

If I *do* paint abstract art, that's what abstract art means to me. I frankly do not understand the question. About twenty-four years ago, I knew a man in Hoboken, a German who used to visit us in the Dutch Seamen's Home. As far as he could remember, he was always hungry in Europe. He found a place in Hoboken where bread was sold a few days old—all kinds of bread: French bread, German bread, Italian bread, Dutch bread, Greek bread, American bread and particularly Russian black bread. He bought big stacks of it for very little money, and let it get good and hard and then he crumpled it and spread it on the floor in his flat and walked on it as on a soft carpet. I lost sight of him, but found out many years later that one of the other fellows met him again around 86th Street. He had become some kind of Jugend Bund leader and took boys and girls to Bear Mountain on Sundays. He is still alive but quite old and is now a Communist. I could never figure him out, but now when I think of him, all that I can remember is that he had a very abstract look on his face.

from *The Museum of Modern Art Bulletin*, vol. 18, no. 3, spring 1951, pp. 4–8. Reprinted with permission of The Museum of Modern Art, New York. © Willem de Kooning

De Kooning read this paper at a symposium held at The Museum of Modern Art, New York, on February 5, 1951, in conjunction with the exhibition *Abstract Painting and Sculpture in America*. The five other participants were George L. K. Morris, Alexander Calder, Fritz Glarner, Robert Motherwell, and Stuart Davis.

Film transcript, 1960

You know how an artist works. I said that when I was painting those figures, I got a feeling like I came into a room someplace—I saw

somebody sitting in a chair; I had a glimpse of this thing—like a happening. And I got interested in painting that—like a frozen glimpse.

I look out of the window, and it happens over there; Or I can sit in a chair, sit and think. That's the beginning—and I find myself staying with it, not so much with this particular glimpse, but with the emotion of it.

Y'know the real world, this so-called real world, is just something you put up with, like everybody else. I'm in my element when I am a little bit out of this world. Then I'm in the real world—I'm on the beam. Because when I'm falling, I'm doing all right. When I'm slipping, I say, hey, this is interesting! It's when I'm standing upright that bothers me. I'm not doing so good; I'm stiff. As a matter of fact, I'm really slipping, most of the time, into that glimpse. I'm like a slipping glimpser.

excerpted from film script, Sketchbook I, *Time, Inc.*, 1960, pp. 5, 9. Reprinted with permission. © Willem de Kooning

De Kooning's comments were transcribed by an editor from the soundtrack of a documentary film.

Interview with David Sylvester, 1963

When we went to the Academy [in Rotterdam, in the early 1920s]—doing painting, decorating, making a living—young artists were not interested in painting *per se*. We used to call that "good for men with beards." And the idea of a palette, with colors on it, was rather silly. At that time we were influenced by the de Stijl group. The idea of being a modern person wasn't really being an artist in the sense of being a painter. So it wasn't illogical to come to America [instead of going to Paris]. Also, being young, I really didn't understand the nature of painting. I really intended to become an applied artist. I mean, it was more logical to be a designer or a commercial artist. I didn't intend to become a painter—that came later.

 I didn't expect that there were any artists here. We never heard in Holland that there were artists in America. There was still the feeling that this was where an individual could get places and become well off, if he worked hard; while art, naturally, was in

Europe. When I had been here for about six months or a year I found out that there were a lot of artists here too. There was Greenwich Village; there was a whole tradition in painting and in poetry. I just didn't know about it, and it must have directed me back to interests I had when I was fourteen, fifteen, sixteen years old. When you're about nineteen and twenty, you really want to go up in the world and you don't mind giving up art.

I was here only about three days when I got a job in Hoboken as a house painter. I made nine dollars a day, which was quite a large salary, and after being around four or five months doing that, I started looking for a job doing applied art-work. I made some samples and I was hired immediately. I didn't even ask them the salary because I thought if I made twelve dollars a day as a house painter, I would make at least twenty dollars a day being an artist. Then at the end of two weeks, the man gave me twenty-five dollars and I was so astonished I asked him if that was a day's pay. He said, "No, that's for a whole week." And I immediately quit and went back to house painting. It took quite a while for me to make the shift from being a Sunday painter, working most of the time and painting once in a while, to painting for longer periods and taking odd jobs here and there on the side. It was a gradual development and it was really more of a psychological attitude: that it was better to say, "No. I'm an artist. I have to do something on the side to make a living." So I styled myself an artist and it was very difficult. But it was a much better state of mind.

Then, when the Depression came, I got on the WPA, and I met all kinds of other painters and sculptors and writers and poets and architects, all in the same boat, because America never really cared much for people who do those things. I was on the Project about a year or a year and a half, and that really made it stick, this attitude, because the amount of money we made on the Project was rather fair; in the Depression days one could live modestly and nicely. So I felt, well, I have to just keep doing that. The decision to take was: was it worth it to put all my eggs in one basket, that kind of basket of art. I didn't know if I really was competent enough, if I felt it enough.

I met a lot of artists—but then I met Gorky. I had some training in Holland, quite a training, the Academy. Gorky didn't have that at all. He came from no place; he came here when he was sixteen, from Tiflis in Georgia, with an Armenian upbringing. And for some mysterious reason, he knew lots more about painting and art—he just knew it by nature—things I was supposed to know and feel and understand—he really did it better. He had an extraordinary gift for hitting the nail on the head; very remarkable. So I immediately

attached myself to him and we became very good friends. It was nice to be foreigners meeting in some new place. Of course, New York is really like a Byzantine city—it is very natural too. I mean, that is probably one of the reasons why I came myself, without knowing. When I was a child I was very interested in America; it was romantic . . . cowboys and Indians. Even the shield, the medieval shield they have with the stars on top and the stripes on the bottom, was almost like the heraldic period of the Crusaders, with the eagle; as a child I used to be absolutely fascinated by this image.

Now that is all over. It's not so much that I'm an American: I'm a New Yorker. I think we have gone back to the cities, and I feel much more in common with artists in London or Paris. It is a certain burden, this American-ness. If you come from a small nation, you don't have that. When I went to the Academy and I was drawing from the nude, *I* was making the drawing, not Holland. I feel sometimes an American artist must feel, like a baseball player or something—a member of a team writing American history. . . . I think it is kind of nice that at least part of the public is proud that they have their own sports and things like that—and why not their own art? I think it's wonderful that you know where you came from—I mean you know, if you are American, you are an American.

Certain artists and critics attacked me for painting the *Women*, but I felt that this was their problem, not mine. I don't really feel like a non-objective painter at all. Today, some artists feel they have to go back to the figure, and that word "figure" becomes such a ridiculous omen—if you pick up some paint with your brush and make somebody's nose with it, this is rather ridiculous when you think of it, theoretically or philosophically. It's really absurd to make an image, like a human image, with paint, today, when you think about it, since we have this problem of doing it or not doing it. But then all of a sudden it was even more absurd not to do it. So I fear that I have to follow my desires.

The *Women* had to do with the female painted through all the ages, all those idols, and maybe I was stuck to a certain extent; I couldn't go on. It did one thing for me: it eliminated composition, arrangement, relationships, light—all this silly talk about line, color and form—because that was the thing I wanted to get hold of. I put it in the center of the canvas because there was no reason to put it a bit on the side. So I thought I might as well stick to the idea that it's got two eyes, a nose and mouth and neck. I got to the anatomy and I felt myself almost getting flustered. I really could never get hold of it. I almost petered out. I never could complete it

Willem de Kooning
Untitled, 1951
Paint on paper mounted
on canvas, 22¼ × 30¼"
Collection Jasper Johns,
New York

and when I think of it now, it wasn't such a bright idea. But I don't
think artists have particularly bright ideas. Matisse's *Woman in a
Red Blouse*—what an idea that is! Or the Cubists—when you think
about it now, it is so silly to look at an object from many angles.
Constructivism—open, not closed. It's very silly. It's good that they
got those ideas because it was enough to make some of them great
artists.

Painting the *Women* is a thing in art that has been done over and
over—the idol, Venus, the nude. Rembrandt wanted to paint an old
man, a wrinkled old guy—that was painting to him. Today artists
are in a belated age of reason. They want to get hold of things. Take
Mondrian; he was a fantastic artist. But when we read his ideas and
his idea of Neo-Plasticism—pure plasticity—it's kind of silly. Not
for him, but I think one could spend one's life having this desire to
be in and outside at the same time. He could see a future life and a
future city—not like me, who am absolutely not interested in seeing
the future city. I'm perfectly happy to be alive now.

The *Women* became compulsive in the sense of not being able to
get hold of it—it really is very funny to get stuck with a woman's
knees, for instance. You say, "What the hell am I going to do with
that now?"; it's really ridiculous. It may be that it fascinates me,
that it isn't supposed to be done. A lot of people paint a figure
because they feel it ought to be done, because since they're human
beings themselves, they feel they ought to make another one, a
substitute. I haven't got that interest at all. I really think it's sort of

silly to do it. But the moment you take this attitude it's just as silly not to do it.

It became a problem of picture painting, because the very fact that it had words connected with it—"figure of a woman"—made it more precise. Perhaps I am more of a novelist than a poet, but I always like the word in painting. Forms ought to have the emotion of a concrete experience. For instance, I am very happy to see that grass is green. At one time, it was very daring to make a figure red or blue—I think now that it is just as daring to make it flesh-colored.

Content is a glimpse of something, an encounter like a flash. It's very tiny—very tiny, content. When I was painting those figures, I was thinking about Gertrude Stein, as if they were ladies of Gertrude Stein—as if one of them would say, "How do you like me?" Then I could sustain this thing all the time because it could change all the time; she could almost get upside down, or not be there, or come back again, she could be any size. Because this content could take care of almost anything that could happen.

I still have it now from fleeting things—like when one passes something, and it makes an impression, a simple stuff.

I wasn't concerned to get a particular kind of feeling. I look at them now and they seem vociferous and ferocious. I think it had to do with the idea of the idol, the oracle, and above all the hilariousness of it. I do think that if I don't look upon life that way, I won't know how to keep on being around.

I cut out a lot of mouths. First of all, I thought everything ought to have a mouth. Maybe it was like a pun. Maybe it's sexual. But whatever it is, I used to cut out a lot of mouths and then I painted those figures and then I put the mouth more or less in the place where it was supposed to be. It always turned out to be very beautiful and it helped me immensely to have this real thing. I don't know why I did it with the mouth. Maybe the grin—it's rather like the Mesopotamian idols, they always stand up straight, looking to the sky with this smile, like they were just astonished about the forces of nature you feel, not about problems they had with one another. That I was very conscious of—the smile was something to hang on to.

I wouldn't know what to do with the rest, with the hands, maybe, or some gesture, and then in the end I failed. But it didn't bother me because I had, in the end, given it up; I felt it was really an accomplishment. I took the attitude that I was going to succeed, and I also knew that this was just an illusion. I never was interested in how to make a good painting. For many years I was not interested in making a good painting—as one might say, "Now this is really a

good painting" or "perfect work." I didn't work on it with the idea
of perfection, but to see how far one could go—but not with the idea
of really doing it. With anxiousness and dedication to fright maybe,
or ecstasy, like the *Divine Comedy*, to be like a performer: to see
how long you can stay on the stage with that imaginary audience.

The pictures done since the *Women*, they're emotions, most of
them. Most of them are landscapes and highways and sensations of
that, outside the city—with the feeling of going to the city or
coming from it. I'm not a pastoral character. I'm not a—how do you
say that?—"country dumpling." I am here, and I like New York
City. But I love to go out in a car. I'm crazy about weekend drives,
even if I drive in the middle of the week. I'm just crazy about going
over the roads and highways. . . . They are really not very pretty,
the big embankments and the shoulders of the roads and the curves
are flawless—the lawning of it, the grass. This I don't particularly
like or dislike, but I wholly approve of it. Like the signs. Some
people want to take the signs away, but it would break my heart. All
those different big billboards. There are places in New England
where they are not allowed to put those signs, and that's nice too,
but I love those grotesque signs. I mean, I am not undertaking any
social . . . I'm no lover of the new—it's a personal thing.

When I was working on this *Merritt Parkway* picture, this thing
came to me: it's just like the Merritt Parkway. I don't think I set out
to do anything, but I find because of modern painting that things
which couldn't be seen in terms of painting, things you couldn't
paint, for instance, are now—it's not that you paint them but it is
the connection.

I imagine that Cézanne, when he painted a ginger pot and apples
and ordinary everyday wine bottles, must have been very grotesque
in his day, because a still-life was something set up of beautiful
things. It may be very difficult, for instance, to put a Rheingold
bottled beer on the table and a couple of glasses and a package of
Lucky Strikes. There are certain things you cannot paint at a
particular time; and it takes a certain attitude, how to see those
things in terms of art. You feel those things and inasmuch as I
should set out to paint Merritt Parkway years ago, it seems I must
have liked it so much I must have subconsciously found a way of
setting it down on paper, on canvas. It could be that—I'm not sure.

Now I can make some highways, maybe. Of course, there will be
something else. Now I can set out to do it, and then it will be,
maybe it will be a painting of something else. Because if you know
the measure of something—for yourself there's no absolute
measure—you can find the size of something. You say now that's
just this length and immediately with that length you can paint,

well, a cat. If you understand one thing, you can use it for
something else. That is the way I work. I get hold of a certain kind
of area or measure or size and then I can use it. I mean, I have an
attitude. I have to have an attitude.

I feel now if I think of it, it will come out in the painting. In
other words, if I want to make the whole painting look like a bottle,
like a lot of bottles, for instance—maybe the end of the day, when
everything is very light, but not in sunlight necessarily—and so if I
have this image of this bottle and if I really think about it, it will
come out in the painting. That doesn't mean that people notice a
bottle, but I know when I succeed in it—then the painting would
have this. They can interpret it their ways.

I get freer. I feel that I am getting more to myself in the sense of,
I have all my forces. I hope so, anyhow. I have this sort of feeling

Willem de Kooning, 1968
Photograph by Hans Namuth

that I am all there now. It's not even thinking in terms of one's limitations because they have to come naturally. I think whatever you have, you can do wonders with it, if you accept it, and I feel with the help of all the other artists around me doing all these different things—I wouldn't know how to pin it down. But I have some feelings now—a bigger feeling of freedom. I am more convinced about picking up the paint and the brush and drumming it out.

I make a little mystique for myself. Since I have no preference or so-called sense of color, I could take almost anything that could be some accident of a previous painting. Or I set out to make a series. I take, for instance, some pictures where I take a color, some arbitrary color I took from some place. Well, this is gray maybe, and I mix the color for that, and then I find out that when I am through with getting the color the way I want it, I have six other colors in it, to get that color; and then I take those six colors and I use them also with this color. It is probably like a composer does a variation on a certain theme. But it isn't technical. It isn't just like fun because if I am interested in this bottle, I'm not going to find it in any place.

I have this measure, so it's no contradiction really. All these things are already in art and if you can—even if you go to the Academy and you really can do it and you get the point—well, you know how to draw a basket, you see.

I read somewhere that Rubens said students should not draw from life, but draw from all the great classic casts. Then you really get the measure of them, you really know what to do. And *then*, put in your own dimples.

Isn't that marvelous!

Now, of course, we don't do that. You've developed a little culture for yourself, like yoghurt; as long as you keep something of the original microbes, the original thing in it will grow out. So I had—like most artists—this original little sensation, so I don't have to worry about getting stuck. As to the painting being finished, I always have a miserable time over that. But it is getting better now. I just stop. I sometimes get rather hysterical and because of that I find sometimes a terrific picture. As a matter of fact, that's probably the real thing, but I couldn't set out to do that. I set out keeping in mind that this thing will be a flop in all probability, and it sometimes turns out very good.

excerpted from *Location*, vol. I, no. 1, spring 1963. © David Sylvester

This interview was conducted by David Sylvester, a British art critic, for the BBC. *Location* was a periodical edited by Thomas Hess and Harold Rosenberg, which dealt with art and literature.

Adolph Gottlieb, 1962
Photograph by Hans Namuth

Adolph Gottlieb

Statement, 1947

Certain people always say we should go back to nature. I notice they never say we should go forward to nature. It seems to me they are more concerned that we should go back, than about nature.

If the models we use are the apparitions seen in a dream, or the recollection of our pre-historic past, is this less part of nature or realism, than a cow in a field? I think not.

The role of the artist, of course, has always been that of image-maker. Different times require different images. Today when our aspirations have been reduced to a desperate attempt to escape from evil, and times are out of joint, our obsessive, subterranean and pictographic images are the expression of the neurosis which is our reality. To my mind certain so-called abstraction is not abstraction at all. On the contrary, it is the realism of our time.

excerpted from "The Ides of Art," *Tiger's Eye*, vol. I, no. 2, December 1947, p. 43. Reprinted by permission of John Stephan and the Adolph and Esther Gottlieb Foundation, Inc.

Tiger's Eye was a publication edited by Ruth and John Stephan that appeared in nine issues from October 1947 to October 1949. Barnett Newman was associate editor for no. 2, December 1947. It contained poetry, prose, criticism, artists' writings, and reproductions of works of art. The other nine artists to make statements in this issue were Boris Margo, Newman, Stamos, Rothko, Ferber, Felipe Orlando, Hedda Sterne, Mario Carreno, and John Stephan.

"Unintelligibility," 1948

The current reactionary trend in the art world has dangerous implications that concern both the artist and those interested in art. The main danger is a threat to freedom of expression, because of the attempt to stifle new forms of artistic expression. Artists who struggle to find new forms are always the first victims of a reactionary attack. The history of the modern movement is full of familiar examples.

By now it has become a formula to attack new ideas on the grounds of extremism and unintelligibility. Every phase of modern art has in turn been attacked on these grounds, until the new phase became acceptable.

Although the present attacks are focused on those who emphasize the subjective side of abstract painting, the threat to other sections of the modern movement is implicit. The attacks are always focused on those who are considered the black sheep, for reasons of non-conformity. They are conspicuous, because they are different, and therefore make easy targets.

Since almost everyone claims to be for modern art, that is *sound* modern art, which is not *too* modern, of course, the hue and cry is against extremism, against private symbols, against unintelligibility.

This so-called unintelligible painting is labeled, totemism, fetishism, private symbolism, etc. These labels are flung at us like those other derogatory tags that stuck: impressionism, fauvism, cubism.

These charges of extremism and unintelligibility are a smoke screen. The critics accuse us of lack of meaning to conceal their own lack of perception. This is the easiest way to justify a hostility to what is different, unconventional, unique and non-conformist. This antagonism to anything unstereotyped is the crux of the matter.

We are now confronted with a situation in which the critics have ganged up on the non-conformist black sheep. A museum has even changed its name to oppose them and at the same time issued a manifesto against these dangerous creatures of a different color.

Why are these black sheep considered so dangerous?

I think the answer lies in the similarity of the attacks from both the right and the left. The most violent attacks have recently appeared in the art pages of the conservative *New York Times* and the *New York World-Telegram* and at the same time in the American communist publication, *Masses and Mainstream*. The black sheep, it seems, are neither white enough nor red enough, and that is very dangerous from either point of view. Why? Because even a few black sheep in the large flock might contaminate the others. The pure white and pure red might then become grey or maroon. With the cry of unintelligibility the critics attack whatever is out of line with the status quo of art.

This is an expression of intolerance for anything different from the accepted pattern. Granted that some things peculiar may be meretricious. But this intolerance of everything that is off the beaten path, is an attempt to impose conformity. The true artist always refuses to conform to any standards other than his own. That is why the attacks in Russia against Shostakovitch and Prokofiev are identical to the attacks that have been made here against American pioneers of abstract painting like Davis, Holty, or Morris. In Russia, it was Malevich and Gabo, in this country at the moment it is people like Rothko, Baziotes, Pollock, myself and many others who are being attacked. The names may vary, but the methods, the motives, the objects of attack are essentially the same. Only mediocrity is forever immune, because it is forever ready to conform.

Now let us acknowledge the fact that to explain the meaning of painting, is difficult. And when the form and content are really new,

there is not even a vocabulary with which to attempt to explain the new work. This is a problem for critics and a difficult problem.

I think it is about time for the critics to face this problem, as well as the fact that there are a few new forms and ideas in modern painting, that these have validity, that they are here to stay and will be developed whether opposed or not.

Eventually this new work will have to be evaluated critically. Critics cannot continue indefinitely to evade the issues and merely smear this work as unintelligible, because the audience is already quite large and knows better.

I would therefore recommend that the critics get out of their befuddled condition. They should investigate the serious ideas underlying the painting which they malign. Let the critics discuss these ideas on their merits and then criticize the work in relation to the ideas. This would be honest criticism and would also be a constructive effort.

In this way, instead of derogatory epithets, the critics would be throwing light on so-called unintelligible art.

Having censured the critics, I would now like to be helpful. Here are six questions, the answers to which I think could clarify some of the current fog of unintelligibility.

1. If it is true that it does not matter what the artist paints, why are so many attacks made on subject matter, i.e. totemic themes, race memories, etc.?
2. If it was right for Delacroix and Gauguin to travel to far and strange places like Tunis and Tahiti for subjects, what is wrong with traveling to the catacombs of the unconscious, or the dim recollections of a prehistoric past?
3. If the origin of painting was the making of marks or poetic signs should we consider the painter an artisan-poet or is he the artisan-architect of a formal structure? Or both?
4. Can qualitative standards for art be fixed like in dairy products or should standards be fluid in accordance with our situation?
5. If our political and economic problems cannot be solved by past wisdom, can artistic problems be solved by the solutions of our predecessors?
6. Finally, is it necessary to have a double standard, one standard for American art and another for European art, or should we have a *reciprocal* exchange of ideas on an international level, as scientists do?

from a lecture given at "Forum: The Artist Speaks," The Museum of Modern Art, New York, May 5, 1948. Reprinted by permission of The Museum of Modern Art, New York, and the Adolph and Esther Gottlieb Foundation, Inc.

Statement, 1951

I have always worked on the assumption that if something is valid and meaningful to me, it will also be valid and meaningful to many others. Not to everyone, of course. On the basis of this assumption I do not think of an audience when I work, but only of my own reactions. By the same token I do not worry whether what I am doing is art or not. If what I paint is expressive, if it seems to communicate the feeling that is important to me, then I am not concerned if my work does not have known earmarks of art.

My work has been called abstract, surrealist, totemistic and primitive. To me these labels are not very accurate. Therefore, I chose my own label and called my paintings pictographs. However, I do not think labels are important.

After spending a year in Arizona around 1938, I came back to New York with a series of still lifes. Everyone said my paintings had become very abstract. I simply felt that the themes I found in the Southwest required a different approach from that I had used before. I think the same is true of my pictographs. The material I use requires the style I have built around it. If I should find other subjects and forms that interest me more, I shall no doubt find it necessary to use a different method of expression.

People frequently ask why my canvases are compartmentalized. No one ever asks this about a house. A man with a large family would not choose to live in a one-room house. It is understood that for convenience and privacy it is desirable to divide a house into compartments and it can at the same time be beautiful.

I am like a man with a large family and must have many rooms. The children of my imagination occupy the various compartments of my painting, each independent and occupying its own space. At the same time they have the proper atmosphere in which to function together, in harmony and as a unified group. One can say that my paintings are like a house, in which each occupant has a room of his own.

from *Arts and Architecture*, vol. 68, no. 9, September 1951, p. 21. Used by permission of Adolph and Esther Gottlieb Foundation, Inc.

Interview with Dorothy Seckler, 1967

GOTTLIEB: [During the early forties] . . . I wanted to do something figurative. Well, I couldn't visualize a whole man on a canvas. I couldn't see him in a flat space. I felt that I wanted to make a painting primarily with painterly means. So I flattened out my

Adolph Gottlieb
Pictogenic Fragments, 1946
Oil on canvas, 36 × 30″
Hirshhorn Museum and
Sculpture Garden, Smithsonian
Institution, Gift of Joseph H.
Hirshhorn

canvas and made them roughly rectangular divisions, with lines
going out in four directions. That is, vertically and horizontally.
Running right out to the edge of the canvas. And then I would free
associate, putting whatever came to my mind freely within these
different rectangles. There might be an oval shape that would be an
eye or an egg. Or if it was round it might be a sun or whatever. It
could be a wriggly shape and that would be a snake. Then there
would be very little editing or revision. Now it wasn't just picture
writing. I considered myself a painter. I was involved with the
painting ideas and making things painterly. So that it was a complex
process that went on . . . I thought of it as related to the automatic
writing the surrealists were interested in.

SECKLER: It would have been out of character for you to have
introduced objects from the exterior world related to, well, machines
or cars or things of that sort. The organic reference was basic to
your thought.

GOTTLIEB: Well, I was interested in a subjective image. In fact Kootz once had a show called the Intrasubjectives. And my feeling was that I was looking for a subjective imager, stemming perhaps from the subconscious. Because the external world as far as I was concerned had been totally explored in painting and there was a whole ripe new area in the inner world that we all have. Now in order to externalize this you have to use visual means and so the visual means may have some relation to the external world. However, what I was trying to focus on was what I experienced within my mind, within my feelings rather than on the external world which I can see. I see it the same as everybody else sees it.

Around 1950–51 . . . I was finally getting away from the pictographs and looking for something. The reason I sort of got away from all this was I had gotten to a point where I was able to do it very well. I was interested in finding something else to say, to express. So it was necessary to find other forms, a different, changed concept. So finally after a certain period of transition I hit on dividing the canvas into two parts, which then became like an imaginary landscape. However, while this seemed like a great break, it wasn't such a great break because in a philosophical sense what I was doing was the same. In other words I've always done the same thing. That is, I'm interested in certain opposing images.

SECKLER: You've already mentioned your feeling that you didn't want to just go on refining the same approach. And you shifted then into the horizontal division. What other emblems or shapes were now on the canvas?

GOTTLIEB: Well, I had this idea of disparate images you see, which occurred throughout the pictographs. What I was really trying to do when I got away from the pictographs was to make this notion of the kind of polarity clearer and more extreme. So the most extreme thing that I could think of doing at the time was dividing the canvas in half, make two big divisions and put something in the upper division and something in the lower section. So I painted that way, with that in mind for quite a while, for a few years. Oh, I would say roughly from about 1952 to 56, '57. About five years.

SECKLER: To come back for a moment to the period of the pictographs, you were going to tell me something about how they evolved that we passed over.

GOTTLIEB: Well, I'll tell you how the idea of compartmentalization occurred to me. I was looking for some sort of systematic way of getting down these subjective images and I had always admired, particularly admired the early Italian painters who preceded the Renaissance and I very much liked some of the altarpieces in which there would be, for example, the story of Christ told in a series of

boxes, starting with the Nativity and ending with the Resurrection. This would be told chronologically like a comic strip technique. And it seemed to me this was a very rational method of conveying something. So I decided to try it. But I was not interested in telling, in giving something its chronological sequence. What I wanted to do was give something, to present what material I was interested in simultaneously so that you would get an instantaneous impact from it. So I made boxes but then I put the images in with no sequence and no rational order. In other words there was no chronology and you were supposed to see the thing instantaneously. Then, since there was no chronology, there was no rational order, the images appeared apparently at random, they then established themselves in a new system. So that was why all those years I was able to use very similar images, but by having different juxtapositions there will always be a different significance to them.

SECKLER: Well that is a very interesting aside and I am glad we put it in. To return again to the later point of time that we interrupted. You had arrived at a horizontal division of the space and to place in each part a disparate image of what type, initially?

GOTTLIEB: Well, initially, and I pretty much stuck to it, in the upper part I put something like Morse Code, which consisted of very large dots and dashes. Then in the lower section I put a kind of free calligraphy and there were sort of extremes which I felt had no connection with each other but I had a feeling that I could make them cohere in some way. And curiously enough they did. See, I never understand why my paintings hold together because I don't have any tricks for doing it and that is usually what makes a painting academic. There were some well-known devices for making a painting work hold together, have cohesion. This seemed to be organized. But I don't necessarily have to know what the mechanism is. For me, what it really is, is something you have in yourself that makes you feel, it gives the painting a feeling of unity, of oneness, and being all of one piece. . . .

SECKLER: It seemed to me if you took the elements of the forms in the pictographs and sort of compressed them and reduced them that you somehow would arrive at something very close to what you did.

GOTTLIEB: That's true, especially when I see some of my pictographs now. I see the forms that I am using today. But at the time I hadn't simplified or boiled things down as such. I don't know if you want to get to this yet but there was just as big a change in my work later as there was in my work when I started doing pictographs. You see, after doing the imaginary landscapes until say '56, in '57 I came out with the first Burst painting. . . . There was a different type of space than I had ever used and it was a further

clarification of what I was trying to do. The thing that was interesting was that it was a return to a focal point, but it was a focal point with the kind of space that existed in traditional painting. Because this was like a solitary image or two images that were just floating in the canvas space. They had to hold the space and they also had to create all the movement—that took place within the rectangle.

SECKLER: Up until this point, had your direct painting continued? I realize that during the pictograph period you were a very direct painter and that things evolved on the surface. Did it continue to be direct painting into the second stage of the horizontal division? Or would you sometimes make a small sketch and work out an idea?

GOTTLIEB: Sometimes I would make a small sketch, but mostly, even today, throughout my career I've mostly worked directly on the canvas, large or small. I rarely work from sketches although once in a while I do. My theory is or my explanation of it is that working directly on a large canvas I get the spontaneity and directness that people have always valued when an artist does a sketch. So that in a sense my large paintings are my sketches. Sometimes after I do a large painting I will do a small painting or a series of small paintings based on a large painting. But the large painting, when it comes off, has that roughness and unpremeditated quality which I value.

SECKLER: Were you painting on a vertical surface during the first break into the horizontal things or were you working on the floor?

GOTTLIEB: When I started doing the Bursts I began to do part of the painting horizontally. It was necessary to do that because I was working with a type of paint which had a particular viscosity which flowed and if it were on a vertical surface, it would just run. If it were on a horizontal surface, I could control it. So I'd put my paintings down horizontally but I didn't put them on the floor. I had them set up on horses or stools, so that I was at a good working height.

SECKLER: Then were you still using brushes at this point?

GOTTLIEB: I was using a combination of brushes and knives, palette knives.

SECKLER: Do you use palette knives?

GOTTLIEB: Oh yes, I use them a great deal, and spatulas. And for a while I was using squeegees for putting on paint. I've tried everything, rollers, rags, I've put paint on with everything.

Adolph Gottlieb, c. 1959
Photograph by Fred W.
McDarrah

excerpted from *Archives of American Art*, October 25, 1967. © Archives of American Art. Reprinted with permission.

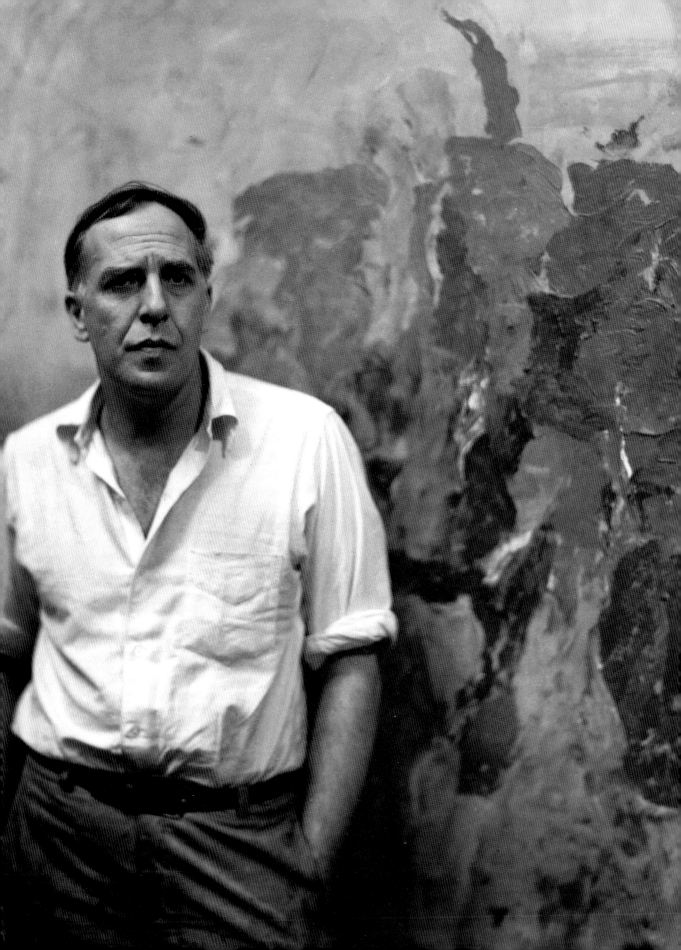

Philip Guston

"The Philadelphia Panel," 1960

. . . art should be made clear. For whom? Someone once said, speaking about the public, that if a violinist came on the concert stage and played his violin as if to imitate the sound of a train coming into the station, everyone would applaud. But if he played a sonata, only the initiated would applaud. What a miserable alternative. The implication is that in the first case the medium is used to imitate something else and in the latter, as they say, is pure or abstract. But isn't it so that the sonata is above all an image? An image of what? We don't know, which is why we continue listening to it.

There is something ridiculous and miserly in the myth we inherit from abstract art: That painting is autonomous, pure and for itself, and therefore we habitually analyze its ingredients and define its limits. But painting is "impure." It is the adjustment of "impurities" which forces painting's continuity. We are image-makers and image-ridden. There are no "wiggly or straight lines" or any other elements. You work until they vanish. The picture isn't finished if they are seen.

excerpted from *It Is*, vol. V, spring 1960 © The Estate of Philip Guston

The panel was given in March 1960 at the Philadelphia Museum School of Art, and the transcript was edited by Philip Pavia and Irving Sandler. The participants were Guston, Motherwell, Reinhardt, and Tworkov. Harold Rosenberg acted as moderator.

It Is: A Magazine of Abstract Art appeared in six issues from spring 1958 to Autumn 1965; it suspended publication between spring 1960 and autumn 1965. It contained artists' statements, critical articles, and reproductions of Abstract Expressionist art.

Philip Guston, 1957
Photograph by Arthur Swoger

"Faith, Hope, and Impossibility," 1966

There are so many things in the world—in the cities—so much to see. Does art need to represent this variety and contribute to its proliferation? Can art be that free? The difficulties begin when you understand what it is that the soul will not permit the hand to make.

To paint is always to start at the beginning again, yet being unable to avoid the familiar arguments about what you see yourself painting. The canvas you are working on modifies the previous ones in an unending, baffling chain which never seems to finish. (What a sympathy is demanded of the viewer! He is asked to "see" the future links.)

For me the most relevant question and perhaps the only one is, "When are you finished?" When do you stop? Or rather, why stop at all? But you have to rest somewhere. Of course you can stay on one surface all your life, like Balzac's Frenhofer. And all of your life's work can be seen as one picture—but that is merely "true." There *are* places where you pause.

Thus it might be argued that when a painting is "finished," it is a compromise. But the conditions under which the compromise is made are what matters. Decisions to settle anywhere are intolerable. But you begin to feel as you go on working that unless painting proves its right to exist by being critical and self-judging, it has no reason to exist at all—or is not even possible.

The canvas is a court where the artist is prosecutor, defendant, jury and judge. Art without a trial disappears at a glance: it is too primitive or hopeful, or mere notions, or simply startling, or just another means to make life bearable.

You cannot settle out of court. You are faced with what seems like an impossibility—fixing an image which you can tolerate. What can be Where? Erasures and destructions, criticisms and judgments of one's acts, even as they force change in oneself, are still preparations merely reflecting the mind's will and movement. There is a burden here, and it is the weight of the familiar. Yet this is the material of a working which from time to time needs to see itself, even though it is reluctant to appear.

To will a new form is inacceptable, because will builds distortion. Desire, too, is incomplete and arbitrary. These strategies, however intimate they might become, must especially be removed to clear the way for something else—a condition somewhat unclear, but which in retrospect becomes a very precise act. This "thing" is recognized only as it comes into existence. It resists analysis—and probably this is as it should be. Possibly the moral is that art cannot and should not be made.

All these troubles revolve around the irritable mutual dependence of life and art—with their need and contempt for one another. Of necessity, to create is a temporary state and cannot be possessed, because you learn and relearn that it is the lie and mask of Art and, too, its mortification, which promise a continuity.

There are twenty crucial minutes in the evolution of each of my paintings. The closer I get to that time—those twenty minutes—the more intensely subjective I become—but the more objective, too. Your eye gets sharper; you become continuously more and more critical.

There is no measure I can hold on to except this scant half-hour of making.

One of the great mysteries about the past is that such masters as Mantegna were able to sustain this emotion for a year.

The problem, of course, is more complex than mere duration of "inspiration." There were pre-images in the fifteenth century, foreknowledge of what was going to be brought into existence. Maybe my pre-image is unknown to me, but today it is impossible to act as if pre-imaging is possible.

Many works of the past (and of the present) complete what they announce they are going to do, to our increasing boredom. Certain others plague me because I cannot follow their intentions. I can tell at a glance what Fabritius is doing, but I am spending my life trying to find out what Rembrandt was up to.

I have a studio in the country—in the woods—but my paintings look more real to me than what is outdoors. You walk outside; the rocks are inert; even the clouds are inert. It makes me feel a little better. But I do have a faith that it is possible if you can move that inch.

I do not think of modern art as Modern Art. The problem started long ago, and the question is: Can there be any art at all?

Maybe this is the content of modern art.

from *ARTnews Annual*, October 1966, pp. 102, 103, 152, 153 © ARTnews Annual, October 1966. Reprinted by permission.

Public forum with Joseph Ablow, 1966

ABLOW: In providing the introduction I began to think about Mr. Guston's career and the style and manner he represents. Abstract Expressionism, or whatever it's called . . .

GUSTON: I prefer the term New York School, by the way. I think that appellation doesn't seem actual to me. It seems like a coined

phrase. As a matter of fact, I don't remember in any of the get-togethers I had with painters of that period that that word was used or exchanged. Nobody ever said, you so-and-so abstract expressionist, you. I don't think that Picasso and Braque said anything about making Cubist paintings; imagine Rousseau saying he was going to make a primitive painting. Like he said to Picasso, "You represent the Egyptian school and I represent the realistic school." It's right. Picasso is a kind of Egyptian painter. There was something going on, of course, and every painter was different. I'm interrupting your question. . . . It was a geographical question. I happened to be there. If I hadn't been there, I don't know what I would have done. You can say the same things about the other men. I think what made of it a unity, a kind of group roughly, which met in each other's studios or in bars, was a kind of dissatisfaction with what had been going on previously, or with what each of us had been doing previously. You didn't know what you wanted to do, but you knew what you didn't want to do. It's very important to know what you don't want to do. Negatives can be very positive. It was also a sense of the time it was, of embarking on something of which you didn't know the outcome at all. It's not like now. And of course, the idea of having a career, this didn't seem possible—it didn't seem possible that you would make a living out of it, or that anybody would look at it. There were maybe 2 or 3 galleries showing that stuff at that time, out of sheer dedication to this idea. So it's not the way it is now. The term was coined, like all terms. Isn't that how the term Impressionist or Cubist was coined? Those two terms, in terms of derision, if I'm not mistaken: he's an *impressioniste*. I think Matisse said, when he wanted to see what the boys were doing when he came back from Africa, they're cubists, they make little cubes. Now it's in the history books, and slides, Cubist paintings are worth so much on the market. The New York School is a better term.

ABLOW: The School of Paris had a life of about 35 years and we are having it reproached to us through various media that the New York School is dead and it was truncated at the age of 16 or 17. Considering the vitality and the purpose of the New York School, why did it happen, or has it happened?

GUSTON: That's better, has it happened? Because "why do I think this happened" is like the "are you still beating your wife" question. I have all kinds of ideas about that. First of all, what I enjoy of the School of Paris, one of the most marvelous things about it, was that everything was going on at the same time. You have to remember that while Picasso and Braque were painting what they were painting during the teens, one of the great painters of the century to

Philip Guston
Untitled, 1962
Ink on paper, 26 × 39½″
Private Collection, New York

my mind, Chirico, was painting his masterpieces at the same time. Soutine, another giant, a little later, was painting what he was painting; Matisse was painting what he was painting. And I prefer to think that in spite of the second generation of the New York School which saw the work of the first generation as a *manner* in which they could comfortably work—in other words, and in spite of all the imitators, each man, I think, was totally different. I see no connection between Mark Rothko and Kline. I could go on mentioning names. There's been so much jazz printed about it that you know all the names. Each person was really different. I've thought a lot about it. I think the original problems that were posed after the war period in painting were the most, to my way of thinking,—it's all my way of thinking, I'm very prejudiced—the most revolutionary problems posed and *still are*. In other words, nothing is dead. You can't put it under a rug and pretend it's gone. I think the reason for wanting it to die off, in terms of critics, dealers, museums—the establishment of the art world, officialdom, avant-garde officialdom, same thing as any other kind of officialdom—they saw the work of Abstract Expressionism as *style*, as a certain way of painting. Now if it's seen that way, then, of course, styles come and go. I mean, everybody gets sick of a certain style. After 10 years or 15 years, you're bored sick of it. Younger painters come along and want to react against it. I think that was one of the motivations for trying to kill it off. It's dead. And then, of course, the American idea of change enters into it, like the idea of new emotions, new feelings, having to find new forms. All this is true. All that exists and there's nothing wrong with it. Yet I

could not paint another minute in the way I do if I didn't believe
that this was a revolution, it really was a powerful revolutionary
instinct, which *may* have lost its power, which may have lost its
efficacy, in our current emotional climate. That's possible, but that
can change. Alright, now, what was this revolution? That's really the
issue. What is it about?

I think it's about, I know it's about, and revolves around, the
issue of whether it's possible to create in our society *at all* . . .
everybody can make pictures, thousands of people go to school,
thousands go to galleries, museums, it becomes not only a way of
life now, it becomes a way to make a living. In our kind of
democracy this is going to proliferate like mad. In the next ten
years there will be even much more than there is now. There'll be
tons of art centers and galleries and pictures. Everybody will be
making pictures.

Painting and sculpture are very archaic forms. It's the only thing
left in our industrial society where an individual alone can make
something with not just his own hands, but brains, imagination,
heart maybe. It's a very archaic form. Same thing can be said with
words, writing poetry, making sounds, music. It is a unique thing.
Just imagine, 99% of the people just report somewhere, are digits,
go to an office, clear a desk, get plastered and then they do the
same thing the next day. So what is this funny activity that you do?
What is it? I think that the original revolutionary impulse behind
the New York School, as I felt it anyway, and as I think my
colleagues felt and the way we talked all the time, was a kind of a
. . . you felt as if you were driven into a corner against the wall
with no place to stand, just the place you occupied, as if the act of
painting itself was not making a picture, there are plenty of pictures
in the world—why clutter up the world with pictures?—it was as if
you had to prove to yourself that truly the act of creation was still
possible. Whether it was just possible. It felt to me as if you were
on trial. I'm speaking very subjectively. I felt as if I was talking to
myself, having a dialectical monologue with myself to see if I could
create.

What do I mean by create? I mean that the things I felt and that
I enjoyed about certain painters of the past that I liked, that
inspired me, like Cézanne and Manet, that thing I enjoyed in their
work, that complete losing of oneself in the work to such an extent
that the work itself, even though it was a picture of a woman in
front of a mirror or some dead fish on the table, the pictures of
these men were not pictures to me. They felt as if a living organism
was posited there on this canvas, on this surface. That's truly to me
the act of creation. It didn't at the time for reasons I don't

understand myself . . . I still worry about it and puzzle about it and I go two steps forward and one step backward or one step forward, two steps backward, because I'm puzzled by a lot of problems that I would not know how to begin talking to you about, and these problems revolve around abstract painting or non-objective painting or image-making and, of course, I'm seeking a place, an area, where these questions would be dissolved, where they don't exist, where somehow in me all this would come together . . . I mean that's my hope. So as I was going to say, for reasons which I do not understand, the late Forties, early Fifties, when I went into non-figurative painting, although I felt I was even then involved with imagery even though I didn't understand the imagery completely myself, but I thought it was imagery, and for some reason that's not quite clear to me yet and maybe I don't want to be clear about it either . . . I was forced and pushed into the kind of painting that I did. That is to say, the demands in this dialogue with myself—I give to it, I make some marks, it speaks to me, I speak to it, we have *terrible* arguments going on all night, weeks and weeks—do I really believe that? I make a mark, a few strokes. I argue with myself, not do I like it or not, but is it true or not? Is that what I mean, is that what I want?

But there comes a point when something catches on the canvas, something grips on the canvas. I don't know what it is, you can put your paint on a surface? Most of the time it looks like paint, and who the hell wants paint on a surface? But there does come a time—you take it off, put it on, goes over here, moves over a foot, as you go closer you start moving in inches not feet, half-inches— there comes a point when the paint doesn't feel like paint. I don't know why. Some mysterious thing happens. I think you have all experienced this, maybe in parts of canvas. Maybe you can do it by painting a face, an eye, a nose, or an apple. It doesn't matter. What counts is that the paint should really disappear, otherwise it's craft. That's what I mean by something grips in a canvas.

The moment that happens you are then sucked into the whole thing. Like some kind of rhythm. I don't mean a dancing rhythm, or action painting rhythm. I mean you're psychologically sucked in and the thing, this plane, starts acquiring a life of its own. Then you're a goner. Then if you're lucky you have a run of 2 or 3 hours. Then you can't repair it, you can't fix it, and you feel as if you've made a thing, a living thing. All I can tell you is what it feels like when you leave the studio. You know, I have all kinds of wonderful ideas . . . a little green there, a little blue there, and you proceed to do it. And then you leave the studio, it's like you have a bunch of rocks in your stomach. You can't stand to see illustrations of your ideas.

Well, then, all the trouble starts and dissatisfaction starts. You go back, scrape it out and move it around, move it around. And then there comes a time, if you persevere long enough, where the paint seems alive, seems actually living and there's some kind of release. Lots of artists who paint have that experience to one degree or another, this release where their thinking doesn't precede their doing. The space is shortened between thinking and doing. It's a funny thing, what I really hate, yet I have to go through with it, is the preparation. You have to go through it, like somebody preparing for sacred vows, the sensation of you putting paint on, and it's so boring to put paint on and to see yourself putting paint on. You're really preparing for those few hours where some kind of umbilical cord is attached between you and it. You do it and the work is done and this cord seems to slacken, as if you left yourself there. And what a relief to leave yourself somewhere, to get out of it entirely. And then you leave the studio and those rocks aren't there anymore.

Then you can go to a movie in the afternoon, two movies, you don't feel guilty about anything. And you've left a living thing there, and I come in the next morning and I know it. And one of the signs that I go by is that when I've left this thing there, I don't remember it. I don't remember what it looks like. I only remember the general feeling about it, but I don't remember parts of it. And *that's* what I want. I don't want to be stuck with parts. I know I haven't finished a picture, when I sit down to eat outside the studio, gee, that's a nice relationship between that part and that part, like a partial relationship. What about the other part? There has to be this peculiar kind of unity. Once you've tasted that or experienced that, it's hard to settle for anything else. Also I'm not convinced that it's a good thing either. I don't propose this as a great value. In some way I think it's like devil's work. Man is not supposed to make life. Only God can make a tree. Why should you make a living organism? You should make *images* of living organisms. It seems presumptuous to attempt to make a thing which breathes and pulsates right there by itself. It's unnatural. What's inhuman about it is, the human way to create, I think, is the way we see, from part to part. You do this and then you do that, then you do that and that. Then you learn about composition, you learn about old masters, you form certain ideas about structure. But the inhuman activity of trying to make some kind of jump or leap, where even though you naturally have to paint, after all a painting is only a painting, the painting is always saying, what do you want from me, I can only be a painting, you have to go from part to part, *but* you shouldn't see yourself go from part to part, that's the whole point. That's some kind of a leap. You can be painting over here and seeing the whole world. That

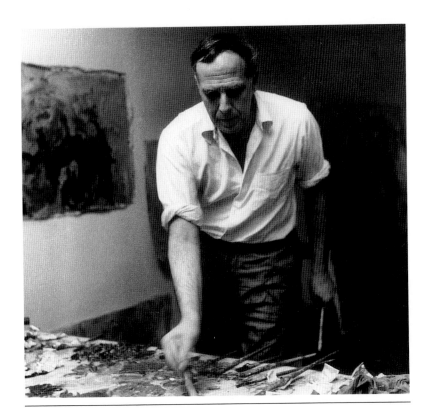

Philip Guston, 1957
Photograph by Arthur Swoger

rectangle or square is the whole world, that's reality. I'm describing
the process of painting.

ABLOW: When you're working and you see something that reminds
you of a literal image, how does this affect you?

GUSTON: I tousle with these things all the time. A few years ago,
like I do quite often, I got very nervous about what I was doing,
maybe exhausted, and I came into the loft one day and I tacked up
a canvas on the wall, I never paint on an easel, a very old loft full
of dirty skylights and a lot of crap around. I thought, I'll just paint
what I see, don't think. So I painted the whole loft, like one of those
Matisses—easel, broken chairs, electrical wire hanging down, all
the way right up to my hand below, painting it. I worked steadily for
8 hours without stopping. I ran across the street, got my wife: Look
at that, I can paint. It's as good as a Bonnard. I was really upset.
This denied *everything* I was doing. It's one of those funny moments
you have, about five years ago. I'm puzzled all the time by
representation or not, the literal image and the non-objective, there's
no such thing as non-objective art. Everything has an object, has a
figure. The question is what kind? Does it have illusions, in what
way can you have figuration? In this case I painted quite literally,
with fancy colors, dirty greys, nice pinks, ochres. Looks terrific. I

had a hard time sleeping that night. I was very upset, where do I
go, is this a new career? Or what? Am I changing, am I afraid to
change? All these psychological problems. I came in the next
morning and there was nothing there, literally nothing there. There
was a representation of all this, but it seemed like a fake, faked up,
because it didn't seem real. It didn't seem concrete. It didn't seem
to have any life of its own. All it did was represent something and
depended on all this recognition, like you have to be briefed on it,
like, oh, yes, a chair, a torn cloth, oh, yeah, a broken mirror. It
was composed nicely, it flowed and moved through one part into the
other, all around your eye moved nicely, absolutely satisfying as a
painting. Well, then, naturally, I proceeded to destroy it. And then I
had to rediscover again and again that, I guess, I'm not interested
in painting, I'm not interested in making a picture. Then what the
hell am I interested in? I must be interested in this process that I'm
talking about. Sometimes a picture comes off and I scrape off a lot.
I don't keep the studio very tidy. You have on the floor, like cow
dung in the field, this big glob of paint on the floor, and something
comes off on the picture, and I look down at this stuff on the floor
and it's just a lot of inert *matter*, inert paint. Then what is it? I look
back at the canvas, and it's not inert, it's active, moving, and living.
And that to me seems like some kind of peculiar miracle that I need
to have again and again. Why I need this kind of miracle, I don't
know, but I need it. My conviction is that this is the act of creation
to me. That's how I have it. So, I'm in a corner with painting and I
can't seem to move out. I've done this, painting the studio, again
and again. A few objects, paint cans on a table, recently, and it
won't stay there. It won't stick there. Last year I got involved with a
five-and-dime coffee cup, cheap coffee cups are kind of nice, that
year—looks so ordinary. Maybe I'll put in two to make it
interesting. It won't stick, it won't hold on the plane. Then you start
shoving this form around, it gets pushed around, it gets distorted,
maybe one side goes up, one ear goes way out. It feels good. I don't
know why. If you push it, it feels good. I don't know what it is. It
must have something to do with kinesthesia.

I feel now that I'm painting I'm not drawing anything, or even
representing non-objective art. You know, you can represent abstract
art, too, as well as heads, figures, nudes. A lot of abstract artists
are just representational painters, you know that. And a lot of
figurative artists are very abstract. I don't feel as if I'm doing that. I
feel more as if I'm shaping something with my hands. I feel as if
I've always wanted to get to that state. Like a blind man in a dark
room had some clay, what would he make? I end up with 2 or 3
forms on a canvas, but it gets very physical for me. I always

thought, I'm a very spiritual man, not interested in paint, and now I discover myself to be very physical and very involved with matter. I want to be involved with how heavy things are, a balloon, how light things are, things levitating, pushing forms, make me feel as if my hand is pushing in a head, bulges out here and pushes there. Like feelings you all have, you see someone's head and you want to push it, squeeze it, see what happens . . . or gravity interests me. You might be able to write a whole book of philosophy about if you had a ball and the floor was just tilted a little bit, at what point would the ball start rolling. Sometimes a form on a canvas gets in some peculiar position, it's about to fall, but it isn't falling because some little thing is holding it up, some peculiar balancing is going on. I'm very involved with all this foolishness. Of course, I believe it's very significant and not foolish at all. It becomes in my mind as important and as crucial as painting the baptism of Christ. I don't know why. It's very important to me. Maybe I'm skeptical about it all, too, because it's a terrible state for man to get down to, but then modern life is like that; when you walk down the street you have to keep your balance, how you walk. I can listen to a couple of guys, as I did the other day, having a heavy philosophical discussion about Sartre, and instead of listening to them, I was watching the way the guy was shifting, the way his pants sagged, and the way he shifted his weight on his hips. It seemed to be very important.

ABLOW: Do you think it's harder to make the jump you spoke of, while working with the object?

GUSTON: No, not at all. I think frequently when I see young painters working non-objectively—whether it's colored stripes, brush strokes, bull's eyes, it doesn't matter, it's all the same—I think it's too limited, not in making pictures, we're not talking about making pictures, we're talking about one's experience, one's enlargement of oneself, that's important, one's evolution of oneself, how can you continue to evolve, how can you bite a big enough hunk of something so that you can evolve? . . . What I was going to say in relation to what you asked, when I see people making quote "abstract" painting, I think it's just a dialogue and a dialogue isn't enough, that is to say, there is you painting and this canvas. I think there has to be a third thing, it has to be a trialogue. Whether that third thing—it must be, to reverberate and make trouble, you have to have trouble and contradictions, it has to become complex because life is complex, emotions are complex—whether that third thing is a still life of something you look at, or an idea or a concept, in each case it has to be a trialogue and above all has to involve you. Painting from something is no assurance at all, just some recognizable objects. The real thing that matters is how

involved you are in that. I can imagine that there are painters who are involved in painting some objects or stories they want to tell and just as involved as I am in putting what where, which is my third thing. . . . coming back to the original question about why abstract expressionism had this demise . . . there is no audience for it. That's a fact. Because the audience for it would be too *demanding*, because it would involve the same kind of feeling, of thinking and questioning, that the creator is putting into it. It demands the same kind of participation. Now, if you're going to tell me that a lot of these paintings are in museums, collections, and in books, that's true. But I believe they saw it as an interesting new style, and not what it really was about.

ABLOW: Do you think of the older artists as exciting?

GUSTON: Who, now?

ABLOW: Chardin.

GUSTON: You know you have to name names. Somebody where I'm teaching now said he was giving a course in modern art. I was lonely that night and prepared for a discussion: Oh, yeah, do you start with Cézanne or Delacroix? Oh, no, he said, I start with Noland and Morris Louis. So you say older, you might mean Rothko, de Kooning, or me. Oh, Chardin, what gallery does he show in? . . .

Philip Guston, 1957
Photograph by Arthur Swoger

I certainly would rather look, there's no question, at Piero's Flagellation painting in Urbino or the Baptism picture in the National Gallery than I would *any* modern painting. It seems so complete, so total, so balanced, unbalanced. All I can tell you is that I've had a reproduction of these two paintings on my wall for about 25 years in the kitchen, where you really look at things, where you are most of the time. I've never gotten tired of them, but I see new things all the time. I'm at a point now where I don't even see the architecture. Everything I thought about it, everything that's written about it, is a lot of baloney. There's no architecture there, they're on the verge of chaos. I think they're the most chaotic, disorganized pictures. They're like trembling. They're just posed there for a split second before they're going to become something else. They're the most peculiar paintings ever painted, I think. And more unclear than most modern painting. As a matter of fact, the trouble with modern painting is it's too clear. Some of the old masters are so unclear that you can't even fathom what their intentions were. In Piero's work, unlike other masters of the Renaissance, particularly the 15th century, his work has a kind of innocence, freshness about it, as if he was a messenger from God looking at the world for the first time. His Baptism is like he came down to earth and opened his eyes up for the first time. You see a tree, angels, ground, water, sky, clouds, hills, limbs. It's as if he came down and started measuring everything and locating everything for the first time. It has that feeling. I want to do that. I want to paint a world that has never been seen before, for the first time. That's what I'd like to do.

ABLOW: In relation to Piero, do you think you're more conscious about his work than he was?

GUSTON: Do you mean that he didn't think about all the things that I think about him? . . . I don't think I could be one millionth conscious about what he was doing as he was. I wonder why that question always comes up. We talk about past masters and the question always comes up did they think of all these things? Well, first of all, how did the painting come into existence?

ABLOW: He liked to do it and so he did it.

GUSTON: Yeah? You know, if you'll forgive my saying so, that's the pure Hollywood idea about artists. The most expressionist of painters, like van Gogh, who was supposed to be this mad genius, cut off his ear, he was compulsive. Did you ever read his letters to his brother Theo? He was the most conscious of artists, the most conscious of what he was doing. He goes on for pages about Rembrandt, Giotto. The reason I say it's a Hollywood idea, is that everybody would like to believe that the average man could, he too,

be van Gogh, or leave his wife, like Gauguin. It's a fantasy. Someone asked Jean Renoir if it wouldn't be nice to make a movie about his father. He asked, What about? He came in, he hit us over the face, he ate, he left, then four hours later he came in again. Nothing happened to poor Renoir. He just painted. Of course painters know what they're doing. There's no such thing as an unintelligent painter. It's an anomaly. Whether you can write about it or talk about it is a question of natural predilection. Some could, some didn't. Delacroix wrote beautifully, Cézanne wrote beautiful letters about what he was doing, so did Pissarro. Corot didn't. Some do, some don't.

ABLOW: What about your painting methods? Why do you leave some of the canvas unpainted?

GUSTON: I left the canvas showing all around. I seemed to have done that over the past 4 or 5 years. It seemed to happen at first in a practical way. I don't stretch the canvas, I just tack it up on the wall and keep working and try to locate these one or two images. And then I stretch it up and there's always an inch or two left. I remember when I first had this happen. I liked it. Why did I like it? The feeling that there was bare canvas around, it seemed part of the total, part of the composition. The other reason why I liked it was that it didn't pretend to be real. It's as if it said, painting is really the art of illusion, I want to show the canvas, it's really just paint on the canvas. It seemed to be part of the complication that I liked. Like if you're making a drawing, you like to show some paper uncovered. Or if you're modeling clay, you know how wonderful it is to see in a Rodin the head worked out and then some clay. It's made of clay. I want to show it's really just paint. Even though I'm trying to eliminate the paint, it's just paint. I enjoyed that feeling.

ABLOW: And color?

GUSTON: I have had lots of thoughts about it over the years. First of all, I've never been interested in color to begin with. I used reds a lot in the early Fifties to become acquainted with red. I didn't use so many colors. They may appear like many colors, but that's just appearance. They're really pinks and reds, touch of green or blue, touch of black. So about color, there has to be a moral value to color. Why should there be that color or that color? It took me a few years to get the feeling of red, and particularly cad red medium, which I happen to love. It's like saying somebody likes pastrami. I like cad red medium. I like it, I can't tell you why. It has a certain resonance to it. You can go both ways with it. So I think I'm more of a tonal painter, maybe, work with a few tones. I don't think I've ever been a colorist, working with color to create space. I've tried to locate forms more with tone. Color puzzles me. I don't know much

about it at all. So I've become attached to a single color and worked with it for years. I had a blue time, I worked with blue for a few years and I don't understand blue at all. Cad red medium seems to stay on the plane, you can't budge it, it's there. Blue is nowhere. It really bothers me. Unless I put black on it, to hold it, like you put your foot on it, to hold it there. I look at Bonnard, a marvelous color painter, it's magnificent. I don't know how he does it. But lately, I got to feeling that I wasn't much involved with color. Since the red seemed to go, I didn't need it, or feel it anymore, I thought, Well, I'm not interested in red anymore. So what's there to work with? Black? I mean, stuff. I don't think of it as black, it's just stuff . . . you put it on. You don't like it when it's over here, so you take it out with white and it's grey. Then you put the mud over here, you don't like it and you put it there. Although I am aware of light, I discovered even though you work with grey and white or black, you can't avoid light, fortunately. And then, I've always puzzled over the masters I've seen, like Goya, Zurbarán, in the Prado those magnificent monks painted just in grey and white, and Hals and late Rembrandt with just a few tones. Grey and black seem magnificent to me. I guess I also want to see how much I can do with very little things, just two colors, white and black, and a brush, my hand, nothing to paste on. I want to see if there is anything left to express with the most *elementary* of means. So far, I've found it very challenging and inexhaustible . . . so far.

excerpted from a transcript of a public forum at Boston University, conducted by Joseph Ablow, 1966 © The Estate of Philip Guston

"Ten Drawings," 1973

It is the bareness of drawing that I like. The act of drawing is what locates, suggests, discovers. At times it seems enough to draw, without the distractions of color and mass. Yet it is an old ambition to make drawing and painting one.

Usually, I draw in relation to my painting, what I am working on at the time. On a lucky day a surprising balance of forms and spaces will appear and I feel the drawing making itself, the image taking hold. This in turn moves me towards painting—anxious to get to the same place, with the actuality of paint and light.

from *Boston University Journal*, autumn 1973 © The Estate of Philip Guston

Hans Hofmann

"Search for the Real in the Visual Arts," 1948

Art is magic. So say the surrealists. But how is it magic? In its
metaphysical development? Or does some final transformation
culminate in a magic reality? In truth, the latter is impossible
without the former. If creation is not magic, the outcome cannot be
magic. To worship the product and ignore its development leads to
dilettantism and reaction. Art cannot result from sophisticated,
frivolous, or superficial effects.

The significance of a work of art is determined then by the
quality of its growth. This involves intangible forces inherent in the
process of development. Although these forces are surreal (that is,
their nature is something beyond physical reality), they,
nevertheless, depend on a physical carrier. The physical carrier
(commonly painting or sculpture) is the medium of expression of the
surreal. Thus, an idea is communicable only when the surreal is
converted into material terms. The artist's technical problem is how
to transform the material with which he works back into the sphere
of the spirit.

This two-way transformation proceeds from metaphysical
perceptions, for metaphysics is the *search* for the essential nature of
reality. And so artistic creation is the metamorphosis of the external
physical aspects of a thing into a self-sustaining spiritual reality.
Such is the magic act which takes place continuously in the
development of a work of art. On this and only on this is creation
based.

Still it is not clear what the intrinsic qualities in a medium
actually are to make the metamorphosis from the physical into the

Hans Hofmann, 1963
Photograph by Hans Namuth

spiritual possible. Metaphysically, a thing in itself never expresses anything. It is the relation between things that gives meaning to them and that formulates a thought. A thought functions only as a fragmentary part in the formulation of an idea.

A thought that has found a plastic expression must continue to expand in keeping with its own plastic idiom. A plastic idea must be expressed with plastic means just as a musical idea is expressed with musical means, or a literary idea with verbal means. Neither music nor literature are wholly translatable into other art forms; and so a plastic art cannot be created through a superimposed literary meaning. The artist who attempts to do so produces nothing more than a show-booth. He contents himself with visual storytelling. He subjects himself to a mechanistic kind of thinking which disintegrates into fragments.

The plastic expression of one relation must in turn be related to a like expression of another relation if a coherent plastic art is to be the outcome. In this way the expression of a work of art becomes synonymous with the sum of relations and associations organized in terms of the medium of expression by an intuitive artist.

The relative meaning of two physical facts in an emotionally controlled relation always creates the phenomenon of a third fact of a higher order, just as two musical sounds, heard simultaneously create the phenomenon of a third, fourth, or fifth. The nature of this higher third is non-physical. In a sense it is magic. Each such phenomenon always overshadows the material qualities and the limited meaning of the basic factors from which it has sprung. For this reason Art expresses the highest quality of the spirit when it is surreal in nature; or, in terms of the visual arts, when it is of a surreal plastic nature.

Let us explain our philosophical perceptions with the help of a practical example: take a sheet of paper and make a line on it. Who can say what its direction is? But when, on this same sheet of paper, you make another shorter line, you can see immediately that the first line is the longer one. By placing the second line so that it is not exactly under the first line, you create a sense of movement which will leave no doubt as to the direction in which the first line moves, and in which direction the second is opposed to it.

Was it necessary to enlarge the first line to make it the longer one? We did not have to touch that line or make any change. We gave it meaning through its relation to the new line; and in so doing, we gave simultaneous meaning also to this new line, meaning which it could not have had otherwise. The dominating thought of any relation is always reflected in both directions. But it is the multi-reflex of a particular thought with respect to an overall idea

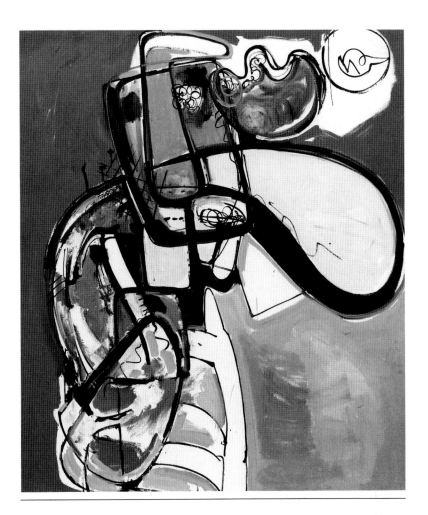

Hans Hofmann
Ecstasy, 1947
Oil on canvas, 68×60 cm
University Art Museum Berkeley,
Gift of the Artist

that finally lifts an artistic expression into the realm of magic. In
other words, it is the surreal content of the work that absorbs and
overshadows the structure and the physical foundation. The spiritual
quality dominates the material.

But, is this all that happened when you made these two lines?
You may think so, but that is by no means the case. You started out
on an empty piece of paper. The paper is no longer empty. What
has happened? Is there nothing but a combination of two lines on
an empty sheet of paper? Certainly not! The fact that you placed
one line somewhere on the paper created a very definite relationship
between this line and the edges of your paper. (You were not aware
perhaps that these edges were the first lines of your composition.)
By adding another line you not only have a certain tension between
the two lines, but also a tension between the unity of these two lines
and the outline of your paper. The fact that your two lines, when
considered either separately, or as a unit, have a definite relation to
the outline, makes the lines and the paper a unified entity which

(since lines and paper are physically different) exists entirely in the intellect.

From the beginning, your paper is limited, as all geometrical figures are limited. Within its confines is the complete creative message. Everything you do is definitely related to the paper. The outline becomes an essential part of your composition. Its own meaning, as a limitation, is related to the multi-meanings of your two lines. The more the work progresses, the more it becomes defined or qualified. It increasingly limits itself. Expansion, paradoxically, becomes contraction.

Expansion and contraction in a simultaneous existence is a characteristic of space. Your paper has actually been transformed into space. A sensation of movement and countermovement is simultaneously created through the position of these two lines in their relation to the outline of the paper. Movement and countermovement result in tension. Tensions are the expression of forces. Forces are the expression of actions. In their surreal relationship, the lines may now give the idea of being two shooting stars which move with speed through the universe. Your empty paper has been transformed by the simplest graphic means to a universe in action. This is real magic. So your paper is a world in itself—or you may call it, more modestly, only an object, or simply a picture with a life of its own—a spiritual life—through which it can become a work of art.

Your two lines carry multi-meanings:

They move in relation to each other.

They have tension in themselves.

They express active mutual forces.

This makes them into a living unit.

The position of this unit bears a definite relation to the entire paper.

This in turn creates tensions of a still higher order.

Visual and spiritual movements are simultaneously expressed in these tensions.

They change the meaning of your paper as it defines and embodies space.

Space must be vital and active—a force impelled pictorial space, presented as a spiritual and unified entity, with a life of its own.

This entity must have a life of the spirit without which no art is
 possible—the life of a creative mind in its sensitive relation to
 the outer world.

The work of art is firmly established as an independent object; this
 makes it a picture.

Outside of it is the outer world.

Inside of it, the world of an artist.

A consciousness of limitation is paramount for an expression of
the Infinite. Beethoven creates Eternity in the physical limitation of
his symphonies. Any limitation can be subdivided infinitely. This
involves the problem of time and relativity. A glimpse heavenward at
a constellation or even at a single star only *suggests* infinity; actually
our vision is limited. We cannot perceive unlimited space; it is
immeasurable. The universe, as we know it through our visual
experience, is limited. It first came into existence with the formation
of matter, and will end with the complete dissolution of matter.
Where there is matter and action, there is space.

Pictorial space exists two dimensionally. When the two
dimensionality of a picture is destroyed, it falls into parts—it
creates the effect of naturalistic space. When a picture conveys only
naturalistic space, it represents a special case, a portion of what is
felt about three-dimensional experience. This expression of the
artist's experience is thus incomplete.

The layman has extreme difficulty in understanding that plastic
creation on a flat surface is possible without destroying this flat
surface. But it is just this conceptual completeness of a plastic
experience that warrants the preservation of the two dimensionality.
A plastic approach which is incomplete conceptually will destroy the
two dimensionality, and being incomplete in concept, the creation
will be inadequate.

Depth, in a pictorial, plastic sense, is not created by the
arrangement of objects one after another toward a vanishing point,
in the sense of the Renaissance perspective, but on the contrary
(and in absolute denial of this doctrine) by the creation of forces in
the sense of *push and pull*. Nor is depth created by tonal
gradation—(another doctrine of the academician which, at its
culmination, degraded the use of color to a mere function of
expressing dark and light).

Since one cannot create "real depth" by carving a hole in the
picture, and since one should not attempt to create the illusion of
depth by tonal gradation, depth as a plastic reality must be two

dimensions in a formal sense as well as in the sense of color. "Depth" is not created on a flat surface as an illusion, but as a plastic reality. The nature of the picture plane makes it possible to achieve depth without destroying the two-dimensional essence of the picture plane. Before proceeding, however, the artist must realize the necessity of differentiating between a line and a plane concept.

A plane is a fragment in the architecture of space. When a number of planes are opposed one to another, a spatial effect results. A plane functions in the same manner as the walls of a building. A number of such walls in a given relation creates architectural space in accordance with the idea of the architect who is the creator of this space. Planes organized within a picture create the pictorial space of its composition. In an old master composition, the outline of a figure was considered as a plane and as such the figure became plastically active in the composition. The old masters were plane-conscious. This makes their pictures restful as well as vital, irrespective of the dramatic emphasis.

A line concept cannot control pictorial space absolutely. A line may flow freely in and out of space, but cannot independently create the phenomenon of *push and pull* necessary to plastic creation. *Push and pull* are expanding and contracting forces which are activated by carriers in visual motion. Planes are the most important carriers, lines and points less so.

The forces of *push and pull* function three dimensionally without destroying other forces functioning two dimensionally. The movement of a carrier on a flat surface is possible only through an act of shifting left and right or up and down. To create the phenomenon of *push and pull* on a flat surface, one has to understand that by nature the picture plane reacts automatically in the opposite direction to the stimulus received; thus action continues as long as it receives stimulus in the creative process. *Push* answers with *pull* and *pull* with *push*. For example, the inside pressure of a balloon is in balance in every direction. By pressing one side of the balloon, you will disturb this balance, and, as a consequence, the other end will swallow up the amount of pressure applied. Needless to say, this procedure can be reversed. Exactly the same thing can happen to the picture plane in a spiritual sense. When a force is created somewhere in the picture that is intended to be a stimulus in the sense of a *push* the picture plane answers automatically with a force in the sense of *pull* and vice versa.

The function of *push and pull* in respect to form contains the secret of Michelangelo's monumentality or of Rembrandt's universality. At the end of his life and at the height of his capacity, Cézanne understood color as a force of *push and pull*. In his

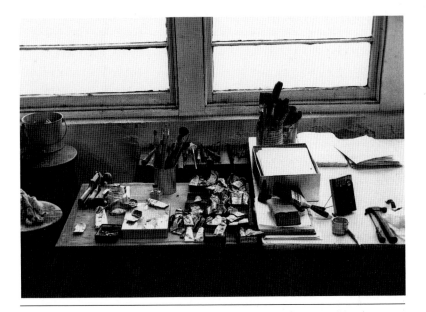

Hans Hofmann's painting table,
1960
Photograph by Fred W.
McDarrah

pictures he created an enormous sense of volume, breathing, pulsating, expanding, contracting through his use of color. His watercolors were forever exercises in this direction. Only very great painting becomes so plastically sensitive, for the expression of the deepest in man calls for unexpected and surprising associations.

The graphic arts deal only with basic problems of form. Painting, however, involves a formal problem which depends in its last analysis on the function of color as well as on the essential nature of the picture plane. A painting (which means no more than "forming with color") may embody the same images as does a work of graphic art through the control of form, but it must be realized by very different ways and means since color has an intricate life of its own. To understand this seemingly dual problem of form and color involved in painting, we must first make clear what the intrinsic life of color really is, and what makes this life a vital factor in plastic creation.

Color is a plastic means of creating intervals. Intervals are color harmonics produced by special relationships, or tensions. We differentiate now between formal tensions and color tensions, just as we differentiate in music between counterpoint and harmony. And just as counterpoint and harmony follow their own laws, and differ in rhythm and movement, both the formal tensions and the color tensions have a development of their own in accordance with the inherent laws from which they are separately derived. Both, however, as we have stated, aim toward the realization of the same image. And both deal with the depth problem.

The creative possibilities of color are not limited to plastic

expression. Although the composition and function of color are two of the most important factors in determining the qualitative content of a painting, the reciprocal relation of color to color produces a phenomenon of a more mysterious order. This new phenomenon is psychological. A high sensitivity is necessary in order to expand color into the sphere of the surreal without losing creative ground. Color stimulates certain moods in us. It awakens joy or fear in accordance with its configuration. In fact, the whole world, as we experience it visually, comes to us through the mystic realm of color. Our entire being is nourished by it. This mystic quality of color should likewise find expression in a work of art.

One must realize that, apart from considerations of color and form, there are two fundamentally different ways of regarding a medium of expression: one is based on taste only—an approach in which the external physical elements of expression are merely pleasingly arranged. This way results in decoration with no spiritual reaction. Arrangement is not art. The second way is based on the artist's power of empathy, to feel the intrinsic qualities of the medium of expression. Through these qualities the medium comes to life and varies plastically as an idea develops.

The whole field of commercial art and much that comes under the heading of applied art is handled in the first way and is chiefly decorative arrangement. The so-called fine arts are handled in the second way to give the total of man's inner self his spiritual world which he can offer only as an artist in the most profound sense. . . .

We should differentiate between decorative in a plastic sense, and decorative in a non-plastic sense. The works of Klee and Kandinsky are diametrically opposed to ornamentation and decorative, abstract design. The fact that any great plastic work is also decorative in its two-dimensional completeness does not mean that any design on a flat surface is a plastic creation. The phenomenon of plastic movement determines whether or not a work belongs in the category of the fine arts or in the category of the applied arts. It is the greatest injustice done to Mondrian that people who are plastically blind see only decorative design instead of the plastic perfection which characterizes his work. The whole de Stijl group from which Mondrian's art was derived must be considered a protest against such blindness. This group aimed toward the purest plastic perfection.

We have spoken of a seemingly dual problem involved in painting. Only a few very great painters in history have understood how to approach or proceed in this seemingly two-fold concept. I emphasize "seemingly" because this double or to say it more

correctly this multi-problem characterizes the very nature of painting. Painting at its greatest is a synthesis arrived at by mastering its multi-problems. Only painters of the stature of Rembrandt and El Greco have been artist and painter in one, not only because they have understood how to compose with color, but, at the same time, how to express with it the profoundness of man. Throughout his life, Cézanne struggled for a synthesis. Renoir mastered it in a high degree by instinct. Van Gogh and many others have despaired of it. America possesses great potentialities in the search for creative clarification, though she may look back on a generation entirely misunderstood—the tragic generation of the pioneers of Modern Art.

We have explained that quality, a pure, human value, results from the faculty of empathy, the gift of discerning the mystery of each thing through its own intrinsic life. In this life, an intuitive artist discovers the emotive and vital substance which makes a work of art. In the passage of time, the outward message of a work may lose its initial meaning; the communicative power of its emotive and vital substance, however, will stay alive as long as the work is in existence. The life-giving zeal in a work of art is deeply imbedded in its qualitative substance. The spirit in a work is synonymous with its quality. The *Real* in art never dies, because its nature is predominantly spiritual.

excerpted from *Search for the Real and Other Essays*, Addison Gallery of American Art, Andover, MA, pp. 40–48. Reprinted by permission. © The MIT Press (1948).

"Painting and Culture," 1948

Nature exists on the one hand as three-dimensional form, with variations, relations and separations as to the quantities and qualities within its essential unity. On the other hand, the picture plane exists two dimensionally, yet capable of separation into visual planes.

The knowledge of reality, achieved by means of the complete sensory equipment, must be expressed artistically in terms of a medium which appeals to the memory of all sensory experience— but only through the eye.

While the experience of nature is achieved by various sensory approaches, the experience of a picture is achieved by means of a visual impression alone. The picture stands or falls on its appeal to the eye alone, but this stimulus calls up necessary associations with

qualities which have been perceived through other senses and stored in the subconscious, if the observer is sensitively endowed.

In order that visual stimulation may be assisted by memory, the picture must, with this purpose in view, present elements more definitely adapted and ordered than the visual appearance of nature alone.

Light and shade do not always convey the truth about form realized in actual experiences of nature. Only by the aid of our other senses do we gain a proper understanding of the particular form we have before us.

When we lift shapes out of their numerous relationships in the natural world or from the mental associations formed by our senses, we must endow them with an authenticity which is pictorial rather than natural. The picture must be consistent within itself in order to avoid false illusions arising from new relations within the frame of the picture. So the process of re-creating reality is not based upon a simple reproduction of nature. . . .

Creation is dominated by three absolutely different factors: first, nature, which affects us by its laws; second, the artist who creates a spiritual contact with nature and with his materials; and third, the medium of expression through which the artist translates his inner world.

The creative process lies not in imitating, but in paralleling nature—translating the impulse received from nature into the medium of expression, thus vitalizing this medium. The picture should be alive, the statue should be alive and every work of art should be alive.

Every work of art is the product of the artist's power for conscious feeling, and of his sensitivity to life-in-nature and life within the limits of his medium.

The depth of an artistic creation is a question of human development. The deeper the human content, the deeper the understanding of the medium.

The *Ninth Symphony* of Beethoven and any polonaise start from the same musical principle. The contrasts lie in the difference of the human content. One is a world, the other is only an element in a world. . . .

It is the aim of every cultural pursuit to enrich and to give deeper content to life.

Genius is gifted with a vitality which is expended in the enrichment of life through the discovery of new worlds of feeling. Art and science create a balance to material life and enlarge the world of living experience. Art leads to a more profound concept of life, because art itself is a profound expression of feeling.

The artist is born, and art is the expression of his overflowing soul. Because his soul is rich, he cares comparatively little about the superficial necessities of the material world; he sublimates the pressure of material affairs in an artistic experience.

Art is something absolute, something positive, which gives power just as food gives power.

While creative science is mental food, art is the satisfaction of the soul.

A material world which excludes art will remain a troubled world. The materialist flees from the crying need of his unsatisfied spirit to the drive of the "daily grind." Since his physical satisfaction does not necessarily include spiritual satisfaction, the sum total of his living remains unsatisfied. Such a man suffers an inner emptiness, and soon cannot endure thoughtfulness, nor the products of contemplation.

Spinoza says, "Only contemplated experience becomes real experience," which is the reverse of "Let's go places and do things." The materialist flees through an insecure world of shifting illusions, finding no permanent reality.

It takes intelligence and training, self-discipline and fine sensibility, to gain renewed life through leisure occupation. America now suffers spiritual poverty, and art must come more fully into American life before her leisure can become culture. . . .

The general misunderstanding of a work of art is often due to the fact that the key to its spiritual content and technical means is missed. Unless the observer is trained to a certain degree in the artistic idiom, he is apt to search for things which have little to do with the aesthetic content of a picture. He is likely to look for purely representational values when the emphasis is really upon music-like relationships.

Everything rhythmically organic is true. Everything which results from the proper feeling for rhythmically organized spiritual units is true and alive—alive within itself. When we lose the sense for such true beauty we lose our natural sense for the rich flavor of life, which is the basis for all inspirational work.

Things generally taken for beautiful are nothing other than the product of frozen, stereotyped taste, bound by sterile rules and by purely exterior judgment.

The two dimensionality in Oriental visual art, so often copied without the understanding of its plastic content, is an example of such mechanical stylization. Copying of any style, without understanding the vital qualities of its creative impulses, must result in sterile work.

Literary content is objective "story value."

Plastic value in art arises as a result of relations of volumes in space.

The literary artist is apt to stop with the "story value" of the object.

The plastic artist is concerned with the music-like relationships of plastic units just as the musical artist is concerned with the harmonic relationships of musical units.

The plastic artist may or may not be concerned with presenting a superficial appearance of reality, but he is always concerned with the presentation—if not the representation—of the plastic values of reality.

The difference between the arts arises because of the difference in the nature of the mediums of expression and in the emphasis induced by the nature of each medium. Each means of expression has its own order of being, its own units.

The key to understanding lies in the appreciation of the limitations, qualities, and possibilities of variation and relation of these presentational elements.

Unless one recognizes letters, one cannot read.

Speech has arisen through the need for expression. Certain factors have contributed to making it the paramount utilitarian method of expression. There are ideas and things expressible in words, but there are experiences better expressed in music. The person with no musical ear, or without discipline in the language of music, lacks the key to the door of the world of music experience. But we live in a world of volume and space; it is hard to conceive of the person who is space-blind or volume-deaf. The great majority of people have the means of approach to plastic beauty as part of their natural equipment. The teacher can develop this natural endowment as Necessity, the greatest teacher, has developed speech.

Teachers are those who, by enforced discipline, shorten the road to understanding, but they can work only by developing natural endowment.

There is a world of visual beauty open to the one willing to undergo the practice and striving necessary to an understanding of its language.

This world is as important culturally as is the world of words or of music. My ideal is to form and to paint as Schubert sings his songs and as Beethoven creates his world in sounds. That is to say, creation of one's own inner world through the same human and artistic discipline.

excerpted from *Search for the Real and Other Essays*, Addison Gallery of American Art, Andover, MA, pp. 55–58. Reprinted by permission. © The MIT Press (1948).

Franz Kline, 1954
Photograph by Hans Namuth

Franz Kline

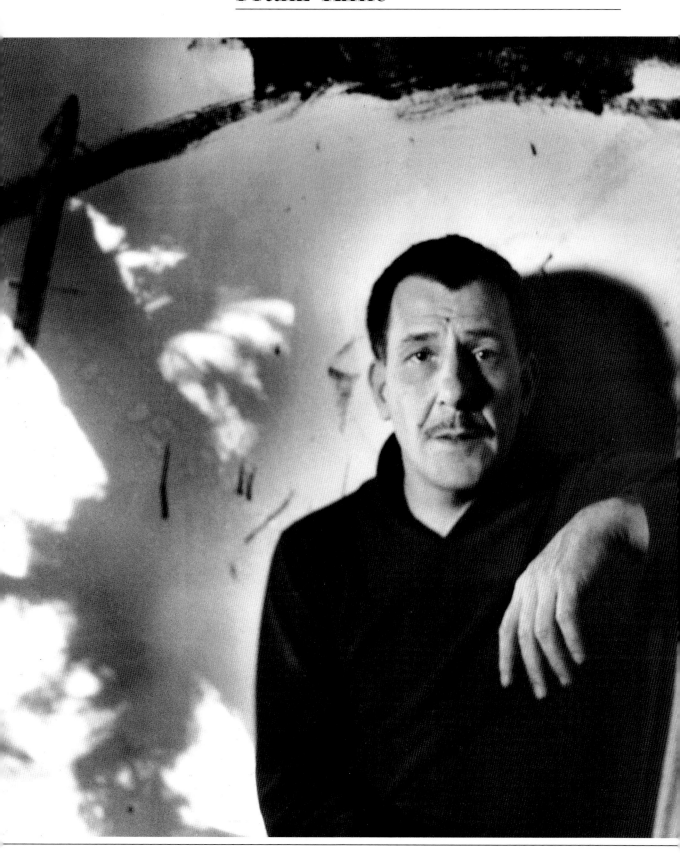

Interview with Frank O'Hara, 1958

FRANZ KLINE: That's Bill's isn't it?* Terrific! You can always tell a de Kooning, even though this one doesn't look like earlier ones or later ones. It's not that style has a particular look, it just adds up. You become a stylist, I guess, but that's not it. . . .

In Braque and Gris, they seemed to have an idea of the organization beforehand in their mind. With Bonnard, he is organizing in front of you. You can tell in Léger just when he discovered how to make it like an engine, as John Kane said, being a carpenter, a joiner. What's wrong with that? You see it in Barney Newman too, that he knows what a painting should be. He paints as he thinks *painting* should be, which is pretty heroic. . . .

I like Fra Angelico. I used to try all the time to do those blue eyes that are really blue. Someone once told me to look at Ingres. I loved Daumier and Rembrandt at the time and I was bored when I looked at Ingres. Before long I began to like it. You go through the different phases of liking different guys who are not like you. You go to a museum looking for Titian and you wind up looking at someone else. But the way of working before Cézanne is hidden. Cézanne is like an analyst and he seems to be right there, you can see him painting the side of a nose red. Even though he wanted to paint like Velásquez. . . .

Criticism must come from those who are around it, who are not shocked that someone should be doing it at all. It should be exciting, and in a way that excitement comes from, in looking at it, that it's *not* that autumn scene you love, it's *not* that portrait of your grandmother. . . .

Tomlin. In a way, they never did much about him and I think it's sad. He didn't start an art school, but he had an influence—his statements were very beautiful. When Pollock talked about painting he didn't usurp anything that wasn't himself. He didn't want to change anything, he wasn't using any outworn attitudes about it, he was always himself. He just wanted to be in it because he loved it. The response in the person's mind to that mysterious thing that has happened has nothing to do with who did it first. Tomlin, however, did hear these voices and in reference to his early work and its relation to Braque, I like him for it. He was not an academician of Cubism even then, he was an extremely personal and sensitive artist. If they want to talk about him, they say he was supposed to be Chopin. He didn't knock over any tables. Well, who's supposed to be Beethoven? Braque? I saw Tomlin's later work at the Arts Club in Chicago when he was abstract and it was the most exciting thing around—you look up who else was in the show.

If you're a painter, you're not alone. There's no way to be alone. You think and you care and you're with all the people who care, including the young people who don't know they do yet. Tomlin in his late paintings knew this. Jackson always knew it: that if you meant it enough when you did it, it will mean that much. . . .

You don't paint the way someone, by observing your life, thinks you *have* to paint, you paint the way you have to in order to *give*, that's life itself, and someone will look and say it is the product of knowing, but it has nothing to do with knowing, it has to do with giving. The question about knowing will naturally be wrong. When you've finished giving, the look surprises you as well as anyone else.

Some painters talking about painting are like a lot of kids dancing at a prom. An hour later you're too shy to get out on the floor.

Hell, half the world wants to be like Thoreau at Walden worrying about the noise of traffic on the way to Boston; the other half use up their lives being part of that noise. I like the second half. Right?

To be right is the most terrific personal state that nobody is interested in.

excerpted from *Evergreen Review*, vol. II, no. 6, autumn 1958, pp. 11–15. © The Estate of Franz Kline

*The initial reference is to an abstract painting by Willem de Kooning ca. 1945, which was in the room during the interview.

Interview with Selden Rodman, 1961

. . . the thing is that painters like Daumier and Ryder don't ever really paint things the way they look. Nobody can ever look at a boat by Ryder—like a hunk of black tar—and say to me that a boat ever looked like that! Or one of Daumier's faces, composed of slabs of paint, deliberately crude! The final test of painting, theirs, mine, any other, is: does the painter's emotion come across? . . .

Procedure is the key word. . . . The difference is that we don't begin with a definite sense of procedure. It's free association from the start to the finished state. The old idea was to make use of your talent. This, we feel, is often to take the line of least resistance. Even a painter like Larry Rivers uses his creative gift in the old way—which is O.K.; I'm not criticizing him or saying that for him it may not be the right way—but painters like Rothko, Pollock, Still, perhaps in reaction to the tendency to *analyze* which has dominated painting from Seurat to Albers, *associate*, with very little analysis. A new form of expressionism inevitably followed. With de Kooning,

the procedure is continual change, and the immediacy of the change. With Pollock, it's the confidence you feel from the concentration of his energy in a given picture. . . . It's the lack of procedure—and the surprise element which that entails. But as I said earlier, the emotion must be there. If I feel a painting I'm working on doesn't have imagery or emotion, I paint it out and work over it until it does. . . .

The thing is that a person who wants to *explore* painting naturally reflects: 'How can I in my work be most expressive?' *Then* the forms develop.

excerpted from *Conversations with Artists* by Selden Rodman. New York: Capricorn Books, 1961, pp. 106, 108, 109. Copyright © 1990 Pollock-Krasner Foundation/ARS N.Y.

Interview with Katherine Kuh, 1962

KUH: Do you think that great artists have always been innovators?
KLINE: Throughout the history of painting there have been great figures—usually innovators. In fact, all the greatest artists, I suppose, have been innovators. I've never consciously thought of myself as one. As to the contemporary artists I've been around— some of them have influenced me and I've influenced some of them. I realize that certain artists claim that being influenced detracts from their reputation. A painting doesn't have to look like another person's work to have been influenced by it. The average artist maturing around the age of forty, as I did, for instance (I had my first one-man show at Egan's gallery when I was that age), has been influenced by both the old masters and by his contemporaries. As for me, I've always liked Tintoretto, Goya, Velásquez and Rembrandt. Rembrandt's drawing is enough in itself! . . .
KUH: Do you prefer Velásquez to El Greco?
KLINE: Yes, I much prefer him. Talk about painting! With Velásquez there's a solidity—there's a lot more than that, but so much has been said about him you don't need my comments.
KUH: Critics claim you've been influenced by Oriental calligraphy. Is there any truth in this?
KLINE: No. I don't think of my work as calligraphic. Critics also describe Pollock and de Kooning as calligraphic artists, but calligraphy has nothing to do with us. It's interesting that the Oriental critics never say this. The Oriental idea of space is an infinite space; it is not painted space, and ours is. In the first place, calligraphy is writing, and I'm not writing. People sometimes think I take a white canvas and paint a black sign on it, but this is

not true. I paint the white as well as the black, and the white is just as important. For instance, in this canvas we're looking at right now, you can see how I've painted out areas of black with my whites.

KUH: What was your early training and has it affected your work?

KLINE: I had an academic background—studied and drew from the model. I don't really know whether this is important or not. There's a lot of stuff you've learned that you've got to eliminate as you go along. I happen to like drawing. I can't very well estimate how much my training helped me. I suppose what you've really got to do is learn pretty much everything yourself. After all, what you finally do is a decision only you can make. If anyone had told me that at forty I would be painting only in black and white, I wouldn't have believed it. These things happen slowly.

KUH: Is there any symbolism in your painting?

KLINE: There's imagery. Symbolism is a difficult idea. I'm not a symbolist. In other words, these are painting experiences. I don't decide in advance that I'm going to paint a definite experience, but in the act of painting, it becomes a genuine experience for me. It's not symbolism any more than it's calligraphy. I'm not painting bridge constructions, skyscrapers or laundry tickets. You know that people have been drawing and painting in black and white for centuries. The only real difference between my work and theirs is that they use a kind of metaphor growing out of subject matter. I don't paint objectively as they did in their period; I don't paint a given object—a figure or a table; I paint an organization that becomes a painting. If you look at an abstraction, you can imagine that it's a head, a bridge, almost anything—but it's not these things that get me started on a painting. . . .

KUH: Does immediate mood affect you?

KLINE: Sometimes I think it must, but not always.

KUH: Some artists claim they are painting themselves. How about you?

KLINE: I say, if that's me, I suppose, then, that's me. But this is pretty hard to answer. Who knows, but you certainly couldn't be painting somebody else, now, could you?

KUH: Do you plan your compositions in advance or do you work directly?

KLINE: I do both. I make preliminary drawings, other times I paint directly, other times I start a painting and then paint it out so that it becomes another painting or nothing at all. If a painting doesn't work, throw it out. When I work from preliminary sketches, I don't just enlarge these drawings, but plan my areas in a large painting by using small drawings for separate areas. I combine them in a final painting, often adding to or subtracting from the original

Franz Kline
Untitled, 1950
Ink on paper, 8 × 11½″
Private collection, whereabouts
unknown

sketches. When I work directly, I work fast. I suppose I work fast
most of the time, but what goes into a painting isn't just done while
you're painting. There are certain canvases here in my studio—the
little one over there—that I've worked on for a good six months—
painting most of it out and then painting it over and over again. I
think I've got it now.

KUH: Does size have anything to do with what you want to say?

KLINE: I think the presence of a large painting is quite different
from that of a small one. A small one can have as much scale,
vigor, space, but I like to paint the large ones. There's an
excitement about the larger areas, and I think you confront yourself
much more with a big canvas. I don't exactly know why.

KUH: Do you feel that the addition of color in recent years has
changed your work?

KLINE: I don't think of this as an addition. I don't think about
adding color. I merely want to feel free to paint in color, or in black
and white. I painted originally in color and finally arrived at black
and white by painting the color out. Then I started with only color,
white and no black—then color and black and white. I'm not
necessarily after the same thing with these different combinations,
for, though some people say that black and white is color, for me
color is different. In other words, an area of strong blue or the
interrelationship of two different colors is not the same thing as
black and white. In using color, I never feel I want to add to or

decorate a black-and-white painting. I simply want to feel free to work both ways. And because someone uses pink, yellow and red doesn't necessarily make him a colorist.

KUH: Do you paint in series?

KLINE: I don't paint in series but sometimes there are paintings that are similar, related visually more than in meaning or sources. After you've thought of, let's say, four titles, that's about as much as you can think of, so when my paintings look somewhat alike I give them similar titles. Now take the paintings I've called Bethlehem. You'll find quite a number of Pennsylvania titles among my pictures because I came from that part of the country. Sometimes it's just that I like the names—the words themselves. For instance, the painting I called "Dahlia" doesn't have anything to do with a dahlia. The name "Bethlehem" has nothing to do with steel. Some pictures I don't even title, and if I do (as long as six months after they've been painted) it's only for identification. Often titles refer to places I've been at about the time a picture was painted, like the composition I called Palladio. It was done after I'd been to the Villa Malcontenta near Venice, but it didn't have a thing to do with Palladian architecture. I always name my paintings after I've painted them. . . .

KUH: How did you happen to go to art school in London in 1937?

KLINE: My mother was English. I'd hoped to go to England and then on to study in Paris, but I never got to Paris at that time. As a matter of fact, last year was the first time I ever went to Paris or the Continent.

KUH: Do you feel you are very much an American painter?

KLINE: Yes, I think so. I can't imagine myself working very long in Europe or, for that matter, anywhere but New York. I find Chicago terrific, but I've been living in New York now for twenty-odd years and it seems to be where I belong.

excerpted from *The Artist's Voice: Talks with Seventeen Artists* by Katherine Kuh. New York: Harper & Row, 1962, pp. 143–45, 152, 153. Copyright © by Harper & Row. Reprinted by permission of Harper & Row, Publishers, Inc.

Interview with David Sylvester, 1963

KLINE: . . . Paint never seems to behave the same. Even the same paint doesn't, you know. In other words, if you use the same white or black or red, through the use of it, it never seems to be the same. It doesn't dry the same. It doesn't stay there and look at you the same way. Other things seem to affect it. There seems to be

something that you can do so much with paint and after that you start murdering it. There are moments or periods when it would be wonderful to plan something and do it and have the thing only do what you planned to do, and then, there are other times when the destruction of those planned things becomes interesting to you. So then, it becomes a question of destroying—of destroying the planned form; it's like an escape, it's something to do; something to begin the situation. You yourself, you don't decide, but if you want to paint you have to find out some way to start this thing off, whether it's painting it out or putting it in, and so on.

SYLVESTER: But what about stopping it? I mean, when you decide that you're going to leave a painting alone, can you in any way rationalize or explain what it is about it that satisfies you?

KLINE: It can at times become like the immediate experience of beginning it; in other words, I can begin a painting if I decide it would be nice to have a large triangle come up and meet something that goes across like this. Now, on other occasions, I can think the whole thing through. The triangle needs an area that goes this way and then at the top something falls down and hits about here and then goes over there. So I try and rid my mind of anything else and attack it immediately from that complete situation. Other times, I can begin it with just the triangle meeting a large form that goes over that way, and when I do it, it doesn't seem like anything. When this series of relationships that go on in the painting relate—I don't particularly know what they relate *to*—but the relationship of those forms, I, in some way, try to form them in the original conception of what I rather imagined they would look like. Well then, at times, it's a question of maybe making them more than that. You see what I mean. It'd be a question of, say, eliminating the top or the bottom. Well, I can go through and destroy the whole painting completely without even going back to this original situation of a triangle and a long line, which seems to appear somewhere else in the painting. When it appears the way I originally thought it should, boy, then it's wonderful!

SYLVESTER: But it seems to you to relate?

KLINE: Yes. But it's not an illusionistic thing. It just seems as though there are forms in some experience in your life that have an excitement for you. I remember years ago in Spurrier's class; he, being an illustrator, the idea was to take a subject or a story and do something about this thing so that when somebody picked up a magazine, they looked at the illustration and they thought, "Terrific, I'll read that." The particular subject that we were to handle had to do with a scene in the railway station in the first war, with soldiers, and the engine coming into a French village. Well then, I knew

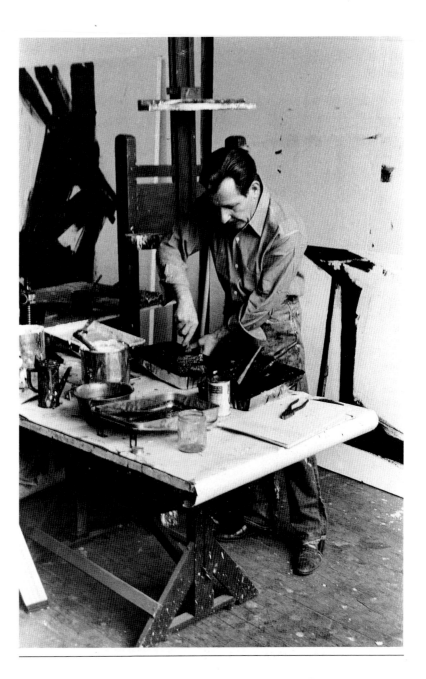

Franz Kline, 1961
Photograph by Fred W.
McDarrah

exactly, not exactly what an engine looked like but there was something to draw, you know. I mean that was completely different from someone saying: "A girl sat on the divan and said 'Henry, I love you, darling.'" Those sort of forms in your experience do, in some way, not dominate, but they become the things that you are involved with. I don't mean that squares become windows; after all, squares become heads, they become everything, you know. I don't mean it in that sense. A curve line or a rhythmical relationship do have, in some way, some psychological bearing, not only on the

person who looks at them after they've been conceived but also they do have a lot to do with the creative being who is involved with wondering just how exciting it can be. And then, of course, the elimination and agitation and the simplification come in through the many varied experiences that go on just through the experience of painting.

SYLVESTER: Do you ever encourage an image along? Consciously? Do you ever nurse it?

KLINE: No, no. There are forms that are figurative to me, and if they develop into a figurative image that's—it's all right if they do. I don't have the feeling that something has to be completely non-associative as far as figure form is concerned.

SYLVESTER: But do you have a feeling that they have to be associative either? I mean the way that de Kooning in his later paintings, you know the paintings, the sort of outdoor paintings in the last two years, wants them, really wants them to correspond to experiences of parkways and. . . . You don't think in those terms?

KLINE: I think that if you use long lines, they become—what could they be? The only thing they could be is either highways or architecture or bridges.

SYLVESTER: If somebody were to say to you that they felt that one of the excitements of your painting was this kind of sense of city life that it has . . .

KLINE: Oh, I like that (You like that?) because I like the city better than I do the country.

SYLVESTER: But would that seem to you to be an irrelevant or a relevant response to your paintings?

KLINE: No, that's all right. After all I've lived here—I've lived in New York for twenty years. Years ago, when I went out with a paintbox, I painted from roof-tops and I painted from studio windows; so, the last recollection I have of objective painting has been in the city, you see. . . .

SYLVESTER: Are you conscious of particular paintings having particular feeling tones? Particular emotional content? That some of them might be, say, angry; that one of them might be cheerful; that some of them might be sad? (Yes.) You do feel them that way? (Yes.) Is this important for you?

KLINE: Yes. As a matter of fact it is nice to paint a happy picture after a sad one. I think that there is a kind of loneliness in a lot of them which I don't think about as the fact that I'm lonely and therefore I paint lonely pictures, but I like kind of lonely things anyhow; so if the forms express that to me, there is a certain excitement that I have about that. Any composition—you know, the overall reality of that does have something to do with it; the

impending forms of something, do maybe have a brooding quality, whereas in other forms, they would be called or considered happier.

SYLVESTER: Are you aware of these qualities when you are actually painting or only after you have finished the painting?

KLINE: No, I'm aware of them as I paint. I don't mean that I retain those. What I try to do is to create the painting so that the overall thing has that particular emotion; not particularly just the forms in it.

SYLVESTER: But you do try to retain a certain emotion in the overall thing? (Yes.) An emotion you might be able to name while you are painting it?

KLINE: Yes, at times, yes.

SYLVESTER: That you might do something in a painting because you wanted to preserve a particular brooding quality?

KLINE: Yes. I think it has to do with the movement, even though it can be static. In other words, there's a particular static or heavy form that can have a look to it, an experience translated through the form; so then it does have a mood. And when that is there, well then it becomes—it becomes a painting whereas all the other pictures that have far more interesting shapes and so on, don't become that to me.

SYLVESTER: So if there was one sort of criterion for you, the success of a painting that you were doing, would it be this, that it conveyed a particular mood?

KLINE: Yes, that could be one of the aspects of it. I mean, there are other paintings that through the complete mishandling of them, become an irrevocable . . . in other words, there couldn't be a thing either added or taken away.

SYLVESTER: A lot has been made of this thing of spontaneity in abstract expressionism but you make a lot of use of preliminary drawing in your painting.

KLINE: I rather feel that painting is a form of drawing and the painting that I like has a form of drawing to it. I don't see how it could be disassociated from the nature of drawing. As to whether you rush up to the canvas and knock yourself out right away or you use something . . . I find that in many cases a drawing has been the subject of the painting—that would be a preliminary stage to that particular painting. I've taken drawings I like. But I've also worked with drawings that I didn't think very good.

SYLVESTER: When you decide to use a drawing for a painting, are you interested in that drawing because it already seems to contain a certain mood (Sometimes, yes.)—and in what happens in the painting does this mood often become transformed?

KLINE: Yes, quite often it does. The painting can develop into

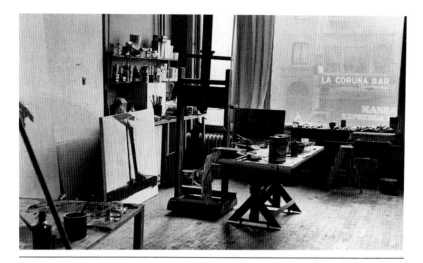

Franz Kline's 14th Street Studio, 1961
Photograph by Fred W. McDarrah

something that is not at all related to the drawing and have no particular mood about it at all; it's just a cool kind of reality that has a series of involvements within it; and the pure excitement of those things happening within this form is enough for that particular painting. The other thing is that it depends apparently on the scale of things. When I started first to work large, what I thought was large then—in other words, six by eight feet was a pretty large canvas then.

SYLVESTER: What—about 1950?

KLINE: That's right. So a friend of mine let me borrow some money from him and we wound up buying eleven yards of canvas for forty dollars, and that was an awful lot of canvas. Most artists wouldn't use up that in their life. So then the situation came of previous years of not having canvas; then there was that excitement about painting over old paintings and using the things underneath that rather kidded you along, you know, and there was a nice texture, and the whole thing became another process of painting. Well, after having purchased this eleven yards . . . I guess the canvas was something like seven feet high and eleven yards long. Well then, I thought it would be rather nice to treat it just as paper, stop worrying about this Belgian canvas. So, in the procedures of working large, I still had that grief, you know, about wasting all this material, so at that time I did a lot of drawings on the telephone book. I could go through the whole telephone book in one night. And then instead of looking at them critically the next day, I just put them away, forgot about them. And then as time went on, say a month or two later, or even three months later, I'd go back through these so-called drawings, and then they formed in some way the beginning of something that I could work on, six by eight feet.

SYLVESTER: Do you still work in this way?

KLINE: I go on doing that but I also paint without a smaller sketch to start with. A lot of the paintings have developed through painting out other paintings and then, in some way, I can use some reference maybe from part of another drawing, that maybe I had done three years ago, or something like that. I look around nervously for some situation to set this thing off again. It might become then a process of over-painting and under-painting to a certain extent.

SYLVESTER: You might use several drawings in doing a painting? (Yes.) Have you been using the drawings in the colour paintings you've done recently? (No, no.) Not at all?

KLINE: No. I get a particular sense of mass or scale from my own drawings. My drawings don't change, you know. Some of them become more or less similar and then they become rather boring to me. Then, over say a period of hours or a day, I'd see something in another drawing that probably doesn't have that same familiarity which hooked up to a previous experience in a painting before that, you see. So then I am not able to translate that particular form into a colour. I think the colour—use of colour—obviously works against it. The pictures that developed with colour, I didn't particularly want to use or add colour to black and white and I guess it was just the experience of being rather bored with looking at a lot of black-and-white paintings . . . and every now and then I have the feeling it would be marvellous just to do a large area in yellow or red or something like that. But of course I fail most of the time, but not always. Sometimes it is a red or yellow or blue area in the painting. I think that the things that I did develop in colour were the ones that worried me most, you know, in the last exhibition, and that wasn't because of the colour particularly or that I had an attitude about colour. I think it was just a question of the feelings of the paintings.

SYLVESTER: You work on the paintings for a long time?

KLINE: Well, no, not necessarily. I like to do them right away, you know, and when they come off and I'm done with them, they're marvellous. But I can't do it all the time of course!

SYLVESTER: Do you ever find you can work with a painting over a long period and it comes off? Or do you find that if it doesn't come off fairly quickly, it doesn't come off at all?

KLINE: Some of the pictures I work on a long time and they look as if I've knocked them out, you know, and there are other pictures that come off right away. The immediacy can be accomplished in a picture that's been worked on for a long time just as well as if it's been done rapidly, you see. But I don't find that any of these things prove anything really.

excerpted from *Living Arts*, vol. I, no. 1, spring 1963, pp. 4, 7, 10, 12. © David Sylvester

Robert Motherwell

"Beyond the Aesthetic," 1946

For the goal which lies beyond the strictly aesthetic the French artists say the "unknown" or the "new," after Baudelaire and Rimbaud; Mondrian used to say "true reality." "Structure" or "gestalt" may be more accurate: reality has no degrees, nor is there a "super" one (surréalisme). Still, terminology is unimportant. Structures are found in the interaction of the body-mind and the external world; and the body-mind is active and aggressive in finding them. As Picasso says, there is no use looking at random: to find is the thing.

The aesthetic is the *sine qua non* for art: if a work is not aesthetic, it is not art by definition. But in this stage of the creative process, the strictly aesthetic—which is the sensuous aspect of the world—ceases to be the chief end in view. The function of the aesthetic instead becomes that of a medium, a means for getting at the infinite background of feeling in order to condense it into an object of perception. We feel through the senses, and everyone knows that the content of art is feeling; it is the creation of an object for sensing that is the artist's task; and it is the qualities of this object that constitute its felt content. Feelings are just how things feel to us; in the old-fashioned sense of these words, feelings are neither "objective" nor "subjective," but both, since all "objects" or "things" are the result of an interaction between the body-mind and the external world. "Body-mind" and "external

Robert Motherwell, 1953
Photograph by Hans Namuth

world" are themselves sharp concepts only for the purposes of critical discourse, and from the standpoint of a stone are perhaps valid but certainly unimportant distinctions. It is natural to rearrange or invent in order to bring about states of feeling that we like, just as a new tenant refurnishes a house.

The passions are a kind of thirst, inexorable and intense, for certain feelings or felt states. To find or invent "objects" (which are, more strictly speaking, relational structures) whose felt quality satisfies the passions—that for me is the activity of the artist, an activity which does not cease even in sleep. No wonder the artist is constantly placing and displacing, relating and rupturing relations: his task is to find a complex of qualities whose feeling is just right—veering toward the unknown and chaos, yet ordered and related in order to be apprehended.

The activity of the artist makes him less socially conditioned and more human. It is then that he is disposed to revolution. Society stands against anarchy; the artist stands for the human against society; society therefore treats him as an anarchist. Society's logic is faulty, but its intimation of an enemy is not. Still, the social conflict with society is an incidental obstacle in the artist's path.

It is Cézanne's feeling that determined the form of his pictorial structure. It is his pictorial structure that gives off his feeling. If all his pictorial structures were to disappear from the world, so would a certain feeling.

The sensation of physically operating on the world is very strong in the medium of the *papier collé* or collage, in which various kinds of paper are pasted to the canvas. One cuts and chooses and shifts and pastes, and sometimes tears off and begins again. In any case, shaping and arranging such a relational structure obliterates the need and often the awareness of representation. Without reference to likenesses, it possesses feeling because all the decisions in regard to it are ultimately made on the grounds of feeling.

Feelings must have a medium in order to function at all; in the same way, thought must have symbols. It is the medium, or the specific configuration of the medium that we call a work of art that brings feeling into being, just as do responses to the objects of the external world. Apart from the struggle to endure—as Spinoza says, substance is no stronger than its existence—the changes that we desire in the world, public or private, are in the interests of feeling. The medium of painting is such changing and ordering on an ideal plane, ideal in that the medium is more tractable, subtle, and capable of emphasis (abstraction is a kind of emphasis) than everyday life.

Drama moves us: conflict is an inherent pattern in reality.

Harmony moves us too: faced as we are with ever imminent disorder, it is a powerful ideal. Van Gogh's drama and Seurat's silent harmony were born in the same country and epoch; but they do not contradict one another; they refer to different patterns among those which constitute reality. In them the projection of the human has become so desocialized as to take on the aspect of the "unknown." Yet what seems more familiar when we confront it?

The "pure" red of which certain abstractionists speak does not exist, no matter how one shifts its physical contexts. Any red is rooted in blood, glass, wine, hunters' caps, and a thousand other concrete phenomena. Otherwise we should have no feeling toward red or its relations, and it would be useless as an artistic element.

But the most common error among the whole-hearted abstractionists nowadays is to mistake the medium for an end in itself, instead of a means.

On the other hand, the surrealists erred in supposing that one can do without a medium, that in attacking the medium one does not destroy just one's means for getting into the unknown. Color and space relations constitute such a means because from them can be made structures which exhibit the various patterns of reality.

Like the cubists before them, the abstractionists felt a beautiful thing in perceiving how the medium can, of its own accord, carry one into the unknown, that is, to the discovery of new structures. What an inspiration the medium is! Colors on the palette or mixed in jars on the floor, assorted papers, or a canvas of a certain concrete space—no matter what, the painting mind is put into motion, probing, finding, completing. The internal relations of the medium lead to so many possibilities that it is hard to see how anyone intelligent and persistent enough can fail to find his own style.

Like Rimbaud before them, the surrealists abandoned the aesthetic altogether; it takes a certain courage to leave poetry for Africa. They revealed their insight as essentially moral in never forgetting for a moment that most living is a process of conforming to an established order which is inhuman in its drives and consequences. Their hatred sustained them through all the humiliating situations in which the modern artist finds himself, and led them to perceptions beyond the reach of more passive souls. For them true "poetry" was freedom from mechanical social responses. No wonder they loved the work of children and the insane—if not the creatures themselves.

In the end one must agree with Rilke when he says that with "nothing can one touch a work of art so little as with critical words; they always come down to more or less happy misunderstandings."

It was Marcel Duchamp who was critical, when he drew a moustache on the Mona Lisa. And so was Mondrian when he dreams of the dissolution of painting, sculpture, and architecture into a transcendent ensemble.

from *Design*, vol. 48, no. 8, April 1946. © Robert Motherwell

"The Painter and the Audience," 1954

What a disagreeable subject!

To the degree that the modern painter's activity outside the studio is exhibiting, I suppose that he might be called an audience seeker. Painters must have begun to have exhibitions at that moment in history when commissions were no longer the custom and an audience had to be sought out—just as writers must have begun to publish when they ceased reciting to their patrons. The painters' loss caused by this change was not merely economic; it was as well a loss of collaboration with others; both losses profoundly affected the character of "modern" art. Perhaps this new situation calls for some examination, though here I feel rather ill at ease: for most painters nowadays, examination is self-examination—this is all that we are accustomed to—while the relation to the audience is a social matter. And it is our pictures, not ourselves, that live the social life and meet the public. . . . It is interesting that the creations of solitary individuals should turn out to have such a gift for sociability!

When my generation of "abstract" painters began exhibiting ten years ago, we never expected a general audience, not at least one that would make its presence obvious to us. After many years of genre painting in this country, and the great imports coming from Europe, it would have been unreasonable for us to expect one, no matter what we did; and yet an audience was there all the time, as it was for the cubists in their own time. . . . Ten years ago, it seemed that we were embarked upon a solitary voyage, undertaken, I think—in regard to painting—in the belief that "the essence of life is to be found in the frustrations of the established order." We were trying to revise modern painting in relation to some of its obvious frustrations, so that painting would represent our sense of reality better. This general tendency each of us followed in his own way. . . .

A modern painter may have many audiences or one or none; he paints in relation to none of them, though he longs for the audience of other modern painters; and if the modern painter should have a

relation with any audience, it is because that audience has somehow found *him*, and managed to approach the center of his being, i.e., the character of his painting. Someone does find you, though it never can be, in a period like ours, everybody . . . As everyone senses, it is curious when a modern painter like Braque paints a public ceiling for the Louvre; and yet the intent on his side and that of the audience was surely that this is the way things should be. . . .

For the "audience" that a modern painter *could* treat sociably is a ceiling or wall. It is a question of direct social contact. If the painter is commissioned to paint a specific wall in a specific place for a specific person, he must take into consideration the wall's needs, as well as his own, and a real marriage could come about, lessening perhaps the distance between the modern artist and the public. Yet certainly these marriages usually fail to be consummated, as I believe was true of Braque in the Louvre; collaboration is so rare that painter and public have difficulty in understanding each other; besides, in our time, painters cannot be married to institutions . . . And from the standpoint of the public, how many walls have been turned over during the past fifty years to the most celebrated and esteemed painters? So far as I know, to Matisse thrice, once by a Russian millionaire, once by an American millionaire, once by a French nunnery; to Picasso once, a temporary pavilion, for which he painted *Guernica*. Doubtless both painters have made even greater works in the studio's solitary inspiration; but still, what a triumph these four commissions represent as efforts to reach beyond that solitude! A solitude that has become traditional in modern society. Georges Seurat was born to paint walls, the large scale was inherent in his painting methods; yet no one ever asked him to; and there would not be even an easel painting of his in France, if it weren't for the bequest of an American collector.

Sometimes when I walk down Park Avenue and regard the handsome and clean-cut Lever Brothers building, which I suppose belongs to the same "family" as the tall UN skyscraper, I think to myself how the interior walls need the sensuality and moral integrity of modern painting; but then one cannot help reflecting that what lies behind this building is not the possibility of collaboration between men on "ultimate concerns," but instead big business, that is, a popular soap, whose needs in the end will determine everything, including how its makers think about reality. It is strange when a commodity is more powerful than the men who make it.

My emphasis is the absence of direct social relations between the modern painter and his audience. One *can* understand, though it is

Robert Motherwell
Beside the Sea #24, 1962
Oil on Rag Paper, 29 × 23″
Collection of the Artist

curious to think this way, that a Picasso is regarded by speculators as a sounder investment than French government bonds; but what a peculiar responsibility or circumstance for a solitary artist. Indeed, our society, which has seemed so freedom-giving and passive in its attitudes toward the artist, really makes extraordinary demands upon him: on the one side, to be free in some vague spiritual sense, free to act only as an artist, and yet on the other side to be rigorously tested as to whether the freedom he has achieved is great enough to be more solidly dependable than a government's financial structure—as though the painter's *realistic* audience, as opposed to an audience with sentiment, were rare stamp collectors. No wonder that modern painters, in view of these curious relations to society, have taken art matters into their own hands, decided for themselves what art is, what its subjects are to be, and how they are to be treated. Art like love is an active process of growth and

development, not a God-given talent; and since in modern society the audience rarely sees the actual process of art, the audience's remoteness from the act of painting has become so great that practically all writing about modern art has become explaining to the audience what the art is that the audience has got so far away from. And those whose profession is to do the explaining are more often than not mistaken. It is in this context that one has to understand the fury of Picasso's famous statement of 1935 beginning, "Everyone wants to understand art. Why not try to understand the song of a bird? One loves the night, flowers, everything around one, without trying to understand them. While with painting everyone must *understand*. If only they would realize that an artist works above all of necessity . . ." What angers Picasso is not the desire to understand, but that understanding should pose a problem, that his audience is unprepared for him. More exactly, prepared for something else.

Let us begin again. Modern art is often called a painter's painting, the assumption being that painters are the people most deeply involved with it, and in a sense the only people who can be, apart from a few *aficionados* and speculators. But what is not commonly observed is how modern painters themselves tend to judge modern painting, which I think might be the clue to the audience to what baffles it—still, in a verbal society, most people are "form-blind," in the sense that a few people are tone-deaf, which increases the difficulties of true understanding. I believe that painters' judgments of painting are first ethical, then aesthetic, the aesthetic judgments flowing from an ethical context. Doubtless no painter systematically thinks this way; but it does seem to me to be basically what happens when modern painters judge any new manifestations of painting. Sören Kierkegaard, who did not value painting, was nevertheless very much aware of this distinction in his general analysis of existence. In quite another context, he wrote, "If anything in the world can teach a man to venture, it is the ethical, which teaches to venture everything for nothing, to risk everything, and also therefore to renounce the flattery of the world-historical . . . the ethical is the absolute, and in all eternity the highest value. . . .

"Besides, a daring venture is surely not merely a high-sounding phrase, or a bold ejaculation, but a toilsome labor; a daring venture is not a tumultuous shriek, however reckless, but a quiet consecration which makes sure of nothing beforehand, but risks everything. Therefore, says the ethical, dare to renounce everything, including this loftily pretentious yet delusive intercourse

with world-historical contemplation; dare, dare to become nothing at all, to become a particular individual, of whom God requires all, without your being relieved of the necessity of being enthusiastic: Behold, that is the venture!" For "only in the ethical is your eternal consciousness: Behold, that is the reward!"

Now if venturesomeness is valued by painters, as it is by those working in the specifically "modern" milieu, it is evident that certain aesthetics, e.g., academic ones *for which you can prepare,* are deliberately ruled out, not arbitrarily, but as beneath the level of the ethical. It is in this sense that Picasso added, "Academic training in beauty is a sham. . . . It is not what the artist *does* that counts, but what he *is:* Cézanne never would have interested me a bit if he had lived and thought [like an academic painter], even if the apple that he painted had been ten times as beautiful. What forces our interest is Cézanne's anxiety—that's Cézanne's lesson. The torments of van Gogh—that is the actual drama of the man."

Venturesomeness is only one of the ethical values respected by modern painters. There are many others, integrity, sensuality, sensitivity, knowingness, passion, dedication, sincerity, and so on, which taken altogether represent the ethical background of judgment in relation to any given work of modern art. Every aesthetic judgment of importance is ultimately ethical in background. It is its unawareness of this background that is an audience's chief problem. And one has to have an intimate acquaintance with the language of contemporary painting to be able to see the real beauties of it; to see the ethical background is even more difficult. It is a question of consciousness.

What is interesting in the poet Guillaume Apollinaire's relation to cubism is not the book he wrote about cubist painting, but that in his own poems he had the cubist consciousness, and therefore quite rightly was called a "cubist" poet.

An artist's "art" is just his consciousness, developed slowly and painstakingly with many mistakes en route. How dare they collect those ugly early van Goghs like trophies, because he happened to sign them!

Consciousness is not something that the painter's audience can be given; it must be gained, as it is by the painter, from experience. If this seems difficult, then—as Spinoza says at the end of his *Ethic*— all noble things are as difficult as they are rare.

Without ethical consciousness, a painter is only a decorator.

Without ethical consciousness, the audience is only sensual, one of aesthetes.

from *Perspectives*, no. 9, autumn 1954, pp. 107–12. © Robert Motherwell

Interview with David Sylvester, 1960

SYLVESTER: How clear an idea do you have, before you start to paint, of what the painting is going to be like?

MOTHERWELL: Usually not much. More simply, I begin from an impulse, an intense and irrational desire that takes you over, prompting you to start moving. And from experience, with some knowledge of what moves oneself, I think it's not altogether arbitrary what one begins with. I mean, I think that any painter would instinctively begin with forms, colours, spatial areas, kinds of format, that in general have been more sympathetic to him than others have been. But certainly implicit partially is the feeling, not that "I'm going to paint something I know," by "through the act of painting I'm going to find out exactly how I feel," both generally and about whatever is specific.

SYLVESTER: In which case, the term "action painting" has got quite a lot of validity for you, among others?

MOTHERWELL: It depends on what emphasis the word "action" is given. If it's given the emphasis that a painting is an activity—yes. If it's given the emphasis that it's like a cowboy with a six-shooter that goes bang, bang, or is a gesture—then, no.

SYLVESTER: You don't, for example, have any idea before you start a painting, whether the forms are going to be packed fairly tight or whether it's going to be rather open and spacious, so to speak?

MOTHERWELL: In my case, I find a blank canvas so beautiful that to work immediately, in relation to how beautiful the canvas is as such, is inhibiting and, for me, demands *too much too quickly*; so that my tendency is to get the canvas "dirty," so to speak, in one way or another, and then, so to speak, "work in reverse," and try to bring it back to an equivalent of the original clarity and perfection of the canvas that one began on. . . .

SYLVESTER: What point do you feel a painting is finished—if this is a question to which one can give a verbal answer?

MOTHERWELL: I think, when your feeling is completed. (It was a big issue with American painters ten years ago.) I think it's really a question of the completeness of the feeling. One would think, well, that's relatively simple, when you've done what you're going to do, that's that. But actually all artists are haunted, much as one tries to get away from it, by *a priori* conceptions about what a picture is, about what pictures have been, about what they ought to look like. And it's very easy for one of these *a priori* conceptions to take over one's mind and drive one too far, or not allow one to go far enough. And, I think for myself, and I believe for most of the painters I

know, judging the exact critical moment when everything that is
necessary is there and nothing more is there, is one of the most
difficult and crucial steps in the act of painting. . . .

excerpted from an interview recorded and broadcasted over BBC, October 22, 1960. *Metro*,
no. 7, 1962, pp. 94–97. © Robert Motherwell

Metro was a magazine published in Milan from 1960–70, with texts in Italian, French, and
English.

Interview, 1963

About collage. For example, the labels in my collages from
"Gauloises," "Players:" I sometimes smoke them. . . . The papers
in my collages are usually things that are familiar to me, part of my
life. . . . Collages are a modern substitute for still-life. . . .
Traditional still-life seems funny in America, but in Europe
completely natural since you see one at the end of each meal. In
collage there are a lot of ready-made details, for when one wants
details. My painting deals in large simplifications for the most part.
Collage in contrast is a way to work with autobiographical
material—which one wants sometimes. . . . I do feel more joyful
with collage, less austere. A form of play. Which painting, in
general, is not, for me, at least. . . .

 I take an elegy to be a funeral lamentation or funeral song for
something one cared about. The "Spanish Elegies" are not
"political," but my private insistence that a terrible death happened
that should not be forgot. They are as eloquent as I could make
them. But the pictures are also general metaphors of the contrast
between life and death and their interrelation.

excerpted from *Robert Motherwell*. Smith College Museum of Art, Northampton, MA, 1963.
© Smith College Museum of Art, Northampton, MA, 1963. Reprinted with permission.

The catalogue accompanied an exhibition of the artist's work that was held in conjunction with
Motherwell's lecture at Smith College on January 14, 1963.

"The Universal Language of Children's Art, and Modernism," 1970

I am highly honored to have been selected to speak at the plenary

session of such a talented and renowned group as the present participants in this Conference on International Exchanges in the Arts. And extremely intimidated. One would have thought the choice from this distinguished group would be a writer, perhaps a poet, or some other man of letters. . . .

We live intellectually dominated by verbal discourse. Certainly one would not expect a painter—one of those slow, clumsy beasts who admittedly have a feeling for workmanship, for the character of certain physical materials, a certain unashamed sensuality and café gregariousness; a creature closest to the peasant in the hierarchy of high art—no, one would not expect a painter to be selected to speak. The French like to say, *"bête comme un peintre."* Moreover, painters have a traditional distrust, even hostility, toward words, especially toward rhetoric. Every living painter, at one time or another, and more often than not, has been deeply wounded by the words of journalists and critics, in whose hands his immediate social fate so often lies, and before whom he cannot easily defend himself, since, in doing so, he must play *their* game of words. Although all the obvious issues are those of the eye, I think that at times every painter feels like Argus, *like a body covered with eyes*. . . .

Moreover, the history of twentieth-century painting is in large part the history of the rise of abstraction into a position of international dominance, despite much opposition within the world of painting, and almost total opposition without. And what is modernism, among other things, but the effort to get rid of rhetoric in art?

Nevertheless, painters are not without a sort of existential ingenuity. Without it, none of us would have survived those difficult and solitary early years. So let me struggle to speak in this other language, that of everyday life, and hope that you will listen patiently, as we all do—except, perhaps, the French—to a foreigner with his inadequate grasp of our own use of words, with, moreover, a more monotonous grasp than his unfettered intelligence functioning at will in its own language. Certainly a price one pays for some mastery of one language is a terrible sense of inadequacy in any other. (Which reminds me of an international dinner in Switzerland last autumn for Martin Heidegger, who spoke only in German although he clearly understood other languages well, and when I inquired why, the opinion was that he did not feel *exact enough* in any language but his own. I was both startled and sympathetic, for exactness of weights of feeling is everything in art.) For my part, I find that I write best on handmade drawing paper, absurd and expensive as that may seem! But, on the other hand,

how could a painter cut off his interest in how lines look on a
sensuous sheet of paper? As our late great American sculptor, David
Smith, used to say, "Art is a luxury"—a luxury, he meant to say,
that, among the various poor, artists themselves are the most likely
to pay for. *That* is the beginning of our ingenuity in regard to
everyday life! Every New York artist of a certain age, for instance,
is a gourmet of Chinese food (although he may prefer Italian or
French cuisine when he grows to understand wine), for in the old
days it was in Chinatown that one's deep-rooted sensuality could be
satisfied for a modest sum. . . .

Still, at an international conference on international exchange in
the arts, thrown back on my resources as a painter (ironically),
perhaps a painter is not such a comic choice after all. For, so far as
I know, painting is the single language that is both universal and of
some sophistication (by this latter qualification I wish to exclude a
baby's sounds and gestures). Throughout the world, regardless of
biological inheritance or cultural conditioning and environment,
small children employ an identical repertoire of twenty or so painted
signs at precisely the same ages in their growth, thus *creating an
unqualifiedly universal language* (whether the child is French,
African, Indian, Chinese, North American or South Seas Islander)
in order to express their vision of the world. Perhaps it is owing to
my ignorance, but I know of no parallel universality of language
among any persons in music or dance, or in the other arts, *above
all, not in words*. Perhaps the painter's intuition, which is beginning
to be widely shared by the present TV younger generation, that
words represent the most artificial and easily manipulated language
for empty ends is more than a class protest, more than an
expression of resentment at being manipulated by another verbally
more powerful group; it might even be a sturdy insight about our
very nature, such as those close to the soil sometimes have about
the natural world. But that is another topic, that has less to do with
the universal than with power elites, who are only universal in a
more degrading sense. . . .

What a stupefying fact it is that, as modern anthropologists and
psychologists seem to believe, all the small children of the world
have a universal language, *painting*, with an identical iconography
at the same ages of growth, a language that is taught to them *by no
one*, that they need never have seen. A child reared in solitude uses
a similar painting vocabulary as his more socialized
contemporaries. In painting, the small children of the world have a
language even more universal than sexuality (sexuality is culturally
conditioned and the painting we are speaking of is not), a language
of rudimentary but beautiful signs—a circular scribble, an oval, a

circle, a square, a triangle, a cross and so on, colored or not, according to the materials available—with which they construct a completely adequate and beautiful, in its deeply felt drawing, picture of the universe, both of inside the dome of their own craniums, and of the visible limits of the dome of heaven, and of everything in between. Who would believe, let alone hope, that a universal language, so universal that not a single exception exists on the whole of our globe, not only exists, but has existed unchanged or untouched since the dim beginnings of mankind, of our human world. (One of the most baffling problems in art education is what we grown-ups do, or what children do to themselves, so that their universal language disappears at a later age even more rapidly than it begins and develops into a full-fledged expression.) One might suggest that small children need international exchange least of all, and, by the same token, perhaps the older one grows, the more one needs it. For instance, Matisse's voyages to North Africa in middle age modified the course of modern art, as did Kandinsky's emigration to Munich, Picasso's to Paris, and, more recently, Mondrian's and the European Surrealists' to New York (during World War II). Another implication comes to mind: perhaps there is the unpleasant issue of quality; perhaps the most unique and creative individuals, rather than the undeveloped and the underprivileged or unendowed, should be sent abroad! The president of this Institute of International Education has said, "The artist's instant recognition of common denominators in human awareness makes him perhaps the most truly international individual." For my part, I would like to see him even more worldly. So far as I know, for example, of the greatest living European painters, only the Spaniard Miró has often visited New York, watched its painting's growth continually, and taken back from it what he pleased, as some of us in New York in turn had taken from him. But, having ventured this notion spontaneously, I am not sure that I wish to pursue it, but I cannot help emphasizing the painter's traditional interest in quality. For obviously part of what painting is universally, to the degree that it is art, is the condensing of quantity, so to speak, through exact amounts of quantity, into quality. Nothing else is precise enough to weigh this process of the human sensibility, so far more subtle is the accuracy of human feeling. Yesterday, for instance, I spent hours looking at a print of mine, deciding whether there were a few too many millimeters of white, and whether the white of an English Saunders paper or a French Arches was more exactly correspondent to my particular feeling for white. And when my children were small, they used to think that the act of painting on my part consisted of squinting with

one eye, with the other closed, and they would shriek with laughter, "Oh daddy, you are painting again!" as I would squint at a picture on the wall. What I was doing, of course, by squinting, was blurring the particulars in the painting as much as I could in order to see more clearly the emphases. So the children were not mistaken. I suppose that is why Goya, if he did as reputed, put on the finishing strokes of his canvas by candlelight. The great Englishman, Turner, used to "emphasize" in public before his colleagues on varnishing day, to their admiration (often grudging), and despair. (Because of him, perhaps, the English understood perfectly our own great abstract expressionist, Mark Rothko, whose recent tragic suicide we in America still mourn. But in Paris, as I understand it, his great colorful retrospective was shown below ground level in a certain museum and he was largely unnoticed, as Lorca was when he lived in New York, and Lenin during the Dada days in Zurich.)

My emphasis here is that *quantitative* foreign exchange does not always work, certainly not automatically and easily (as anyone who has been a traveler knows). It is partly a question of what entrée one has or has not, and partly of the generosity, hostility or indifference of one's hosts—less a question of oneself—because internationalized minds, like children's, are pretty much alike everywhere, while chauvinism and politics tend to be localized, by definition, sometimes violently. For example, Max Ernst and André Masson believe that, at a certain moment on the first Western front, it is probable, certainly possible, that they were shooting at each other. I remember Walter Gropius telling me that at the beginning of that war he was one of more than fifteen hundred Uhlans, going to war on horseback with lances; at the end, he was the only one left, a photographer in military aircraft. The print of mine that I referred to earlier is for an international album of prints for the benefit of the International Rescue Committee that got so many gifted artists and intellectuals, Jewish and gentile alike, out of Nazi Europe during World War II. (With such a gesture one feels fortunate to be both a painter and an internationalist, to the degree that both are vehicles of the humanity that is so universal that only with difficulty, even in our violent epoch, can the powers that be get committed men—that is, men from whom feeling has not drained—to destroy other people, vulnerable though we all are and clear as to where others are vulnerable: even to death, psychological or physical.)

Part of the enterprise of modern art is to strip away from painting the costumes, the masquerades, the status symbols of church and state and politics—hence, its so-called abstraction, which is actually a humanly felt universalism. This universalism is not unparallel to

Robert Motherwell, studio wall, spring 1960
Photograph by Peter A. Juley & Son

that of small children, as when the French Fauves and the German
Expressionists began to paint more and more directly, colorfully,
immediately and expressively, or when Kandinsky in Munich began
to understand the significance of the scribble (before he fell into
logic in Paris), or Klee in Germany began turning his own scribbles
into the fairyland of his magical art, as did Miró and the French
Surrealists in Paris, and as later the American Abstract
Expressionists in New York used the scribble in the interests of a
more sublime or tragic art than the intimacy of prewar Paris. Or, as
Picasso quite consciously did in those great drawings during the
Spanish Civil War after *Guernica*, drawings much greater than the
painting itself. While in his picture he relied on cubism, which is
essentially a lyrical, and not a dramatic or tragic, mode of
expression, in the drawings he relied some on Goya—natural
enough for a Spanish painter during those terrible days of the rise of

Fascism—but, above all, on the directness of children's line drawings; for the world of the tragic is not alien, any more than the world of joy or anxiety or any other mode of feeling, to children's expressions. Still, in those Picassos, there is a maturity and a freedom of choice that is more exhilarating than children's art, which, after all, seems to be inherent in them, in an Aristotelian (or perhaps Jungian) sense, whereas Picasso's freedom is hard-won, in that spirit-breaking struggle against everything that is provincial, parochial, ironclad conventional in the traditional classes and the nationalisms that surround every grown man, and which he may never conquer, but to which he dare not succumb without distorting the most valuable part of his inheritance, his universal humanity. (Which is not to say what is universal and what is particular. It is evident, for instance, that Catholic Latin Europe and South America find abstract painting more alien than do Northern Protestant Europe and America, perhaps because the one is surrounded by imagery from childhood, and the other is not. Who is more universal, Johann Sebastian Bach or Mozart? Or, more pointedly, in the instance of the great nineteenth-century Russian novel, is it the chauvinistic Slavophile Dostoevski or the Westernized Francophile Turgenev who is more universal? Perhaps total provincial concretion is as universal as abstract generalization. . . .)

Who does not love the complexity of particulars in reality? At the same time, one *must* abstract—that is, select from—in order to manage reality at all. Meaning, after all, is a matter of emphasis, a selection; abstraction is the process of emphasis, no matter how relatively complex the work. To be a master of a language is to be a master of emphasis. What is emphasized is at once the form and the content. Renoir used to say, I am not a butcher, I do not paint flesh, but *skin*. That emphasis, the skin of the world, is the essence of his art, and the definition of the purely aesthetic.

I speak so much of universals and particulars here because, of course, I am thinking of internationalisms and nationalisms, of an international effort to move nationals to another nationality. The beauties and contradictions of this effort I take to be the subject matter of the discussions to follow, and now leave you to them. But not, as a particular New Yorker, without the warmest welcome to our Istanbul, which is not exactly America, but just New York City, and with best wishes for fruitful encounters here. Thank you, and welcome once more.

from *The American Scholar*, vol. 40, no. 1, winter 1970. Copyright © 1970 by the United Chapters of Phi Beta Kappa.

An address given April 29, 1970, at the opening plenary session of a conference on International Exchange in the Arts, sponsored by the Institute of International Education.

Interview with Irmeline Lebeer, 1973

LEBEER: Would you say that there's no essential difference between your recent works, such as the paintings you call the "Open" series, and your previous work, other than a greater serenity?

MOTHERWELL: There is more emphasis on "feeling" and less on "emotion." The "Open" series is less aggressive than my older paintings. I have placed more emphasis on the format and the color in them. In most of them, color plays a dominant role, whereas in my earlier work, color was not at all favored over other structural elements. I must add that the "Open" paintings make a subtle but genuine reference to one of the most classic themes of modern art: the window, or French door, through which one looks outward from an interior—it appears again and again, in the work of Caspar David Friedrich, the impressionists, Bonnard, Matisse, Picasso, and countless others.

LEBEER: How did you discover these "Open" paintings?

MOTHERWELL: The idea came almost by chance. I had leaned a small canvas against a larger one, to make room in the studio, and one day as I passed by them I was abruptly struck by the beauty of their proportional relationship. I drew a charcoal line on the big canvas around the contour of the small one. When I took the small one away, I realized that I had just drawn a sort of doorway. So the first "Open" painting had an opening that suggested a door. But the more I thought about it, the more it seemed I would need a long period of investigation before I could determine the "real" character of the opening; today, after having painted some 190 "Open" paintings in two years, it seems to me that I was right in thinking that the concept would allow for more possibilities if the canvas were turned around, with the opening at the top of the canvas, which is reminiscent of a window rather than a door. A door imprisons, and it suggests the entrance to a cave or temple, whereas I seek the opposite: an opening into an airy, rising world.

LEBEER: What is your conception of space in the "Open" series?

MOTHERWELL: When I was young, I was more obsessed with the materiality of things, and I would have undoubtedly thought of paintings of this kind as walls. Today I'm more interested in air and atmosphere. This is why I deliberately treat space ambivalently. For example, an orange painting with white lines might be viewed as an orange wall with white lines, but the orange color is no less atmospheric for all of that. It abounds with light, and the white lines vibrate in a deep space, too, as well as an orange "wall."

excerpted from *Robert Motherwell: Recent Work*, Princeton Art Museum, January 5–February 17, 1973, pp. 10, 13. Copyright © 1973 by the Trustees of Princeton University.

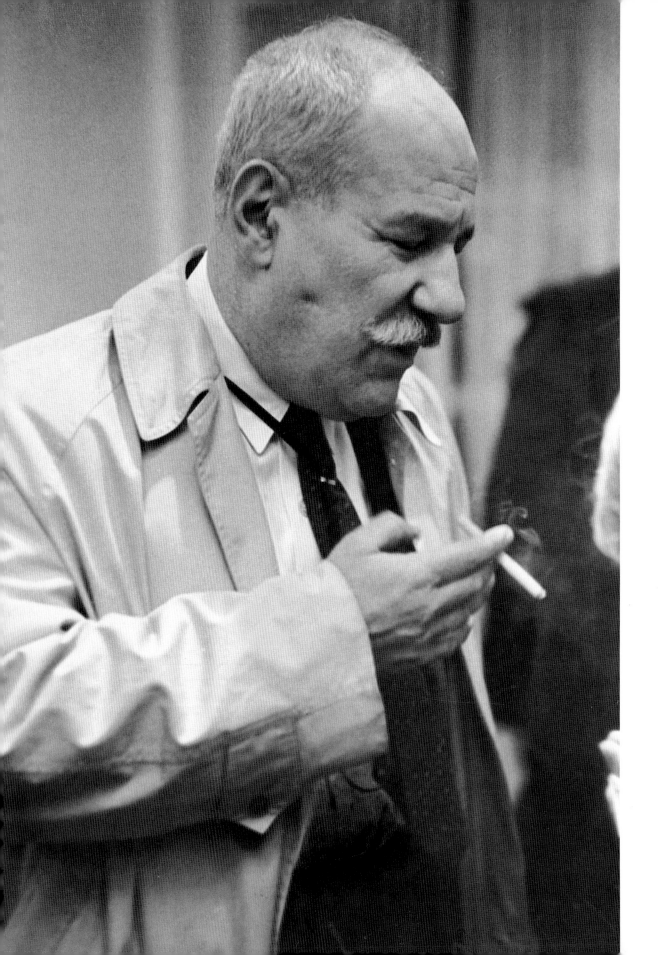

Barnett Newman

"What About Isolationist Art?" 1942

Isolationist painting, which they named the American Renaissance, is founded on politics and on an even worse aesthetic. Using the traditional chauvinistic, isolationist brand of patriotism, and playing on the natural desire of American artists to have their own art, they succeeded in pushing across a false esthetic that is inhibiting the production of any true art in this country. First, the isolationists preached their cardinal political principle of nationalistic dogma, that to have your own life you must repudiate the world. It followed that if you are to have your own art you must repudiate the art and artists of the world. To achieve their goal isolationists did not try delicate methods. Isolationism, we have learned by now, is Hitlerism. Both are expressions of the same intense, vicious nationalism. . . . [Both use] the "great lie," the intensified nationalism, false patriotism, the appeal to race, the re-emphasis of the home and homey sentiment. The art of the world, ranted [the isolationists], as focused in the Ecole de Paris, is degenerate art, fine for Frenchmen, but not for us Americans. This French art is like themselves, a foreign, degenerate, Ellis Island, international art appealing to international minded perverts. It is definitely un-American. How could French art be any good anyway? The French people themselves are no good, a bunch of filthy, pennypinching, tourist-gouging, drunken lot of foreigners. And who are their American fellow-travelers, a bunch of New York Ellis Islanders who aren't even 50 percent American, most of them communist and international minded, etc. What we need is a good 100 percent American art based on the good old things we know and recognize, that our good old straight-standing, clean American folks back home can understand . . . the beauty of our land, the traditions of our folk-lore, the cows coming, the cotton-picker, the farmer struggling against the weather—the good old oaken bucket. . . .

The isolationist esthetic . . . is based on two fallacies so flagrant one wonders how they could have succeeded with any artist group that wasn't intellectually corrupt. First they claimed the need of an American art. . . . How? By painting Americana instead of

Barnett Newman, 1960
Photograph by Fred W.
McDarrah

stimulating the emergence of great minds by creating conditions that might help to stimulate their appearance, they created a label based on bad logic around which mediocre minds equipped with some manual skill could rally to create a movement. It is easy to create a label. It pays men unusual power if they can enforce it. It is surrender to submit to it. Yet the artists did. . . . Art in America today stands at a point where anything that cannot fit into the American Scene label is doomed to be completely ignored.

What was this America that artists were to paint? Was it a certain national character one was to express, a point of view, a taste, a cultural nuance? Not at all. Even if these qualities could have been evoked they were not wanted. To the isolationist artists, America was the geographic life around them. The crassest philistinism. A complete reversion to the exaltation of subject matter. Here they ran into a bit of trouble.

They solved it easily by some more sleight-of-hand logic. They knew that despite their noisy attack they were up against the solid wall of modernism. Despite all their disparagement of the Ecole de Paris, so complete was the victory of modernism over the Victorian subject-matter picture that it would have been suicide for them to have attempted to announce a straight reversion to subject matter. The isolationist master-minds here executed a cunning piece of propaganda only a Hitler can properly appreciate. For they agreed immediately with the point of view that modern esthetics did not permit a re-emphasis of subject matter. And if subject matter isn't important, so what is? It's *how* the subject is painted. If it is a good picture it makes no difference what is painted. Well, then any subject is valid. If so, why not America, with its rich source material, its varied landscape, its inexhaustible treasury of picture motifs?

Strangely enough, the American artist fell for this subtle fallacy, paint, brush and sketch-box. So seductive was the isolationist bloc, it didn't mind a bit if the artist stole European painting styles and techniques, so long as they were confined to the American Scene. . . . The result has been the emergence of an ever-expanding school of genre painters who, using borrowed painting techniques, have dedicated themselves to telling the story of America's life of humdrum. Their commercial success has been tremendous, amidst the widest art-buying public in history. Many have been fooled into believing that this has meant a rising art audience, a veritable Renaissance. Alas, it is the same sentiment-buying public that has supported every academy. The only difference has been that the American Scenists modernized the sentiment. Instead of the old oaken bucket, it based its appeal on

the hurricane cellar; instead of the man behind the plow, now it was the poor, starved sharecropper; instead of Bess coming down the road, it was an old Okie jalopy. Instead of that whole school of sentiment based on sex, with its hundreds of lacy ladies against a looming sky or lost among the shadowy willows, it was the new sentiment of rural America, of sweet old pa and ma leaning on their pitchforks. It worked well. The pull was there. Subject matter was back—it had come in through the back door.

Its complete success was marred for a moment by a leftist "revolt" which thought it had a new esthetic—social painting. But it turned out to be nothing but a variation of the same theme. Their "revolt" was an insistence on a redefinition of what makes up the American Scene. They wanted prior rights for the industrial worker, the introduction of class struggle. But it was still American Scene. Essentially it was a struggle of leftist artists—who had been ostracized as Ellis Island artists by the original regionalist tinge of the American Scene movement—to join the philistines. They agreed to the fundamental isolationist premise of American painting. All they wanted was to be able to include the worker, the Pittsburgh smelter, alongside the Kansas farmer. . . . *Art in America* was purposefully made regional. The South painted its Negroes, the West its cowboys, the Middle West its corn and hogs, its fat cattle and its ditch water, and the East its factories and foundries. And all told the same story of a picture-postcard art done in modern painting surfaces, with modern distortions, in modern color and design. The whole mess a cheap, successful, new commercial art.

Every nation has its commercial artists. But no nations, not even the Fascist nations, claim that they have made art history with them. All except America. Here our commercial official art is called an American Renaissance by our critics, dealers and museum directors. They fill the American wings of our museums, they dominate our art schools, our art galleries. They have their own Museum. They have penetrated the Museum of *Modern* Art!

It might be of interest to tell how this happened, how once they had succeeded with the artists it was necessary to achieve and maintain social position for complete success. How they got Gertrude Whitney, sculptress, millionairess, and old family, to put money behind them, society behind them, a museum around them so that it would be ready bait for all the museum director graduates of the Yale and Harvard art schools, who, full of discovery of a great American art movement, gave them the domineering position they sought. But it would achieve little to fight against the Museums, the dealers, the publishers and prize committees. They do not make an art. Neither do they unmake it. It is the artists who make and

unmake art. And in America it is the artists who stand guilty of corruption.

It is easy to repeat that Isolationist art found its easy place in America because America as a nation is immature in matters of taste and culture, that suffering from an inferiority complex on the account, it fell easy prey to a Nazi philosophy that promised to bolster up an injured pride and a warped national ego, very much as the German people fell prey to a similar movement in the political field. But is this the case? Is it the real reason or is it not an easy excuse?

Such an explanation would be valid if its implications were true; if it were true that it was the people, i.e., the art public made up of the inexperienced cultural mass that fell victim to isolationist art propaganda against the struggle of an alert, mature minority of artists and art connoisseurs who had tried to prevent it. We cannot say this. It was not the inexperienced art public that became American Scenists. It was the artists themselves, a highly sophisticated group, thoroughly familiar with the art work and the art traditions of the world, who had flocked to Paris to participate in the great cultural center, who were very conscious of the Impressionist and Post-Impressionist revolutions, who fell for this propaganda. It is upon them that responsibility falls. Their support of this reactionary philistinism is an inexcusable betrayal.

The so-called American Renaissance was a deliberate exploitation of a deep-seated desire by our artists to make a native contribution to the art of the world by a regional group of commercially minded artists who, hungry for personal success, misled a generation of artists, art students and the art public. Those artists who joined believing in it did so because they needed the movement to cover over their mediocrity. Those artists of ability, however, who joined the movement or who tolerate its presence . . . are traitors to art. For they are willing to overlook the ruthless reaction, inhibiting philistinism, in order to be able to join the bandwagon for the slight ballyhoo that will fall to them. They know that otherwise they shall have to compete with European artists on equal terms. That might prove difficult. . . .

In order to keep out the more talented foreign artists, small men calling themselves artists have succeeded in imprisoning the American cultural world. . . . For can we believe that the American artists are telling us the truth? Has there been an art Renaissance in America? . . . Anybody with a critical eye and an honest respect for art and America can only contemplate the mass of cheap genre painting with sadness. It is not an art but an expanded Currier & Ives revival.

On the political front Isolationism has been wiped clean. There is hope of a new political outlook. Are we going to create a new philosophy of American politics and world society only to lose our art and culture to isolationist philistines? How long are artists to remain silent?

It is time for the artists to wake up and re-examine their esthetic foundations; to rid themselves of the millstone that has made art in America an expensive picture-postcard factory. It is time they understood the political foundation of their art, cleaned house and went back to the study of art, where they belong. It is time artists refused isolationist money, repudiated the art dealers, the favor of the museum directors. It is time artists forgot about success. . . .

excerpted from *Barnett Newman*, by Thomas B. Hess, The Museum of Modern Art, New York, 1971, pp. 35–36. Reprinted by permission of The Museum of Modern Art. © The Museum of Modern Art (1971).

"The Plasmic Image," 1943–45

All artists whether primitive or sophisticated have been involved in the handling of chaos. The painter of the new movement clearly understands the separation between abstraction and the art of the abstract. He is therefore not concerned with geometric forms per se but in creating forms which by their abstract nature carry some abstract intellectual content. . . .

There is an attempt being made to assign a Surrealist explanation to the use these painters make of abstract forms . . . [but] Surrealism is interested in a dream world that will penetrate the human psyche. To that extent it is a mundane expression. . . . The present painter is concerned not with his own feelings or with the mystery of his own personality but with the penetration into the world mystery. His imagination is therefore attempting to dig into metaphysical secrets. To that extent his art is concerned with the sublime. It is a religious art which through symbols will catch the basic truth of life which is its sense of tragedy.

The present painter can be said to work with chaos not only in the sense that he is handling the chaos of the blank picture plane but also in that he is handling the chaos of form. In trying to go beyond the visible and the known world he is working with forms that are unknown even to him. He is therefore engaged in a true act of discovery in the creation of new forms and symbols that will have the living quality of creation. No matter what the psychologists say these forms arise from, that they are the inevitable expression of the

Barnett Newman
Untitled, 1946
Ink on paper, $23^{13}/_{16} \times 17^{11}/_{16}''$
Collection of Whitney Museum of
American Art. Purchase
with funds from the Drawing
Committee (89.25)

unconscious, the present painter is not concerned with the process. Herein lies the difference between them and the Surrealists. At the same time in his desire, in his will to set down the ordered truth, that is the expression of his attitude towards the mystery of life and death, it can be said that the artist like a true creator is delving into chaos. It is precisely this that makes him an artist for the Creator in creating the world began with the same material, for the artist tries to wrest truth from the void. . . .

The new painter feels that abstract art is not something to love for itself, but is a language to be used to project important visual ideas. . . . I therefore wish to call the new painting "plasmic" because the plastic elements of the art have been converted into

mental plasma. The effect of these new pictures is that the shapes and colors act as symbols to (elicit) sympathetic participation on the part of the beholder with the artist's thought. . . . The new painter owes the abstract artist a debt for giving him his language, but the new painting is concerned with a new type of abstract thought. . . .

He (the new painter) is declaring that the art of Western Europe is voluptuous art first, an intellectual art by accident. He is reversing the situation by declaring that art is an expression of the mind first and whatever sensuous elements are involved are incidental to that expression. The new painter is therefore the true revolutionary, the real leader who is placing the artist's function on its rightful plane of the philosopher and the pure scientist who is exploring the world of ideas, not the world of the senses. Just as we get a vision of the cosmos through the symbols of a mathematical equation, just as we get a vision of truth in terms of abstract metaphysical concepts, so the artist is today giving us a vision of the world of truth in terms of visual symbols.

We are reasserting man's natural desire for the exalted, for a concern with our relationship to the absolute emotions. We do not need the obsolete props of an outmoded and antiquated legend. We are creating images whose reality is self-evident and which are devoid of the props and crutches that evoke associations with outmoded images, both sublime and beautiful. We are freeing ourselves of the impediments of memory, association, nostalgia, legend, myth, or what have you, that have been the devices of Western European painting. Instead of making *cathedrals* out of Christ, man, or "life," we are making it out of ourselves, out of our own feelings. The image we produce is the self-evident one of revelation, real and concrete, that can be understood by anyone who will look at it without the nostalgic glasses of history.

excerpted from *Barnett Newman*, by Thomas B. Hess, The Museum of Modern Art, New York, 1971, pp. 37–39. Reprinted by permission of The Museum of Modern Art. © The Museum of Modern Art (1971).

"The Sublime Is Now," 1948

The invention of beauty by the Greeks, that is, their postulate of beauty as an ideal, has been the bugbear of European art and European aesthetic philosophies. Man's natural desire in the arts to express his relation to the Absolute became identified and confused with the absolutisms of perfect creations—with the fetish of

quality—so that the European artist has been continually involved in the moral struggle between notions of beauty and the desire for sublimity.

The confusion can be seen sharply in Longinus, who, despite his knowledge of non-Grecian art, could not extricate himself from his platonic attitudes concerning beauty, from the problem of value, so that to him the feeling of exaltation became synonymous with the perfect statement—an objective rhetoric. But the confusion continued on in Kant, with his theory of transcendent perception, that the phenomenon is *more* than phenomenon; and with Hegel, who built a theory of beauty, in which the sublime is at the bottom of a structure of *kinds of beauty*, thus creating a range of hierarchies in a set of relationships to reality that is completely formal. (Only Edmund Burke insisted on a separation. Even though it is an unsophisticated and primitive one, it is a clear one and it would be interesting to know how closely the Surrealists were influenced by it. To me Burke reads like a Surrealist manual.)

The confusion in philosophy is but the reflection of the struggle that makes up the history of the plastic arts. To us today there is no doubt that Greek art is an insistence that the sense of exaltation is to be found in perfect form, that exaltation is the same as ideal sensibility, in contrast, for example, with the Gothic or Baroque, in which the sublime consists of a desire to destroy form; where form can be formless.

The climax in this struggle between beauty and the sublime can best be examined inside the Renaissance and the reaction later against the Renaissance that is known as modern art. In the Renaissance the revival of the ideals of Greek beauty set the artists the task of rephrasing an accepted Christ legend in terms of absolute beauty as against the original Gothic ecstasy over the legend's evocation of the Absolute. And the Renaissance artists dressed up the traditional ecstasy in an even older tradition—that of eloquent nudity or rich velvet. It was no idle quip that moved Michelangelo to call himself a sculptor rather than a painter, for he knew that only in his sculpture could the desire for the grand statement of Christian sublimity be reached. He could despise with good reason the beauty-cults who felt the Christ drama on a stage of rich velvets and brocades and beautifully textured flesh tints. Michelangelo knew that the meaning of the Greek humanities for his time involved making Christ—the man, into Christ—who is God; that his plastic problem was neither the medieval one, to make a cathedral, nor the Greek one, to make a man like a god, but to make a cathedral out of man. In doing so he set a standard for sublimity that the painting of his time could not reach. Instead,

painting continued on its merry quest for a voluptuous art until in modern times, the Impressionists, disgusted with its inadequacy, began the movement to destroy the established rhetoric of beauty by the Impressionist insistence on a surface of ugly strokes.

The impulse of modern art was this desire to destroy beauty. However, in discarding Renaissance notions of beauty, and without an adequate substitute for a sublime message, the Impressionists were compelled to preoccupy themselves, in their struggle, with the culture values of their plastic history so that instead of evoking a new way of experiencing life they were able only to make a transfer of values. By glorifying their own way of living, they were caught in the problem of what is really beautiful and could only make a restatement of their position on the general question of beauty; just as later the Cubists, by their Dada gestures of substituting a sheet of paper. So strong is the grip of the *rhetoric* of exaltation as an attitude in the large context of the European culture pattern that the elements of sublimity in the revolution we know as modern art, exist in its effort and energy to escape the pattern rather than in the realization of a new experience. Picasso's effort may be sublime but there is no doubt that his work is a preoccupation with the question of what is the nature of beauty. Even Mondrian, in his attempt to destroy the Renaissance picture by his insistence on pure subject matter, succeeded only in raising the white plane and the right angle into a realm of sublimity, where the sublime paradoxically becomes an absolute of perfect sensations. The geometry (perfection) swallowed up his metaphysics (his exaltation).

The failure of European art to achieve the sublime is due to this blind desire to exist inside the reality of sensation (the objective world, whether distorted or pure) and to build an art within a framework of pure plasticity (the Greek ideal of beauty, whether that plasticity be a romantic active surface, or a classic stable one). In other words, modern art, caught without a sublime content, was incapable of creating a new sublime image, and unable to move away from the Renaissance imagery of figures and objects except by distortion or by denying it completely for an empty world of geometric formalisms—a pure rhetoric of abstract mathematical relationships, became enmeshed in a struggle over the nature of beauty; whether beauty was in nature or could be found without nature.

I believe that here in America, some of us, free from the weight of European culture, are finding the answer, by completely denying that art has any concern with the problem of beauty and where to find it. The question that now arises is how, if we are living in a time without a legend or mythos that can be called sublime, if we

refuse to admit any exaltation in pure relations, if we refuse to live in the abstract, how can we be creating a sublime art?

from *Tiger's Eye*, vol. I, no. 6, December 15, 1948. Reprinted by permission of John Stephan.

Contribution by Newman in the section titled "The Ides of Art: 6 Opinions on 'What is Sublime in Art?'" The other five contributors were Kurt Seligmann, Motherwell, A. D. B. Sylvester, Nicolas Calas, and John Stephan.

Letter to the editor of *Art Digest*, 1954

To the editor:

. . . [I] wish to reject the insinuation that I maintain a body of "belief" and that this "doctrine" is held in common with Ad Reinhardt and Mark Rothko. This is unjust to everyone concerned. One of the most important implications of my work is precisely that I am against dogmatic belief. And I have often made it clear that I am not only against the dogma of others but that I do not come with dogmatic belief for others. I take full and single responsibility for my work, thought, acts as I feel one should.

I should like, therefore, to make clear to your readers that I have no affiliation either with the beliefs or non-beliefs of Rollin Crampton, of the artists he mentions, Ad Reinhardt, Mark Rothko, or of anyone else.

Barnett Newman
New York, N.Y.

from *Art Digest*, vol. 28, no. 10, February 15, 1954, p. 3. © Art Digest, XXVIII, no. 10, February 1954. Reprinted by permission.

A letter in response to Rollin Crampton's contribution to "Symposium: The Creative Process," in the January 15, 1954, issue of *Art Digest*. Crampton lists as vital those "modern painters whose beliefs are similar to my philosophical searching, such as Ad Reinhardt, Barney Newman and Mark Rothko."

Statement, 1959

It is precisely this death image, the grip of geometry that has to be confronted.

In a world of geometry, geometry itself has become our moral crisis. And it will not be resolved by jazzed-up kicks but only by the answer of no geometry of any kind. Unless we face up to it and discover a new image based on new principles, there is no hope for freedom.

Can anyone, therefore, take seriously the mock aesthetic war that the art journalists and their artist friends have been waging against the new Pyramid—while they sit in it under a canopy of triangulation—with their feeble frenzy-weapons of the hootchy-cootchy dancer?

I realize that my paintings have no link with, nor any basis in, the art of World War I with its principles of geometry that tie it into the nineteenth century. To reject Cubism or Purism, whether it is Picasso's or Mondrian's, only to end up with the collage scheme of free association forms, whether it is Miró's or Malevich's, is to be caught in the same geometric trap. Only an art free from any kind of the geometry principles of World War I, only an art of no geometry can be a new beginning.

Nor can I find it by building a wall of lights; nor in the dead infinity of silence; nor in the painting performance, as if it were an instrument of pure energy full of a hollow biologic rhetoric.

Painting, like passion, is a living voice, which, when I hear it, I must let speak, unfettered.

from *The New American Painting*, by Alfred H. Barr, Jr. The Museum of Modern Art, New York, 1959. Reprinted by permission of The Museum of Modern Art. © The Museum of Modern Art (1959).

Interview with Dorothy Seckler, 1962

SECKLER: A general public image of your work conceives of it as excessively logical, hieratic, involved with structure and intellectual dialectic.

NEWMAN: This is not art criticism. This is art politics. It is advanced by painters, and their institutional friends, to give themselves the cloak of romantic spontaneity. I repudiate all these charges. I like your phrase that I am concerned with the immediate and the particular without using a general formula for the painting process with its many particulars. My concern is with the fullness that comes from emotion, not with its initial explosion, or its emotional fall-out, or the glow of its expenditure. The fact is, I am an intuitive painter, a direct painter. I have never worked from sketches, never planned a painting, never "thought out" a painting. I start each painting as if I had never painted before. I present no dogma, no system, no demonstrations. I have no formal solutions. I have no interest in the "finished" painting. I work only out of high passion.

SECKLER: Do you consider yourself a romantic painter?

NEWMAN: I don't consider myself in terms of labels but if I am anything, I am romantic. There is no such thing as the classical. The Greek artists were a bunch of romantics. The notion of a classical style is the invention of certain book-makers and those who build their art from the book-makers and who play with the book-makers. Like the proverbial horse players, they must lose. The issue is not whether or not I am a romantic or a classicist. These epithets are always used by those who think they can establish *quality* by conducting a war of terminology. The real issue is what is the *nature* of the romance. After all, it takes more than the way the knife slashes or the way the brush tickles a canvas to make romance. There is such a thing, you know, as contrived spontaneity. There are those who work with great deliberation and calculation from sketches that they enlarge or from a variety of sketches that they swing together, or they build up scintillating color areas which they keep correcting and correcting. It is perfectly all right to work this way. I am not arguing that. But I deplore the use of this *lack* of spontaneity as a weapon against my work, which cannot be done except directly and spontaneously. For me painting involves an immediate exercise of total commitment. It is what I am trying to say that is important. And I hope that I say it at once and in one

moment. In 1951, at the time of my second one-man show, I was asked by a viewer how long it took me to paint *Vir Heroicus Sublimis*. I explained that it took a second but the second took a lifetime.

The concept and execution have to work together at the exact, same moment. Impulse and control have to join. This is obviously unscientific and illogical since theoretically one follows the other. But physically this is what *has* to happen. This is the paradox of the miraculous event. Somehow the two things get joined.

SECKLER: Are you concerned with the void as, for example, the painter, Yves Klein, appears to be?

NEWMAN: I have always hated the void and in certain of my work of the Forties I always made it clear. In my work of that time, I notice, I had a section of the painting as a kind of void from which and around which life emanated—as in the original Creation—for example, *Gea* done in 1945 and *Pagan Void*, 1946.

When I started moving into my present concern or attitude in the mid-Forties, I discovered that one does not destroy the void by building patterns or manipulating space or creating new organisms. A canvas full of rhetorical strokes may be full but the fullness may be just hollow energy, just as a scintillating wall of colors may be full of colors but have no *color*. My canvases are full not because they are full of colors but because color makes the fullness. *The fullness thereof* is what I am involved in. It is interesting to me to notice how difficult it is for people to take the intense heat and blaze of my color. If my paintings were empty they could take them with ease. I have always worked with color without regard for existing rules concerning intensity, value or non-value. Also I have never manipulated colors, I have tried to create *color*.

SECKLER: How would you define your sense of space?

NEWMAN: I don't manipulate or play with space. I declare it. It is by my declaration that my paintings become full. All of my paintings have a top and a bottom. They are never divided; nor are they confined or constricted; nor do they jump out of their size. Since childhood I have always been aware of space as a space-dome. I remember years ago shocking my friends by saying I would prefer going to Churchill, Canada, to walk the tundra than go to Paris. For me space is where I can feel all four horizons, not just the horizon in front of me and in back of me because then the experience of space exists only as volume. In architecture the concern with volume is valid. Unfortunately, painting is still involved in the notion of space as architectural volumes—intricate small volumes, medium volumes, or pulsating total volumes. I am glad that by 1945 I got out of it.

Barnett Newman's White Street Studio, 1970
Photograph by Alexander Liberman

Is space where the orifices are in the faces of people talking to each other, or is it not between the glance of their eyes as they respond to each other? Anyone standing in front of my paintings must feel the vertical dome-like vaults encompass him to awaken an awareness of his being alive in the sensation of complete space. This is the opposite of creating an environment. The environment is separate from the painting. A painter friend, Kamrowski, said it well; he said my paintings are hostile to the environment. The room space is empty and chaotic but the sense of space created by my painting should make one feel, I hope, full and alive in a spatial-dome of 180 degrees going in all four directions. This is the only real sensation of space. At the same time I want to make it clear that I never set out to paint space-domes *per se*. I am, I hope, involved in much more.

SECKLER: What about subject-matter?

NEWMAN: The central issue of painting is the subject-matter. Most people think of subject-matter as what Meyer Schapiro has called "object-matter." It is the "object-matter" that most people want to see in a painting. That is what, for them, makes the painting seem full. For me both the use of objects and the manipulation of areas for the sake of the areas themselves must end up being anecdotal. My subject is anti-anecdotal. An anecdote can be subjective and internal as well as of the external world so that the expression of the biography of self or the intoxicated moment of glowing ecstasy must in the end also become anecdotal. All such painting is essentially episodic, which means it calls for a sequel. This must happen if a painting does not give a sensation of wholeness or fulfillment. That is why I have no interest in the episodic or ecstatic, however abstract. The excitement always ends at the brink and leaves the subject, so to speak, hanging there like the girl in "The Perils of Pauline." The next painting repeats the excitement, in a kind of ritual. One expects the girl to be saved finally, but she is again left hanging on the brink and so on and on. This is the weakness of the ecstatic and the episodic. It is an endless search for a statement of personality that never takes place. The truly passionate exists on a different level.

SECKLER: You have the reputation of being a slow worker.

NEWMAN: It is easy to be a fast worker. I have great admiration for raw, boundless energy but I cannot work out of boredom, to keep myself busy or only to express myself. Or to tell the story of my life. Or to find my personality in painting by acting out some character. I paint out of high passion, and although my way of working may seem simple, for me it is difficult and complex.

It would be easy for me now to talk about the transcendental, the

self, revelation, etc. All painting worth anything has all this. I prefer to talk on the practical or technical level. I don't mean making *drawings*, although I have always done a lot of them. I mean the drawing that exists in my painting. Yet no writer on art has ever confronted that issue. I am always referred to in relation to my color. Yet I know that if I have made a contribution, it is primarily in my drawing. The impressionists changed the way of seeing the world through their kind of drawing; the cubists saw the world anew in their drawing, and I hope that I have contributed a new way of seeing through drawing. Instead of using outlines, instead of making shapes or setting off spaces, my drawing declares the space. Instead of working with the remnants of space, I work with the whole space.

SECKLER: Can you clarify the meaning of your work in relation to society?

NEWMAN: It is full of meaning, but the meaning must come from the seeing, not from the talking. I feel, however, that one of its implications is its assertion of freedom, its denial of dogmatic principles, its repudiation of all dogmatic life. Almost 15 years ago Harold Rosenberg challenged me to explain what one of my paintings could possibly mean to the world. My answer was that if he and others could read it properly it would mean the end of all state capitalism and totalitarianism. That answer still goes.

excerpted from *Art in America*, vol. 50, no. 2, summer 1962, pp. 82–87. © Art in America, 1962. Reprinted by permission.

"The New York School Question," 1965

The history of these works can best be approached if one considers that they have never been successfully pigeonholed. We have been attacked as and labeled Abstract-Expressionism, Abstract-Impressionism, Action Painting, Informed, Tachisme, Field Painting, Color Painting, and now New York School. None can stick the way Pop and Op have because the meaningful work of the artists in this show is so powerfully personal that stylistic slogans at best can only apply to individuals. This was never a movement in the conventional sense of a "style," but a collection of individual voices. That is why to talk of the movement as being dead is ridiculous. With us, only the individual artist can die or continue to grow and live. . . .

excerpted from *ARTnews*, vol. 64, September 1965, p. 40. © ARTnews, vol. 64, September 1965. Reprinted by permission.

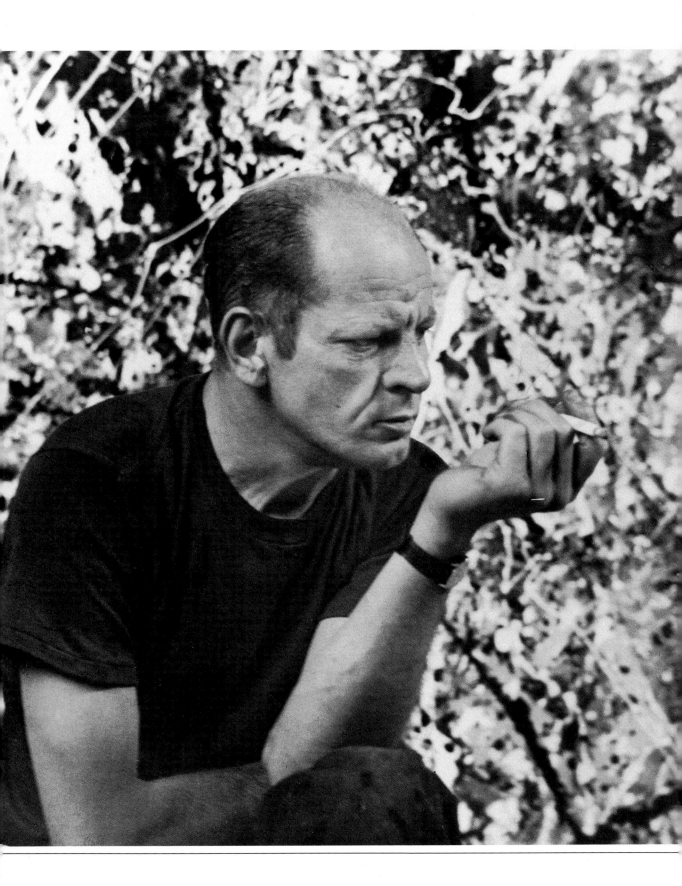

Jackson Pollock

Answers to a questionnaire, 1944

Q: Where were you born?

POLLOCK: Cody, Wyoming, in January, 1912. My ancestors were Scotch and Irish.

Q: Have you traveled any?

POLLOCK: I've knocked around some in California, some in Arizona. Never been to Europe.

Q: Would you like to go abroad?

POLLOCK: No. I don't see why the problems of modern painting can't be solved as well here as elsewhere.

Q: Where did you study?

POLLOCK: At the Art Student[s] League, here in New York. I began when I was seventeen. Studied with Benton, at the League, for two years.

Q: How did your study with Thomas Benton affect your work, which differs so radically from his?

POLLOCK: My work with Benton was important as something against which to react very strongly, later on; in this, it was better to have worked with him than with a less resistent personality who would have provided a much less strong opposition. At the same time, Benton introduced me to Renaissance art.

Q: Why do you prefer living here in New York to your native West?

POLLOCK: Living is keener, more demanding, more intense and expansive in New York than in the West; the stimulating influences are more numerous and rewarding. At the same time, I have a definite feeling for the West: the vast horizontality of the land, for

Jackson Pollock, 1950
Photograph by Hans Namuth

instance; here only the Atlantic ocean gives you that.Q: Has being a Westerner affected your work?

POLLOCK: I have always been very impressed with the plastic qualities of American Indian art. The Indians have the true painter's approach in their capacity to get hold of appropriate images, and in their understanding of what constitutes painterly subject-matter. Their color is essentially Western, their vision has the basic universality of all real art. Some people find references to American Indian art and calligraphy in parts of my pictures. That wasn't intentional; probably was the result of early memories and enthusiasms.

Q: Do you consider technique to be important in art?

POLLOCK: Yes and no. Craftsmanship is essential to the artist. He needs it just as he needs brushes, pigments, and a surface to paint on.

Q: Do you find it important that many famous modern European artists are living in this country?

POLLOCK: Yes. I accept the fact that the important painting of the last hundred years was done in France. American painters have generally missed the point of modern painting from beginning to end. (The only American master who interests me is Ryder.) Thus the fact that good European moderns are now here is very important, for they bring with them an understanding of the problems of modern painting. I am particularly impressed with their concept of the source of art being the unconscious. This idea interests me more than these specific painters do, for the two artists I admire most, Picasso and Miró, are still abroad.

Q: Do you think there can be a purely American art?

POLLOCK: The idea of an isolated American painting, so popular in this country during the thirties, seems absurd to me, just as the idea of creating a purely American mathematics or physics would seem absurd. . . . And in another sense, the problem doesn't exist at all; or, if it did, would solve itself: An American is an American and his painting would naturally be qualified by the fact, whether he wills it or not. But the basic problems of contemporary painting are independent of any one country.

from *Arts & Architecture*, vol. 61, no. 2, February 1944. Copyright © 1990 Pollock-Krasner Foundation/ ARS N.Y.

Statement, 1947

My painting does not come from the easel. I hardly ever stretch my

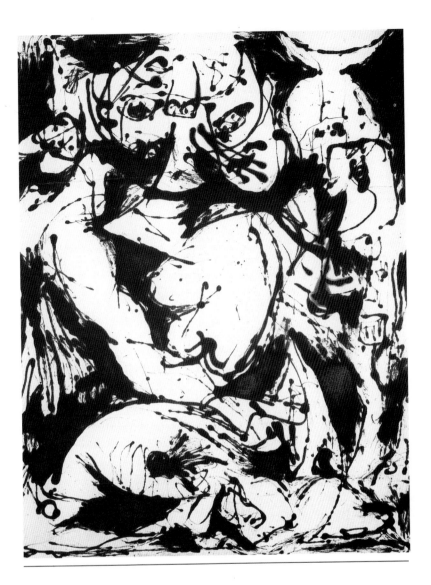

Jackson Pollock
Number 22, 1951
Oil on canvas, 58⅛ × 45⅛″
Collection Andrew and Denise
Saul

canvas before painting. I prefer to tack the unstretched canvas to
the hard wall or the floor. I need the resistance of a hard surface.
On the floor I am more at ease. I feel nearer, more a part of the
painting, since this way I can walk around it, work from the four
sides and literally be *in* the painting. This is akin to the method of
the Indian sand painters of the West.

I continue to get further away from the usual painter's tools such
as easel, palette, brushes, etc. I prefer sticks, trowels, knives and
dripping fluid paint or a heavy impasto with sand, broken glass and
other foreign matter added.

When I am *in* my painting, I'm not aware of what I'm doing. It is
only after a sort of "get acquainted" period that I see what I have
been about. I have no fears about making changes, destroying the

image, etc., because the painting has a life of its own. I try to let it come through. It is only when I lose contact with the painting that the result is a mess. Otherwise there is pure harmony, an easy give and take, and the painting comes out well.

from *Possibilities*, vol. 1, no. 1, winter 1947–48, p. 79. Copyright © 1990 Pollock-Krasner Foundation/ ARS N.Y.

Possibilities appeared as a single issue. The editors were Robert Motherwell, art; Harold Rosenberg, literature; Pierre Chareau, architecture; John Cage, music. The magazine was concerned exclusively with contemporary American art and included statements by artists, along with reproductions of their work. The impetus for the publication came from Motherwell and Rosenberg.

Interview with William Wright, 1950

WRIGHT: Mr. Pollock, in your opinion, what is the meaning of modern art?

POLLOCK: Modern art to me is nothing more than the expression of contemporary aims of the age that we're living in.

WRIGHT: Did the classical artists have any means of expressing their age?

POLLOCK: Yes, they did it very well. All cultures have had means and techniques of expressing their immediate aims—the Chinese, the Renaissance, all cultures. The thing that interests me is that today painters do not have to go to a subject matter outside of themselves. Most modern painters work from a different source. They work from within.

WRIGHT: Would you say that the modern artist has more or less isolated the quality which made the classical works of art valuable, that he's isolated it and uses it in a pure form?

POLLOCK: Ah—the good ones have, yes.

WRIGHT: Mr. Pollock, there's been a good deal of controversy and a great many comments have been made regarding your method of painting. Is there something you'd like to tell us about that?

POLLOCK: My opinion is that new needs need new techniques. And the modern artists have found new ways and new means of making their statements. It seems to me that the modern painter cannot express this age, the airplane, the atom bomb, the radio, in the old forms of the Renaissance or of any other past culture. Each age finds its own technique.

WRIGHT: Which would also mean that the layman and the critic would have to develop their ability to interpret the new techniques.

POLLOCK: Yes—that always somehow follows. I mean, the strangeness will wear off and I think we will discover the deeper meanings in modern art.

WRIGHT: I suppose every time you are approached by a layman they ask you how they should look at a Pollock painting, or any other modern painting—what they look for—how do they learn to appreciate modern art?

POLLOCK: I think they should not look for, but look passively—and try to receive what the painting has to offer and not bring a subject matter or preconceived idea of what they are to be looking for.

WRIGHT: Would it be true to say that the artist is painting from the unconscious, and the canvas must act as the unconscious of the person who views it?

POLLOCK: The unconscious is a very important side of modern art and I think the unconscious drives do mean a lot in looking at paintings.

WRIGHT: Then deliberately looking for any known meaning or object in an abstract painting would distract you immediately from ever appreciating it as you should?

POLLOCK: I think it should be enjoyed just as music is enjoyed— after a while you may like it or you may not. But it doesn't seem to be too serious. I like some flowers and others, other flowers I don't like. I think at least it gives—I think at least give it a chance.

WRIGHT: Well, I think you have to give anything that sort of chance. A person isn't born to like good music, they have to listen to it and gradually develop an understanding of it or liking for it. If modern painting works the same way—a person would have to subject himself to it over a period of time in order to be able to appreciate it.

POLLOCK: I think that might help, certainly.

WRIGHT: Mr. Pollock, the classical artists had a world to express and they did so by representing the objects in that world. Why doesn't the modern artist do the same thing?

POLLOCK: H'm—the modern artist is living in a mechanical age and we have a mechanical means of representing objects in nature such as the camera and photograph. The modern artist, it seems to me, is working and expressing an inner world—in other words— expressing the energy, the motion, and other inner forces.

WRIGHT: Would it be possible to say that the classical artist expressed his world by representing the objects, whereas the modern artist expresses his world by representing the *effects* the objects have upon him?

POLLOCK: Yes, the modern artist is working with space and time, and expressing his feelings rather than illustrating.

WRIGHT: Well, Mr. Pollock, can you tell us how modern art came into being?

POLLOCK: It didn't drop out of the blue; it's a part of a long tradition dating back with Cézanne, up through the cubists, the post-cubists, to the painting being done today.

WRIGHT: Then, it's definitely a product of evolution?

POLLOCK: Yes.

WRIGHT: Shall we go back to this method question that so many people today think is important? Can you tell us how you developed your method of painting, and why you paint as you do?

POLLOCK: Well, method is, it seems to me, a natural growth out of a need, and from a need the modern artist has found new ways of

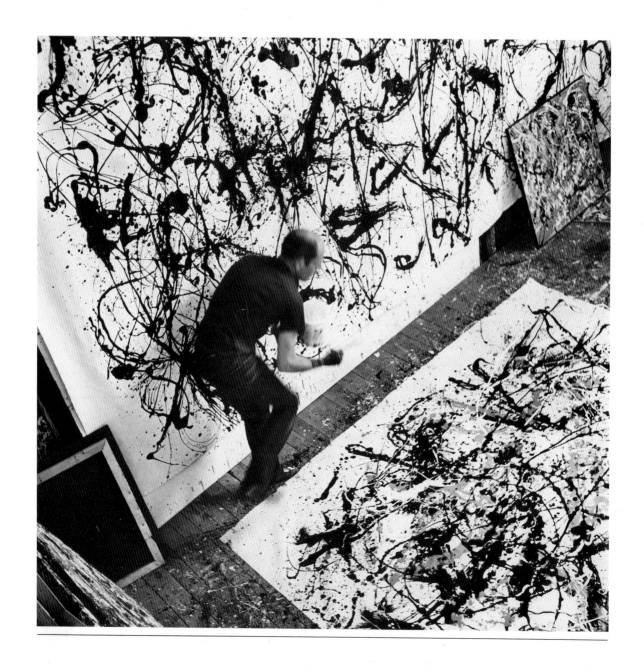

expressing the world about him. I happen to find ways that are different from the usual techniques of painting, which seems a little strange at the moment, but I don't think there's anything very different about it. I paint on the floor and this isn't unusual—the Orientals did that.

WRIGHT: How do you go about getting the paint on the canvas? I understand you don't use brushes or anything of that sort, do you?

POLLOCK: Most of the paint I use is a liquid, flowing kind of paint. The brushes I use are used more as sticks rather than brushes—the brush doesn't touch the surface of the canvas, it's just above.

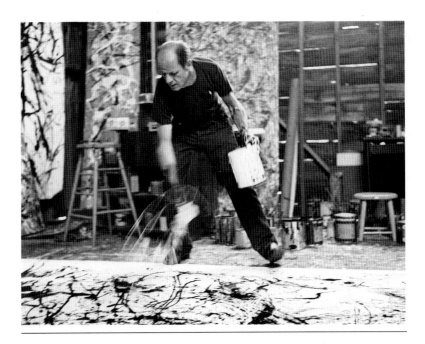

Jackson Pollock, 1950
Photograph by Hans Namuth

WRIGHT: Would it be possible for you to explain the advantage of using a stick with paint—liquid paint—rather than a brush on canvas?

POLLOCK: Well, I'm able to be more free and to have greater freedom and move about the canvas, with greater ease.

WRIGHT: Well, isn't it more difficult to control than a brush? I mean, isn't there more a possibility of getting too much paint or splattering or any number of things? Using a brush, you put the paint right where you want it and you know exactly what it's going to look like.

POLLOCK: No, I don't think so. I don't—ah—with experience—it seems to be possible to control the flow of the paint, to a great extent, and I don't use—I don't use the accident—'cause I deny the accident.

Jackson Pollock, 1950
Photograph by Hans Namuth

WRIGHT: I believe it was Freud who said there's no such thing as an accident. Is that what you mean?

POLLOCK: I suppose that's generally what I mean.

WRIGHT: Then you don't actually have a preconceived image of a canvas in your mind?

POLLOCK: Well, not exactly—no—because it hasn't been created, you see. Something new—it's quite different from working, say, from a still life where you set up objects and work directly from them. I do have a general notion of what I'm about and what the results will be.

WRIGHT: That does away, entirely, with all preliminary sketches?

POLLOCK: Yes, I approach painting in the same sense as one approaches drawing; that is, it's direct. I don't work from drawings, I don't make sketches and drawings and color sketches into a final painting. Painting, I think, today—the more immediate, the more direct—the greater the possibilities of making a direct—of making a statement.

WRIGHT: Well, actually every one of your paintings, your finished canvases, is an absolute original.

POLLOCK: Well—yes—they're all direct painting. There is only one.

WRIGHT: Well, now, Mr. Pollock, would you care to comment on modern painting as a whole? What is your feeling about your contemporaries?

POLLOCK: Well, painting today certainly seems very vibrant, very alive, very exciting. Five or six of my contemporaries around New York are doing very vital work, and the direction that painting seems to be taking here—is—away from the easel—into some sort, some kind of wall—wall painting.

WRIGHT: I believe some of your canvases are of very unusual dimensions, isn't that true?

POLLOCK: Well, yes, they're an impractical size—9 by 18 feet. But I enjoy working big and—whenever I have a chance, I do it whether it's practical or not.

WRIGHT: Can you explain why you enjoy working on a large canvas more than on a small one?

POLLOCK: Well, not really. I'm just more at ease in a big area than I am on something 2 by 2 [feet]; I feel more at home in a big area.

WRIGHT: You say "in a big area." Are you actually on the canvas while you're painting?

POLLOCK: Very little. I do step into the canvas occasionally—that is, working from the four sides I don't have to get into the canvas too much.

WRIGHT: I notice over in the corner you have something done on

plate glass. Can you tell us something about that?

POLLOCK: Well, that's something new for me. That's the first thing I've done on glass and I find it very exciting. I think the possibilities of using painting on glass in modern architecture—in modern construction—terrific.

WRIGHT: Well, does the one on glass differ in any other way from your usual technique?

POLLOCK: It's pretty generally the same. In this particular piece I've used colored glass sheets and plaster slabs and beach stones and odds and ends of that sort. Generally it's pretty much the same as all of my paintings.

WRIGHT: Well, in the event that you do more of these for modern buildings, would you continue to use various objects?

POLLOCK: I think so, yes. The possibilities, it seems to me, are endless, what one can do with glass. It seems to me a medium that's very much related to contemporary painting.

WRIGHT: Mr. Pollock, isn't it true that your method of painting, your technique, is important and interesting only because of what you accomplish by it?

POLLOCK: I hope so. Naturally, the result is the thing and it doesn't make much difference how the paint is put on as long as something has been said. Technique is just a means of arriving at a statement.

from *Jackson Pollock*, by Francis V. O'Conner, The Museum of Modern Art, New York, 1967, pp. 79–81. Reprinted by permission of the Museum of Modern Art. © The Museum of Modern Art (1967).

Taped in the summer of 1950 for a radio station, but never used.

Statement, 1950

Abstract painting is abstract. It confronts you. There was a reviewer a while back who wrote that my pictures didn't have any beginning or any end. He didn't mean it as a compliment, but it was. It was a fine compliment. Only he didn't know it.

excerpted from "Unframed Space," *The New Yorker*, vol. 26, no. 24, August 5, 1950, p. 16. Reprinted by permission; © 1950, 1978 The New Yorker Magazine, Inc.

Letter to Alfonso Ossorio and Edward Dragon, 1951

I've had a period of drawing on canvas in black—with some of my early images coming thru—think the non-objectionists will find

them disturbing—and the kids who think it simple to splash a
Pollock out.

from *The New York School*, Los Angeles County Museum, Los Angeles, 1965, p. 25.
Copyright © 1990 Pollock-Krasner Foundation/ARS N.Y.

Letter of June 7, 1951.

Interview with Selden Rodman (undated)

What a ridiculous idea, he said, expressing the city—never did it in
my life! . . .

Nothing so specific . . . My times and my relation to them . . .
No. Maybe not even that. The important thing is that Clyff Still—
you know his work?—and Rothko, and I—we've changed the nature
of painting. . . .

I don't mean there aren't any other good painters. Bill
[de Kooning] is a good painter but he's a *French* painter. I told him
so, the last time I saw him, after his last show. . . .

All those pictures in his last show start with an image. You can
see it even though he's covered it up, or tried to. . . .

Style—that's the French part of it. He has to cover it up with
style. . . .

I don't care for 'abstract expressionism' . . . and it's certainly not
'nonobjective,' and not 'nonrepresentational' either. I'm very
representational some of the time, and a little all of the time. But
when you're painting out of your unconscious, figures are bound to
emerge. We're all of us influenced by Freud, I guess. I've been a
Jungian for a long time. . . . Painting is a state of being. . . .
Painting is self-discovery. Every good artist paints what he is.

Excerpted from *Conversations with Artists*, by Selden Rodman. New York: Capricorn Books,
1961, pp. 84–85. Copyright © 1990 Pollock-Krasner Foundation/ARS N.Y.

Rodman interviewed Pollock in Easthampton in June, 1956.

Letter from Clyfford Still, 1953

Went up to Janis' gallery with Barney [Newman] the other day and
took the liberty of pushing into the office to see some of the
paintings you did this summer.

What each work said, what its position, what each achieved you
must know. But above all these details and intentions the great
thing, to me, came through. It was that here a *man* had been at
work, at the profoundest work a man can do, facing up to what he is
and aspires to be.

I left the room with the gratitude and renewal of courage that always comes at such moments. This is just my way of saying thanks, with the hope some of my work has brought some of the same to you.

from *Jackson Pollock*, by Francis V. O'Connor. The Museum of Modern Art, New York, 1967. Reprinted by permission of the Museum of Modern Art. © The Museum of Modern Art (1967).

"Jackson Pollock: An Artists' Symposium," 1967

ROBERT MOTHERWELL: I was also struck by how his artistic affinities—his admiration for Ryder, his study with Thomas Hart Benton, his involvement in Orozco and El Greco and, lastly, his immersion in the Picasso of the 1930's—were invariably for artists, however else they might differ, who had in common an overriding emphasis on an intensely Expressionist rhythm. I think he responded to rhythm more than anything else in art. Indeed, perhaps it is not too much to assert that his greatest works are marked by the intensity and violence of his rhythm, modified by an incorruptible respect for the works' flat surface, an art masculine and lyrical and, as in a Celtic dance, measured, despite its original primitive impulse. That he also meant to me, his rhythm. . . .

BARNETT NEWMAN: The paintings of Jackson Pollock? The time has come to praise a colleague, not to bury a hero.

Let us hope it is not too late, for he has already been thrust into art theory—drip, all-over, stain, gesture, performance, wall-painting, etc.

Is this all that the admiring theorists and the self-serving dancers on his grave see in him—Pollock, "the picture-maker," the inventor of "styles?"

Is Pollock the prophet of our fate?

Pollock was more than a great "picture-maker." His work was *his* lofty statement in the grand dialogue of human passion, rich with sensitivity and sensibility. But it must not be forgotten that moving through the work is that revolutionary core that gave it life.

Before the art historians succeed in burying that revolution, let us remember what happened. In 1940, some of us woke up to find ourselves without hope—to find that painting did not really exist. Or to coin a modern phrase, painting—a quarter of a century before it happened to God—was dead.

The awakening had the exaltation of a revolution. It was that awakening that inspired the aspiration—the high purpose—quite a

different thing from ambition—to start from scratch, to paint as if
painting never existed before. It was that naked revolutionary
moment that made painters out of painters.

excerpted from *ARTnews*, vol. 66, no. 2, April, 1967. © ARTnews, LXVI, No. 2 April 1967.
Reprinted by permission.

On November 30, 1956, a memorial honoring Pollock was held by The Club. Many artists and
critics took part including James Brooks, Clement Greenberg, Reuben Kadish, Frederick
Kiesler, Franz Kline, Willem de Kooning, and Conrad Marca-Relli. Harold Rosenberg acted
as moderator.

Lee Krasner interviewed by B. H. Friedman, 1969

KRASNER: Jackson used rolls of cotton duck, just as he had
intermittently since the early forties. All the major black-and-white
paintings were on unprimed duck. He would order remnants, bolts
of canvas anywhere from five to nine feet high, having maybe fifty
or a hundred yards left on them—commercial duck, used for ships
and upholstery, from John Boyle down on Duane Street. He'd roll a
stretch of this out on the studio floor, maybe twenty feet, so the
weight of the canvas would hold it down—it didn't have to be
tacked. Then typically he'd size it with a coat or two of 'Rivit' glue
to preserve the canvas and to give it a harder surface. Or
sometimes, with the black-and-white paintings, he would size them
after they were completed, to seal them. The 'Rivit' came from
Behlen and Brother on Christopher Street. Like Boyle's, it's not an
art-supplier. The paint Jackson used for the black-and-white was
commercial too—mostly black industrial enamel, Duco or Davoe &
Reynolds. There was some brown enamel in a couple of the
paintings. So his 'palette' was typically a can or two of his enamel,
thinned to the point he wanted it, standing on the floor beside the
rolled-out canvas. Then, using sticks, and hardened or worn-out
brushes (which were in effect like sticks), and basting syringes, he'd
begin. His control was amazing. Using a stick was difficult enough,
but the basting syringe was like a giant fountain pen. With it he had
to control the flow of ink as well as his gesture. He used to buy
those syringes by the dozen . . . With the larger black-and-whites
he'd either finish one and cut it off the roll of canvas, or cut it off in
advance and then work on it. But with the smaller ones he'd often do
several on a large strip of canvas and then cut that strip from the
roll to make more working space and to study it. Sometimes he'd
ask, 'Should I cut it here? Should this be the bottom?' He'd have
long sessions of cutting and editing, some of which I was in on, but
the final decisions were always his. Working around the canvas—in

JACKSON POLLOCK

RECENT PAINTINGS

JANUARY 5 TO JANUARY 23, 1948

BETTY PARSONS GALLERY
15 EAST 57 STREET · NEW YORK 22, N. Y.

REPRESENTS: HERBERT FERBER, JEROME KAMROWSKI, PIETRO LAZZARI, BORIS MARGO, WALTER MURCH, BARNETT B. NEWMAN, ALFONSO OSSORIO, CHARLES OWENS, JAKSON POLLOCK, AD REINHARDT, MARK ROTHKO, DAY SCHNABEL, THEODOROS S. STAMOS, JOHN STEPHAN, HEDDA STERNE, CLYFFORD STILL, SEYMOUR LIPTON, OSSIP ZADKINE.

Jackson Pollock
Announcement for one-man show
at Betty Parsons Gallery,
January 5–23, 1948

'the arena' as he called it—there really was no absolute top or bottom. And leaving space between paintings, there was no absolute top or bottom. And leaving space between paintings, there was no absolute 'frame' the way there is working on a pre-stretched canvas. Those were difficult sessions. His signing the canvases was even worse. I'd think everything was settled—tops, bottoms, margins— and then he'd have last-minute thoughts and doubts. He hated signing. There's something so final about a signature . . . Sometimes, as you know, he'd decide to treat two or more successive panels as one painting, as a diptych, or triptych, or whatever. *Portrait and a Dream* is a good example. And, do you know, the same dealer who told me Jackson's black-and-whites were *accepted*, asked him now, two years later, why he didn't cut *Portrait and a Dream* in half!

excerpted from *Jackson Pollock: Black and White*, by B. H. Friedman. Marlborough Gallery, New York, 1969, pp. 9, 10. © B. H. Friedman.

This is the clearest description we have of Pollock's working methods and was related by his wife, the painter Lee Krasner.

Ad Reinhardt

Statement, 1952

It's been said many times in world-art writing that one can find some of painting's meanings by looking not only at what painters do but at what they refuse to do.

A glance at modern-art history shows that for Courbet—no antiques or angels, no traditional authorities or academies, no classical idealisms or romantic exoticisms, no fantasies, no world beyond our world. For Manet and Cézanne—no myths or messages, no actions or imitations, no orgies, no pains, no dreams, no stories, no disorders. For Monet, no subjects or objects, no fixities or absolutes, no chiaroscuro or plasticities, no textures or compositions, no timelessness, no terror, no studio setups, no imaginary scenes, no muddy colors. For the cubists—no pictures or puzzles, no closed or natural forms, no fixed arrangements, no irrationalism, no unconsciousness. For Mondrian—no particularities or local elements, no irregularities or accidents or irrelevancies, no oppression of time or subjectivity, no primitivism, no expressionism.

And today many artists like myself refuse to be involved in some ideas. In painting, for me,—no fooling-the-eye, no window-hole-in-the-wall, no illusions, no representations, no associations, no distortions, no paint-caricaturing, no dream pictures or drippings, no delirium trimmings, no sadism or slashings, no therapy, no kicking-the-effigy, no clowning, no acrobatics, no heroics, no self-pity, no guilt, no anguish, no supernaturalism or subhumanism, no divine inspiration or daily perspiration, no personality-picturesqueness, no romantic bait, no gallery gimmicks, no neo-religious or neo-architectural hocus-pocus, no poetry or drama or theatre, no entertainment business, no vested interests, no Sunday-hobby, no drug-store-museums, no free-for-all-history, no art history in America of ashcan-regional-WPA-pepsi-cola styles, no professionalism, no equity, no cultural enterprises, no bargain-art-commodity, no juries, no contests, no masterpieces, no prizes, no mannerisms or techniques, no communication or information, no magic tools, no bag of tricks-of-the-trade, no structure, no paint qualities, no impasto, no plasticity, no relationships, no experiments, no rules, no coercion, no anarchy, no anti-intellectualism, no irresponsibility, no innocence, no irrationalism, no low level of consciousness, no nature-mending, no reality-

reducing, no life-mirroring, no abstracting from anything, no nonsense, no involvements, no confusing painting with everything that is not painting.

from *Contemporary American Painting*, University of Illinois, Urbana, 1952, pp. 226–27. Reprinted by permission of the University of Illinois at Urbana-Champaign.

Three Statements, 1955–1961

A square (*neutral, shapeless*) canvas, five feet wide, five feet high, as high as a man, as wide as a man's outstretched arms (*not large, not small, sizeless*), trisected (*no composition*), one horizontal form negating one vertical form (*formless, no top, no bottom, directionless*), three (*more or less*) dark (*lightless*) non-contrasting (*colorless*) colors, brushwork brushed out to remove brushwork, a matte, flat, free-hand painted surface (*glossless, textureless, non-linear, no hard edge, no soft edge*) which does not reflect its surroundings—a pure, abstract, non-objective, timeless, spaceless, changeless, relationless, disinterested painting—an object that is self-conscious (*no unconsciousness*) ideal, transcendent, aware of no thing but art (*absolutely no anti-art*).

excerpted from *Pax*, no. 18, 1962. Reprinted by permission of Rita Reinhardt and Anna Reinhardt. © Anna Reinhardt.

"Two Quotations from the Old Ecole de Paris and the New American Academy" and "Ten Quotations from the Old New York School," 1960

"My painting represents the victory of the forces of light and peace over the powers of darkness and evil."

PICASSO, 1958

"My painting represents the victory of the forces of darkness and peace over the powers of light and evil."

REINHARDT, 1957

"Voyaging into the night, one knows not where, on an unknown vessel, an absolute struggle with the elements of the real."

ROBERT MOTHERWELL, 1959

"Voyaging into the night, one knows exactly where, on a known vessel, an absolute harmony with the elements of the unreal."

AD REINHARDT, 1959

"There is no such thing as a good painting about nothing."

ADOLPH GOTTLIEB and MARK ROTHKO, 1947

"There is no such thing as a good painting about something."

AD REINHARDT, 1947

"Art never seems to make me peaceful or pure."

WILLIAM DE KOONING, 1951

"Art never seems to make me vulgar or violent."

AD REINHARDT, 1951

"I looked at Picasso until I could smell his armpits."

WILLIAM BAZIOTES and RUDI BLESH, 1956

"Study the old masters. Look at nature. Watch out for armpits."

PAUL CÉZANNE and AD REINHARDT, 1956

"Let no man undervalue the implications of this work, or its power for life, or for death, if it is misused."

CLYFFORD STILL, 1959

"Let no man undervalue the implications of this work, or its power for cash, or for bad credit, if it is misused."

AD REINHARDT, 1929

from *Pax*, no. 13, 1960. Reprinted by permission of Rita Reinhardt and Anna Reinhardt. © Anna Reinhardt.

Letter to the editor of *ARTnews*, 1961

Sir:
The Manhattan New York City Telephone Directory for 1960–61 lists, consecutively, on page 1158, seven National Institutes:

National Institute for Architectural Education
National Institute for Disaster Mobilization
National Institute for Straight Thinking

National Institute for the Blind
National Institute of Arts and Letters
National Institute of Credit
National Institute of Diaper Services

Anybody want to make anything of that?

Ad Reinhardt
New York

from *ARTnews*, vol. 60, no. 2, April 1961, p. 6. © ARTnews, LX, No. 2, April 1961.
Reprinted by permission.

"The Next Revolution in Art: Art-as-Art Dogma Part II," 1964

The one thing to say about art is that it is one thing. Art is art-as-art and everything else is everything else. Art-as-art is nothing but art. Art is not what is not art.

The one object of fifty years of abstract art is to present art-as-art and as nothing else, to make it into the one thing it is only, separating and defining it more and more, making it purer and emptier, more absolute and more exclusive—non-objective, non-representational, non-figurative, non-imagist, non-expressionist, non-subjective. The only and one way to say what abstract art or art-as-art is, is to say what it is not.

The one subject of a hundred years of modern art is that awareness of art of itself, of art preoccupied with its own process and means, with its own identity and distinction, art concerned with its own unique statement, art conscious of its own evolution and history and destiny, toward its own freedom, its own dignity, its own essence, its own reason, its own morality and its own conscience. Art needs no justification with "realism" or "naturalism," "regionalism" or "nationalism," "individualism" or "socialism" or "mysticism," or with any other ideas.

The one content of three centuries of European or Asiatic art and the one matter of three millennia of Eastern or Western art, is the same "one significance" that runs through all the timeless art of the world. Without an art-as-art continuity and art-for-art's sake conviction and unchanging art spirit and abstract point of view, art would be inaccessible and the "one thing" completely secret.

The one idea of art as "fine," "high," "noble," "liberal," "ideal" of the seventeenth century is to separate fine and intellectual art from manual art and craft. The one intention of the word

"aesthetics" of the eighteenth century is to isolate the art experience from other things. The one declaration of all the main movements in art of the nineteenth century is of the "independence" of art. The one question, the one principle, the one crisis in art of the twentieth century centers in the uncompromising "purity" of art, and in the consciousness that art comes from art only, not from anything else.

The one meaning in art-as-art, past or present, is art-meaning. When an art object is separated from its original time and place and use and is moved into the art museum, it gets emptied and purified of all its meanings except one. A religious object that becomes a work of art in an art museum loses all its religious meanings. No one in his right mind goes to an art museum to worship anything but art, or to learn about anything else.

The one place for art-as-art is the museum of fine art. The reason for the museum of fine art is the preservation of ancient and modern art that cannot be made again and that does not have to be done again. A museum of fine art should exclude everything but fine art, and be separate from museums of ethnology, geology, archaeology, history, decorative-arts, industrial arts, military arts, and museums of other things. A museum is a treasure-house and tomb, not a counting-house or amusement center. A museum that becomes an art-curator's personal-monument or an art-collector-sanctifying-establishment or an art-history manufacturing-plant or an artists'-market-block, is a disgrace. Any disturbance of a true museum's soundlessness, timelessness, airlessness and lifelessness is a disrespect.

The one purpose of the art academy university is the education and "correction of the artist"-as-artist, not the "enlightenment of the public" or the popularization of art. The art college should be a cloister-ivyhall-ivory-tower-community of artists, an artists' union and congress and club, not a success-school or service station or rest home or house of artists' ill-fame. The notion that art or an art museum or art university "enriches life" or "fosters a love of life" or "promotes understanding and love among men" is as mindless as anything in art can be. Anyone who speaks of using art to further any local, municipal, national or international relations is out of his mind.

The one thing to say about art and life is that art is art and life is life, that art is not life and life is not art. A "slice-of-life" art is no better or worse than a "slice-of-art" life. Fine art is not a "means of making a living" or a "way of living a life," and an artist who dedicates his life to his art or his art to his life burdens his art with his life and his life with his art. Art that is a matter of life and death is neither fine nor free.

The one assault on fine art is the ceaseless attempt to subserve it as a means to some other end or value. The one fight in art is not between art and non-art, but between true and false art, between pure art and action-assemblage art, between abstract art and surrealist-expressionist anti-art, between free art and servile art. Abstract art has its own integrity, not someone else's "integration" with something else. Any combining, mixing, adding, diluting, exploiting, vulgarizing, or popularizing abstract art deprives art of its essence and depraves the artist's artistic consciousness. Art is free, but it is not a free-for-all.

The one struggle in art is the struggle of artists against artists, of artist against artist, of the artist-as-artist within and against the artist-as-man, -animal, or -vegetable. Artists who claim their art work comes from nature, life, reality, earth or heaven, as "mirrors of the soul" or "reflections of conditions" or "instruments of the universe," who cook up "new images of man"—figures and "nature-in-abstraction"—pictures, are subjectively and objectively rascals or rustics. The art of "figuring" or "picturing" is not a fine art. An

Installation of Reinhardt exhibit at The Jewish Museum, New York, 1966. Jewish Museum of New York/Art Resource, New York

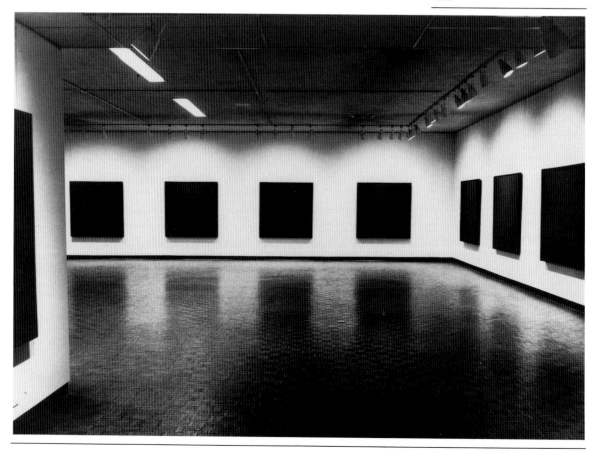

artist who is lobbying as a "creature of circumstances" or log rolling as a "victim of fate" is not a fine master artist. No one ever forces an artist to be pure.

The one art that is abstract and pure enough to have the one problem and possibility, in our time and timelessness, of the "one single grand original problem," is pure abstract painting. Abstract painting is not just another school or movement or style but the first truly unmannered and untrammeled and unentangled, styleless, universal painting. No other art or painting is detached or empty or immaterial enough.

The one history of painting progresses from the painting of a variety of ideas with a variety of subjects and objects, to one idea with a variety of subjects and objects, to one subject with a variety of objects, to one object with a variety of subjects, then to one object with one subject, to one object with no subject, and to one subject with no object, then to the idea of no object and no subject and no variety at all. There is nothing less significant in art, nothing more exhausting and immediately exhausted, than "endless variety."

The one evolution of art forms unfolds in one straight logical line of negative actions and reactions, in one predestined, eternally recurrent stylistic cycle, in the same all-over pattern, in all times and places, taking different times in different places, always beginning with an "early" archaic schematization, achieving a climax with a "classic" formulation, and decaying with "late" endless variety of illusionisms and expressionisms. When late stages wash away all lines of demarcation, framework and fabric, with "anything can be art," "anybody can be an artist," "that's life," "why fight it," "anything goes," and "it makes no difference whether art is abstract or representational," the artists' world is a mannerist and primitivist art trade and suicide-vaudeville, venal, genial, contemptible, trifling.

The one way in art comes from art working and the more an artist works the more there is to do. Artists come from artists and art forms come from art forms, painting comes from painting. The one direction in fine or abstract art today is in the painting of the same one form over and over again. The one intensity and the one perfection come only from long and lonely routine preparation and attention and repetition. The one originality exists only where all artists work in the same tradition and master the same convention. The one freedom is realized only through the strictest art discipline and through the most similar studio ritual. Only a standardized, prescribed and proscribed form can be imageless, only a stereotyped image can be formless, only a formularized art can be

formulaless. A painter who does not know what or how or where to paint is not a fine artist.

The one work for a fine artist, the one painting, is the painting of the one-size canvas—the single scheme, one formal device, one color-monochrome, one linear division in each direction, one symmetry, one texture, one free-hand brushing, one rhythm, one working everything into one dissolution and one indivisibility, each painting into one overall uniformity and non-irregularity. No lines or imaginings, no shapes or composings or representings, no visions or sensations or impulses, no symbols or signs or impastos, no decoratings or colorings or picturings, no pleasures or pains, no accidents or ready-mades, no things, no ideas, no relations, no attributes, no qualities—nothing that is not of the essence. Everything into irreducibility, unreproducibility, imperceptibility. Nothing "useable," "manipulatable," "saleable," "dealable," "collectable," "graspable." No art as a commodity or a jobbery. Art is not the spiritual side of business.

The one standard in art is oneness and fineness, rightness and purity, abstractness and evanescence. The one thing to say about art is, its breathlessness, lifelessness, deathlessness, contentlessness, formlessness, spacelessness and timelessness. This is always the end of art.

from *Art International*, vol. 8, no. 2, March 1964, pp. 36, 37. © Art International, 77 rue des Archives, 75003 Paris, France. Reprinted by permission.

Working notes (undated)

Black, *symbol*	Bible—*"good/evil," white/black, "light/dark"*	
"Blacks," "coloureds," lightness-darkness	White you're right,	
Colour-caste, "high yellow," stigma	Light, you can fight	
Self-image	Brown, stand around,	
"Yearning-for-whiteness"	Black, stand back.	

White above black in our culture
"Black as sin," evil, ignorance, wickedness
White, beauty, purity, white-goddess, white prince, black knight
Cowboy-hero-white-hat-horse, black villain
White-hope, whitewash
Black-hearted, black-list, black-mail, black-sheep
Black-death, illness, hatred, morbidity, despair, sorrow
 inferior, feminine

 "logos piercing the darkness"

Chaucer, Milton, Shakespeare
"Black is the badge of hell, the hue of dungeons and the suit of
 night" (Love's Labour's Lost)
"The devil damn thee black." (Macbeth)
"Arise, black vengeance" (Othello)

Alchemy {
Gold
Red
White
Black
}

Black, tiger, north, winter, water (tortoise?)
Dionysos, symbol of wrath, cruelty
China, symbol of darkness and of the new moon

"Castle of darkness: inhabited by a "black knight," Pluto-abode
Castle of no-return "Lord of the underworld"
Hell-void, "intolerable ache of absence, chill negation of love"
Heaven-myth, cross-shape, warm shadows of redemption into depths
 of infinity
Forces of darkness, *formless, unformed;* chaos
Initial, germinal stage of all processes, primal, unconscious
Darkness, *maternal*, dark-earth-mother, Diana of Ephesus
Occult, the *hidden*, chaos, regressive, base, unsublimated
Guilt, origin, latent forces, "prime matter," penitence
Profound mystery of *the origin* "primordial darkness"
Void, diluted by matter, disturbed by light split-up
 sucks time, space, identity into absolute of nothingness
Inevitability of *fate*
Withdrawal of recluse, *rebirth* in seclusion, recapitulation or atone-
 ment
Inner, subterranean, caves, grottos
"Black castle," rain-cloud on mountain-top, alchemist's lair,
 mansion of *the beyond, entrance* to other world,
The other side, transcendent

"Sayings of C. Dooley, New York School as Reported by A. Reinhardt" (undated)

The way I look at it is if art is life and life is
art, is the artist a hard liver or a soft lifer and if
me and you don't live it up these days, who is, —right?

The way I look at it is if the relation of the pot to
the hole in art makes it either organic or geometric and
potty or holy, and if me and you don't feel
painting is more than the scum of its pots, who is, —
right?

The way I look at it is if the
cold war has warmed up and the artists have stopped
"sweating out" the hot critic who was "sweating out" the artists who
 were "sweating out" cubism, why
should me and you get steamed up, —right?

The way I look at it is why do me and you
have to choose between carpentry and garbage
when carpentry soon becomes junk anyway and
garbage-art becomes furniture after all, and if
me and you don't keep the new york school clean,
who is, —right?

The way I look at it is there are two
struggling artists in every struggling artist and
one of them is a little whore in danger of
becoming a big hero and the other a bad conscience
in danger of becoming an old maid and losing
the business, so if me and you don't watch out
for the guilt about not feeling guilty about one's
 guilt, who is, —right?

Ad Reinhardt, 1962
Photograph by Fred W.
McDarrah

The way I look at it is if curators and critics
want to cook up careers for half-baked artists with
souped-up pictures that will sell like hot cakes, that's
the way the cookies crumble, —right?

The way I look at it is if someone comes up
and whispers in your ear why does so much sculpture
nowadays look like teeth, its no skin off my
and your nose, —right?

The way I look at it is if some bad artist
after years of hard pulling gets around to making
a not-bad painting while some good artist
starts pushing lousy pictures, if me and you don't
give them credit, who is, —right?

Ad Reinhardt, 1962
Photograph by Fred W.
McDarrah

The way I look at it is if me and you read
what one jazzy writer writes on page eighty four
of his book that ". . . it is only today, forty three
years after the Armory Show . . . that the last
of the darkness is beginning to lift," and if me
and you don't ask, "Look, what light?" who is, —
right?

The way I look at it is if an artist worries
over the shape of his content what kind of an
artist is he anyway and even if he worries over
the content of his shape it's not much better and
why should me and you get stomach trouble, —
right?

The way I look at it is that those two
mythopoetic artists who said there is no such
thing as a good painting about nothing in nineteen
 hundred and forty seven were not talking to
artist like me and you but peddling their
hanky-panky in public, —right?

The way I look at it is if someone thinks
painting is ah a clock or paradox that sees each
end of the street in all that vastness of space

ah which lies outside the touch of the finger as
the edge of the world, ah, why should me and
you worry about people, — right?

from working notes (undated) from Ad Reinhardt Papers, Archives of American Art, microfilm no. N69-103, frame no. 297. Reprinted by permission of Rita Reinhardt and Anna Reinhardt. © Anna Reinhardt.

Working notes (undated)

Things are lousy. The avant-garde is arrears. Artists are selling themselves like hot cakes. Art is a good thing. Art education is a holy-schmo business. Artists are jobbing. The lousy government is in this dirty war. One doesn't know what one can do about it. The art critics are all corrupt. The art critics are the art curators and they're also the art collectors and assistant art dealers too. The good old artwords are dead. Things are awful. Artists don't know what to do, they're repeating themselves, they're making movies. Artists make telephone directions for making art instead of making it themselves. Some people still think the mass-media can explain things. Artists are like businessmen.

 Things are great. The avant-garde is behind us. Artists are making out. Lots of money around. Art is a good thing, everywhere. You can do anything you want. Artists are free of expressionism. The old rackets, scumbling, fumbling, staining, straining, striping, stripping are all gone. The art critics are all corrupt. Artists are freer than they've ever been. There are bigger and nicer art books than ever before. Artists are working more and bigger and faster. Telephones have never been so busy. The mass-media give more space to artists who are working that gap between technology and life.

from Ad Reinhardt Papers, Archives of American Art, microfilm no. N/69-103, frame no. 284. Reprinted by permission of Rita Reinhardt and Anna Reinhardt. © Anna Reinhardt.

Working notes (undated)

There is nothing there. What you see is not what you see.
 What you see is nothing. Nothing but shapes, lines,
 colors. What you see is whats in your mind. What
 you see is something somebody told you to look for.
 Look out for anything you see! Watch it! Watch out!
 Take care! Don't leap before you look out!

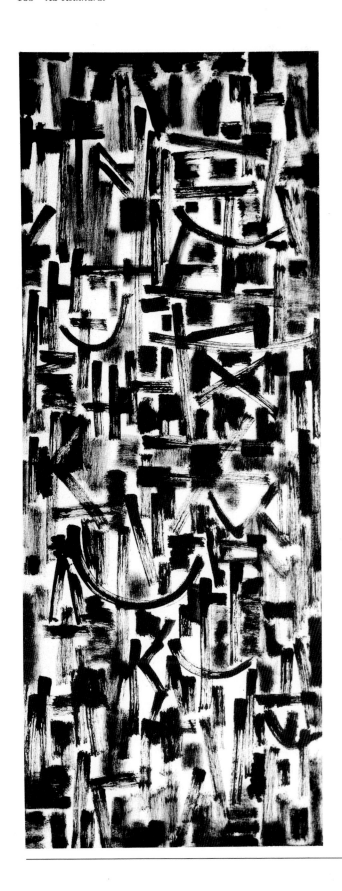

Ad Reinhardt
Abstract Painting, 1948
Oil on canvas, 50 × 20"
Whereabouts unknown

Painting as fine art is absolutely transparent always,
and what you look at you look through. What you
look through is through your brain. Your eye-ball
is connected to your brain-box. Coin a word, call it
mind's eye. Eye-wash is brain-wash. A cleaner
New York School is up to you. Evey litter bit
hurts you. Keep it clean. For heavens sake.

Be a champ. Be a muscles "do" chump. Ted Williams said
"you can say thank you, or you can spit." Miles Davis
said "sometimes you get it up to here." Who said
"everything turns into shit and money?"

Hard Times {

Never underestimate this work for its cash value and
its power for life and death. Holler hang the
museums until they hang you then clam up and
collect. Don't shoot off your mouth until you
see the spondulics in their eyes.

gate (UNPUBLISHED)

Which First Generation/artist pulled and pushed
the New York School to the last?
Who opened the door first? Who broke through last?
Who pulled down the shade first? Who closed the
door first? Who put out the lights last?
Who brought down the house first?
Who cried all the way to the bank first? Who cashed
in last?
Who hit the jackpot last? Who sold out first?
Who made out the most? Who made in the least?
Who got the dirty end of the stick of the boom in
the end first? Who got it in the end last?

Who had the largest appetite for experience? Who
had the smallest lust for life? Who had the first
thirst for success? Who had the prick of conscience
last?

Who did the most hand-to-mouth living? Who
did the least mouth-to-hand work?

Which artist first said, "The New York School is
a nice place to visit but I wouldn't want to live
there?
Who said last, "A cleaner New York School Is Up
To You?"

Who went into the streets the fastest?
Who satisfied the customers the slowest?

Ad Reinhardt
Working notes (undated)

Build up your hunger for experience, lust for life, taste for money,
feel for flesh, finger in the pie,
exercise your conscience, abandon all thoughts
Loosen up, make believe that your mind is a make-believe.
Pin your heart, sweat and tears on your sleeves
put them all together in your painting. Then let
them have it.

from Ad Reinhardt Papers, Archives of American Art, microfilm no. N/69-103, frame no. 268. Reprinted by permission of Rita Reinhardt and Anna Reinhardt. © Anna Reinhardt.

Working notes (undated)

Which First Generation artist pulled and pushed
the New York School to the last?
Who opened the gate first? Who broke through last?
Who pulled down the shade first? Who closed the
door first? Who put out the lights last?
Who brought down the house first?
Who went into the streets the fastest?
Who satisfied the customers the slowest?
Who cried all the way to the bank first? Who cashed
in last?
Who hit the jackpot last? Who sold out first?
Who made out the most? Who made in the least?
Who got the dirty end of the stuck of the boom in
the end first? Who got it in the end last?

Who had the largest appetite for experience? Who
had the smallest lust for life? Who had the first
thirst for success? Who had the prick of conscience
last?

Who did the most hand-to-mouth living? Who
did the least mouth-to-hand work?

Which artist first said, "The New York School is
a nice place to visit but I wouldn't want to live there?"

Who said last, "A cleaner New York School Is Up
To You?"

from Ad Reinhardt Papers, Archives of American Art, microfilm no. N69-103, frame no. 285. Reprinted by permission of Rita Reinhardt and Anna Reinhardt. © Anna Reinhardt.

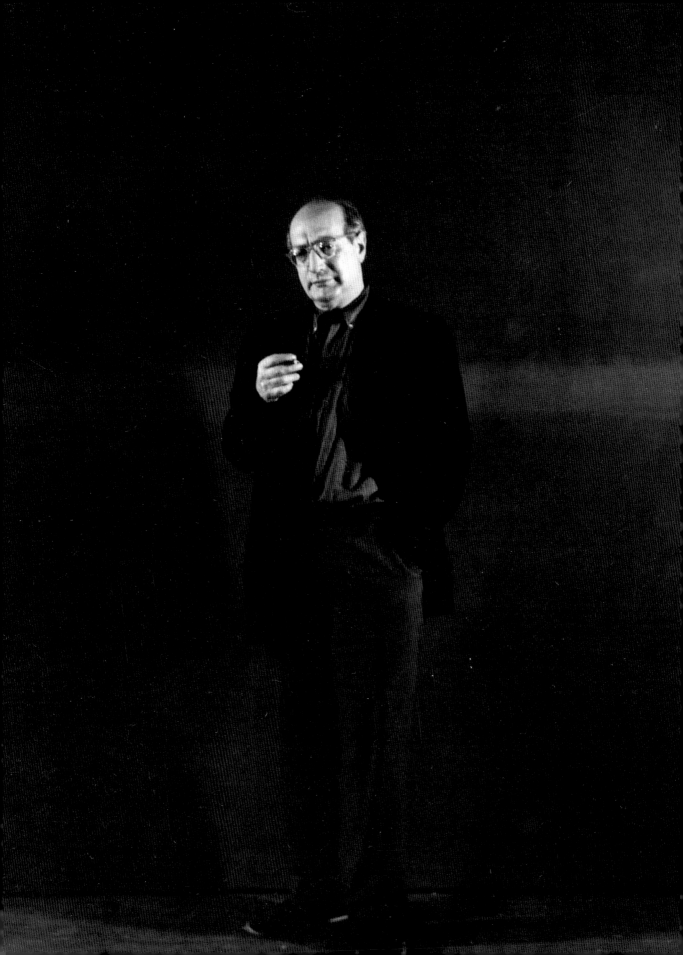

Mark Rothko

Mark Rothko, c. 1960
Photograph by Rudolph
Burckhardt

"The Romantics Were Prompted," 1947

The romantics were prompted to seek exotic subjects and to travel to far off places. They failed to realize that, though the transcendental must involve the strange and unfamiliar, not everything strange or unfamiliar is transcendental.

The unfriendliness of society to his activity is difficult for the artist to accept. Yet this very hostility can act as a lever for true liberation. Freed from a false sense of security and community, the artist can abandon his plastic bank-book, just as he has abandoned other forms of security. Both the sense of community and of security depend on the familiar. Free of them, transcendental experiences become possible.

I think of my pictures as dramas; the shapes in the pictures are the performers. They have been created from the need for a group of actors who are able to move dramatically without embarrassment and execute gestures without shame.

Neither the action nor the actors can be anticipated, or described in advance. They begin as an unknown adventure in an unknown space. It is at the moment of completion that in a flash of recognition, they are seen to have the quantity and function which was intended. Ideas and plans that existed in the mind at the start were simply the doorway through which one left the world in which they occur.

The great cubist pictures thus transcend and belie the implications of the cubist program.

The most important tool the artist fashions through constant practice is faith in his ability to produce miracles when they are needed. Pictures must be miraculous; the instant one is completed, the intimacy between the creation and the creator is ended. He is an outsider. The picture must be for him, as for anyone experiencing it later, a revelation, an unexpected and unprecedented resolution of an eternally familiar need.

On shapes:

They are unique elements in a unique situation.

They are organisms with volition and a passion for self-assertion.

They move with internal freedom, and without need to conform with or to violate what is probable in the familiar world.

They have no direct association with any particular visible experience, but in them one recognizes the principle and passion of organisms.

The presentation of this drama in the familiar world was never possible, unless everyday acts belonged to a ritual accepted as referring to a transcendent realm.

Even the archaic artist, who had an uncanny virtuosity found it necessary to create a group of intermediaries, monsters, hybrids, gods and demi-gods. The difference is that, since the archaic artist was living in a more practical society than ours, the urgency for transcendent experience was understood, and given an official status. As a consequence, the human figure and other elements from the familiar world could be combined with, or participate as a whole in the enactment of the excesses which characterize this improbable hierarchy. With us the disguise must be complete. The familiar identity of things has to be pulverized in order to destroy the finite associations with which our society increasingly enshrouds every aspect of our environment.

Without monsters and gods, art cannot enact our drama: art's most profound moments express this frustration. When they were abandoned as untenable superstitions, art sank into melancholy. It

Mark Rothko
Untitled, 1944–45
Watercolor on paper,
49⅞ × 27½″
Estate of Mark Rothko

became fond of the dark, and enveloped its objects in the nostalgic intimations of a half-lit world. For me the great achievements of the centuries in which the artist accepted the probable and familiar as his subjects were the pictures of the single human figure—alone in a moment of utter immobility.

But the solitary figure could not raise its limbs in a single gesture that might indicate its concern with the fact of mortality and an insatiable appetite for ubiquitous experience in face of this fact. Nor could the solitude be overcome. It could gather on beaches and

streets and in parks only through coincidence, and, with its companions, form a *tableau vivant* of human incommunicability.

I do not believe that there was ever a question of being abstract or representational. It is really a matter of ending this silence and solitude, of breathing and stretching one's arms again.

from *Possibilities*, vol. 1, no. 1, winter 1947–48, p. 84. © 1990 by Kate Rothko Prizel and Christopher Rothko. Reproduced by their kind permission.

Statement, 1947

A picture lives by companionship, expanding and quickening in the eyes of the sensitive observer. It dies by the same token. It is therefore a risky and unfeeling act to send it out into the world. How often it must be permanently impaired by the eyes of the vulgar and the cruelty of the impotent who would extend their affliction universally!

from "Ides of Art," *Tiger's Eye*, vol. 1, no. 2, December 1947, p. 44. Reprinted with permission of John Stephan.

Draft of a letter to Clyfford Still (undated)

I will say without reservations that from my view there can be no abstractions. Any shape or area which has not the pulsating concreteness of real flesh and bones, its vulnerability to pleasure or pain is nothing at all. Any picture which does not provide the environment in which the breath of life can be drawn does not interest me.

© 1990 by Kate Rothko Prizel and Christopher Rothko. Reproduced by their kind permission.

Statement, 1949

The progression of a painter's work, as it travels in time from point to point, will be toward clarity: toward the elimination of all obstacles between the painter and the idea, and between the idea and the observer. As examples of such obstacles, I give (among others) memory, history or geometry, which are swamps of generalization from which one might pull out parodies of ideas (which are ghosts) but never an idea in itself. To achieve this clarity is, inevitably, to be understood.

excerpted from *Tiger's Eye*, vol. I, no. 9, October 1949, p. 114. Reprinted with permission of John Stephan.

Mark Rothko, 1964
Photograph by Hans Namuth

Statement, 1950

Rather be prodigal than niggardly, I would sooner confer anthropomorphic attributes upon a stone, than dehumanize the slightest possibility of consciousness.

from *Personal Statement: Painting Prophecy—1950*, David Porter Gallery, Washington, D.C., 1950. © 1990 Kate Rothko Prizel and Christopher Rothko. Reproduced by their kind permission.

Personal statements printed in this pamphlet were written by a group of artists whose paintings had been included in an exhibition called "A Painting Prophecy—1950," first shown in February, 1945, at the David Porter Gallery. Includes statements by Motherwell, Helion, Davis, Baziotes, Gottlieb, Glarner, Ferren, Pousette-Dart, I. Rice Pereira, Jimmy Ernst, and others.

Statement, 1951

I would like to say something about large pictures, and perhaps touch on some of the points made by the people who are looking for a spiritual basis for communion.

I paint very large pictures. I realize that historically the function of painting large pictures is painting something very grandiose and pompous. The reason I paint them, however—I think it applies to other painters I know—is precisely because I want to be very intimate and human. To paint a small picture is to place yourself outside your experience, to look upon an experience as a stereopticon view or with a reducing glass. However you paint the larger picture, you are in it. It isn't something you command.

from *Interiors*, vol. 110, no. 10, May 1951, p. 104. © 1990 by Kate Rothko Prizel and Christopher Rothko. Reproduced by their kind permission.

This excerpt is from a symposium "How to Combine Architecture and Sculpture" at The Museum of Modern Art, New York

Letter to Lloyd Goodrich, 1952

Mark Rothko
1288 6th Ave. N.Y.C.
Dec. 20, 1952

Mr. Lloyd Goodrich
Whitney Museum

Dear Mr. Goodrich:

Betty Parsons has informed me that you have asked for two of my pictures to be sent before the holidays to be viewed by your purchasing committee. In view of the fact that I must decline the invitation, I hasten to get these remarks to you in due time.

I am addressing these remarks to you personally because we have already talked about related matters in regard to your present annual; and I feel therefore that there is some basis of understanding. My reluctance to participate, then, was based on the conviction that the real and specific meaning of the pictures was lost and distorted in these exhibitions. It would be an act of self deception for me to try to convince myself that the situation would be sufficiently different, in view of a possible purchase, if these pictures appeared in your permanent collection. Since I have a deep sense of responsibility for the life my pictures will lead out in the world, I will with gratitude accept any form of their exposition in which their life and meaning can be maintained, and avoid all occasions where I think that this cannot be done.

I know the likelihood of this being viewed as arrogance. But I assure you that nothing could be further from my mood which is one

of great sadness about this situation: for, unfortunately, there are few existing alternatives for the kind of activity which your museum represents. Nevertheless, in my own life at least, there must be some congruity between convictions and actions if I am to continue to function and work. I hope that I have succeeded in explaining my position.

Sincerely,
Mark Rothko

from Betty Parsons Gallery Papers (1941–1968), Archives of American Art, microfilm no. N68-70, frame no. 638. © 1990 Kate Rothko Prizel and Christopher Rothko. Reproduced by their kind permission.

Working notes (undated)

I use colors that have already been experienced through the light of day and through the states of mind of the total man. In other words, my colors are not colors that are laboratory tools which are isolated from all accidentals or impurities so that they have a specified identity or purity.

Public forum, 1958

(Some of the "ingredients" listed by Rothko as his "recipe" for art)

A clear preoccupation with death. All art deals with intimations of mortality.

Sensuality, the basis for being concrete about the world.

Tension: conflict or desire which in art is curbed at the very moment it occurs.

Irony: a modern ingredient. (The Greeks didn't need it.) A form of self-effacement and self-examination in which a man can for a moment escape his fate.

Wit, humor.

A few grams of the ephemeral, and chance.

About 10 per cent of hope . . . If you need that sort of thing; the Greeks never mentioned it.

excerpted from *Cimaise*, December 1958. Reprinted by permission of Dore Ashton. © Dore Ashton.

Notes taken by Dore Ashton at a public forum at the Pratt Institute, New York, 1958

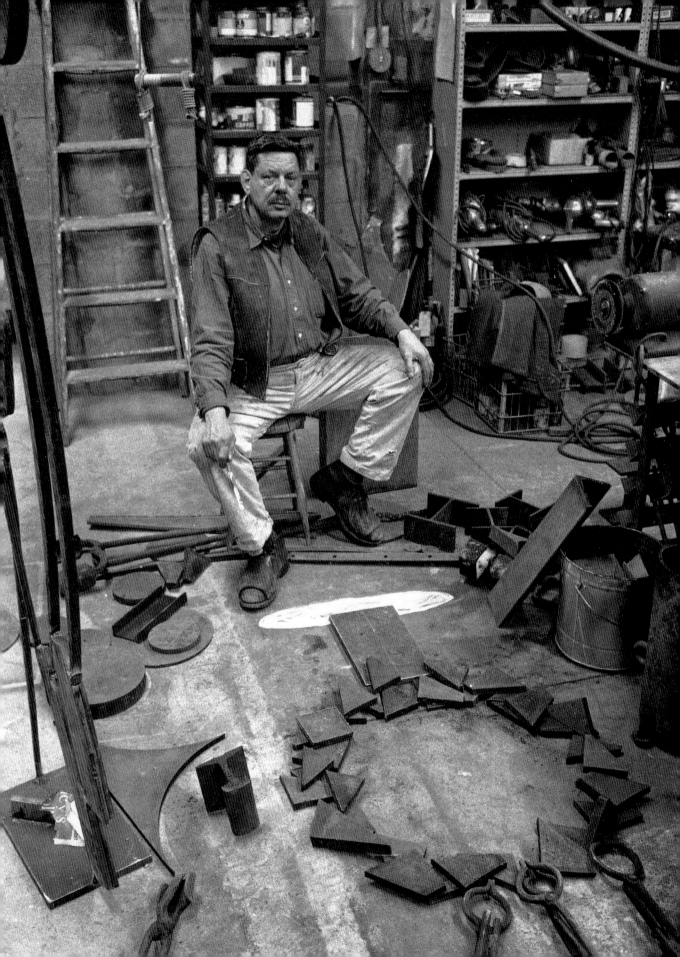

David Smith

Notes for "David Smith Makes a Sculpture," 1951

I follow no set procedure in starting a sculpture. Some works start
out as chalk drawings on the cement floor, with cut steel forms
working into the drawings. When the structure can become united,
it is welded into position upright. Then the added dimension
requires different considerations over the more or less profile form
of the floor drawing assembly.

Sometimes I make a lot of drawings using possibly one
relationship on each drawing which will add up in the final work.
Sometimes sculptures just start with no drawing at all. This was the
case of *The Fish*, which is some six feet high and about five feet
long. My drawings are made either in work books or on large sheets
of linen rag. I stock bundles of several types, forgetting the cost so I
can be free with it. The cost problem I have to forget on everything,
because it is always more than I can afford—more than I get back
from sales—most years, more than I earn. My shop is somewhat
like the Federal Government, always running with greater
expenditures than income and winding up with loans.

For instance, 100 troy ounces of silver solder cost over $100,

David Smith, 1962
Photograph by Dan Budnik

phos-copper costs $4 a pound, nickel and stainless steel electrodes cost $1.65 to $2 a pound, a sheet of stainless steel ⅛ inch thick, four feet by eight feet costs $83, etc. When I'm involved aesthetically I cannot consider cost. I work by the need of what each material can do. Usually the costly materials do not even show, as their use has been functional.

The traditions for steel do not exist that govern bronze finishes, patinas, or casting limits. There are no preconceived limits established as there are for marble, the aesthetics of grain and surface or the physical limits of mass to strength. Direction by natural grain, hand rubbing, monolithic structure, or the controls of wood do not apply physically or traditionally to steel.

Steel has the greatest tensile strength, the most facile working ability, as long as its nature relates to the aesthetic demand. It can join with its parent metal or other metals varying in colors, or act as a base for metal deposition, paint, or its own natural oxide, the molecule of which is only one oxygen atom less than the artistic range of iron oxides.

I have two studios. One clean, one dirty, one warm, one cold. The house studio contains drawing tables, etching press, cabinets for work records, photos, and drawing paper stock. The shop is a cinderblock structure, transite roofed, and has a full row of north window skylights set at a 30 degree angle. With heat in each end it is usable to zero weather.

I do not resent the cost of the best material or the finest tools and equipment. Every labor-saving machine, every safety device I can afford I consider necessary. Stocks of bolts, nuts, taps, dies, paints, solvents, acids, protective coatings, oils, grinding wheels, polishing discs, dry pigments, waxes, chemicals, spare machine parts, are kept stocked on steel shelving, more or less patterned after a factory stockroom.

Stainless steel, bronze, copper, aluminum are stocked in ⅛ inch by 4 foot by 8 foot sheets for fabricating. Cold and hot rolled 4 foot by 8 foot sheets are stacked outside the shop in thicknesses from ⅛ inch to ⅞ inch. Lengths of strips, shapes, and bar stock are racked in the basement of the house or interlaced in the joists of the roof. Maybe I brag a bit about my stock, but it is larger since I've been on a Guggenheim Fellowship than it ever has been before. I mention this not because it has anything to do with art, but it indicates how important it is to have material on hand, that the aesthetic vision is not limited by material need, which has been the case too much of my life.

By the amount of work I produce it must be evident that the most functional tools must be used. I've no aesthetic interest in tool

marks; my aim in material function is the same as in locomotive building, to arrive at a given functional form in the most efficient manner. The locomotive method bows to no accepted theory in fabrication. It stands upon the merit of the finished product. The locomotive function incorporates castings, forgings, rivets, welding, brazing, bolts, screws, shrink fits, all used because of their respective efficiency in arriving at a functioning object. Each method imparts its function to varying materials. I use the same method in organizing the visual aesthetic end. I make no claim for my work method over other mediums. I do not use it to the exclusion of other mediums. A certain feeling for form will develop with technical skill, but imaginative form (viz. aesthetic vision) is not a guarantee for high technique.

I handle my machines and materials with ease—their physical resistance and the noise they make in use do not interfere with my thinking and aesthetic flow. The change of one machine or tool to the other means no more than changing brushes to a painter or chisels to a carver.

I do not accept the monolithic limit in the tradition of sculpture. Sculpture is as free as the mind, as complex as life, its statement as full as the other visual mediums combined. I identify form in relationship to man. The front view of a person is ofttimes complete in statement. Sculpture to me may be 1–2–3–4 sides and top view since the bottom by law is the base. Projection of indicated form, continuance of an uncompleted side I leave to the viewer or the suggestion of a solid by lines, or the vision of the forms revolving at given or varying speeds. All such possibilities I consider and expect the viewer to contemplate.

When such incompletions are evident, usually there are directives which can enable the viewer to complete the concept with the given form. The art form should not be platitudinous, predigested, with no intellectual or emotional demands on the consumer.

When I make sculpture all the speeds, projections, gyrations, light changes are involved in my vision, as such things I know in movement associate with all the possibilities possible in other relationships. Possibly steel is so beautiful because of all the movement associated with it, its strength and function. Yet it is also brutal, the rapist, the murderer, and death-dealing giants are also its offspring. But in my Spectre series, I speak of these things and it seems most functional in its method of statement.

Since 1936 I have modeled wax for single bronze castings. I have carved marble and wood, but the major number of works have been steel, which is my most fluent medium and which I control from start to completed work without interruption. There is gratification of

being both conceiver and executor without intrusion. A sculpture is
not quickly produced; it takes time, during which time the
conviction must be deep and lasting. Michelangelo spoke about
noise and marble dust in our profession, but I finish the day more
like a greaseball than a miller. But my concepts still would not
permit me to trade it for cleaner pursuits.

Distance within the work is not an illusion, it relates to the known
measure known as inches in most of our considerations. Inches are
rather big, monotonous chunks related to big flat feet. The only even
inch relationship will be found in the sculpture base wherein the
units 4–6–8–12, etc., are used in mechanical support. Rarely will
an even inch be involved in visual space, and when it is approached
it will occur plus or minus in variants of odd thousandths, odd
64ths, 32nds, and 16ths. This is not planned consciously. It is not
important, but is my natural reaction to symbolic life. Unit
relationships within a work usually involve the number 7 or a
division of its parts. I wasn't conscious of this until I looked back,
but the natural selection seems influenced by art mythology.

My work day begins at 10 or 11 A.M. after a leisurely breakfast
and an hour of reading. The shop is 800 feet from the house. I
carry my 2 P.M. lunch and return to the house at 7 for dinner. The
work day ends from 1 to 2 A.M. with time out for coffee at 11:30.
My shop here is called the Terminal Iron Works, since it closer
defines my beginning and my method than to call it "studio."

At 11:30 when I have evening coffee and listen to WQXR on
AM, I never fail to think of the Terminal Iron Works at 1 Atlantic
Avenue, Brooklyn, and the coffeepot nearby where I went, same
time, same station. The iron works in Brooklyn was surrounded by
all-night activity—ships loading, barges refueling, ferries tied up at
the dock. It was awake 24 hours a day, harbor activity in front,
truck transports on Furman Street behind. In contrast the mountains
are quiet except for occasional animal noises. Sometimes Streevers's
hounds run foxes all night and I can hear them baying as I close up
shop. Rarely does a car pass at night. There is no habitation
between our road and the Schroon River four miles cross country. I
enjoy the phenomenon of nature, the sounds, the Northern Lights,
stars, animal calls, as I did the harbor lights, tugboat whistles,
buoy clanks, the yelling of men on barges around the T.I.W. in
Brooklyn. I sit up here and dream of the city as I used to dream of
the mountains when I sat on the dock in Brooklyn.

I like my solitude, black coffee, and daydreams. I like the
changes of nature; no two days or nights are the same. In Brooklyn
what was nature was all manmade and mechanical, but I like both.
I like the companionship of music. I sometimes can get WNYC but

always WQXR, Montreal, Vancouver, or Toronto. I use the music as company in the manual labor part of sculpture, of which there is much. The work flow of energy demanded by sculpture wherein mental exhaustion is accompanied by physical exhaustion provides the only balance I've ever found, and as far as I know is the only way of life.

Of course I get rides on. When I'm working I get so wound up with work that sleep doesn't come and I work through to 3–4–5 in the morning. This I did back in Brooklyn. All my life the work day has been any part of the 24, on oil tankers, driving hacks, going to school, all three shifts in factories. I once worked in a bank, but cannot stand the routine life. Any two-thirds of the 24 hours are wonderful as long as I can choose.

After 1 A.M. certain routine work has to be done, clearing up, repairing machines, oiling, painting, etc. I turn on WOR and listen to Nick's, Café Society, Eddie Condon's, whoever is on. After several months of good work, when I feel I deserve a reward, I go to New York, concerts at YMHA, gallery shows, museums, eat seafood, Chinese, go to Eddie's, Nick's, Sixth Avenue Cafeteria, Artists Club, Cedar Tavern, run into up-late artists, bum around chewing the fat, talk shop, finish up eating breakfast on Eighth Street, and ride it as hard and as long as I can for a few days, then back to the hills.

Sculpture is a problem. Both to me and to my dealer, the Willard Gallery. Aside from sales, the problem of transport and storage is immense. The intrinsic cost ofttimes is half its price, and never less than one-third. Only a few serious dealers handle it; some museums and a few collectors buy it. As dwelling space contracts, the size and concept of sculpture increases. I foresee no particular use, other than aesthetic, in society, least of all architecture. But demand was never the thing that made art in our period of civilization.

Sometimes I work on two and possibly four pieces at one time, conceptually involved on one, conceptually in abeyance on another waiting for relationships to complete; and on one or two others finished but for a casting to come from the foundry or grinding, finishing and a few hours of manual labor waiting to be done. Sometimes it's only a matter of mounting, weighing, measuring, and naming. Such detail work fits in schedule when the muse has gone. I maintain my identity by regular work, there is always labor when inspiration has fled, but inspiration returns quicker when identity and the work stream are maintained. Actually time overtakes much of my projects. I get only half of my vision into material form. The rest remains as drawings, which, after a certain time growth, I

cannot return to because the pressing demand is the future. I have no organized procedure in creating. *The Fish* went through from start to finish with a small drawing in my work book, during its middle stage. *The Cathedral* matured from start to finish with no drawings. Usually there are drawings, anything from sketches in pocket notebooks to dozens of big sheet paintings.

from *ARTnews*, vol. 67, no. 9, January 1969. © ARTnews, LXVII, no. 9, January 1969. Reprinted by permission.

These notes were written by Smith as general background material for Elaine de Kooning's article "David Smith Makes a Sculpture," published in *ARTnews*, September 1951

"Drawing," 1955

Many students think of drawing as something hasty and preparatory before painting or making sculpture. A sort of purgatory between amateurism and accomplishment. As a preliminary before the great act, because everybody can draw some, and children are uninhibited about it and do it so easily, and writing itself is a style of drawing, and it is common on sidewalks, board fences, phone booths, etc.

But actually only a very experienced artist may appreciate the challenge, because it is so common an expression. It is also the most revealing, having no high expectancy to maintain, not even the authenticating quality of gold frames to artificially price or lend grandeur to its atmosphere. And, by its very conditioning, it comes much closer to the actual bareness of the soul and the nature of free expressionism.

It is not expected to carry the flourish, the professionalism of oil painting, nor the accuracy and mannered clarity in the formal brushing of the watercolorist.

If it is pompous, artificial, pretentious, insincere, mannered, it is so evident, so quick to be detected, and like the written line, it is a quickly recognized key to personality. If it is timid, weak, overbold or blustering, it is revealed much as one perceives it in the letter or a signature. There is not the demand or tradition for technique and conformity. The pureness of statement, the honesty of expression, is laid bare in a black-and-white answer of who that mark-maker is, what he stands for, how strong his conviction, or how weak. Often his true personality is revealed before repetitions or safer symbols can come to his defense. More his truth than other media with technique and tradition, more his truth than words can express, more free from thinking in words than polished techniques, drawing

David Smith
History of Le Roy Burton, 1956
Steel
Portrait of a Painter, 1956
Bronze
The Sitting Printer, 1955
Bronze
Photograph by David Smith

is more shaped like he is shaped, because the pressure of performance has not made him something he isn't.

The drawing that comes from the serious hand can be unwieldy, uneducated, unstyled and still be great simply by the superextension of whatever conviction the artist's hand projects and being so strong that it eclipses the standard qualities critically expected. The need, the drive to express can be so strong that the drawing makes its own reason for being.

Drawing is the most direct, closest to the true self, the most natural liberation of man—and if I may guess back to the action of very early man, it may have been the first celebration of man with his secret self—even before song.

But its need doesn't stand on primitive reconstruction—anyone knows, everyone feels the need to draw. I truly believe that anything anyone has seen he can draw, and that everyone here has now seen everything he ever will see, and that all that stands between his drawing anything in the world is his own inhibition. What that is we don't know. Each must dig himself out of his own mind and liberate the act of drawing to the vision of memory. It is not so much that this correlation is impossible—but more the mental block that keeps him from trying that which he deems impossible.

We are blocked from creative ways of expressing by ways we feel about things and by ways we think we ought to feel, by word pictures that cancel out creative vision, and intimidations that limit creative expression.

If drawing could come now as easily as when a man was six, he would not doubt or think, he would do. But since he approaches it more consciously and not with the child's freedom, he must admit to himself that he is making a drawing—and he approaches mark-making humbly, self-consciously, or timidly. Here he finds pressure and intimidation and inhibition. But the first mark of drawing is made. Sometimes it takes courage to make this one statement. This stroke is as good as he can make, now. The next and those to come lead toward creative freedom. He must try to be himself in the stroke. He dominates the line related to image and does not permit the image to dominate him and the line. Not a line the way others think the line should be—not how history says it once was; nor what multitudes say they cannot do with a straight line. For a line so drawn with conviction is straighter in context than the ruler.

from *David Smith*, Garnett McCoy, ed. New York: Praeger, 1973, pp. 119–20. Copyright © 1973 by Garnett McCoy and the David Smith Estate. Reprinted by permission of Henry Holt and Company, Inc.

This lecture on drawing was delivered at a forum conducted by George Rickey at Sophie Newcomb College, Tulane University, on March 21, 1955.

"Tradition and Identity," 1959

When I lived and studied in Ohio, I had a very vague sense of what art was. Everyone I knew who used the reverent word was almost as unsure and insecure.

Mostly art was reproductions, from far away, from an age past and from some golden shore, certainly from no place like the mud banks of the Auglaze or the Maumee, and there didn't seem much chance that it could come from Paulding County.

Genuine oil painting was some highly cultivated act that came like the silver spoon, born from years of slow method, applied drawing, watercoloring, designing, art structure, requiring special equipment of an almost secret nature, that could only be found in Paris or possibly New York, and when I got to New York and Paris I found that painting was made with anything at hand, building board, raw canvas, self-primed canvas, with or without brushes, on the easel, on the floor, on the wall, no rules, no secret equipment, no anything, except the conviction of the artist, his challenge to the world and his own identity.

Discarding the old methods and equipment will not of course make art. It has only been a symbol in creative freedom from the bondage of tradition and outside authority.

Sculpture was even farther away. Modeling clay was a mystic mess which came from afar. How sculpture got into metal was so complex that it could be done only in Paris. The person who made sculpture was someone else, an ethereal poetic character divinely sent, who was scholar, aesthetician, philosopher, Continental gentleman so sensitive he could unlock the crying vision from a log or a Galatea from a piece of imported marble.

I now know that sculpture is made from rough externals by rough characters or men who have passed through all polish and are back to the rough again.

The mystic modeling clay is only Ohio mud, the tools are at hand in garages and factories. Casting can be achieved in almost every town. Visions are from the imaginative mind, sculpture can come from the found discards in nature, from sticks and stones and parts and pieces, assembled or monolithic, solid form, open form, lines of form, or, like a painting, the illusion of form. And sculpture can be painting and painting can be sculpture and no authority can overrule the artist in his declaration. Not even the philosopher, the aesthetician, or the connoisseur.

I have spoken against tradition, but only the tradition of others who would hold art from moving forward. Tradition holding us to the perfections of others. In this context tradition can only say what art

was, not what art is. Tradition comes wrapped in word pictures; these are traps which lead laymen into cliché thinking. This leads to analogy and comparative evaluation and conclusion, especially in the hands of historians. Where conclusions are felt, the understanding of art has been hampered and the innovations of the contemporary scene are often damned.

Art has its tradition, but it is a visual heritage. The artist's language is the memory from sight. Art is made from dreams, and visions, and things not known, and least of all from things that can be said. It comes from the inside of who you are when you face yourself. It is an inner declaration of purpose, it is a factor which determines artist identity.

The nature to which we all refer in the history of art is still with us, although somewhat changed; it is no longer anecdote or robed and blindfolded virtue, the bowl of fruit, or that very abstract reference called realistic; it is very often the simple subject called the artist. Identifying himself as the artist, he becomes his own

David Smith, 1962
Photographs by Dan Budnik

subject as one of the elements in nature. He no longer dissects it, nor moralizes upon it; he is its part. The outside world of nature is equal, without accent, unquestioning. He is an element in the atmosphere called nature, his reference to nature is more like primitive man addressing it as "thou" and not "it." Aura and association, all the parts into the whole expression, all actions in an emotional flow, manifest the artist as subject, a new position for the artist but natural to his time. Words become difficult, they can do little in explaining a work of art, let alone the position of the artist in the creative irrational flow of power and force which underlies the position and conception. Possibly I can explain my own procedure more easily. When I begin a sculpture I'm not always sure how it is going to end. In a way it has a relationship to the work before, it is in continuity with the previous work—it often holds a promise or a gesture toward the one to follow.

I do not often follow its path from a previously conceived drawing. If I have a strong feeling about its start, I do not need to know its end; the battle for solution is the most important. If the end of the work seems too complete and final, posing no question, I am apt to work back from the end, that in its finality it poses a question and not a solution.

Sometimes when I start a sculpture I begin with only a realized part; the rest is travel to be unfolded, much in the order of a dream.

The conflict for realization is what makes art, not its certainty, its technique, or material. I do not look for total success. If a part is successful, the rest clumsy or incomplete, I can still call it finished, if I've said anything new, by finding any relationship which I might call an origin.

I will not change an error if it feels right, for the error is more human than perfection. I do not seek answers. I haven't named this work nor thought where it would go. I haven't thought what it is for, except that it is made to be seen. I've made it because it comes closer to saying who I am than any other method I can use. This work is my identity. There were no words in my mind during its creation, and I'm certain words are not needed in its seeing; and why should you expect understanding when I do not? That is the marvel—to question but not to understand. Seeing is the true language of perception. Understanding is for words. As far as I am concerned, after I've made the work, I've said everything I can say.

from *David Smith*, ed. Garnett McCoy, New York: Praeger, 1973, pp. 146–48. Copyright © 1973 by Garnett McCoy and the David Smith Estate. Reprinted by permission of Henry Holt and Company, Inc.

Text from a speech given at Ohio University, April 17, 1959. Smith attended Ohio University for a year in 1924–25.

Interview with David Sylvester, 1961

SYLVESTER: There's a picture in London of the American artist of your generation, you and the action painters, of being rather a group. Has there been a sort of collaboration of ideas between you? And did you find knowing Pollock, being a close friend of Pollock and people like that, fruitful for your work?

SMITH: No. We talked about other things usually. But we did spring from the same roots and we had so much in common and our parentage was so much the same that, like brothers, we didn't need to.

SYLVESTER: The parentage, I suppose, of course, was the whole Cubist thing. But why do you think it suddenly exploded in this way into this terrific growth that began in the late forties of American art?

SMITH: Well, Pollock, de Kooning, and practically everybody I can think of who is forty to fifty now and sort of "arrived" artists, in a sense—they all came from a depression time. We all came from the bond of the WPA, which we affectionately call it; it was the Works Progress Administration and it was a government employment of artists for . . .

SYLVESTER: The New Deal thing?

SMITH: Yes, it was definitely the New Deal thing, and somewhat of a defensive thing. We made very little more by working than people drew for not working for unemployed relief. We drew maybe five or six dollars a week more for working. . . .

SYLVESTER: Yes.

SMITH: . . . which was very nice because for the first time, collectively, we belonged somewhere.

SYLVESTER: And this gave you a stimulus?

SMITH: Well, we belonged to society that way. It gave us unity, it gave us friendship, and it gave us a collective defensiveness.

SYLVESTER: You mean belonging to society at large or merely belonging to your own group?

SMITH: In a sense we belonged to society at large. It was the first time we ever belonged or had recognition from our own government that we existed. . . .

SYLVESTER: . . . weren't you in Europe yourself for some time in the late thirties?

SMITH: In 1935 and '36. Most of us tried to go to Europe if we could; most of us did. Of course, de Kooning had come from Europe . . .

SYLVESTER: Quite.

Postcard from David Smith to
Clement Greenberg on
the death of Jackson Pollock,
August 14, 1956

SMITH: And Gorky had come from Europe. Graham was a Russian, and he had come from Europe. Stuart Davis had gone to Europe earlier.

SYLVESTER: How do you feel it affected your development—going there at that moment?

SMITH: It was very important. Most of all, it was one of the greatest points of my own liberation mentally. You see, before—in the early part of the thirties—we all were working for a kind of utopian position, or at least a position where somebody liked our work. In the early thirties none of us—like Pollock or Gorky or de Kooning— could really, none of us could show our work any place, nobody wanted to show it, and it seemed that the solution was to be expatriates. Most of the men a little older than we were had seen the solution in expatriatism all the way from Mallorca to Paris itself.

And the one thing that I learned in 1935 and '36—I was in England and Russia and Greece and France and places like that—and the one thing when I came back that I realized was that I belonged here; my materials were here, my thoughts were here, my birth was here, and whatever I could do had to be done here. I thoroughly gave up any idea of ever being an expatriate. So I laid into work very hard. That must have been in the minds of other men. Otherwise, there wouldn't be so many of us here now.

SYLVESTER: It's often said that one of the reasons why American art built up after the war was that it was stimulated by European artists who came here from Paris in 1940 and stayed here during the war. Do you think there is anything in that or not?

SMITH: That is part of the scene and it is important. It has been very rewarding to us to have men like Lipchitz, and Mondrian, and Gabo become Americans and live here with us; that is good and it's been very nice. We have met them and we have found that they were humans like we were and they were not gods and they were fine artists. And so we know more about the world now. . . .

SYLVESTER: I talk about your being abstract, but it isn't fair; a lot of your forms seem to me to be referential to nature. I see a lot of your big stainless steel things as personage. Are they at all this for you?

SMITH: They don't start that way. But how can a man live off of his planet? How on earth can he know anything that he hasn't seen or doesn't exist in his own world? Even his visions have to be made up of what he knows, of the forms and the world that he knows. He can't go off his planet with visions no matter how they're put together. And he naturally uses his proportion and his sort of objectivity. He can't get away from it. There is no such thing as *truly* abstract. Man always has to work from his life.

SYLVESTER: You have no preconceptions about which way the thing is going to go?

SMITH: I try not to have. I try to approach each thing without following the pattern that I made with the other one. They can begin with any idea. They can begin with a found object, they can begin with no object. They can begin sometimes even when I'm sweeping the floor and I stumble and kick a few parts and happen to throw them into an alignment that sets me off thinking and sets off a vision of how it would finish if it all had that kind of accidental beauty to it. I want to be like a poet, in a sense. I don't want to seek the same orders. Of course, I'm a human being, I have limited ability, and there's always an order there. People recognize my work even if I think that I've really been far out in this work. I strive very hard to move a little bit but you can't move very far. Picasso

moves far. He's a great man who moves very far. But I still recognize Picasso's work no matter how far he's moved from one phase or one new picture or one new sculpture; I always recognize his work.

SYLVESTER: How would you analyze the difference between your work and its intentions and the Cubist constructions—you know, González, Picasso—of which it's a continuation?

SMITH: Well, living here in America at that time, going to school at the time that I went to school, I didn't read French, so when I had a *Cahiers d'Art* I didn't know what it was about. I learned from the pictures just the same as if I were a child, in a certain sense. I learned the world from seeing before I ever learned the world from words. So my world was the Dutch movement De Stijl; it was Russian Constructivism; it was Cubism; it was even Surrealism. Or even German Expressionism. Or even Monet. All these things I did not know had divisions in them. They all fitted in to me. They were all so new and so wonderful and they all came to me at one time, practically. The historians hadn't drawn the lines yet as to which was which and where at which particular time, and my heritage was all those things simultaneously. So I am all those things, I hope, with a very strong kind of intellectual regard for Cubism and an admiration for it because it was great at a particular time. It was both painting and sculpture.

SYLVESTER: Taking Cubism, Surrealism, Expressionism, not worrying about the thing—I wonder whether the vitality of postwar American art has something to do with this sort of absolute freedom of attitude which you've talked about in yourself. I wonder whether this also applies to people like de Kooning and Pollock, and whether this has helped them not to worry but to take what they could and what they wanted to take quite freely from earlier modern art.

SMITH: . . . I think it has. . . . We were all together at a particular time in the early days, and we were sort of expatriates. We drank coffee together in cafeterias, and when I say we drank coffee it was usually one cup because few of us could afford more than one five-cent cup of coffee in those days, plus a cookie maybe. And all we did was walk around and talk sometimes. But mostly we worked. And we each sort of took according to what we wanted. You must remember I had come from Indiana and I had only seen a sculpture a couple of years before that, or a painting. Gorky came into Providence and de Kooning came into New York (from Europe). I think they all had a little bit more, knowing of museums and art, than I did before, and they both were European in a sense, and I think all Europeans know more about art than people from Indiana do. I don't think I had seen art out in Indiana or Ohio other than

some very, very dark picture with sheep in it in the public library.
But I didn't know anything about art until I came to New York.

excerpted from *Living Arts*, April, 1964. © David Sylvester

Letter to the Fine Arts Committee, Carnegie Institute, 1961

Terminal Iron Works
Bolton Landing, New York
October 26, 1961

The Fine Arts Committee of
The Board of Trustees of
Carnegie Institute
c/o Mr. Gordon B. Washburn
4400 Forbes Avenue
Pittsburgh 13, Pennsylvania

Gentlemen:

I do not wish to accept the prize your guest jury has honored me with.

I wish the money involved returned to Institute direction, and I hope applied to use for purchase.

I believe the awards system in our day is archaic.

In my opinion all costs of jury, travel, miscellaneous expenses of the award machinery could be more honorably extended to the artist by purchase.

A few years ago I was chairman of a panel in Woodstock, New York, wherein the prize system was under discussion. The majority of artists spoke against the prize system. Dr. Taylor, then President of the Metropolitan Museum, was recognized as a speaker for the prize system. He spoke eloquently and defended this as of being the donor's prerogative and ended by summing up that the prize system is longstanding and honorable and goes back to the days of Ancient Rome when a prize was given for virginity. After the applause—a hand was raised for recognition by painter Arnold Blanch. His question—would the last speaker care to qualify the technical merits for second and third prize.

Thank you and greetings.

David Smith

from *David Smith*, Garnett McCoy, ed. New York: Praeger, 1973 © 1973 by Garnett McCoy and the David Smith Estate. Reprinted by permission of Henry Holt and Company, Inc.

"A Major American Sculptor: David Smith" by Robert Motherwell, 1965

I have known David Smith for twenty years, ever since that afternoon that we met by prearrangement (but unknown to each other) during the 1940s. We instinctively tried to drink each other under the table on Irish whiskey and Guinness Stout. We left each other late at night, wobbly, but walking. In those days I was full of French Symbolist aesthetics, of Rimbaud and Mallarmé, and of André Breton, of the possibilities of representing reality indirectly but passionately in one's medium. I can still see David saying, with his characteristic bluntness and inalterable sense of his own identity, "I don't know about those guys, I don't read French, but I don't need them. I've read James Joyce!" He was right, all of it *is* in *Ulysses*, and I looked at him with a sudden intellectual respect that has not diminished as my affection for him has continually grown.

When you see his burly figure in workman's clothes, you sense a cultivated man who knows his ancient and modern art intimately, including all the most recent developments. When you see him in Irish tweeds and with Monte Cristo cigars these past years, you are aware still of a man who spends most of his days cutting and welding hunks of steel often far too heavy for a single man to lift, driving his professional helpers as hard as himself, knowing that the workings of the greatest national economy the world has ever known are inadequate, not only to absorb his prodigious amount of work, but even to exhibit much of it.

It is not an especially comfortable place (Bolton Landing, New York), especially for women, but on its grounds, like sentinels, stands the greatest permanent one-man show of heroic contemporary sculpture in the Americas. A folk song runs: "It takes a worried man to sing a worried song." Well, it takes an iron will to have made all those weighty iron sculptures strewn about his mountain landscape, each silhouetted against an enormous sky.

For some years now during daylight hours, David Smith works on four separate streams of sculptural concepts simultaneously — painted pieces in which colour is of major importance, stainless steel structures, a series of iron "wagons" with bronze wheels, and heavy, welded structures of raw iron. At night, he continues an endless series of drawings ("the delicate pursuit of my life"). These are often nudes from life.

Oh David! You are as delicate as Vivaldi, and as strong as a Mack truck.

excerpted from *Vogue*, February 1, 1965. © Robert Motherwell.

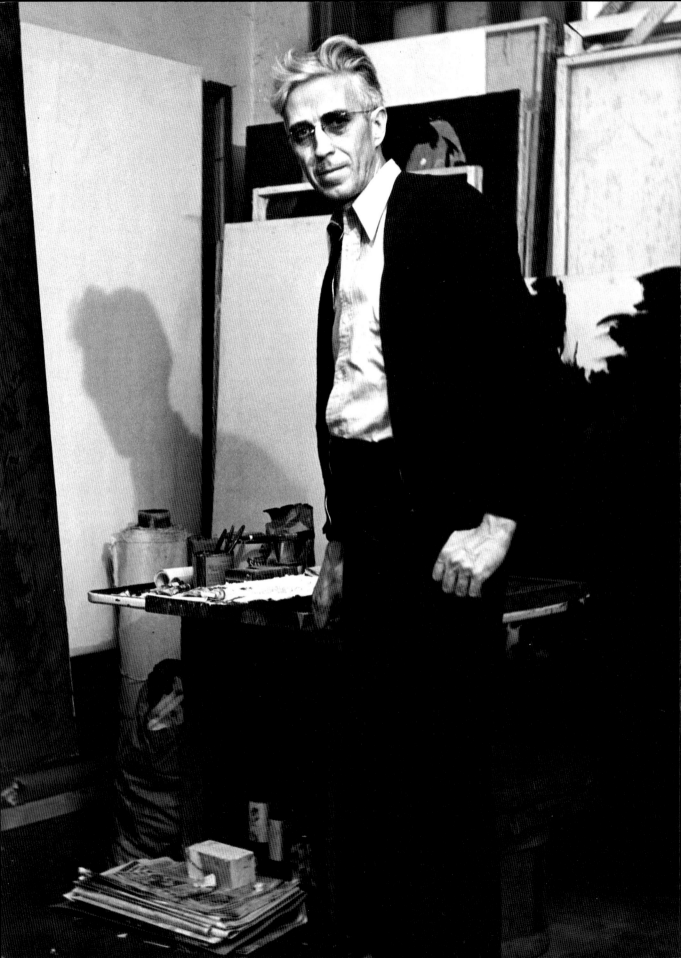

Clyfford Still

Letter to Dorothy Miller, 1952

That pigment on canvas has a way of initiating conventional reactions for most people needs no reminder. Behind those reactions is a body of history matured into dogma, authority, tradition. The totalitarian hegemony of this tradition I despise, its presumptions I reject. Its security is an illusion, banal, and without courage. Its substance is but dust and filing cabinets. The homage paid to it is a celebration of death. We all bear the burden of this tradition on our backs but I cannot hold it a privilege to be a pallbearer of my spirit in its name.

From the most ancient times the artist has been expected to perpetuate the values of his contemporaries. The record is mainly one of frustration, sadism, superstition, and the will to power. What greatness of life crept into the story came from sources not yet fully understood, and the temples of art which burden the landscape of nearly every city are a tribute to the attempt to seize this elusive quality and stamp it out.

The anxious men find comfort in the confusion of those artists who would walk beside them. The values involved, however, permit no peace, and mutual resentment is deep when it is discovered that salvation cannot be bought.

We are now committed to an unqualified art, not illustrating outworn myths or contemporary alibis. One must accept total responsibility for what he executes. And the measure of his greatness will be in the depth of his insight and his courage in realizing his own vision.

Demands for communication are both presumptuous and irrelevant. The observer usually will see what his fears and hopes and learning teach him to see. But if he can escape these demands that hold up a mirror to himself, then perhaps some of the implications of the work may be felt. But whatever is seen or felt it should be remembered that for me these paintings had to be something else. It is the price one has to pay for clarity when one's means are honored only as an instrument of seduction or assault.

excerpted from *15 Americans*, by Dorothy C. Miller, The Museum of Modern Art, New York, 1952, pp. 21–22. Reprinted by permission of the Museum of Modern Art. © The Museum of Modern Art (1952).

The artists in the exhibit *15 Americans* were Baziotes, Edward Corbett, Edwin Dickinson, Ferber, Joseph Glasco, Herbert Katzman, Frederick Kiesler, Irving Kriesberg, Lippold, Pollock, Herman Rose, Rothko, Still, Tomlin, and Thomas Wilfred. The letter is dated February 5, 1952.

Clyfford Still, 1952
Photograph by Hans Namuth

Letter to Gordon Smith, 1959

January 1, 1959

Dear Gordon Smith:

Your suggestion that I write a few notes for the catalog of this collection of paintings raises the same interest and the same qualifications that were present when the exhibition itself was first considered. The paradox manifest by the appearance of this work in an institution whose meaning and function must point in a direction opposite to that implied in the paintings—and my own life—was accepted. I believe it will not be resolved, but instead will be sharpened and clarified. For it was never a problem of aesthetics, or public or private acceptance, that determined my responsibility to the completed work. Rather, it was the hope to make clear its conceptual germination of idea and vision, without which all art becomes but an exercise in conformity with shifting fashions or tribal ethics. Perhaps a brief review is in order—

In the few directions we were able to look during the 1920's, whether to past cultures or the scientific, aesthetic, and social myths of our own, it was amply evident that in them lay few answers valid for insight or imagination.

The fog had been thickened, not lifted, by those who, out of weakness or for positions of power, looked back to the Old World for means to extend their authority in this newer land. Already mired by moralists and utilitarians in the swamps of folkways and synthetic traditions, we were especially vulnerable to the mechanistic interpretations of motive and meaning. There followed a deluge of total confusion.

Self-appointed spokesmen and self-styled intellectuals with the lust of immaturity for leadership invoked all the gods of Apology and hung them around our necks with compulsive and sadistic fervor. Hegel, Kierkegaard, Cézanne, Freud, Picasso, Kandinsky, Plato, Marx, Aquinas, Spengler, Einstein, Bell, Croce, Monet;—the list grows monotonous. But that ultimate in irony,—the Armory Show of 1913—had dumped upon us the combined and sterile conclusions of Western European decadence. For nearly a quarter of a century we groped and stumbled through the nightmare of its labyrinthine evasions. And even yet its banalities and trivia are welcomed and exploited by many who find the aura of death more reassuring than their impotence or fears. No one was permitted to escape its fatalistic rituals—yet I, for one, refused to accept its ultimatums.

To add to the body of reference or "sensibility" which indulges

homage or acquiescence to the collectivist rationale of our culture, I must equate with intellectual suicide. The omnivorousness of the totalitarian mind, however, demands a rigor of purpose and subtlety of insight from anyone who would escape incorporation.

Semantically and ethically the corruption is complete. Preoccupation with luminous devices is equated with spiritual enlightenment. The laws of Euclid are publicly damned to promote work illustrating an authoritarian dialectic. Witless parodies are displayed as evidence of social artistic commitment; and qualitative arrangements are presented as evidence of access to supernal mysteries. The rush to betray, in the name of aesthetics or "painting," an imagery born in repudiation of socio-psychological fallacies becomes a popular, but sinister, measure of its power.

Unknown are the crimes not covered by the skirts of that ubiquitous old harridan called Art. Even the whimperings and insolence of the venal are treasured in her name—and for their reassurance—by the arrogant and contemptuous. Indeed, among ambitious aesthetes, artists, architects, and writers, the burden of our heritage is borne lightly but mainly by hatred or cynicism. The impudence and sterility which so hypnotically fascinate the indifferent, perform a sordid substitute for responsibility and truth. . . .

I held it imperative to evolve an instrument of thought which would aid in cutting through all cultural opiates, past and present, so that a direct, immediate, and truly free vision could be achieved, and an idea be revealed with clarity.

To acquire such an instrument, however,—one that would transcend the powers of conventional technics and symbols, yet be as an aid and instant critic of thought—demanded full resolution of the past, and present, through it. No shouting about individualism, no capering before an expanse of canvas, no manipulation of academic conceits or technical fetishes can truly liberate. These only make repetition inevitable and compound deceit.

Thus it was necessary to reject the superficial value of material— its qualities, its tensions, and its concomitant ethic. Especially it became necessary not to remain trapped in the banal concepts of space and time, nor yield to the morbidity of "the objective position;" nor to permit one's courage to be perverted by authoritarian devices for social control.

It was as a journey that one must make, walking straight and alone. No respite or short-cuts were permitted. And one's will had to hold against every challenge of triumph, or failure, or the praise of *Vanity Fair.* Until one had crossed the darkened and wasted valleys and come at last into clear air and could stand on a high and

limitless plain. Imagination, no longer fettered by the laws of fear, became as one with Vision. And the Act, intrinsic and absolute, was its meaning, and the bearer of its passion.

The work itself, whether thought of as image of idea, as revelation, or as a manifest of meaning, could not have existed without a profound concern to achieve a purpose beyond vanity, ambition, or remembrance, for a man's term of life. Yet, while one looks at this work, a warning should be given, lest one forget, among the multitude of issues, the relation I bear to those with "eyes." Although the reference is in a different context and for another purpose, a metaphor is pertinent as William Blake set it down:

THE Vision of Christ that thou dost see
 Is my Vision's Greatest Enemy:
Thine is the friend of All Mankind,
 Mine speaks in parables to the Blind:

Therefore, let no man under-value the implications of this work or its power for life;—or for death, if it is misused.

Although several large and significant areas of the work cannot be exhibited, I believe what will be shown will justify the interest and effort you have so courageously given.

Sincerely,
Clyfford Still

from *Paintings by Clyfford Still*, The Buffalo Fine Arts Academy and Albright Art Gallery, Buffalo, November 5–December 13, 1959, pp. 6–8. Reprinted by permission of the Albright-Knox Art Gallery and The Buffalo Fine Arts Academy, Buffalo, N.Y.

Interview with Benjamin J. Townsend, 1961

Each painting is an episode in a personal history, an entry in a journal. . . .

I fight in myself any tendency to accept a fixed, sensuously appealing, recognizable style. . . . I am always trying to paint my way out of and beyond a facile, doctrinaire idiom. I do not want other artists to imitate my work—they do even when I tell them not to—but only my example for freedom and independence from all external, decadent and corrupting influences. . . .

The fact that I grew up on the prairies has nothing to do with my paintings, with what people think that they find in them. I paint only myself, not nature. . . .

I am not an action painter. Each painting is an act, the result of action and the fulfillment of action. . . . No painting stops with itself, is complete of itself. It is a continuation of previous paintings and is renewed in successive ones. . . . I do not have a comic or tragic period in any real sense. I have always painted dark pictures; always some light pictures. I will probably go on doing so. . . .

Orchestral. My work in its entirety is like a symphony in which each painting has its part.

excerpted from *Gallery Notes*, Albright-Knox Art Gallery, vol. 24, no. 2, summer 1961, pp. 9–14. Reprinted by permission of the Albright-Knox Art Gallery and The Buffalo Fine Arts Academy, Buffalo, N.Y.

Open letter to an Art Critic, 1959–63

Dear K:

Riffling through some old magazines a few days ago, an article by you in a 1959 *Evergreen Review* [Kenneth B. Sawyer, "The Importance of a Wall: Galleries," *Evergreen Review*, Spring 1959, pp. 122–135] stopped me abruptly. For, as you must remember, it dealt with the art dealers and galleries in New York, with special emphasis on the importance of their walls to the artists during the 1940s and 1950s, and the alleged role they played for the artist and public then and now. The issues involved are strangely up-to-date in view of the quickly shifting relationships among dealers and their stables of painters today, and the numerous articles, and several books about to appear, purporting to be a history of those years and institutions. That they are mainly a record of fantasy rather than fact, of shameless hypocrisy wrapped in saccharine words of dedication, has become obvious to all who know the record. It is unfortunately to your discredit that yours was one of the first articles to initiate this sordid parade of falsification and apology.

When I first saw your article, K, I was so outraged by it that I went to my typewriter and wrote you a letter. When I had finished it, I realized that it was too late; what you had done was not born of ignorance, but of positive motive and in full awareness of the facts. So I put the letter away in my files and wrote the short statement of disappointment which you received.

But as events have turned and locked into one another, I think that now is not too late. This time, however, I am sending what I wrote to you, as an open letter. It is a rebuke and reminder, however small, to those whose commercial ambitions and indifference obscured all that was worthy of attention in those critical years, and reduced the artist to his present level of

competitor with political double-talk, the Broadway flea market, and the collectivist castration ward.

That I speak in the first person qualifies no points I mention. The few whom I had invited to walk with me in those first years in New York quickly abdicated in favor of fear or ambition or, in two conspicuous cases, proved themselves to have been already dedicated to the machine of exploitation, only posing as men of integrity until their goals of success had been achieved.

This, then, is the letter I wrote to you on June 11, 1959, but did not send:

Dear K:

Yesterday my attention was drawn to a small magazine called *Evergreen Review* and in particular to an article in it written by you. I read it very carefully because most of the people, their actions, and the consequences thereof, have for many years been familiar and of deep concern to me.

Now there is a body of interesting fact indirectly related to those gas-chamber white walls you extol so generously. It is one of the great stories of all time, far more meaningful and infinitely more intense and enduring than the wars of the bullring or the battlefield—or of diplomats, laboratories, or commerce. For it was in two of those arenas some thirteen years ago that was shown one of the few truly liberating concepts man has ever known. There I had made it clear that a single stroke of paint, backed by work and a mind that understood its potency and implications, could restore to man the freedom lost in twenty centuries of apology and devices for subjugation. It was instantly hailed, and recognized by two or three men that it threatened the power ethic of this culture, and challenged its validity. The threat was vaguely felt and opposed by others who presented an almost united front in defense of their institutions.

Remember, I was invited, even begged, by many dealers to show my work on their walls. I was told I must not fail friends of delicate conviction, nor "believers in painting" who needed my company, nor the "lovers of art" who would welcome blows for the new world to come. That I accepted briefly their urgings as being in good faith is one of the mistakes I can never permit myself to forget. But in those years I learned beyond all doubt that it was a time of testing, a time for rigor without compromise. The details are too numerous and vicious to recount here. Certainly the characters who ran those sordid "gift-shoppes" knew every nerve and how to press it. Unwillingness to join the herd invited malicious interpretations of one's work and acts. Glib praise to the right people denied one the

right to speak the truth; museum politicians and hucksters determined all values, and those who sold out ranged themselves in the ranks of authority—for the price of a flunky's handout. Thus in those dead rooms the way was prepared for self-contempt, for clowns, for the obscenity that degrades the discipline of true freedom and perverts the idea that marks the moment of elevation.

The little men were numbered and took their place in file. Oh, some alibied their abdication with insolence, some with syntheses of fashionable devices, some with simulated protest, and some with gestures of futility. Others were indifferent because they had always been thus. The ambitious, the shrewd, the frustrated, each found his niche in the activity that satisfied his desires. These above all, the public understood; and any quarrel they provoked was specious, a mere barroom debate, a lovers' wrangle.

Be assured, few truths were ever really seen on the sterile walls of those who now beg for remembrance and honor. The professionals? They admit they would not or could not look at my work. For those walls and their owners abetted—*demanded*—the empty, the socioliterary, the blatant effect that arrested the jaded and insensitive for a moment in their boring rounds.

The painters? One group of them begged one of the most eminent dealers you mention with approbation, for any terms when he threw them out after collecting the paintings demanded in their preposterous contract. I saw their confusion and weakness and offered to speak out in their behalf. They crawled back like whipped dogs to him when he was ready to readmit them. For, as the affluent one among them expressed it, "He might be useful to us some day." Another dealer, rated as a queen among queens in the hierarchy of galleries, demanded with a coolness that would make Shylock blush, one-third of the value of a painting from one of the impecunious in her stable who had given it to a dentist for his dental bill. Each gallery impresario performed his or her dutifully promoted role and the men they exploited were each in time brought to heel. It is a tale repeated with only slight variation in nearly every gallery, without honor, or courage, or evidence of shame.

I mention the above incidents only to confirm the issue in general. The men and their work and their agents became as one, and no borrowed images, political illustration, Bauhaus sterilities, symbols of potency, pseudoreligious titles, nor any concealment behind that most faceless of apologies, "Art," should hide the puerility and meanness of their purpose and games. And they all are amply worthy of the contempt and hatred they secretly exchange with one another even unto their deaths.

It has always been my hope to create a free place or area of life

where an idea can transcend politics, ambition, and commerce. It will perhaps always remain a hope. But I must believe that somewhere there may be an exception.

Meanwhile, I must charge you not to give life to those, who, whimpering from their morbid cribs, would be remembered as they were not, and given an honor they schemed to shame when one defended his name and his purpose.

The truth is usually hard and sometimes bitter, but if man is to live, *it* must live. What transpired and became clear to some in the last three decades is known by a very few, and those few would hide for expediency what they know; only its influence and parodies are commonly evident. It remains a tremendous untold story, a testing of men and minds in the shadows. The memory of it still haunts those who worked to use and betray the spirit from which it was born. Dig out the truth and one man is a match for all of them. Accept their premises and you will walk on your knees the rest of your life.

from *Artforum*, December 1963. Reprinted by permission of Artforum. © Artforum, vol. II, no. 6, December 1963

Interview with Ti-Grace Sharpless, 1963

I speak of my work indirectly and only to clear a way to it.

My work is neither of protest nor apology. I have not sufficient fear to spill my energy on the first, nor the self-contempt to find comfort in the last.

I felt it necessary to evolve entirely new concepts (of form and space and painting) and postulate them in an instrument that could continue to shake itself free from dialectical perversions. The dominant ones, cubism and expressionism, only reflected the attitudes of power or spiritual debasement of the individual.

By 1941, space and the figure in my canvases had been resolved into a total psychic entity, freeing me from the limitations of each, yet fusing into an instrument bounded only by the limits of my energy and intuition. My feeling of freedom was now absolute and infinitely exhilarating.

From the mid-thirties I have spoken freely of these matters to artists, students, and friends from New York to San Francisco—from Washington to Virginia. The uniqueness and the intensity of my ensuing works, and the interest they evoked, bore additional proof for me of the rightness of my position and purpose.

There have been lapses due to fatigue, lack of time, recapitulations, and distractions, but usually they have been of brief duration.

I'm not interested in illustrating my time. A man's 'time' limits him, it does not *truly* liberate him. Our age—it is of science—of mechanism—of power and death. I see no point in adding to its mammoth arrogance the compliment of graphic homage.

I have no brief for signs or symbols or literary allusions in painting. They are just crutches for illustrators and politicians desperate for an audience.

The sublime? A paramount consideration in my studies and work from my earliest student days. In essence it is most elusive of capture or definition—only surely found least in the lives and works of those who babble of it the most. The dictator types have made a cliché of 'sublime' conceits throughout the centuries to impress and subjugate the ignorant or desperate.

The artists of our Madison Avenue Bauhaus and the armies of industry understand the devices or order. May they remind us in perpetuum of the folly of a Maginot morality.

Action painting? A tricky phrase. Misleading especially to those to whom it is usually applied. By their definitions they really mean 'reaction' painting. But that would lose the glamour of the literary 'mot,' plus some dialectical footwork.

As for 'taste' as a criterion of painting I find that it is most frequently applied to work that is essentially insensitive, brutal or vulgar beyond question. Could it now be a term with political undertones to seduce, or cover profounder motives of exploitation? I propose it be kept to the wine cellar. There it deceives no one but him who over-indulges.

excerpted from *Clyfford Still*, by Ti-Grace Sharpless, Institute of Contemporary Art, University of Pennsylvania, Philadelphia, 1963, pp. 5–10. Courtesy of the Institute of Contemporary Art, University of Pennsylvania.

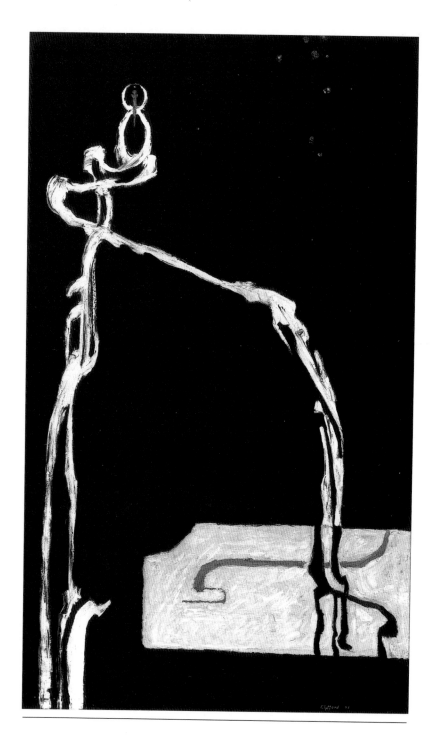

Clyfford Still
Untitled, 1945
Oil on canvas, 71 × 42⅛″
Collection San Francisco Museum
of Modern Art,
Gift of Peggy Guggenheim

Letter to the editor of *Artforum*, 1964

Sirs:
I take the liberty of mentioning one point which I feel is most
appropriate and pertinent, whether intended or not. Few men could

better exemplify the antithesis of my work than Marcel Duchamp. Please remember I speak without rancor—I have known Duchamp personally and well for many years—and I approve the juxtaposition. When all the social platitudes and psychological clichés are forgotten the issues will become clearer. When all the work of our hands and minds have been sublimated to symbols the essence of our commitment will remain revealed in the pages of your magazine. I refer to Duchamp's masterpiece, his urinal—and Still's not so modest painting, 1957-K.

Clyfford Still

from Artforum, vol. 2, no. 8, February 1964, p. 2. Reprinted by permission of Artforum. © Artforum, vol. 2, no. 8, February 1964.

The December 1963 issue of *Artforum* included an article on Marcel Duchamp by Paul Wescher which followed "An Open Letter to an Art Critic" (reprinted above) by Still, with six reproductions of his paintings.

Catalogue introduction by Mark Rothko, 1946

It is significant that Still, working out West, and alone, has arrived at pictorial conclusions so allied to those of the small band of Myth Makers who have emerged here during the war. The fact that his is a completely new facet of this idea, using unprecedented forms and completely personal methods, attests further to the vitality of this movement.

Bypassing the current preoccupation with genre and the nuances of formal arrangements, Still expresses the tragic-religious drama which is generic to all Myths at all times, no matter where they occur. He is creating new counterparts to replace the old mythological hybrids who have lost their pertinence in the intervening centuries.

For me, Still's pictorial dramas are an extension of the Greek Persephone myth. As he himself has expressed it, his paintings are "of the Earth, the Damned, and of the Recreated."

Every shape becomes an organic entity, inviting the multiplicity of associations inherent in all living things. To me they form a theogony of the most elementary consciousness, hardly aware of itself beyond the will to live—a profound and moving experience.

from *Clyfford Still*, Art of This Century Gallery, New York, February–March, 1946. © 1990 Kate Rothko Prizel and Christopher Rothko. Reproduced by their kind permission.

Catalogue introduction/Art of This Century, New York, February 12–March 2, 1946. Peggy Guggenheim Papers, Archives of American Art. This was Clyfford Still's first one-man show.

Group Statements

Artists' Session, Studio 35,
April 1950
(left to right: Brooks, Reinhardt,
Pousette-Dart, Bourgeois, Ferber,
Tomlin, Biala, Goodnough,
Sterne, Hare, Newman, Lipton,
Lewis, J. Ernst)

Letter to the editor of *The New York Times*, 1943

Mr. Edward Alden Jewell
Art Editor, New York Times
229 West 43rd Street
New York, N.Y.

Dear Mr. Jewell:

To the artist, the workings of the critical mind is one of life's mysteries. That is why, we suppose, the artist's complaint that he is misunderstood, especially by the critic, has become a noisy commonplace. It is therefore an event when the worm turns and the critic of the *Times* quietly yet publicly confesses his "befuddlement," that he is "non-plussed" before our pictures at the Federation Show. We salute this honest, we might say cordial reaction towards our "obscure" paintings, for in other critical quarters we seem to have created a bedlam of hysteria. And we appreciate the gracious opportunity that is being offered us to present our views.

We do not intend to defend our pictures. They make their own

defense. We consider them clear statements. Your failure to dismiss or disparage them is *prima facie* evidence that they carry some communicative power.

We refuse to defend them not because we cannot. It is an easy matter to explain to the befuddled that "The Rape of Persephone" [by Adolph Gottlieb] is a poetic expression of the essence of the myth; the presentation of the concept of seed and its earth with all its brutal implications; the impact of elemental truth. Would you have us present this abstract concept with all its complicated feelings by means of a boy and girl lightly tripping?

It is just as easy to explain "The Syrian Bull," [by Mark Rothko] as a new interpretation of an archaic image, involving unprecedented distortions. Since art is timeless, the significant rendition of a symbol, no matter how archaic, has as full validity today as the archaic symbol had then. Or is the one 3000 years old truer?

But these easy program notes can help only the simple-minded. No possible set of notes can explain our paintings. Their explanation must come out of a consummated experience between picture and onlooker. The appreciation of art is a true marriage of minds. And in art, as in marriage, lack of consummation is ground for annulment.

The point at issue, it seems to us, is not an "explanation" of the paintings but whether the intrinsic ideas carried within the frames of these pictures have significance.

We feel that our pictures demonstrate our aesthetic beliefs, some of which we, therefore, list:

1. To us art is an adventure into an unknown world, which can be explored only by those willing to take the risks.
2. This world of the imagination is fancy-free and violently opposed to common sense.
3. It is our function as artists to make the spectator see the world our way—not his way.
4. We favor the simple expression of the complex thought. We are for the large shape because it has the impact of the unequivocal. We wish to reassert the picture plane. We are for flat forms because they destroy illusion and reveal truth.
5. It is a widely accepted notion among painters that it does not matter what one paints as long as it is well painted. This is the essence of academicism. There is no such thing as good painting about nothing. We assert that the subject is crucial and only that subject matter is valid which is tragic and timeless. That is why we profess spiritual kinship with primitive and archaic art.

Consequently if our work embodies these beliefs, it must insult anyone who is spiritually attuned to interior decoration; pictures for the home; pictures for over the mantle; pictures of the American scene; social pictures; purity in art; prize-winning potboilers; the National Academy, the Whitney Academy, the Corn Belt Academy; buckeyes; trite tripe; etc.

Sincerely yours,
Adolph Gottlieb
Marcus Rothko

130 State Street
Brooklyn, New York

from *The New York Times*, June 13, 1943, sec. 2, p. 9. Used by permission of Adolph and Esther Gottlieb Foundation, Inc.

This letter, dated June 7, 1943, was written to Alden Jewell, art critic for *The New York Times*, in response to his negative review of the third annual Federation of Modern Painters and Sculptors exhibition held at Wildenstein and Co., New York, June 3–26, 1943. Barnett Newman helped write the letter, but did not sign it.

Radio script, "The Portrait and the Modern Artist," 1943

GOTTLIEB: We would like to begin by reading part of a letter that has just come to us:

"The portrait has always been linked in my mind with a picture of a person. I was therefore surprised to see your paintings of mythological characters with their abstract rendition, in a portrait show, and would therefore be very much interested in your answers to the following— . . ."

Now, the questions that this correspondent asks are so typical and at the same time so crucial that we feel that in answering them we shall not only help a good many people who may be puzzled by our specific work but we shall best make clear our attitude as modern artists concerning the problem of the portrait, which happens to be the subject of today's talk. We shall therefore, read the four questions and attempt to answer them as adequately as we can in the short time we have. Here they are:

1. Why do you consider these pictures to be portraits?
2. Why do you as modern artists use mythological characters?
3. Are not these pictures really abstract paintings with literary titles?

4. Are you not denying modern art when you put so much emphasis on subject matter?

Now, Mr. Rothko, would you like to tackle the first question? Why do you consider these pictures to be portraits?

ROTHKO: The word portrait cannot possibly have the same meaning for us that it had for past generations. The modern artist has, in varying degrees, detached himself from appearance in nature, and therefore, a great many of the old words, which have been retained as nomenclature in art have lost their old meaning. The still life of Braque and the landscapes of Durcat have no more relationship to the conventional still life and landscape than the double images of Picasso have to the traditional portrait. New Times! New Ideas! New Methods!

Even before the days of the camera there was a definite distinction between portraits which served as historical or family memorials and portraits that were works of art. Rembrandt knew the difference; for, once he insisted upon painting works of art, he lost all his patrons. Sargent, on the other hand, never succeeded in creating either a work of art or in losing a patron—for obvious reasons.

There is, however, a profound reason for the persistence of the word 'portrait' because the real essence of the great portraiture of all time is the artist's eternal interest in the human figure, character and emotions—in short in the human drama. That Rembrandt expressed it by posing a sitter is irrelevant. We do not know the sitter but we are intensely aware of the drama. The Archaic Greeks, on the other hand, used as their models the inner visions which they had of their gods. And in our day, our visions are the fulfillment of our own needs.

It must be noted that the great painters of the figure had this in common. Their portraits resemble each other far more than they recall the peculiarities of a particular model. In a sense they have painted one character in all their works. This is equally true of Rembrandt, the Greeks' Olympics or Modigliani, to pick someone closer to our own time. The Romans, on the other hand, whose portraits are facsimiles of appearance never approached art at all. What is indicated here is that the artist's real model is an ideal which embraces all of human drama rather than the appearance of a particular individual.

Today the artist is no longer constrained by the limitation that all of man's existence is expressed by his outward appearance. Freed from the need of ascribing a particular person, the possibilities are endless. The whole of man's experience becomes his model, and in

Mark Rothko and Clyfford Still,
1946

that sense it can be said that all of art is a portrait of an idea.

GOTTLIEB: That last point cannot be overemphasized. Now, I'll take the second question and relieve you for a moment. The question reads "Why do you as modern artists use mythological characters?"

I think that anyone who looks carefully at my portrait of Oedipus, or at Mr. Rothko's Leda, will see that this is not mythology out of Bulfinch. The implications here have direct application to life, and if the presentation seems strange, one could without exaggeration make a similar comment on the life of our time.

What seems odd to me, is that our subject matter should be questioned, since there is so much precedent for it. Everyone knows that Grecian myths were frequently used by such diverse painters as Rubens, Titian, Veronese and Velásquez, as well as by Renoir and Picasso more recently.

It may be said that these fabulous tales and fantastic legends are unintelligible and meaningless today, except to an anthropologist or student of myths. By the same token the use of any subject matter

which is not perfectly explicit either in past or contemporary art might be considered obscure. Obviously this is not the case since the artistically literate person has no difficulty in grasping the meaning of Chinese, Egyptian, African, Eskimo, Early Christian, Archaic Greek or even Pre-historic art, even though he has but a slight acquaintance with religious or superstitious beliefs of any of these peoples.

The reason for this is simply, that all genuine art forms utilize images that can be readily apprehended by anyone acquainted with the global language of art. That is why we use images that are directly communicable to all who accept art as the language of the spirit, but which appear as private symbols to those who wish to be provided with information or commentary.

And now, Mr. Rothko, you may take the next question. Are not these pictures really abstract paintings with literary titles? ROTHKO: Neither Mr. Gottlieb's painting nor mine should be considered abstract paintings. It is not their intention either to create or to emphasize a formal color-space arrangement. They depart from natural representation only to intensify the expression of the subject implied in the title—not to dilute or efface it. If our titles recall the known myths of antiquity, we have used them again because they are the eternal symbols upon which we must fall back to express basic psychological ideas. They are the symbols of man's primitive fears and motivations, no matter in which land or what time, changing only in detail but never in substance, be they Greek, Aztec, Icelandic, or Egyptian. And modern psychology finds them persisting still in our dreams, our vernacular, and our art, for all the changes in the outward conditions of life.

Our presentation of these myths, however, must be in our own terms, which are at once more primitive and more modern than the myths themselves—more primitive because we seek the primeval and atavistic roots of the idea rather than their graceful classical version: more modern than the myths themselves because we must redescribe their implications through our own experience. Those who think that the world of today is more gentle and graceful than the primeval and predatory passions from which these myths spring, are either not aware of reality or do not wish to see it in art. The myth holds us, therefore, not through its romantic flavor, not through the remembrance of the beauty of some bygone age, not through the possibilities of fantasy, but because it expresses to us something real and existing in ourselves, as it was to those who first stumbled upon the symbols to give them life. And now, Mr. Gottlieb, will you take the final question? Are you not denying modern art when you put so much emphasis on subject matter?

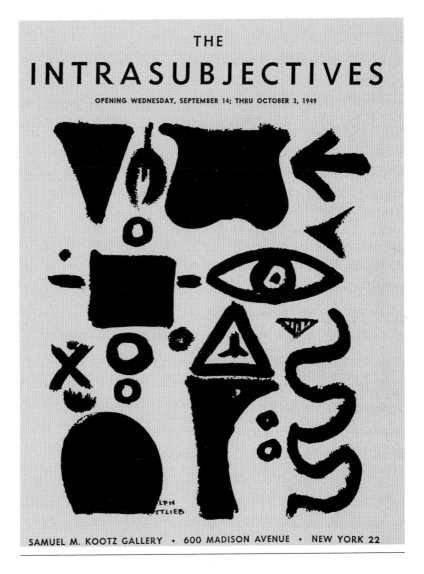

Catalogue for "The Intrasubjectives," a group show at the Samuel Kootz Gallery, New York September 14–October 3, 1949. Cover design by Adolph Gottlieb. Artists in the show included Baziotes, de Kooning, Gorky, Gottlieb, Morris Graves, Hofmann, Motherwell, Pollock, Reinhardt, Rothko, Tobey, and Tomlin.

GOTTLIEB: It is true that modern art has severely limited subject matter in order to exploit the technical aspects of painting. This has been done with great brilliance by a number of painters, but it is generally felt today that this emphasis on the mechanics of picture-making has been carried far enough. The surrealists have asserted their belief in the subject matter, but to us it is not enough to illustrate dreams.

While modern art got its first impetus through discovering the forms of primitive art, we feel that its true significance lies not merely in formal arrangements, but in the spiritual meaning underlying all archaic works.

That these demonic and brutal images fascinate us today, is not because they are exotic, nor do they make us nostalgic for a past

which seems enchanting because of its remoteness. On the contrary, it is the immediacy of their images that draws us irresistibly to the fancies, the superstitions, the fables of savages and the strange beliefs that were so vividly articulated by primitive man.

If we profess a kinship to the art of primitive men, it is because the feelings they expressed have a particular pertinence today. In times of violence, personal predilections for niceties of color and form seem irrelevant. All primitive expression reveals the constant awareness of powerful forces, the immediate presence of terror and fear, a recognition and acceptance of the brutality of the natural world as well as the eternal insecurity of life.

That these feelings are being experienced by many people throughout the world today is an unfortunate fact, and to us an art that glosses over or evades these feelings, is superficial or meaningless. That is why we insist on subject matter, a subject matter that embraces these feelings and permits them to be expressed.

from script prepared for radio broadcast by Adolph Gottlieb and Mark Rothko on "Art in New York," H. Stix, Director, WNYC, New York, October 13, 1943. Used by permission of Kate Rothko Prizel and Christopher Rothko and the Adolph and Esther Gottlieb Foundation, Inc.

Artists' Session at Studio 35, 1950

MOTHERWELL: What then exactly constitutes the basis of our community?

STERNE: We need a common vocabulary. Abstract should really mean abstract, and modern should really mean modern. We don't mean the same things with the same words.

HOFMANN: Why should we? Everyone should be as different as possible. There is nothing that is common to all of us except our creative urge. It just means one thing to me: to discover myself as well as I can. But everyone of us has the urge to be creative in relation to our time—the time to which we belong may work out to be our thing in common. . . .

HOFMANN: A very great Chinese painter once said the most difficult thing in a work of art is to know the moment when to stop. . . .

MOTHERWELL: The question then is, "How do you know when a work is finished?"

LIPPOLD: . . . I would say the work seems finished to me when it concludes successfully the prophecy of its beginning and the problems involved in its working out. It may be that my work, by nature, almost determines its own conclusion; it is not possible to

make many changes once the thing is quite far along. . . . As we all know, the first line or brush stroke can lead to millions of possibilities, and for me to keep clear is to keep a title in mind. It is of value to me at the beginning. When an experience has made itself so persistent in my unconscious or conscious mind—or both—that I feel that I want to make something which reflects that experience, I find my eyes constantly observing all things. While that experience is a memory, suitable forms can be suggested by any number of objects in life: a line on someone's face, or a crack on the floor, or an experience at a newsreel theatre. Then the problem of how to work out the experience which I have had presents itself; I may begin with that idea, and I have to adapt it to my medium. I have to make it clear enough for others to see in its relationships. All of this takes place in the sketch stage—in the models I make from drawings. The drawings become more conclusive as I work. Generally, when I work on a piece I make very few changes. I can't talk about conclusions without talking about intent. On rare occasions I have seen a form which suggested some kind of relationship which called back a memory or experience. It is always an interplay between the two, I find. It is never one thing or the other.

BROOKS: I think quite often I don't know when a work is "finished," because I often carry it a little too far. There is some peculiar balance which it is necessary to preserve all through a painting which keeps it fluid and moving. It can't be brought to a stop. I think you have to abandon it while it is still alive and moving, and so I can't consider a painting "finished." I can't think of working with a clear intent on a painting, because it often develops as I go. It quite often changes in the middle of a painting. But the "end" is a very difficult thing, something that is determined, not by the form that is "finished," but by the fact that I have worked on it. It satisfies a need of some kind. . . .

BAZIOTES: I consider my painting finished when my eye goes to a particular spot on the canvas. But if I put the picture away about thirty feet on the wall and the movements keep returning to me and the eye seems to be responding to something living, then it is finished.

GOTTLIEB: I usually ask my wife. . . . I think a more interesting question would be, "Why does anyone start a painting instead of finishing it?"

FERBER: I would say that I don't think any piece of sculpture I make is really "finished." Nor do I think it possible to call a piece a realization of any particular idea evolving from a specific emotion or event. There is a stream of consciousness out of which these things

pop like waves, and fall back. Therefore works aren't really complete in themselves. I think the day of the "masterpiece" is over. When we look at our own work, in ten or fifteen examples, we really understand what we are doing. The sense of "finishing" a particular work is meaningless.

LIPPOLD: I would like to ask you if what you describe applies to an individual piece: It is a thing which exists within its own particular shape. How can that come about?

FERBER: For a sculptor to insist that a piece of sculpture rises out of his stream of consciousness is perhaps ridiculous because sculpture is so three-dimensional and hard. But I don't believe there is any great difference between one piece and another in the development and fulfillment of a particular aesthetic idea which may permeate several works.

LASSAW: I would consider a work finished when I sense a "togetherness," a participation of all parts as in an organism. This does not mean that I entirely understand what I have created. To me, a work is, at first, quite unknown. In time, more and more enters into consciousness. It would be better to consider a work of art as a process that is started by the artist. In that way of thinking a sculpture or painting is never finished, but only begun. If successful, the work starts to live a life of its own, a work of art begins to work. . . .

NEWMAN: I think the idea of a "finished" picture is a fiction. I think a man spends his whole life-time painting one picture or working on one piece of sculpture. The question of stopping is really a decision of moral considerations. To what extent are you charmed by its inner life? And to what extent do you then really approach the intention or desire that is really outside of it. The decision is always made when the piece has something in it that you wanted. . . .

DE KOONING: I refrain from "finishing" it. I paint myself out of the picture, and when I have done that, I either throw it away or keep it. I am always in the picture somewhere. The amount of space I use I am always in, I seem to move around in it, and there seems to be a time when I lose sight of what I wanted to do, and then I am out of it. If the picture has a countenance, I keep it. If it hasn't, I throw it away. I am not really very much interested in the question. . . .

REINHARDT: It has always been a problem for me—about "finishing" paintings. I am very conscious of ways of "finishing" a painting. Among modern artists there is a value placed upon "unfinished" work. Disturbances arise when you have to treat the work as a finished and complete object, so that the only time I think

I "finish" a painting is when I have a dead-line. If you are going to present it as an "unfinished" object, how do you "finish" it? . . .

HOFMANN: To me a work is finished when all parts involved communicate themselves, so that they don't need me.

MOTHERWELL: I dislike a picture that is too suave or too skillfully done. But, contrariwise, I also dislike a picture that looks too inept or blundering. I noticed in looking at the Carré exhibition of young French painters who are supposed to be close to this group, that in "finishing" a picture they assume traditional criteria to a much greater degree than we do. They have a real "finish" in that the picture is a real object, a beautifully made object. We are involved in "process" and what is a "finished" object is not so certain. . . .

HOFMANN: Yes, it seems to me all the time there is the question of a heritage. It would seem that the difference between the young French painters and the young American painters is this: French pictures have a cultural heritage. The American painter of today approaches things without basis. The French approach things on the basis of cultural heritage—that one feels in all their work. It is a working toward a refinement and quality rather than working toward new experiences, and painting out these experiences that may finally become tradition. The French have it easier. They have it in the beginning.

DE KOONING: I am glad you brought up this point. It seems to me that in Europe every time something new needed to be done it was because of traditional culture. Ours has been a striving to come to the same point that they had—not to be iconoclasts. . . .

GOTTLIEB: There is a general assumption that European . . . specifically French—painters have a heritage which enables them to have the benefits of tradition, and therefore they can produce a certain type of painting. It seems to me that in the last fifty years the whole meaning of painting has been made international. I think Americans share that heritage just as much, and that if they deviate from tradition it is just as difficult for an American as for a Frenchman. It is a mistaken assumption in some quarters that any departure from tradition stems from ignorance. I think that what Motherwell describes is the problem of knowing what tradition is, and being willing to reject it in part. This requires familiarity with his past. I think we have this familiarity, and if we depart from tradition, it is out of knowledge, not innocence.

DE KOONING: I agree that tradition is part of the whole world now. The point that was brought up was that the French artists have some "touch" in making an object. They have a particular something that makes them look like a "finished" painting. They have a touch which I am glad not to have.

Barnett Newman, Jackson
Pollock, and Tony Smith
at the Betty Parsons Gallery,
1951
Photograph by Hans Namuth

BAZIOTES: We are getting mixed up with the French tradition. In
talking about the necessity to "finish" a thing, we then said
American painters "finish" a thing that looks "unfinished," and the
French, they "finish" it. I have seen Matisses that were more
"unfinished" and yet more "finished" than any American painters.
Matisse was obviously in a terrific emotion at the time and he was
more "unfinished" than "finished."

STERNE: I think that the titling of paintings is a problem. The titles
a painter gives his paintings help to classify him, and this is wrong.
A long poetic title or number. . . . Whatever you do seems a
statement of attitude. The same thing if you give a descriptive
title. . . . Even refraining from giving any at all creates a
misunderstanding.

REINHARDT: If a title does not mean anything and creates a
misunderstanding, why put a title on a painting?

BROOKS: To me a title is nothing but identification. I have a very
hard time finding a title and it is always inadequate. I think when
titles are very suggestive, they are a kind of a fraud, because they
throw the spectator away from the picture rather than into it. But
numbers are inadequate.

GOTTLIEB: I think the point Miss Sterne raised is inevitable. That

is, whenever an artist puts a title on a painting, some interpretation about his attitude will be made. It seems obvious that titles are necessary when everybody uses them—whether verbal or numbers; for purposes of exhibition, identification and the benefit of the critics there must be some way of referring to a picture. It seems to me that the artist, in making up titles for his pictures, must decide what his attitude is. . . .

POUSETTE-DART: I think if we could agree on numbers it would be a tremendous thing. In music they don't have this dilemma. It would force people to just look at the object and try to find their own experience. . . .

REINHARDT: The question of abandoning titles arose, I am sure, because of aesthetic reasons. Even titles like "still life" and "landscape" do not say anything about a painting. If a painting does have a reference or association of some kind, I think the artist is apt to add a title. I think this is why titles are not used by a great many modern painters—because they don't have anything to do with the painting itself. . . .

MOTHERWELL: I think Sterne is dealing with a real problem—what is the content of our work? What are we really doing? The question is how to name what as yet has been unnamed. . . .

BAZIOTES: Whereas certain people start with a recollection or an experience and paint that experience, to some of us the act of doing it becomes the experience; so that we are not quite clear why we are engaged on a particular work. And because we are more interested in plastic matters than we are in a matter of words, one can begin a picture and carry it through and stop it and do nothing about the title at all. All pictures are full of association.

REINHARDT: Titles are very important in surrealist work. But the emphasis with us is upon a painting experience, and not on any other experience. The only objection I have to a title is when it is false or tricky, or is something added that the painting itself does not have. . . .

DE KOONING: I think that if an artist can always title his pictures, that means he is not always very clear.

LASSAW: In titling a construction, I have used combinations of words or syllables without any meaning. Lately, I have adopted the use of the names of stars or other celestial objects, similar to the way ships are named. Such titles are just names, and are not to imply that the constructions express, symbolize, or represent anything. A work of art *is* like a work of nature.

FERBER: What we all have been saying is that the designation of a painting or a piece of sculpture has become more important as a problem than it has been before. An Assumption or a Crucifixion

needed no title. I think that numbering pieces is really begging the question. Because numbering the piece is an admission or a statement or a manifesto that this is pure painting or sculpture— that it stands by itself without relation to any other discipline. We should not cut ourselves off from this great rich world. . . .

NEWMAN: I think it would be very well if we could title pictures by identifying the subject matter so that the audience could be helped. I think the question of titles is purely a social phenomenon. The story is more or less the same when you can identify them. I think the implication has one of two possibilities: (1) We are not smart enough to identify our subject matter, or (2) Language is so bankrupt that we can't use it. I think both are wrong. I think the possibility of finding language still exists, and I think we are smart enough. Perhaps we are arriving at a new state of painting where the thing has to be seen for itself. . . .

LIPPOLD: It has seemed to me that the whole business of title or what to make is a phenomenon peculiar to our times. The job was a great deal easier, in any period but our own. The idea of what to paint was already pre-determined. I am talking of such cultures as the oriental and our middle ages—in which a sculptor was asked to carve a king or queen. It wasn't his job to complain because he did not want to make a king or queen. And there are people like that now, too. I believe that in our own time the discipline that is enforced upon our work has to come from ourselves. The title for me exists at the beginning and all through the piece, and it keeps me clearly on the road, I believe, to the conclusion of the work. The only thing I am interested in resolving is that intent with which I begin, because I feel in our time there is very little else with which to begin. To grope through a series of accidents is not the function of the artist. The job of the artist is only the job of a craftsman.

BAZIOTES: Mr. Lippold's position, as I understand it, is that the beginning of a work now has something about it that would not have seemed quite logical to artists of the past. We apparently begin in a different way. Is that what you mean, Mr. Lippold?

LIPPOLD: Yes.

BAZIOTES: I think the reason we begin in a different way is that this particular time has gotten to a point where the artist feels like a gambler. He does something on the canvas and takes a chance in the hope that something important will be revealed.

REINHARDT: I would like to ask a question about the exact involvement of a work of art. What kind of love or grief is there in it? I don't understand, in a painting, the love of anything except the love of painting itself. If there is agony, other than the agony of painting, I don't know exactly what kind of agony that would be. I

Cedar Street Tavern, 1957
(Clockwise from left: Mercedes
Matter, Willem de Kooning,
Frank O'Hara, Elaine de
Kooning, and Philip
Guston)
Photograph by Arthur Swoger

am sure external agony does not enter very importantly into the
agony of our painting. . . .

DE KOONING: I feel it isn't so much the act of being obliged to
someone or to society, but rather one of conviction. I think,
whatever happens, every man works for himself, and he does it on
the basis of convincing himself. I force my attitude upon this world,
and I have this right—particularly in this country—and I think it is
wonderful, and if it does not come off, it is alright, too. I don't see
any reason why we should go and look into past history and find a
place or try to take a similar position. . . .

REINHARDT: Exactly what is our involvement, our relation to the
outside world? I think everybody should be asked to say something
about this.

BARR: Apparently many people don't want to answer the question.

DE KOONING: I think somebody who professes something never is a
professor. I think we are craftsmen, but we really don't know exactly
what we are ourselves, but we have no position in the world—
absolutely no position except that we just insist upon being
around. . . .

MOTHERWELL (TO BROOKS): I am extremely interested in
something you do, which is painting behind the canvas.

BROOKS: My work is improvisation to start with. My purpose is to
get as much unknown on the canvas as I can. Then I can start
digesting or changing. The first thing is to get a great many
unfamiliar things on the surface. The working through on another

side is an unfamiliar attack. There are shapes suggested that start improvising themselves, which I then start developing. Sometimes there is a terrible confusion, and a retreat into tradition. If then, for example, I rely on cubism, my painting loses its newness to me. If I can manage to keep a balance with improvisation, my work can get more meaning; it reaches a certain fullness.

GOTTLIEB: Isn't it possible that a straight line could develop on your canvas? I am inclined to think that it does not appear because it is excluded. Swirling shapes are not just the result of unconscious process.

BROOKS: It is not as deliberate as you think. I have a preference for it, but that is as far as I can go.

TOMLIN: Can one interchange the words "automatic" and "improvise?"

BROOKS: No. I don't consider them synonymous.

TOMLIN: Do you feel that the "automatic" enters into your work at all?

BROOKS: I am not able to define what the mixture is.

DE KOONING: I consider all painting free. As far as I am concerned, geometric shapes are not necessarily clear. When things are circumspect or physically clear, it is purely an optical phenomenon. It is a form of uncertainty; it is like accounting for something. It is like drawing something that then is bookkeeping. Bookkeeping is the most unclear thing.

REINHARDT: An emphasis on geometry is an emphasis on the "known," on order and knowledge.

Cedar Street Tavern, 1957
(left to right: Norman Bluhm,
Joan Mitchell, and Franz Kline)
Photograph by Arthur Swoger

FERBER: Why is geometry more clear than the use of swirling shapes?

REINHARDT: Let's straighten out our terminology, if we can. Vagueness is a "romantic" value, and clarity and "geometricity" are "classic" values.

DE KOONING: I meant geometry in art. Geometry was against art — the beauty of the rectangle, I mean.

LIPPOLD: This means that a rectangle is unclear?

DE KOONING: Yes.

MOTHERWELL: Lippold resents the implication that a geometric form is not "clear."

DE KOONING: The end of a painting in this kind of geometric painting would be almost the graph for a possible painting — like a blueprint.

TOMLIN: Would you say that automatic structure is in the process of becoming, and that "geometry" has already been shown and terminated?

DE KOONING: Yes.

MOTHERWELL: It seems to me that what de Kooning is saying is plain. He feels resentful that one mode of expression should be called more clear, precise, rational, finished, than another.

BAZIOTES: I think when a man first discovers that two and two is four, there is "beauty" in that; and we can see why. But if people stand and look at the moon and one says, "I think it's just beautiful tonight," and the other says, "The moon makes me feel awful," we are both "clear." A geometric shape — we know why we like it; and an unreasonable shape, it has a certain mystery that we recognize as real; but it is difficult to put these things in an objective way.

NEWMAN: The question of clarity is one of intention.

STERNE: I think it has to do with Western thinking. A Chinese thinks very well, but does not use logic. The use of geometrical forms comes from logical thinking.

REINHARDT (TO STERNE): Your work to some extent looks generally planned and preconceived. I would like some discussion on it.

STERNE: Preconceived only partly. Because as I go the painting begins to function by rules of its own, often preventing me from achieving my original vision. . . .

HOFMANN: I believe that in an art every expression is relative, not absolutely defined as long as it is not the expression of a relationship. Anything can be changed. We speak here only about means, but the application of the means is the point. You can change one thing into another with the help of the relations of the thing. One shape in relation to other shapes makes the "expression"; not one shape or another, but the relationship between the two

makes the "meaning." As long as a means is only used for itself, it cannot lead to anything. Construction consists of the use of one thing in relation to another, which then relates to a third, and higher, value.

MOTHERWELL (TO HOFMANN): Would you say that a fair statement of your position is that the "meaning" of a work of art consists of the relations among the elements, and not the elements themselves?

HOFMANN: Yes, that I would definitely say. You make a thin line and a thick line. It is the same as with geometrical shapes. It is all relationship. Without all of these relationships it is not possible to express higher art.

FERBER: The means are important but what we were concerned with is an expression of a relationship to the world. Truth and validity cannot be determined by the shape of the elements of the picture.

DE KOONING: About this idea of geometric shapes again: I think a straight line does not exist. There is no such thing as a straight line in painting.

REINHARDT: We are losing Ferber's point. I would like to get back to the question of whether there is another criterion of truth and validity, apart from the internal relationships in a work of art.

MOTHERWELL: It would be very difficult to formulate a position in which there were no external relations. I cannot imagine any structure being defined as though it only has internal meaning.

REINHARDT: I want to know the outside truth. I think I know the internal one.

MOTHERWELL: Reinhardt was emphasizing very strongly that the quality of a work depends upon the relations within it. Between Ferber and Reinhardt the question is being raised as to whether these internal relations also relate externally to the world or better, as to what this external relation is.

TOMLIN: May I take this back to structure? In what was said about the parts in relation to Brooks's work, the entire structure was embraced. We were talking about shape, without relation to one possibility of structure. I would like to say that I feel that geometric shapes can be used to achieve a fluid and organic structure.

HOFMANN: There is a fluidity in the elements which can be used in a practical way, which is often used by Klee. It is related to handwriting—it often characterizes a complete personality. It can be used in a graphic sense and in a plastic sense. It leads a point to a relation with another point. It is a relationship of all points considered in plastic relation. It offers a number of possibilities.

REINHARDT (TO HOFMANN): Do you consider the interrelationship of the elements in a work of art to be self-contained?

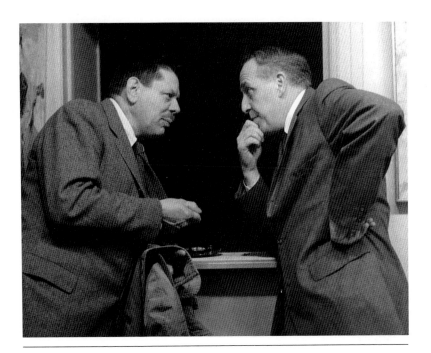

David Smith and Philip Guston
at the Sidney Janis Gallery, 1960
Photograph by Arthur Swoger

HOFMANN: It is related to all of this world—to what you want to express. You want to express something very definitely and you do it with your means. When you understand your means, you can.

MOTHERWELL: I find that I ask of the painting process one of two separate experiences. I call one the "mode of discovery and invention," the other the "mode of joy and variation." The former represents my deepest painting problem, the bitterest struggle I have ever undertaken, to reject everything I do not feel and believe. The other experience is when I want to paint for the sheer joy of painting. These moments are few. The strain of dealing with the unknown, the absolute, is gone. When I need joy, I find it only in making free variations on what I have already discovered, what I know to be mine. We modern artists have no generally accepted subject matter, no inherited iconography. But to re-invent painting, its subject matter and its means, is a task so difficult that one must reduce it to a very simple concept in order to paint for the sheer joy of painting, as simple as the Madonna was to many generations of painters in the past. . . . The other mode is a voyaging into the night, one knows not where, on an unknown vessel, an absolute struggle with the elements of the real.

REINHARDT: Let's talk about that struggle.

MOTHERWELL: When one looks at a Renaissance painter, it is evident that he can modify existing subject matter in a manner that shows his uniqueness and fineness without having to re-invent

painting altogether. But I think that painters like Mondrian tend to move as rapidly as they can toward a simple iconography on which they can make variations. Because the strain is so great to re-invent reality in painting.

REINHARDT: What about the reality of the everyday world and the reality of painting? They are not the same realities. What is the creative thing that you have struggled to get and where did it come from? What reference or value does it have, outside of the painting itself? . . .

DE KOONING: If we talk in terms of what kinds of shapes or lines we are using, we don't mean that and we talk like outsiders. When Motherwell says he paints stripes, he doesn't mean that he is painting stripes. That is still thinking in terms of what kind of shapes we are painting. We ought to get rid of that. If a man is influenced on the basis that Mondrian is clear, I would like to ask Mondrian if he was so clear. Obviously, he wasn't clear, because he kept on painting. Mondrian is not geometric, he does not paint straight lines. A picture to me is not geometric—it has a face . . . It is some form of impressionism . . . We ought to have some level as a profession. Some part of painting has to become professional.

NEWMAN: De Kooning has moved from his original position that straight lines do not exist in nature. Geometry can be organic. Straight lines do exist in nature. When I draw a straight line, it does exist. It exists optically. When de Kooning says it doesn't exist optically, he means it doesn't exist in nature. On that basis, neither do curved lines exist in nature. But the edge of the U. N. building is a straight line. If it can be made, it does exist in nature. A straight line is an organic thing that can contain feelings.

DE KOONING: What is called Mondrian's optical illusion is not an optical illusion. A Mondrian keeps changing in front of us.

GOTTLIEB: It is my impression that the most general idea which has kept cropping up is a statement of the nature of a work of art as being an arrangement of shapes or forms of color which, because of the order or ordering of materials, expresses the artist's sense of reality or corresponds with some outer reality. I don't agree—that some expression of reality can be expressed in a painting purely in terms of line, color, and form, that those are the essential elements in painting, and anything else is irrelevant and can contribute nothing to the painting. . . .

NEWMAN: We are raising the question of subject matter and what its nature is.

DE KOONING: I wonder about the subject matter of the Crucifixion scene—was the Crucifixion the subject matter or not? What is the subject matter? Is an interior subject matter?

HOFMANN: I think the question goes all the time back to subject matter. Every subject matter depends on how to use meaning. You can use it in a lyrical or dramatic manner. It depends on the personality of the artist. Everyone is clear about himself, as to where he belongs, and in which way he can give aesthetic enjoyment. Painting is aesthetic enjoyment, I want to be a "poet." As an artist I must conform to my nature. My nature has a lyrical as well as a dramatic disposition. Not one day is the same. One day I feel wonderful to work and I feel an expression which shows in the work. Only with a very clear mind and on a clear day I can paint without interruptions and without food because my disposition is like that. My work should reflect my moods and the great enjoyment which I had when I did the work. . . .

BARR: What is the most acceptable name for our direction or movement? (It has been called Abstract-Expressionist, Abstract-Symbolist, Intra-Subjectivist, etc.)

SMITH: I don't think we do have unity on the name.

ROSENBERG: We should have a name through the years.

SMITH: Names are usually given to groups by people who don't understand them or don't like them.

BARR: We should have a name for which we can blame the artists— for once in history! . . .

MOTHERWELL: In relation to the question of a name here are three names: Abstract-Expressionist; Abstract-Symbolist; Abstract-Objectionist.

BROOKS: A more accurate name would be "direct" art. It doesn't sound very good, but in terms of meaning, abstraction is involved in it.

TOMLIN: Brooks also remarked that the word "concrete" is meaningful; it must be pointed out that people have argued very strongly for that word. "No-objective" is a vile translation.

NEWMAN: I would offer "Self-evident" because the image is concrete.

DE KOONING: It is disastrous to name ourselves.

excerpted from *Modern Artists in America*, Robert Goodnough, ed. New York: Wittenborn, Schultz, 1951. © Wittenborn Art Books, Inc., New York

A three-day closed conference took place April 21–23, 1950, from four to seven p.m. It constituted the final activity of Studio 35. The participants who attended one or more of the sessions were William Baziotes, Janice Biala, Louise Bourgeois, James Brooks, Willem de Kooning, Jimmy Ernst, Herbert Ferber, Adolph Gottlieb, Peter Grippe, David Hare, Hans Hofmann, Weldon Kees, Ibram Lassaw, Norman Lewis, Seymour Lipton, Barnett Newman, Richard Pousette-Dart, Ad Reinhardt, Ralph Rosenberg, Theodoros Stamos, Hedda Sterne, David Smith, and Bradley Walker Tomlin. The moderators were Alfred H. Barr, Jr., Director of The Museum of Modern Art, Richard Lippold, and Robert Motherwell.

Modern Artists in America was the first and only issue of this magazine edited by Motherwell and Reinhardt.

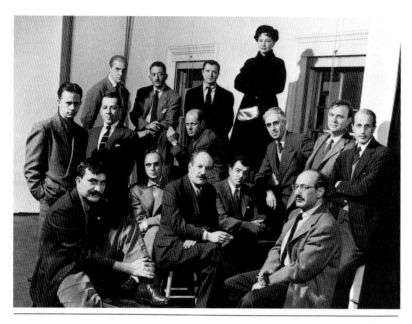

Open letter to Roland L. Redmond, President, The Metropolitan Museum of Art, 1950

The undersigned painters reject the monster national exhibition to be held at The Metropolitan Museum of Art next December, and will not submit work to its jury.

The organization of the exhibition and the choice of the jurors by Francis Henry Taylor and Robert Beverly Hale, the Metropolitan's Director and Associate Curator of American Art, does not warrant any hope that a just proportion of advanced art will be included.

We draw to the attention of those gentlemen the historical fact that, for roughly a hundred years, only advanced art has made any consequential contribution to civilization.

Mr. Taylor on more than one occasion has publicly declared his contempt for modernist painting; Mr. Hale, in accepting a jury notoriously hostile to advanced art, takes his place beside Mr. Taylor.

We believe that all the advanced artists of America will join us in our stand.

(Signed) Jimmy Ernst, Adolph Gottlieb, Robert Motherwell, William Baziotes, Hans Hofmann, Barnett Newman, Theodoros Stamos, Clyfford Still, Richard Pousette-Dart, Ad Reinhardt, Jackson Pollock, Mark Rothko, Bradley Walker Tomlin, Willem de Kooning, Hedda Sterne, James Brooks, Weldon Kees, Fritz Bultman.

The following sculptors support this stand.

(Signed) Herbert Ferber, David Smith, Ibram Lassaw, Mary

Callery, Day Schnabel, Seymour Lipton, Peter Grippe, Theodore Roszak, David Hare, Louise Bourgeois.

from *ARTnews*, vol. 49, no. 4, summer 1950. © ARTnews, XLIX (49), No. 4, Summer 1950. Reprinted by permission.

This letter, dated May 20, 1950, protests the jury selected for the exhibition *American Painting Today—1950*, planned for The Metropolitan Museum of Art. This group was later labeled "The Irascibles," which led to the now-famous photograph by Nina Leen.

Letter to the editor of *The New York Times*, 1961

Reading Mr. John Canaday's columns on contemporary art, we regard as offensive his consistent practice of going beyond discussion of exhibitions in order to impute to living artists en masse, as well as to critics, collectors and scholars of present-day American art, dishonorable motives, those of cheats, greedy lackeys or senseless dupes.

Here are some instances:

Sept. 20, 1959: ". . . a situation built on fraud at worst and gullibility at best has produced a school of such prolix mediocrity . . ."

July 24, 1960: "The chaotic, haphazard and bizarre nature of modern art is easily explained: The painter finally settles for whatever satisfaction may be involved in working not as an independent member of a society that needs him, but as a retainer for a small group of people who as a profession or as a hobby are interested in the game of comparing one mutation with another."

Sept. 6, 1959: "But as for the freaks, the charlatans and the misled who surround this handful of serious and talented artists, let us admit at least that the nature of abstract expressionism allows exceptional tolerance for incompetence and deception."

"In the meanwhile, critics and educators have been hoist with their own petard, sold down the river. We have been had."

Sept. 11, 1960: ". . . for a decade the bulk of abstract art in America has followed that course of least resistance and quickest profit."

"There is not a dealer in town, nor a collector, nor a painter hoping to hang in the Museum of Modern Art who doesn't study each of Mr. Barr's syllables in an effort to deduce what he should offer for sale, what he should buy, or what he should paint . . ."

Oct. 23, 1960: ". . . brainwashing . . . goes on in universities and museums."

Mr. Canaday is entitled, of course, to the freedom of his opinions regarding works of art. We submit, however, that his terminology of

insults is scarcely adequate to describe emerging art works and tendencies, and we scorn this waging of a polemical campaign under the guise of topical reporting.

If Mr. Canaday has a political or social or aesthetic "position" or philosophy, let him state what it is and openly promote his aims. Every style and movement in art history contains examples of work by imitative or uninterested artists. To keep referring to these in order to impugn the whole, instead of attempting to deal seriously with the work of the movement, is the activity not of a critic but of an agitator.

James S. Ackerman, Professor of Fine
 Arts, Harvard University
William Barrett, Professor of
 Philosophy, New York University
Walter Bareiss, Collector
Donald Blinken, Collector
Bernard Brodsky, M.D., Collector
James Brooks, Painter
John Cage, Composer
Bernard Chaet, Associate Professor of
 Painting, School of Art and
 Architecture, Yale University
Howard Conant, Chairman, Dept. of
 Art Education, New York University
Stuart Davis, Painter
Edwin Denby, Writer
Henry Epstein, Collector
John Ferren, Painter
Alfred Frankfurter, Editor & President,
 ARTnews
Percival Goodman, Architect, F.A.I.A.
Adolph Gottlieb, Painter
Jack M. Greenbaum, Collector
Mr. & Mrs. I. Harold Grossman,
 Collectors
David Hare, Sculptor
Ben Heller, Collector
Thomas B. Hess, Executive Editor,
 ARTnews
Hans Hofmann, Painter
Sam Hunter, Director, Rose Art
 Museum, Brandeis University
Kenneth Koch, Writer
Willem de Kooning, Painter

Stanley Kunitz, Poet
Kermit Lansner, Writer
Boris Leavitt, Collector
Erle Loran, Painter and Teacher
Arnold H. Maremont, Collector,
 Chicago
Robert Motherwell, Painter
E. A. Navaretta, Poet and Critic
Albert H. Newman, Collector
Barnett Newman, Painter
Raymond Parker, Painter
Philip Pavia, Sculptor, Editor, *It Is*
Gifford Phillips, Collector, Publisher,
 Frontier Magazine
William Phillips, Editor, *Partisan
 Review*
Fairfield Porter, Art Critic, *The Nation*
David A. Prager, Collector
Harold Rosenberg, Writer
Robert Rosenblum, Assistant Professor,
 Dept. of Art & Archaeology,
 Princeton University
Barney Rossett, Publisher, Grove Press
Irving Sandler, Writer and Critic
Kenneth B. Sawyer, Art Critic,
 Baltimore Sun
David Smith, Sculptor
Whitney S. Stoddard, Professor of Art
Meyer Schapiro, Professor, Dept. of Art
 History and Archaeology, Columbia
 University
Paul Weiss, Professor of Philosophy,
 Yale University

Mr. Canaday notes that this letter brought responses from more than 600 readers; about 550 of these responses supported Canaday. (An example of Mr. Canaday's criticism appears on page 272.)

Part II: Critics

Robert Coates, "The Art Galleries," 1946

The Mortimer Brandt Gallery is exhibiting, through this Saturday, a group of paintings by Hans Hofmann. Hofmann, curiously, though he was a painter of some reputation in Munich before coming to this country, has been known here chiefly as a teacher, and while his art schools in New York and Provincetown have prospered, it is only comparatively recently that he has received any attention as an artist. In part, this is due to a certain retiringness of his own, for despite the fact that he has lived here for twelve years or more, the present showing is only his third to date and is, moreover, his first full-scale one. In part, too, it is due to his style, for he is certainly one of the most uncompromising representatives of what some people call the spatter-and-daub school of painting and I, more politely, have christened Abstract Expressionism.

There's no doubt that his painting is "difficult," and there are four or five of the eighteen canvases in the show in which the emphasis on accidental effects (that is, spatters and daubs) is so strong that I'd be willing to dismiss them as sheer nonsense if in some of the others he didn't display a combination of subtlety and power which argues an over-all intention too well developed to be brushed aside so lightly.

excerpted from *The New Yorker*, vol. XXII, no. 7, March 30, 1946. Reprinted by permission. © 1946, 1974. The New Yorker Magazine, Inc.

In this review, the term "abstract expressionism" is used for the first time in discussing New York artists. Alfred H. Barr, Jr. had employed the same term in relation to Kandinsky in 1936 in his book *Cubism and Abstract Art*.

René D'Harnoncourt et al., "A Statement on Modern Art," 1950

The Institute of Contemporary Art, Boston, The Museum of Modern Art, New York, and the Whitney Museum of American Art, New York, all institutions devoted primarily to the art of our time, have joined in the following statement of general principles governing their relation to contemporary art. This statement is made in the hope that it may help to clarify current controversial issues about modern art, which are confusing to the public and harmful to the artist. Its object is not to bar honest differences of opinion, but to state certain broad principles on which we are agreed.

The field of contemporary art is immensely wide and varied, with many diverse viewpoints and styles. We believe that this diversity is a sign of vitality and the freedom of expression inherent in a

democratic society. We oppose any attempt to make art or opinion about art conform to a single point of view.

We affirm our belief in the continuing validity of what is generally known as modern art, the multiform movement which was in progress during the opening years of the twentieth century and which has produced the most original and significant art of our period. We believe that the modern movement was a vital force not only in its pioneer phases, but that its broad, everchanging tradition of courageous exploration and creative achievement is a vital force today, as is proved by the continuing capacity of the younger generation of artists to embody new ideas in new forms. At the same time we believe in the validity of conservative and retrospective tendencies when they make creative use of traditional values. We do not assume that modernity in itself is any guarantee of quality or importance.

We believe that a primary duty of a museum concerned with contemporary art is to be receptive to new tendencies and talents. We recognize the historic fact that the new in art, as in all other creative activities, is appreciated at first by a relatively small proportion of the public; almost all the art of the past hundred and fifty years now generally accepted as good was originally misunderstood, neglected or ridiculed not only by the public but by many artists, critics and museum officials. We place in evidence the careers of Blake, Turner, Constable, Delacroix, Corot, Millet, Courbet, Manet, Whistler, Monet, Cézanne, Renoir, Rodin, Gauguin, van Gogh, Eakins, Ryder, not to mention the leaders of the twentieth century. We also recognize that some artists of unquestionable merit never become popular, although their work may eventually have a widespread influence. We therefore believe that it is a museum's duty to present the art that it considers good, even if it is not yet generally accepted. By so doing, we believe, the museum best fulfills its long-range responsibility to the public.

We believe that the so-called "unintelligibility" of some modern art is an inevitable result of its exploration of new frontiers. Like the scientist's innovations, the procedures of the artist are often not readily understood and make him an easy target for reactionary attack. We do not believe that many artists deliberately aim to be unintelligible, or have voluntarily withdrawn from the public. On the contrary, we believe that most artists today desire communication with a receptive audience. The gap between artist and public, in our opinion, has been greatly exaggerated; actually the public interest in progressive art, as proved by attendance at exhibitions and by attention in the popular press, is larger than at any previous time in history.

We believe in the humanistic value of modern art even though it may not adhere to academic humanism with its insistence on the human figure as the central element of art. Art which explores newly discovered levels of consciousness, new concepts of science and new technological methods is contributing to humanism in the deepest sense, by helping humanity to come to terms with the modern world, not by retreating from it but by facing and mastering it. We recognize the humanistic value of abstract art as an expression of thought and emotion and the basic human aspirations toward freedom and order. In these ways modern art contributes to the dignity of man.

Contrary to those who attack the advanced artist as anti-social, we believe in his spiritual and social role. We honor the man who is prepared to sacrifice popularity and economic security to be true to his personal vision. We believe that his unworldly pursuit of perfection has a moral and therefore a social value. But we do not believe that unreasonable demands should be made on him. Though his spiritual energy may be religious in the broadest sense, he should not be asked to be priest or saint. Though his art may symbolize discipline or liberty, he cannot be asked to save civilization.

Believing strongly in the quality and vitality of American art, we oppose its definition in narrow nationalistic terms. We hold that American art which is international in character is as valid as art obviously American in subject matter. We deplore the revival of the tendency to identify American art exclusively with popular realism, regional subject and nationalistic sentiment.

We also reject the assumption that art which is aesthetically an innovation must somehow be socially or politically subversive, and therefore un-American. We deplore the reckless and ignorant use of political or moral terms in attacking modern art. We recall that the Nazis suppressed modern art, branding it "degenerate," "bolshevistic," "international," and "un-German"; and that the Soviets suppressed modern art as "formalistic," "bourgeois," "subjective," "nihilistic," and "un-Russian"; and that Nazi officials insisted and Soviet officials still insist upon a hackneyed realism saturated with nationalistic propaganda.

We believe that it is not a museum's function to try to control the course of art or to tell the artist what he shall or shall not do; or to impose its tastes dogmatically upon the public. A museum's proper function, in our opinion, is to survey what artists are doing, as objectively as possible, and to present their works to the public as impartially as is consistent with those standards of quality which the museum must try to maintain. We acknowledge that humility is

required of those who select works of art, as it is of those who
create them or seek to understand them.

We believe that there is urgent need for an objective and open-
minded attitude toward the art of our time, and for an affirmative
faith to match the creative energy and integrity of the living artist.

The Institute of Contemporary Art, Boston
James S. Plaut, Director
Frederick S. Wight, Director of Education

The Museum of Modern Art, New York
René d'Harnoncourt, Director
Alfred H. Barr, Jr., Director, Museum Collections
Andrew C. Ritchie, Director, Department of Painting and Sculpture

Whitney Museum of American Art, New York
Hermon More, Director
Lloyd Goodrich, Associate Director

reprinted by permission of The Institute of Contemporary Art, Boston; The Museum of
Modern Art, New York; and the Whitney Museum of American Art, New York

This statement was published as a pamphlet and represents an official statement made by
three of the leading American institutions concerned with contemporary art.

Harold Rosenberg, "The American Action Painters," 1952

At a certain moment the canvas began to appear to one American
painter after another as an arena in which to act—rather than as a
space in which to reproduce, redesign, analyze or "express" an
object, actual or imagined. What was to go on the canvas was not a
picture but an event.

The painter no longer approached his easel with an image in his
mind; he went up to it with material in his hand to do something to
that other piece of material in front of him. The image would be the
result of this encounter.

It is pointless to argue that Rembrandt or Michelangelo worked in
the same way. You don't get Lucrece with a dagger out of staining a
piece of cloth or spontaneously putting forms into motion upon it.
She had to exist some place else before she got on the canvas, and
the paint was Rembrandt's means for bringing her here. Now,
everything must have been in the tubes, in the painter's muscles
and in the cream-colored sea into which he dives. If Lucrece should
come out she will be among us for the first time—a surprise. To the

painter, she *must* be a surprise. In this mood there is no point in an act if you already know what it contains.

"B. is not modern," one of the leaders of this mode said to me the other day. "He works from sketches. That makes him Renaissance."

Here the principle, and the difference from the old painting, is made into a formula. A sketch is the preliminary form of an image the *mind* is trying to grasp. To work from sketches arouses the suspicion that the artist still regards the canvas as a place where the mind records its contents—rather than itself the "mind" through which the painter thinks by changing a surface with paint.

If a painting is an action, the sketch is one action, the painting that follows it another. The second cannot be "better" or more complete than the first. There is just as much significance in their difference as in their similarity.

Of course, the painter who spoke had no right to assume that the other had the old mental conception of a sketch. There is no reason why an act cannot be prolonged from a piece of paper to a canvas. Or repeated on another scale and with more control. A sketch can have the function of a skirmish.

Call this painting "abstract" or "Expressionist" or "Abstract-Expressionist," what counts is its special motive for extinguishing the object, which is not the same as in other abstract or Expressionist phases of modern art.

The new American painting is not "pure art," since the extrusion of the object was not for the sake of the aesthetic. The apples weren't brushed off the table in order to make room for perfect relations of space and color. They had to go so that nothing would get in the way of the act of painting. In this gesturing with materials the aesthetic, too, has been subordinated. Form, color, composition, drawing, are auxiliaries, any one of which—or practically all, as has been attempted, logically, with unpainted canvases—can be dispensed with. What matters always is the revelation contained in the act. It is to be taken for granted that in the final effect, the image, whatever be or be not in it, will be a *tension*.

A painting that is an act is inseparable from the biography of the artist. The painting itself is a "moment" in the adulterated mixture of his life—whether "moment" means, in one case, the actual minutes taken up with spotting the canvas or, in another, the entire duration of a lucid drama conducted in sign language. The act-painting is of the same metaphysical substance as the artist's existence. The new painting has broken down every distinction between art and life. . . .

A good painting in this mode leaves no doubt concerning its

reality as an action and its relation to a transforming process in the artist. The canvas has "talked back" to the artist not to quiet him with Sibylline murmurs or to stun him with Dionysian outcries but to provoke him into a dramatic dialogue. Each stroke had to be a decision and was answered by a new question. By its very nature, action painting is painting in the medium of difficulties.

excerpted from "The American Action Painters," *ARTnews*, vol. 51, no. 8, December 1952, pp. 22–23. © ARTnews, LI, No. 8, December 1952. Reprinted by permission.

Harold Rosenberg was an early champion of Abstract Expressionism. In this article, he formulated the phrase "action painting," often used thereafter by other critics and the public. Rosenberg was art critic for *The New Yorker* from 1962 until his death in 1978. He regularly contributed to *ARTnews* from the early 1950s on.

Clement Greenberg, "'American-Type' Painting," 1955

Advanced painting continues to create scandal when little new in literature or music does (sculpture is a different question). This would be enough of itself to indicate that painting is the most alive of the avant-garde arts at the present moment, for only a substantial and meaningful newness can upset right-thinking people. But why should painting monopolize this kind of newness? Among a variety of reasons, I single out one that I feel to be most to the point: namely, the relative slowness, despite all appearances to the contrary, of painting's evolution as a modernist art.

Though it may have started toward modernism earlier than the other arts, painting has turned out to have a greater number of *expendable* conventions imbedded in it, or at least a greater number of conventions that are difficult to isolate in order to expend. It seems to be a law of modernism—thus one that applies to almost all art that remains truly alive in our time—that the conventions not essential to the viability of a medium be discarded as soon as they are recognized. This process of self-purification appears to have come to a halt in literature simply because the latter has fewer conventions to eliminate before arriving at those essential to it. In music, the same process, if not halted, seems to have slowed down because it is already so far advanced, most of the expendable conventions of music having proved relatively easy to isolate. I am simplifying drastically, of course. And it is understood, I hope, that conventions are overhauled, not for revolutionary effect, but in order to maintain the irreplaceability and renew the vitality of art in the face of a society bent in principle on rationalizing everything. It is

understood, too, that the devolution of tradition cannot take place except in the presence of tradition.

Painting continues, then, to work out its modernism with unchecked momentum because it still has a relatively long way to go before being reduced to its viable essence. Perhaps it is another symptom of this same state of affairs that Paris should be losing its monopoly on the fate of painting. By no one, in recent years, have that art's expendable conventions been attacked more directly or more sustainedly than by a group of artists who came to notice in New York during and shortly after the war. Labeled variously as "abstract expressionism," "action painting" and even "abstract impressionism," their works constitute the first manifestation of American art to draw a standing protest at home as well as serious attention from Europe, where, though deplored more often than praised, they have already influenced an important part of the avant-garde.[1]

These American painters did not set out to be advanced. They set out to paint good pictures that they could sign with their own names, and they have "advanced" in search of qualities analogous with those they admired in the art of the past. They form no movement or school in any accepted sense. They come from different stylistic directions, and if these converge it is thanks largely to a common vitality and a common ambition and inventiveness in relation to a given time, place and tradition. Their work evinces uniform stylistic traits only when compared on the broadest terms with that of artists who work, or worked, in other times, places or relations. The pictures of some of these Americans startle because they seem to rely on ungoverned spontaneity and haphazard effects; or because, at the other extreme, they present surfaces which appear to be largely devoid of pictorial incident. All this is very much seeming. There is good and bad in this art, and when one is able to tell the difference between them he begins to realize that the art in question is subject to a discipline as strict as any that art obeyed in the past. What puzzles one initially—as it puzzled one initially in every new phase of modernism in the past— is the fact that "abstract expressionism" makes explicit certain constant factors of pictorial art that the past left implicit, and leaves implicit, on the other hand, certain other such factors that the past made explicit. The nature of some of these factors will emerge below, but meanwhile let it suffice to repeat that "abstract expressionism" makes no more of a break with the past than anything before it in modernist art has.

Major art is impossible, or almost so, without a thorough assimilation of the major art of the preceding period or periods. In

the 1930s and the early 1940s New York artists were able to assimilate and digest Klee, Miró and the earlier Kandinsky to an extent unmatched elsewhere either then or previously (we know that none of these three masters became a serious influence in Paris until after the war). At the same time Matisse's influence and example were kept alive in New York by Hans Hofmann and Milton Avery in a period when young painters elsewhere were discounting him. In those same years Picasso, Mondrian and even Léger were very much in the foreground in New York—Picasso to such an extent as to threaten to block the way and even the view. Of the utmost importance to those who were to overcome Picasso after learning from him was the accessibility of a large number of early Kandinskys in what is now the Solomon Guggenheim Museum. All in all, this marked the first time that a generation of American artists could start out fully abreast—and perhaps even a little bit ahead—of their contemporaries elsewhere.

But I doubt whether they would have been able to acquire the artistic culture they did without the opportunity for unconstrained work that most of them got in the late 1930s and early 1940s from the Federal Art Project. Or whether they could have launched themselves so well when they began showing without the small but sophisticated audience provided by the students and graduates of Hans Hofmann's art school in New York. This country's distance from the war was another favorable circumstance, and along with it the presence here during the war years of artists like Mondrian, Masson, Léger, Chagall, Ernst and Lipchitz, together with a number of European critics, dealers and collectors. The proximity of these people, if not their attention, gave these new American painters the sense, wholly new in this country, of being in the center of art in their time.

What real justification there is for the term "abstract expressionism" lies in the fact that some of these painters began looking toward German, Russian or Jewish expressionism when they became restive with Cubism and with Frenchness in general. But it remains that every one of them started from French art and got his instinct for style from it; and it was from the French, too, that they all got their most vivid notion of what major, ambitious art had to *feel* like.

The first problem these young Americans seemed to share was that of loosening up the relatively delimited illusion of shallow depth that the three master Cubists—Picasso, Braque, Léger—had adhered to since the closing out of Synthetic Cubism. If they were to be able to say what they had to say, they had also to loosen up that canon of rectilinear and curvilinear regularity in drawing and design

which Cubism had imposed on almost all previous abstract art. These problems were not tackled by program; very little in "abstract expressionism" is, or ever was, programmatic; individual artists may have made "statements" but there were no manifestoes; nor have there been "spokesmen." What happened, rather, was that a certain cluster of challenges was encountered, separately yet almost simultaneously, by six or seven painters who had their first one-man shows at Peggy Guggenheim's Art of This Century gallery in New York between 1943 and 1946. The Picassos of the thirties and, in lesser but perhaps more crucial measure, the Kandinskys of 1910–1918 were then suggesting new possibilities of expression for abstract and near-abstract art that went beyond the enormously inventive, but unfulfilled ideas of Klee's last decade. It was the unrealized Picasso rather than the unrealized Klee who became the important incentive for Americans like Gorky, de Kooning and Pollock, all three of whom set out to catch, and to some extent did catch (or at least Pollock did) some of the uncaught hares that Picasso had started.

Often, the artist who tries to break away from an overpowering precedent will look at first to an alternative one. The late Arshile Gorky submitted to Miró in the latter thirties as if only in order to escape from Picasso, but while exchanging one seeming bondage for another, he made a number of pictures in which we are now able to discern much more independence than we could before. Kandinsky, whose earlier paintings Gorky scrutinized for hours on end in the first years of the forties, had even more of a liberating effect; and so, too, did Gorky's more frequent adoption of the landscape instead of the figure or still life as a starting point. And a short while later, André Breton's personal encouragement began to give him the self-confidence he had lacked until then. But again, and for the last time, he reached for an influence—that of Matta, with whom he had also come into personal contact during the war years. Matta was, and perhaps still is, a very inventive draftsman and, occasionally, a daring no less than flashy painter. His ideas became more substantial, however, in Gorky's more paint-wise hands, which endowed those ideas with new and very "American" qualities of color and surface, transforming and adding so much that their derivation became conspicuously beside the point. Finding his own way out of Picassoid space, Gorky learned to float flat shapes on a melting, indeterminate ground in a difficult stability that was both like and unlike Miró's. Yet, for all his late-won independence, Gorky remained a votary of French taste and an orthodox easel-painter, a virtuoso of line and a tinter rather than a colorist. He became one of the greatest painters that this country and this time produced, but

he finished rather than started something, and the younger painters who try to follow him have condemned themselves to a new kind of academicism.

Willem de Kooning, who was a mature artist long before his first show at Charles Egan's in 1948, is closest to Gorky among the other initiators of "abstract expressionism"; he has a similar culture and a like orientation to French taste. He may be even more gifted as a draftsman, and he is certainly more inventive. At the same time he enjoys both the advantages and the liabilities of an aspiration larger, perhaps, than that of any other living artist. De Kooning's apparent aim is a synthesis of tradition and modernism that would grant him more flexibility within the confines of the Late Cubist canon of design. The dream of a grand style hovers over all this—the dream of an obviously grand and an obviously heroic style.

De Kooning's figurative paintings are haunted as much as his abstract ones are by the disembodied contours of Michelangelo's, Ingres's and even Rubens's nudes. Yet the dragged off-whites, the grays and the blacks in one phase, and the vermilions, yellows and mint greens in another, which insert these contours in shallow depth continue to remind one of Picasso by their application and inflection. There is the same more or less surreptitious shading of every plane, and a similar insistence on sculptural firmness. No more than Picasso can de Kooning tear himself away from the figure and that modeling of it for which his sense of contour and chiaroscuro so well equip him. And there is perhaps even more Luciferian pride behind de Kooning's ambition than there is behind Picasso's: were he to realize all his aims, all other ambitious painting would have to stop for a generation since he would have set both its forward and its backward limits.

De Kooning has won quicker and wider acceptance in this country than any of the other original "abstract expressionists"; his need to include the past as well as to forestall the future seems to reassure a lot of people who still find Pollock incomprehensible. And he does remain a Late Cubist in a self-evident way that none of the others, except Gorky and perhaps Motherwell, approaches. The method of his savagery continued to be almost old-fashionedly, and anxiously, Cubist underneath the flung and tortured color, when he left abstraction for a while to attack the female figure with a fury more explicit than has animated any of Picasso's violations of physiognomical logic. Equally Late Cubist has been his insistence on *finish*, which has been even more of an obstacle in his case than in Gorky's. Perhaps neither de Kooning nor Gorky has ever reached, in finished and edited oils, the heights they have in fugitive, informal sketches, in drawings and in rapidly done oils on paper.



In some ways Hans Hofmann is the most remarkable phenomenon of "abstract expressionism," as well as the exponent of it with the clearest title so far to the appellation of "master." Active and known as a teacher here and in pre-Hitler Germany, Hofmann did not begin showing consistently until 1944, when in his early sixties, which was only a short time after his art had turned outspokenly abstract. He has since then developed as part of a tendency whose next oldest member is at least twenty years younger than himself. It was natural that Hofmann should have been the most mature one in the beginning, but it is really his prematureness rather than his maturity that has obscured the fact that he was the first to open up certain areas of expression that other artists have gone on to exploit with more spectacular success. Hofmann strains to pass beyond the easel convention, and Cubism along with it, even as he strains to cling to them. For many reasons having to do with tradition, convention and habit, we automatically expect pictorial structure to be presented through contrasts of light and dark, but Hofmann, who assimilated the Fauve Matisse before he did Cubism, will juxtapose shrill colors of the same pitch and warmth in a way that, if it does not actually obscure their value contrast, at least renders it jarring and dissonant. This effect will often be reinforced by his drawing: a sudden razor-sharp line will intervene where least expected—or too often where least needed; or thick gobs of paint, without support of a firm edge, will seem to defy every norm of the art of painting. But Hofmann is never so lucid as when he consigns a picture to thicknesses of paint, nor, I am willing to hazard, has any artist of this century outdone him in the handling of such thicknesses. Where he fails most often is, on the contrary, in forcing the issues of clarity and "synthesis," and in offering draftsman's tokens of these that are too familiar.

Like Klee, Hofmann works in a variety of manners, no one of which he has tried to consolidate so far. He is, if anything, all too ready to accept bad pictures in order to get into position for good ones; which makes it look as though he were conspiring with himself to postpone the just recognition of his art—of his noble easel-painting art, which offers to those who know how to look all the abundance of incident and event that belongs traditionally to the easel picture.

I couple Adolph Gottlieb and Robert Motherwell, for all their dissimilarity, only because they both stay closer to Late Cubism, without quite belonging to it, than do any of the artists still to be discussed. It is too generally assumed that the "abstract expressionists" start from little more than inspired impulse, but Motherwell stands out among them, despite many appearances to the

contrary, precisely because of his reliance on impulse and direct feeling—and also because of his lack of real facility. But though he adheres to the simplified, schematic kind of design established by Matisse and Picasso, he is fundamentally less of a Cubist than either de Kooning or Gorky. Nor does he depend as much on taste as is commonly assumed. Motherwell is, in fact, among the least understood, if not the least appreciated, of all the "abstract expressionists."

There is a promising chaos in him, but not of the kind popularly associated with the New York group. Some of his early collages, in a sort of explosive Cubism like that of de Kooning's more recent paintings, have with time acquired an original and profound unity in which seeming confusion resolves itself into an almost elementary orderliness. And between 1946 and 1950, Motherwell did a number of large pictures that will remain among the masterpieces of "abstract expressionism." Several of these, with broad vertical bands of flat black or ochre played off against white or repeats of black and ochre, show how triumphantly the decorative can become utterly dramatic in the ambitious easel painting of our time. Yet Motherwell has also turned out some of the feeblest works done by any of the leading "abstract expressionists," and an accumulation of these in the early 1950s has deceived the art public as to the real scale of his achievement.

Gottlieb has in a sense been an even more uneven artist. His case is almost the opposite of Motherwell's: capable perhaps of a greater range of controlled effects than any other of the group, he has, I feel, lacked the nerve or the presumptuousness to make this plain to a public that got in the habit of accusing him of being influenced by artists whose work he was hardly acquainted with, or whom he himself had influenced in the first place. Over the years, in a characteristically sober way, Gottlieb has made himself one of the surest craftsmen in contemporary painting: one who can, for instance, place a flat and irregular silhouette, that most difficult of all shapes to adjust in isolation to the rectangle, with a force and rightness no other living painter seems capable of. Some of his best work has come since he abandoned his "pictographs" for paintings called "imaginary landscapes" or "seascapes:" that have usually proved too difficult for Cubist-trained eyes. The one serious objection I have to make to Gottlieb's art in general—and it is related perhaps to the lack of nerve, or rather nerviness, I have just mentioned—is that he works too tightly, too partly, in relation to the frame, whence comes the "set," over-enclosed, static look that diminishes the original power of many of his pictures. But power as such, Gottlieb has in abundance. Right now he seems the least tired

of all the original "abstract expressionists," and one who will give us a lot more than he has given us so far. In the future Gottlieb's status will, I feel sure, be less contested than that of some other artists in the group under discussion.

Pollock was very much of a Late Cubist as well as a hard and fast easel-painter when he entered into his maturity. The first pictures he showed—in murky, igneous colors with fragments of imagery—startled people less by their means than by the violence of temperament they revealed. Pollock had compiled hints from Picasso, Miró, Siqueiros, Orozco and Hofmann to create an allusive and altogether original vocabulary of Baroque shapes with which he twisted Cubist space to make it speak with his own vehemence. Until 1946 he stayed within an unmistakably Cubist framework, but the early greatness of his art bears witness to the success with which he was able to expand it. Paintings like the *She Wolf* (1943) and *Totem I* (1945) take Picassoid ideas and make them speak with an eloquence and emphasis that Picasso himself never dreamed of in their connection. Pollock cannot build with color, but he has a superlative instinct for resounding oppositions of light and dark, and at the same time he is alone in his power to assert a paint-strewn or paint-laden surface as a single synoptic image.

It may be a chronological fact that Mark Tobey was the first to make, and succeed with, easel pictures whose design was "all-over"—that is, filled from edge to edge with evenly spaced motifs that repeated themselves uniformly like the elements in a wallpaper pattern, and therefore seemed capable of repeating the picture beyond its frame into infinity. Tobey first showed his "white writings" in New York in 1944, but Pollock had not seen them when he did his own first "all-over" pictures in the late summer of 1946, in dabs and ribbons of thick paint that were to change at the end of the year into liquid spatters and trickles. Back in 1944, however, he had noticed one or two curious paintings shown at Peggy Guggenheim's by a "primitive" painter, Janet Sobel (who was, and still is, a housewife living in Brooklyn). Pollock (and I myself) admired these pictures rather furtively: they showed schematic little drawings of faces almost lost in a dense tracery of thin black lines lying over and under a mottled field of predominantly warm and translucent color. The effect—and it was the first really "all-over" one that I had ever seen, since Tobey's show came months later—was strangely pleasing. Later on, Pollock admitted that these pictures had made an impression on him. But he had really anticipated his own "all-overness" in a mural he did for Peggy Guggenheim at the beginning of 1944, which is now at the University of Illinois. Moreover when, at the end of 1946, he began working consistently with skeins and

blotches of enamel paint, the very first results he got had a boldness
and breadth unparalleled by anything seen in Sobel or Tobey.

By means of his interlaced trickles and spatters, Pollock created
an oscillation between an emphatic surface—further specified by
highlights of aluminum paint—and an illusion of indeterminate but
somehow definitely shallow depth that reminds me of what Picasso
and Braque arrived at thirty-odd years before, with the facet-planes
of their Analytical Cubism. I do not think it exaggerated to say that
Pollock's 1946–1950 manner really took up Analytical Cubism from
the point at which Picasso and Braque had left it when, in their
collages of 1912 and 1913, they drew back from the utter
abstractness for which Analytical Cubism seemed headed. There is
a curious logic in the fact that it was only at this same point in his
own stylistic evolution that Pollock himself became consistently and
utterly abstract. When he, in his turn, drew back, it was in 1951,
when he found himself halfway between easel painting and an
uncertain kind of portable mural. And it was in the next year that,
for the first time since arriving at artistic maturity, he became
profoundly unsure of himself.

The years 1947 and 1948 constituted a turning point for
"abstract expressionism." In 1947 there was a great stride forward
in general quality. Hofmann entered a new phase, and a different
kind of phase, when he stopped painting on wood or fiberboard and
began using canvas. In 1948 painters like Philip Guston and
Bradley Walker Tomlin "joined up," to be followed two years later
by Franz Kline. Rothko abandoned his "surrealist" manner; de
Kooning had his first show; and Gorky died. But it was only in
1950 that "abstract expressionism" jelled as a general
manifestation. And only then did two of its henceforth conspicuous
features, the huge canvas and the black and white oil, become
ratified.

Gorky was already trying his hand at the big picture in the early
1940s, being the first in this direction as in others. The increasing
shallowness of his illusion of depth was compelling the ambitious
painter to try to find room on the literal surface of his canvas for an
equivalent of the pictorial transactions he used to work out in the
imagined three-dimensional space behind it. At the same time he
began to feel a need to "escape" from the frame—from the enclosing
rectangle of the canvas—which Cézanne and the Cubists had
established as the all-controlling coordinate of design and drawing
(making explicit a rule that the Old Masters had faithfully observed
but never spelled out). With time, the obvious reference of every
line and even stroke to the framing verticals and horizontals of the
picture had turned into a constricting habit, but it was only in the

middle and late 1940s, and in New York, that the way out was discovered to lie in a surface so large that its enclosing edges would lay outside or only on [the] periphery of the artist's field of vision as he worked. In this way he was able to arrive at the frame as a *result*, instead of subjecting himself to it as something given in advance. But this was not all that the large format did, as we shall see below.

It was in 1945, or maybe even earlier, that Gorky painted black and white oils that were more than a *tour de force*. De Kooning followed suit about a year or two later. Pollock, after having produced isolated black and white pictures since 1947, did a whole show of them in 1951. But it was left to Franz Kline, a latecomer, to restrict himself to black and white consistently, in large canvases that were like monumental line drawings. Kline's apparent allusions to Chinese or Japanese calligraphy encouraged the cant, already started by Tobey's case, about a general Oriental influence on "abstract expressionism." This country's possession of a Pacific coast offered a handy received idea with which to explain the otherwise puzzling fact that Americans were at last producing a kind of art important enough to be influencing the French, not to mention the Italians, the British and the Germans.

Actually, not one of the original "abstract expressionists"—least of all Kline—has felt more than a cursory interest in Oriental art. The sources of their art lie entirely in the West; what resemblances to Oriental modes may be found in it are an effect of convergence at the most, and of accident at the least. And the new emphasis on black and white has to do with something that is perhaps more crucial to Western painting than to any other kind. Value contrast, the opposition of the lightness and darkness of colors, has been Western pictorial art's chief means, far more important than perspective, to that convincing illusion of three-dimensionality which distinguishes it most from other traditions of pictorial art. The eye takes its first bearings from quantitative differences of illumination, and in their absence feels most at loss. Black and white offers the extreme statement of these differences. What is at stake in the new American emphasis on black and white is the preservation of something—a main pictorial resource—that is suspected of being near exhaustion; and the effort at preservation is undertaken, in this as in other cases, by isolating and exaggerating that which one wants to preserve.

And yet the most radical of all the phenomena of "abstract expressionism"—and the most revolutionary move in painting since Mondrian—consists precisely in an effort to repudiate value contrast as the basis of pictorial design. Here again, Cubism has revealed

itself as a conservative and even reactionary tendency. The Cubists may have discredited sculptural shading by inadvertently parodying it, but they succeeded in restoring value contrast to its old pre-eminence as the means to design and form as such, undoing all that the Impressionists and the Late Impressionists, and Gauguin and the Fauves, had done to reduce its role. Until his very last pictures Mondrian relied on light and dark contrast as implicitly as any academic artist of his time, and the necessity of such contrast went unquestioned in even the most doctrinaire abstract art. Malevich's *White on White* remained a mere symptom of experimental exuberance, and implied nothing further—as we can see from what Malevich did later. Until a short while ago Monet, who had gone furthest in the suppression of value contrast, was pointed to as a warning in even the most adventurous circles, and Vuillard's and Bonnard's *fin de siècle* muffling of light and dark kept them for a long while from receiving their due from the avant-garde.

It was maybe a dozen years ago that some of Monet's later paintings began to seem "possible" to people like myself, which was at about the same time that Clyfford Still emerged as one of the original and important painters of our time—and perhaps as more original, if not more important, than any other in his generation. His paintings were the first *serious* abstract pictures I ever saw that were almost altogether devoid of decipherable references to Cubism; next to them, Kandinsky's early filiations with Analytical Cubism became more apparent than ever. And as it turned out, Still, along with Barnett Newman, was an admirer of Monet.

The paintings I remember from Still's first show, in 1946, were in a vein of abstract symbolism, with "archaic" as well as Surrealist connotations of a kind much in the air at that moment, and of which Gottlieb's "pictographs" and Rothko's "dream landscapes" gave another version. I was put off then by Still's slack, willful silhouettes, which seemed to defy every consideration of plane or frame; the result looked to me then—and perhaps would still look so—like a kind of art in which everything was allowed. Still's subsequent shows, at Betty Parsons', were in what I saw as a radically different manner, but they still struck me as being utterly uncontrolled. The few large and vertically arranged area-shapes which made up the typical Still of that time—and really continue to make up the typical Still of today—were too arbitrary in contour, and too hot and dry in color as well as in paint quality, for my taste. I was reminded, uncomfortably, of amateur Victorian decoration. Not until 1953, when for the first time I saw a Still of 1948 alone on a wall, did I begin to get an intimation of his real quality. And after I had seen several more of his pictures in

isolation that intimation became large and definite. (And I was impressed, aside from everything else, and as never before, by how upsetting and estranging originality in art could be; how the greater its challenge to taste, the more stubbornly and angrily taste would resist it.)

Turner, really, was the one who made the first significant break with the conventions of light and dark. In his last period he bunched value intervals together at the light end of the color scale, to show how the sky's light or any brilliant illumination tended to obliterate half tones and quarter tones of shading and shadow. The picturesque effects Turner arrived at made his public forgive him relatively soon for the way he had dissolved sculptural form. Besides, clouds, steam, mist, water and atmosphere were not expected to have definite shapes, and so what we now take for a daring abstractness on Turner's part was then accepted in the end as another feat of naturalism. The same applies to Monet's close-valued late painting. Iridescent colors please banal taste in any event, and will as often as not be accepted as a satisfactory substitute for verisimilitude. But even when Monet darkened or muddied his color, the public of his time still did not seem to object. It may be that the popular appetite for sheer or close-valued color revealed by this popular acceptance of Turner's and Monet's late phases signified the emergence of a new kind of pictorial taste in Europe, in reaction perhaps against Victorian color. Certainly, what was involved was an uncultivated taste that ran counter to high tradition, and what may have been expressed was an underground change in Western sensibility. This may also help explain why the later painting of Monet, after having for such a long time made the avant-garde shudder, should now begin to stand forth as a peak of revolutionary art.

How much conscious attention Still has paid to this aspect of Monet's painting I do not know, but Still's uncompromising art has its own kind of affinity with popular or bad taste. It is the first body of painting I know of that asks to be called Whitmanesque in the worst as well as the best sense, indulging as it does in loose and sweeping gestures, and defying certain conventions (like light and dark) in the same gauche way that Whitman defied meter. And just as Whitman's verse assimilated to itself quantities of stale journalistic and oratorical prose, Still's painting assimilates to itself some of the stalest and most prosaic painting of our time: in this case, the kind of open-air painting in autumnal colors (and they prevail regardless of season) that may have begun with Old Crome and the Barbizon School, but which has spread among half-trained painters only since Impressionism became popular. Though of an

astounding homogeneity, this kind of painting is not "primitive"; its practitioners usually draw with a semblance of academic correctness. Every one of them is intent, moreover, and intent in a uniform way, on an Impressionistic vividness of light effect that lies beyond their uniformly inadequate command of the capacities of oil color, which is due in turn to their inability ever to learn how to take into account the limitations of oil color. These painters try to match the brightness of sunlight with incrustations of dry paint, and seek to wrest directly, from the specific hue and density and grain of a pigment, effects of open-air lighting that, as the Impressionists themselves have shown, can be obtained or approximated, only through *relations*. The process of painting becomes, for these half-trained artists, a race between hot shadows and hot lights in which both lose; the result is inevitably a livid, sour picture with a brittle, unpleasant surface. Examples of this kind of landscape abound in the outdoor shows around Washington Square and in Greenwich Village restaurants, and I understand that they abound in Europe too. (I can see how easy it is to fall into "sweet and sour" color when lights and darks are not put in beforehand, and especially when the paint is reworked and re-covered constantly in the effort to increase its brightness, but I cannot for the life of me understand why the results should be so uniform and why the legion of those who devote most of their time to this sort of art can never learn anything more than they do.)

Still is the only artist I know of who has managed to put this demotic-Impressionist kind of painting, with its dark heat and dry skin (dry under no matter how much varnishing or glazing) into serious and sophisticated art. And he has even taken over some of the drawing that goes with this species of "buckeye," to judge from the frayed-leaf and spread-hide contours that wander across his canvases like souvenirs of the great American outdoors. These things can spoil a picture or render it weird in an unrefreshing way, but when such a picture does succeed it represents the rehabilitation of one more depressed area of art.

But what is most important about Still, aside from his quality, is that he shows abstract painting a way beyond Late Cubism that can be taken, as Pollock's cannot, by other artists. Still is the only "abstract expressionist" to have founded a school, by which I mean that at least two of the many painters he has stimulated and influenced have not lost their independence thereby. Barnett Newman is one of these, and Newman might have realized himself in much the same way had he never seen a Still. Though Newman runs bands of color which are generally dimly contrasted, in either hue or value, across or down "blank" areas of paint, he is not interested in

straight lines or even flat surfaces; his art has nothing whatsoever to do with Mondrian's, Malevich's, or anything else in geometrical abstraction. His thin, straight, but not always sharp-edged lines, and his incandescent color zones are means to a vision as broad as any other expressed in the painting of our day. Still may have led in opening the picture down its middle, and in the interlocking of area-shapes, but Newman, I think, has influenced Still in turn in the matter of a forthright verticality as well as in that of an activated, pregnant "emptiness." And at the same time Newman's color functions more exclusively as *hue* with less help from differences of value, saturation or warmth.

Newman's huge and darkly burning pictures constitute perhaps the most direct attack yet on the easel convention. Mark Rothko's rejection of that convention is less aggressive. That his art appears, moreover, to be indebted as much to Newman as to Still (Rothko has, in effect, turned the former's vertical line sideways) detracts absolutely nothing from its independence, uniqueness or perfection. Nor does the fact that the originality of Rothko's color, like the originality of Newman's and Still's, manifests itself first of all in a persistent bias toward warmth; or even that, like Newman (though it is Rothko who probably did the influencing here), he seems to soak his paint into the canvas to get a dyer's effect and avoid the connotations of a discrete layer of paint on *top* of the surface. (Actually, the two or three banks of somber but glowing color that compose the typical Rothko painting achieve the effect they do because they are scumbled over other colors.) Where Rothko separates himself most perhaps from Newman and Still is in his willingness to accept something from French art *after* Impressionism; his way of insinuating certain contrasts of warm and cool, I feel, does betray a lesson he learned from Matisse. But this, again, explains very little. The simple and firm sensuousness, and the splendor, of Rothko's pictures belong entirely to himself.

A new kind of flatness, one that breathes and pulsates, is the product of the darkened, value-muffling warmth of color in the paintings of Newman, Rothko and Still. Broken by relatively few incidents of drawing or design, their surfaces exhale color with an enveloping effect that is enhanced by size itself. One reacts to an environment as much as to a picture hung on a wall. But still, in the end one does react to the picture as a picture, and in the end these pictures, like all others, stand or fall by their unity as taken in at a single glance. The issue is raised as to just where the pictorial stops and the decorative begins, and the issue is surmounted. Artiness may be the great liability of these three painters but it is not the artiness of the decorative.

What is most new, and ironical, is the refusal of Newman's and Rothko's linearity to derive from or relate in any way to Cubism. Mondrian *had* to accept his straight lines, and Still has had to accept the torn and wandering ones left by his palette knife. Rothko and Newman have refused, however, to take the way out of Cubist geometry that Still shows them. They have preferred to *choose* their way out rather than be compelled to it; and in choosing, they have chosen to escape geometry through geometry itself. Their straight lines, Newman's especially, do not echo those of the frame, but parody it. Newman's picture becomes all frame in itself, as he himself makes clear in three special paintings he has done— paintings three to four feet long but only two to three inches wide, that are covered with but two or three vertical bands of color. What is destroyed is the Cubist, and immemorial, notion and feeling of the picture edge as a confine; with Newman, the picture edge is repeated inside, and *makes* the picture, instead of merely being *echoed*. The limiting edges of Newman's larger canvases, we now discover, act just like the lines inside them: to divide but not to separate or enclose or bound; to delimit, but not limit. The paintings do not merge with surrounding space; they preserve—when they succeed—their integrity and separate unity. But neither do they sit there in space like isolated, insulated objects; in short, they are hardly that, they have escaped the "object" (and luxury-object) associations that attach themselves increasingly to the easel picture. Newman's paintings have to be called, finally, "fields."

So, too, do Still's, but they make a different point, and one easier to grasp. The Old Masters had kept the frame in mind because it was necessary, whether they wished it or not, to integrate the surface and remind the eye that the picture was flat; and this had to be done in some part by insisting on the shape of the surface. What had been a mere necessity for the Old Masters became an urgency for Cézanne when his pictures began flattening themselves of their own accord. He had to resort to drawing and design that was more geometrical, or regular, than that of the Old Masters because he had to deal with a surface made hypersensitive by the draining of the sculptural illusion behind it. Edges could be prevented from breaking through this tautened surface only by being kept regular and near-geometrical, so that they would echo the shape of the frame more insistently; to the same end it was also useful to orient edges, whether regular or not, on clearly vertical or horizontal axes corresponding to those of the frame's top, bottom and sides. This was the system that the Cubists inherited, but which Late Cubism converted into an inhibiting habit. Still's great insight was to recognize that the edges of a shape could be made less conspicuous,

therefore less cutting, by narrowing the value contrast that its color made with the colors adjacent to it. This permitted the artist to draw and design with greater freedom in the absence of a sufficient illusion of depth; with the muffling of light-and-dark contrasts, the surface was spared the sudden jars or shocks that might result from "complicatedness" of contour. The early Kandinsky may have had a glimpse of this solution, but if he did it was hardly more than a glimpse. Pollock had had more than that in several of his huge "sprinkled" canvases of 1950—*One* and *Lavender Mist*—as well as in *Number One* (1948), he had literally pulverized value contrasts in a vaporous dust of interfused lights and darks in which every suggestion of a sculptural effect was obliterated. (But in 1951 Pollock had turned to the other extreme, as if in violent repentance, and had done a series of paintings, in linear blacks alone, that took back almost everything he had said in the three previous years.)

It was left to Still not only to define the solution but also to make it viable. This—along with Still's personality—may explain the number of his followers at present. It may also explain why William Scott, the British painter, said that Still's art was the only completely and originally American kind he had ever seen. This is not necessarily a compliment—Pollock, who is less "American," despite all the journalism to the contrary, has a larger vision, and Hofmann, who was born and brought up abroad, is capable of more real variety—but Scott meant it very much as a compliment.

When they started out, the "abstract expressionists" had had the traditional diffidence of American artists. They were very much aware of the provincial fate lurking all around them. This country had not yet made a single contribution to the mainstream of painting or sculpture. What united the "abstract expressionists" more than anything else was their resolve to break out of this situation. By now, most of them (along with the sculptor, David Smith) have done so, whether in success or failure. Whatever else may remain doubtful, the "centrality," the resonance, of the work of these artists is assured.

When I say, in addition, that such a galaxy of strong and original talents has not been seen in painting since the days of Cubism, I shall be accused of chauvinist exaggeration, not to speak of the lack of a sense of proportion. But I make no more allowance for American art than I do for any other kind. At the Biennale in Venice in 1954, I saw how de Kooning's exhibition put to shame not only the neighboring one of Ben Shahn, but that of every other painter his age or under in the other pavilions. The general impression is still that an art of high distinction has as much chance of coming out of this country as a great wine. Literature—

yes, we know that we have done some great things in that line; the English and French have told us so. Now they can begin to tell us the same about our painting.*

*First published in *Partisan Review* in 1955. From *Art and Culture: Critical Essays*. Boston: Beacon Press, 1961, pp. 208–29. Copyright © 1961 by Clement Greenberg. Reprinted by permission of Beacon Press.

[1]I believe Robert Coates of *The New Yorker* invented "abstract expressionism," at least in order to apply it to American painting; it happens to be very inaccurate as a covering term. "Action painting" was concocted by Harold Rosenberg in *Art News*. "Abstract impressionism" denotes very inaccurately certain after-comers, none of whom are dealt with in this piece. In London, I heard Patrick Heron refer in conversation to "American-type painting," which at least has the advantage of being without misleading connotations. It is only because "abstract expressionism" is the most current term that I use it here more often than any other. Charles Estienne calls the French equivalent *"tachisme;"* Michel Tapié has dubbed it *"art informel"* and *"art autre."* Estienne's label is far too narrow, while both of Tapié's are radically misleading in the same way that "action painting" is. Since the Renaissance began calling medieval art "Gothic," tendencies in art usually have received their names from enemies. But now these names seem to be more the product of misunderstanding and impotence than of outright hostility, which only makes the situation worse.

Clement Greenberg was one of the first critics to write passionately on behalf of the new advanced American painters. This essay is the centerpiece of his critical writing on the subject and deals with its aesthetics and historical framework.

[Addenda] Letter to Clyfford Still from Clement Greenberg, 1955

15 April 55

Dear Clyfford Still,

I'm glad you didn't find my piece [American-Type Painting] too far wrong about your painting, but if Barney's upset about it, I'll be upset too. I know he's been difficult lately, but he's one person I make allowances for (which have nothing to do with his art but with him personally) and I'll have to try to straighten it out with him. If he's said hard things about me behind my back, that's too bad, but it won't make much difference in the way I feel about him. I just can't help liking him no matter how impatient he might make me.

But let me tell you meanwhile that before I finished the article, neither he nor any one else tried to "educate" me about your art beyond the point of saying that they liked it or didn't like it. The Pollocks did say that you had influenced Rothko and Barney, but I knew that anyhow. Barney, like the Pollocks, Rothko, and Ossorio, has in expressing his admiration for your painting never attempted

to characterize it or explain it in my hearing. Nor has anyone ever told me anything that you yourself have said about your own work or your attitude to painting in general.

In my piece I stated the source of every perception or generalization that I had gotten from someone else. All the rest is strictly my own. What I said about your work came straight from my own experience of it. It's no compliment to me to imply that whatever I had to say in criticism of it was the result of briefing. Of course, we're all open to suggestion, unconsciously, but as I've said, I can remember no one's having characterized your work in other than qualitative terms to me *before* I sent the article to press.

Barney was the first one I heard name a certain kind of painting as buckeye, but he did not apply the term to yours. When I, some time later, told Barney that I thought there was a relation between buckeye and your painting, or rather some aspects of it, he protested vehemently and said your stuff was too good for that. And when I went on to characterize you as the first Whitmanesque artist I knew of, he was willing to agree with me to the extent that I meant it as a compliment—which I did in large part, more than I myself realized. In any case Barney has always praised you and stood up for you, and done it more steadfastly than most people do for artists they admire. Nothing he has ever said to me about you could be construed as indicating the slightest jealousy. I wish I myself had a defender like him.

Incidentally, I began admiring the late Monet before I heard from Barney that he did, and when I related Monet to the Still "school" it was without prompting from him. Had I gotten the notion from him I would have said so in my piece. (I'm taking the trouble to explain these things because I have the impression from your letter that you think, or were told, that Barney briefed me on your work and what to say about it.)

I'm sorry that you feel that my "public effort" in behalf of "American-type" painting will be negated by the qualifications I expressed about your painting. I disagree with you. I've learned something about such things in recent years, and according to what I've learned, the main point is to take an important artist importantly. You don't, I hope, doubt that I take you importantly. And another point is to say what you really think and feel. Otherwise you'll get caught out, and it won't do anybody any good. At the same time I can understand how you in particular feel, since you've had to sweat it out as nobody else on the scene has before getting recognition. I take my hat off to you for that, and I'll say it in print some time. A lot of Barney's present bitterness comes, I feel, from his unwillingness to sweat it out with his art. But I never

saw anything really good come along in art that didn't require the artist concerned to sweat it out before getting recognition. (I assume we all want recognition; I know I do.)

Thanks for your letter, and I'm glad you think I'm honest. If I am, it's by calculation; you just can't get away in the long run with being anything else.

Sincerely,
Clement Greenberg

from Clement Greenberg Correspondence, Archives of American Art microfilm no. N70-7, frame no. 527. © Clement Greenberg. Reprinted by permission.

The preceding letter was sent in response to a letter from Clyfford Still dated April 12, 1955. Four months later, on August 9, Barnett Newman wrote to Greenberg on the same topic. The Still and Newman letters were not available for publication. While the substance of Greenberg's essay was not radically altered when it was revised for re-publication in 1958, certain points were shifted and refined, including some of those touched on by Still and Newman in their letters, both of which contained strong objections.

Randall Jarrell, "The Age of the Chimpanzee," 1957

A devil's advocate opposes, as logically and forcibly as he can, the canonization of a new saint. What he says is dark, and serves the light. The devil himself, if one can believe Goethe, is only a sort of devil's advocate. Here I wish to act as one for Abstract-Expressionism.

Continued long enough, a quantitative change becomes qualitative. The latest tradition of painting, Abstract-Expressionism, seems to me revolutionary. It is not, I think, what it is sometimes called: the purified essence of that earlier tradition which has found a temporary conclusion in painters like Bonnard, Picasso, Matisse, Klee, Kokoschka. It is the specialized, intensive exploitation of one part of such painting, and the rejection of other parts and of the whole.

Earlier painting is a kind of metaphor: the world of the painting itself, of the oil-and-canvas objects and their oil-and-canvas relations is one that stands for—that has come into being because of—the world of flesh-and-blood objects and their flesh-and-blood relations, the "very world, which is the world/ Of all of us,—the place where, in the end,/ We find our happiness or not at all." The relation between the representing and the represented world sometimes is a direct, mimetic one; but often it is an indirect, far-

fetched, surprising relation, so that it is the difference between the subject and the painting of it that is insisted upon, and is a principal source of our pleasure. In the metaphors of painting, as in those of poetry, we are awed or dazed to find things superficially so unlike, fundamentally so like; superficially so like, fundamentally so unlike. Solemn things are painted gaily; overwhelmingly expressive things—the Flagellation, for instance—painted inexpressively; Vollard is painted like an apple, and an apple like the Fall; the female is made male or sexless (as in Michelangelo's *Night*), and a dreaming, acquiescent femininity is made to transfigure a body factually masculine (as in so many of the nude youths on the ceiling of the Sistine Chapel). Between the object and its representation there is an immense distance: within this distance much of painting lives.

All this sums itself up for me in one image. In Georges de la Tour's *St. Sebastian Mourned by St. Irene* there is, in the middle of a dark passage, a light one: four parallel cylinders diagonally intersected by four parallel cylinders; they look like a certain sort of wooden fence, as a certain sort of Cubist painter would have painted it; they are the hands, put together in prayer, of one of St. Irene's companions. As one looks at what has been put into—withheld from—the hands, one is conscious of a mixture of emotion and empathy and contemplation; one is moved, and is unmoved, and is something else one has no name for, that transcends either affect or affectlessness. The hands are truly like hands, yet they are almost more truly unlike hands; they resemble (as so much art resembles) the symptomatic gestures of psychoanalysis, half the expression of a wish and half the defense against the wish. But these parallel cylinders of La Tour's—these hands at once oil-and-canvas and flesh-and-blood; at once dynamic processes in the virtual space of the painting, and spiritual gestures in the "very world" in which men are martyred, are mourned, and paint the mourning and the martyrdom—these parallel cylinders are only, in an Abstract-Expressionist painting, four parallel cylinders: they are what they are.

You may say, more cruelly: "If they are part of such a painting, by what miracle have they remained either cylindrical or parallel? In this world bursting with action and accident—the world, that is, of Abstract-Expressionism—are they anything more than four homologous strokes of the paint-brush, inclinations of the paint-bucket; the memory of four gestures, and of the four convulsions of the Unconscious that accompanied them? . . . We need not ask—they are what they are: four oil-and-canvas processes in an oil-and-canvas continuum; and if, greatly daring, we venture beyond this

world of the painting itself, we end only in the painter himself. A universe has been narrowed into what lies at each end of a paint brush."

But ordinarily such painting—a specialized, puritanical reduction of earlier painting—is presented to us as its final evolution, what it always ought to have been and therefore "really" was. When we are told (or worse still, shown) that painting "really" is "nothing but" this, we are being given one of those definitions which explain out of existence what they appear to define, and put a simpler entity in its place. If this is all that painting is, why, what painting was was hardly painting. Everyone has met some of the rigorously minded people who carry this process of reasoning to its conclusion, and value Piero della Francesca and Goya and Cézanne only in so far as their paintings are, in adulterated essence, the paintings of Jackson Pollock. Similarly, a few centuries ago, one of those Mannerist paintings in which a Virgin's face is setting after having swallowed alum must have seemed, to a contemporary, what a Donatello Virgin was "really" intended to be, "essentially" was.

The painting before Abstract-Expressionism might be compared to projective geometry: a large three-dimensional world of objects and their relations, of lives, emotions, significances, is represented by a small cross-section of the rays from this world, as they intersect a plane. Everything in the cross-section has two different kinds of relations: a direct relation to the other things in the cross-section, and an indirect—so to speak, transcendental—relation to what it represents in the larger world. And there are also in the small world of the picture-process many absences or impossible presences, things which ought to be there but are not, things which could not possibly be there but are. The painter changes and distorts, simplifies or elaborates the cross-section; and the things in the larger world resist, and are changed by, everything he does, just as what he has done is changed by their resistance. Earlier painters, from Giotto to Picasso, have dealt with two worlds and the relations between the two: their painting is a heterogeneous, partly indirect, many-levelled, extraordinarily complicated process. Abstract-Expressionism has kept one part of this process, but has rejected as completely as it could the other part and all the relations that depend on the existence of this other part; it has substituted for a heterogeneous, polyphonic process a homogeneous, homophonic process. One sees in Abstract-Expressionism the terrible esthetic disadvantages of directness and consistency. Perhaps painting can do without the necessity of imitation; can it do without the possibility of distortion?

As I considered some of the phrases that have been applied to

Abstract-Expressionism—revolutionary; highly non-communicative; non-representational; uncritical; personal; maximizing randomness; without connection with literature and the other arts; spontaneous; exploiting chance or unintended effects; based on gesture; seeking a direct connection with the Unconscious; affirming the individual; rejecting the external world; emphasizing action and the process of making the picture—it occurred to me that each of them applied to the work of a painter about whom I had just been reading. She has been painting only a little while, yet most of her paintings have already found buyers, and her friends hope, soon, to use the money to purchase a husband for the painter. She is a chimpanzee at the Baltimore Zoo. Why should I have said to myself, as I did say: "I am living in the first age that has ever bought a chimpanzee's paintings?" It would not have occurred to me even to get her to paint them; yet in the case of Action Painting, is it anything but unreasoning prejudice which demands that the painter be a man? Hath not an ape hands? Hath not an animal an Unconscious, and quite a lot less Ego and Superego to interfere with its operations?

I reminded myself of this as, one Saturday, I watched on Channel 9 a chimpanzee painting; I did not even say to myself, "I am living in the first age that has ever televised a chimpanzee painting." I watched him (since he was dressed in a jumper, and named Jeff, I judged that he was a male) dispassionately. His painting, I confess, did not interest me; I had seen it too many times before. But the way in which he painted it! He was, truly, magistral. He did not look at his model once; indeed, he hardly looked even at the canvas. Sometimes his brush ran out of paint and he went on with the dry brush—they had to remind him that the palette was there. He was the most active, the most truly sincere, painter that I have ever seen; and yet, what did it all produce?—nothing but that same old Abstract-Expressionist painting. . . .

I am joking. But I hope it is possible to say of this joke what Goethe said of Lichtenberg's: "Under each of his jokes there is a problem." There is an immense distance between my poor chimpanzee's dutiful, joyful paintings and those of Jackson Pollock. The elegance, force and command of Pollock's best paintings are apparent at a glance—are, indeed, far more quickly and obviously apparent than the qualities of a painter like Chardin. But there is an immense distance, too, between Pollock's paintings and Picasso's; and this not entirely the result of a difference of native genius. If Picasso had limited himself to painting the pictures of Jackson Pollock—limited himself, that is, to the part of his own work that might be called Abstract-Expressionism—could he have been as great a painter as he is? I ask this as a typical, general question; if

I spoke particularly I should of course say: If Picasso limited himself in anything he would not be Picasso: he loves the world so much he wants to steal it and eat it. Pollock's anger at things is greater than Picasso's, but his appetite for them is small; is neurotically restricted. Much of the world—much, too, of the complication and contradiction, the size and depth of the essential process of earlier painting—is inaccessible to Pollock. It has been made inaccessible by the provincialism that is one of the marks of our age.

As I go about the world I see things (people; their looks and feelings and thoughts; the things their thoughts have made, and the things that neither they nor their thoughts had anything to do with making: the whole range of the world) that, I cannot help feeling, Piero della Francesca or Brueghel or Goya or Cézanne would paint if they were here now—could not resist painting. Then I say to my wife, sadly: "What a pity we didn't live in an age when painters were still interested in the world!" This is an exaggeration, of course, even in the recent past many painters have looked at the things of this world and seen them as marvelously as we could wish. But ordinarily, except for photographers and illustrators—and they aren't at all the same—the things of our world go unseen, unsung. All that the poet must do, Rilke said, is praise: to look at what is, and to see that it is good, and to make out of it what is at once the same and better, is to praise. Doesn't the world need the painter's praise anymore?

Malraux, drunk with our age, can say about Cézanne: "it is not the mountain he wants to realize but the picture." All that Cézanne said and did was not enough to make Malraux understand what no earlier age could have failed to understand: that to Cézanne the realization of the picture necessarily involved the realization of the mountain. And whether we like it or not, notice it or not, the mountain is still there to be realized. Man and the world are all that they ever were—their attractions are, in the end, irresistible; the painter will not hold out against them long.

from *ARTnews*, vol. LVI, no. 4, summer, 1957, pp 34–36. © ARTnews, LVI, no. 4, Summer 1957. Reprinted by permission.

Randall Jarrell was a leading American poet and literary critic who also wrote art criticism for *ARTnews* from 1951 to 1957.

Meyer Schapiro, "The Liberating Quality of Avant-Garde Art," 1957

"The vital role that painting and sculpture play in modern culture"

In discussing the place of painting and sculpture in the culture of our time, I shall refer only to those kinds which, whether abstract or not, have a fresh inventive character, that art which is called "modern" not simply because it is of our century, but because it is the work of artists who take seriously the challenge of new possibilities and wish to introduce into their work perceptions, ideas and experiences which have come about only within our time.

In doing so I risk perhaps being unjust to important works or to aspects of art which are generally not comprised within the so-called modern movement.

There is a sense in which all the arts today have a common character shared by painting; it may therefore seem arbitrary to single out painting as more particularly modern than the others. In comparing the arts of our time with those of a hundred years ago, we observe that the arts have become more deeply personal, more intimate, more concerned with experiences of a subtle kind. We note, too, that in poetry, music and architecture, as well as in painting, the attitude to the medium has become much freer, so that artists are willing to search further and to risk experiments or inventions which in the past would have been inconceivable because of fixed ideas of the laws and boundaries of the arts. I shall try to show however that painting and sculpture contribute qualities and values less evident in poetry, music and architecture.

It is obvious that each art has possibilities given in its own medium which are not found in other arts, at least not in the same degree. Of course, we do not know how far-reaching these possibilities are; the limits of an art cannot be set in advance. Only in the course of work and especially in the work of venturesome personalities do we discover the range of an art, and even then in a very incomplete way.

In the last fifty years, within the common tendency towards the more personal, intimate and free, painting has had a special role because of a unique revolutionary change in its character. In the first decades of our century painters and sculptors broke with the long-established tradition that their arts are arts of representation, creating images bound by certain requirements of accord with the forms of nature.

That great tradition includes works of astounding power upon which artists have been nourished for centuries. Its principle of representation had seemed too self-evident to be doubted, yet that

tradition was shattered early in this century. The change in painting and sculpture may be compared to the most striking revolutions in science, technology, and social thought. It has affected the whole attitude of painters and sculptors to their work. To define the change in its positive aspect, however, is not easy because of the great diversity of styles today even among advanced artists.

One of the charges brought most frequently against art in our time is that because of the loss of the old standards, it has become chaotic, having no rule or direction. Precisely this criticism was often made between 1830 and 1850, especially in France, where one observed side by side works of Neo-classic, Romantic, and Realistic art—all of them committed to representation. The lack of a single necessary style of art reminded many people of the lack of clear purpose or of common ideals in social life. What seemed to be the anarchic character of art was regarded as a symptom of a more pervasive anarchy or crisis within society as a whole.

But for the artists themselves—for Ingres, Delacroix and Courbet—each of these styles was justified by ideal ends that they served, whether of order, liberty or truth; and when we look back now to the nineteenth century, the astonishing variety of its styles, the many conflicting movements and reactions, and the great number of distinct personalities, appear to us less as signs of weakness in the culture than as examples of freedom, individuality and sincerity of expression. These qualities corresponded to important merging values of the social and political life of that period, and even helped to sustain them.

In the course of the last fifty years the painters who freed themselves from the necessity of representation discovered whole new fields of form-construction and expression (including new possibilities of imaginative representation) which entailed a new attitude to art itself. The artist came to believe that what was essential in art—given the diversity of themes or motifs—were two universal requirements: that every work of art has an individual order or coherence, a quality of unity and necessity in its structure regardless of the kind of forms used; and, second, that the forms and colors chosen have a decided expressive physiognomy, that they speak to us as a feeling-charged whole, through the intrinsic power of colors and lines, rather than through the imaging of facial expressions, gestures and bodily movements, although these are not necessarily excluded—for they are also forms.

That view made possible the appreciation of many kinds of old art and of the arts of distant peoples—primitive, historic, colonial, Asiatic and African, as well as European—arts which had not been accessible in spirit before because it was thought that true art had

to show a degree of conformity to nature and of mastery of representation which had developed for the most part in the West. The change in art dethroned not only representation as a necessary requirement but also a particular standard of decorum or restraint in expression which had excluded certain domains and intensities of feeling. The notion of the humanity of art was immensely widened. Many kinds of drawing, painting, sculpture and architecture, formerly ignored or judged inartistic, were seen as existing on the same plane of human creativeness and expression as "civilized" Western art. That would not have happened, I believe, without the revolution in modern painting.

The idea of art was shifted, therefore, from the aspect of imagery to its expressive, constructive, inventive aspect. That does not mean, as some suppose, that the old art was inferior or incomplete, that it had been constrained by the requirements of representation, but rather that a new liberty had been introduced which had, as one of its consequences, a greater range in the appreciation and experience of forms.

The change may be compared, perhaps, with the discovery by mathematicians that they did not have to hold to the axioms and postulates of Euclidian geometry, which were useful in describing the everyday physical world, but could conceive quite other axioms and postulates and build up different imaginary geometries. All the new geometries, like the old, accepted one, were submitted to the rules of logic; in each geometry the new theorems had to be consistent with each other and with the axioms and postulates. In painting as in mathematics, the role of structure or coherence became more evident and the range of its applications was extended to new elements.

The change I have described in the consciousness of form is more pronounced in painting and sculpture than it is in any other art. It is true that music and architecture are also unconcerned with representation—the imaging of the world—but they have always been that. The architect, the musician, and the poet did not feel that their arts had undergone so profound a change, requiring as great a shift in the attitude of the beholder, as painting and sculpture in the beginning of our century. Within the totality of arts, painting and sculpture, more than the others, gave to artists in all mediums a new sense of freedom and possibility. It was the ground of a more general emancipation.

Even poets, who had always been concerned with images and with language as a medium which designates, poets, too, now tried to create a poetry of sounds without sense. But that movement did not last very long, at least among English-speaking poets, although

it was strong at one time in Russia and exists today in Holland and Belgium.

This sentiment of freedom and possibility, accompanied by a new faith in the self-sufficiency of forms and colors, became deeply rooted within our culture in the last fifty years. And since the basic change had come about through the rejection of the image function of painting and sculpture, the attitudes and feelings which are bound up with the acceptance or rejection of the environment entered into the attitude of the painter to the so-called abstract or near-abstract styles, affecting also the character of the new forms. His view of the external world, his affirmation of the self or certain parts of the self, against devalued social norms—these contributed to his confidence in the necessity of the new art.

Abstraction implies then a criticism of the accepted contents of the preceding representations as ideal values or life interests. This does not mean that painters, in giving up landscape, no longer enjoy nature; but they do not believe, as did the poets, the philosophers and painters of the nineteenth century, that nature can serve as a model of harmony for man, nor do they feel that the experience of nature's moods is an exalting value on which to found an adequate philosophy of life. New problems, situations and experiences of greater import have emerged: the challenge of social conflicts and development, the exploration of the self, the discovery of its hidden motivations and processes, the advance of human creativeness in science and technology.

All these factors should be taken into account in judging the significance of the change in painting and sculpture. It was not a simple studio experiment or an intellectual play with ideas and with paint; it was related to a broader and deeper reaction to basic elements of common experience and the concept of humanity, as it developed under new conditions.

In a number of respects, painting and sculpture today may seem to be opposed to the general trend of life. Yet, in such opposition, these arts declare their humanity and importance.

Paintings and sculptures, let us observe, are the last hand-made, personal objects within our culture. Almost everything else is produced industrially, in mass, and through a high division of labor. Few people are fortunate enough to make something that represents themselves, that issues entirely from their hands and mind, and to which they can affix their names.

Most work, even much scientific work, requires a division of labor, a separation between the individual and the final result; the personality is hardly present even in the operations of industrial planning or in management and trade. Standardized objects

produced impersonally and in quantity establish no bond between maker and user. They are mechanical products with only a passing and instrumental value.

What is most important is that the practical activity by which we live is not satisfying: we cannot give it full loyalty, and its rewards do not compensate enough for the frustrations and emptiness that arise from the lack of spontaneity and personal identifications in work: the individual is deformed by it, only rarely does it permit him to grow.

The object of art is, therefore, more passionately than ever before, the occasion of spontaneity or intense feeling. The painting symbolizes an individual who realizes freedom and deep engagement of the self within his work. It is addressed to others who will cherish it, if it gives them joy, and who will recognize in it an irreplaceable quality and will be attentive to every mark of the maker's imagination and feeling.

The consciousness of the personal and spontaneous in the painting and sculpture stimulates the artist to invent devices of handling, processing, surfacing, which confer to the utmost degree the aspect of the freely made. Hence the great importance of the mark, the stroke, the brush, the drip, the quality of the substance of the paint itself, and the surface of the canvas as a texture and field of operation—all signs of the artist's active presence. The work of art is an ordered world of its own kind in which we are aware, at every point, of its becoming.

All these qualities of painting may be regarded as a means of affirming the individual in opposition to the contrary qualities of the ordinary experience of working and doing.

I need not speak in detail about this new manner, which appears in figurative as well as abstract art; but I think it is worth observing that in many ways it is a break with the kind of painting that was most important in the 1920s. After the First World War, in works like those of Léger, abstraction in art was affected by the taste for industry, technology and science, and assumed the qualities of the machine-made, the impersonal and reproducible, with an air of coolness and mechanical control, intellectualized to some degree. The artist's power of creation seems analogous here to the designer's and engineer's. That art, in turn, avowed its sympathy with mechanism and industry in an optimistic mood as progressive elements in everyday life, and as examples of strength and precision in production which painters admired as a model for art itself. But the experiences of the last twenty-five years have made such confidence in the values of technology less interesting and even distasteful.

In abstraction we may distinguish those forms, like the square and circle, which have object character and those which do not. The first are closed shapes, distinct within their field and set off against a definite ground. They build up a space which has often elements of gravity, with a clear difference between above and below, the ground and the background, the near and far. But the art of the last fifteen years tends more often to work with forms which are open, fluid or mobile; they are directed strokes or they are endless tangles and irregular curves, self-involved lines which impress us as possessing the qualities not so much of things as of impulses, of excited movements emerging and changing before our eyes.

The impulse, which is most often not readily visible in its pattern, becomes tangible and definite on the surface of a canvas through the painted mark. We see, as it were, the track of emotion, its obstruction, persistence or extinction. But all these elements of impulse which seem at first so aimless on the canvas are built up into a whole characterized by firmness, often by elegance and beauty of shapes and colors. A whole emerges with a compelling, sometimes insistent quality of form, with a resonance of the main idea throughout the work. And possessing an extraordinary tangibility and force, often being so large that it covers the space of a wall and therefore competing boldly with the environment, the canvas can command our attention fully like monumental painting in the past.

It is also worth remarking that as the details of form become complicated and free and therefore hard to follow in their relation to one another, the painting tends to be more centered and compact— different in this respect from the type of abstraction in which the painting seems to be a balanced segment of a larger whole. The artist places himself in the focus of your space.

These characteristics of painting, as opposed to the characteristic of industrial production, may be found also in the different sense of the words "automatic" and "accidental" as applied in painting, technology and the everyday world.

The presence of chance as a factor in painting, which introduces qualities that the artist could never have achieved by calculation, is an old story. Montaigne in the sixteenth century already observed that a painter will discover in his canvas strokes which he had not intended and which are better than anything he might have designed. That is a common fact in artistic creation.

Conscious control is only one source of order and novelty: the unconscious, the spontaneous and unpredictable are no less present in the good work of art. But that is something art shares with other activities and indeed with the most obviously human function:

speech. When we speak, we produce automatically a series of words which have an order and a meaning for us, and yet are not fully designed. The first word could not be uttered unless certain words were to follow, but we cannot discover, through introspection, that we had already thought of the words that were to follow. That is a mystery of our thought as well.

Painting, poetry, and music have this element of unconscious, improvised serial production of parts and relationships in an order, with a latent unity and purposefulness. The peculiarity of modern painting does not lie simply in its aspect of chance and improvisation but elsewhere. Its distinctiveness may be made clear by comparing the character of the formal elements of old and modern art.

Painters often say that in all art, whether old or modern, the artist works essentially with colors and shapes rather than with natural objects. But the lines of a Renaissance master are complex forms which depend on already ordered shapes in nature. The painting of a cup in a still-life picture resembles an actual cup, which is itself a well-ordered thing. A painting of a landscape depends on observation of elements which are complete, highly ordered shapes in themselves—like trees or mountains.

Modern painting is the first complex style in history which proceeds from elements that are not pre-ordered as closed articulated shapes. The artist today creates an order out of unordered variable elements to a greater degree than the artist of the past.

In ancient art an image of two animals facing each other orders symmetrically bodies which in nature are already closed symmetrical forms. The modern artist, on the contrary, is attracted to those possibilities of form which include a considerable randomness, variability and disorder, whether he finds them in the world or while improvising with his brush, or in looking at spots and marks, or in playing freely with shapes—inverting, adjusting, cutting, varying, reshaping, regrouping, so as to maximize the appearance of randomness. His goal is often an order which retains a decided quality of randomness as far as this is compatible with an ultimate unity of the whole. That randomness corresponds in turn to a feeling of freedom, an unconstrained activity at every point.

Ignoring natural shapes, he is alert to qualities of movement, interplay, change, and becoming in nature. And he provokes within himself, in his spontaneous motions and play, an automatic production of chance.

While in industry accident is that event which destroys an order, interrupts a regular process and must be eliminated, in painting the

random or accidental is the beginning of an order. It is that which the artist wishes to build up into an order, but a kind of order that in the end retains the aspect of the original disorder as a manifestation of freedom. The order is created before your eyes and its law is nowhere explicit. Here the function of ordering has, as a necessary counterpart, the element of randomness and accident.

Automatism in art means the painter's confidence in the power of the organism to produce interesting unforeseen effects and in such a way that the chance results constitute a family of forms; all the random marks made by one individual will differ from those made by another, and will appear to belong together, whether they are highly ordered or not, and will show a characteristic grouping. (This is another way of saying that there is a definite style in the seemingly chaotic forms of recent art, a general style common to many artists and unique individual styles.) This power of the artist's hand to deliver constantly elements of so-called chance or accident, which nevertheless belong to a well-defined, personal class of forms and groupings, is submitted to critical control by the artist who is alert to the rightness or wrongness of the elements delivered spontaneously, and accepts or rejects them.

No other art today exhibits to that degree in the final result the presence of the individual, his spontaneity and the concreteness of his procedure.

This art is deeply rooted, I believe, in the self and its relation to the surrounding world. And the pathos of the reduction or fragility of the self within a culture that becomes increasingly organized through industry, economy and the state intensifies the desire of the artist to create forms that will manifest his liberty in this striking way—a liberty that in the best works, is associated with a sentiment of harmony, and the opposite stability, and even impersonality through the power of painting to universalize itself in the perfection of its form and to reach out into common life. It becomes then a possession of everyone and is related to everyday experience.

Another aspect of modern painting and sculpture which is opposed to our actual world and yet is related to it—and appeals particularly because of this relationship—is the difference between painting and sculpture on the one hand and what are called the "arts of communication." This term has become for many artists one of the most unpleasant in our language.

In the mediums of communication which include the newspaper, the magazine, the radio and TV, we are struck at once by certain requirements that are increasingly satisfied through modern technical means and the ingenuity of scientific specialists. Communication, in this sense, aims at a maximum efficiency

through methods that ensure the attention of the listener or viewer by setting up the appropriate reproducible stimuli which will work for everyone and promote the acceptance of the message. Distinction is made between message and that which interferes with message, i.e. noise—that which is irrelevant. And devices are introduced to ensure that certain elements will have an appropriate weight in the reception.

The theory and practice of communication today help to build up and to characterize a world of social relationships which is impersonal, calculated and controlled in its elements, aiming always at efficiency.

The methods of study applied in the theory of communication have been extended to literature, music and painting as arts which communicate. Yet it must be said that what makes painting and sculpture so interesting in our times is their high degree of non-communication. You cannot extract a message from painting by ordinary means; the usual rules of communication do not hold here, there is no clear code or fixed vocabulary, no certainty of effect in a given time of transmission or exposure. Painting, by becoming abstract and giving up its representational function, has achieved a state in which communication seems to be deliberately prevented. And in many works where natural forms are still preserved, the objects and the mode of representation resist an easy decipherment and the effects of these works are unpredictable.

The artist does not wish to create a work in which he transmits an already prepared and complete message to a relatively indifferent and impersonal receiver. The painter aims rather at such a quality of the whole that, unless you achieve the proper set of mind and feeling towards it, you will not experience anything of it at all.

Only a mind opened to the qualities of things, with a habit of discrimination, sensitized by experience and responsive to new forms and ideas, will be prepared for the enjoyment of this art. The experience of the work of art, like the creation of the work of art itself, is a process ultimately opposed to communication as it is understood now. What has appeared as noise in the first encounter becomes in the end message or necessity, though never message in a perfectly reproducible sense. You cannot translate it into words or make a copy of it which will be quite the same thing.

But if painting and sculpture do not communicate they induce an attitude of communion and contemplation. They offer to many an equivalent of what is regarded as part of religious life: a sincere and humble submission to a spiritual object, an experience which is not given automatically, but requires preparation and purity of spirit. It is primarily in modern painting and sculpture that such

contemplativeness and communion with the work of another human being, the sensing of another's perfected feeling and imagination, becomes possible.

If painting and sculpture provide the most tangible works of art and bring us closer to the activity of the artist, their concreteness exposes them, more than the other arts, to dangerous corruption. The successful work of painting or sculpture is a unique commodity of market value. Paintings are perhaps the most costly man-made objects in the world. The enormous importance given to a work of art as a precious object which is advertised and known in connection with its price is bound to affect the consciousness of our culture. It stamps the painting as an object of speculation, confusing the values of art. The fact that the work of art has such a status means that the approach to it is rarely innocent enough; one is too much concerned with the future of the work, its value as an investment, its capacity to survive in the market and to symbolize the social quality of the owner. At the same time no profession is as poor as the painter's, unless perhaps the profession of the poet. The painter cannot live by his art.

Painting is the domain of culture in which the contradiction between the professed ideals and the actuality is most obvious and often becomes tragic.

About twenty-five years ago a French poet said that if all artists stopped painting, nothing would be changed in the world. There is much truth in that statement, although I would not try to say how much. (It would be less true if he had included all the arts.) But the same poet tried later to persuade painters to make pictures with political messages which would serve his own party. He recognized then that painting could make a difference, not only for artists but for others; he was not convinced, however, that it would make a difference if it were abstract painting, representing nothing.

It is only in terms of an older experience of the arts as the carriers of messages, as well as objects of contemplation, that is, arts with a definite religious or political content, sustained by institutions—the Church, the schools, the State—that the poet conceived the function of painting. It is that aspect of the old art which the poet hoped could be revived today, but with the kind of message that he found congenial.

Nevertheless, in rejecting this goal, many feel that if the artist works more from within—with forms of his own invention rather than with natural forms—giving the utmost importance to spontaneity, the individual is diminished. For how can a complete personality leave out of his life work so much of his interests and

experience, his thoughts and feelings? Can these be adequately translated into the substance of paint and the modern forms with the qualities I have described?

These doubts, which arise repeatedly, are latent within modern art itself: the revolution in painting that I have described, by making all the art of the world available, has made it possible for artists to look at the paintings of other times with a fresh eye, and suggests to them alternatives to their own art. And the artist's freedom of choice in both subject and form opens the way to endless reactions against existing styles.

But granting the importance of all those perceptions and values which find no place in painting today, the artist does not feel obliged to cope with them in his art. He can justify himself by pointing to the division of labor within our culture, if not in all cultures. The architect does not have to tell stories with his forms; he must build well and build nobly. The musician need not convey a statement about particular events and experiences or articulate a moral or philosophical commitment. Representation is possible today through other means than painting and with greater power than in the past.

In the criticism of modern painting as excluding large sectors of life, it is usually assumed that past art was thoroughly comprehensive. But this view rests on an imperfect knowledge of older styles. Even the art of the cathedrals, which has been called encyclopedic, represents relatively little of contemporary actuality, though it projects with immense power an established world-view through the figures and episodes of the Bible. Whether a culture succeeds in expressing in artistic form its ideas and outlook and experiences is to be determined by examining not simply the subject-matter of one art, like painting, but the totality of its arts, and including the forms as well as the themes.

Within that totality today painting has its special tasks and possibilities discovered by the artists in the course of their work. In general, painting tends to reinforce those critical attitudes which are well represented in our literature: the constant searching of the individual, his motives and feelings, the currents of social life, the gap between actuality and ideals.

If the painter cannot celebrate many current values, it may be that these values are not worth celebrating. In the absence of ideal values stimulating to his imagination, the artist must cultivate his own garden as the only secure field in the violence and uncertainties of our time. By maintaining his loyalty to the value of art—to responsible creative work, the search for perfection, the sensitiveness to quality—the artist is one of the most moral and

idealistic of beings, although his influence on practical affairs may
seem very small.

Painting by its impressive example of inner freedom and
inventiveness and by its fidelity to artistic goals, which include the
mastery of the formless and accidental, helps to maintain the critical
spirit and the ideals of creativeness, sincerity and self-reliance,
which are indispensable to the life of our culture.

originally appeared in *ARTnews*, vol. 56, no. 4, summer 1957, pp. 36–42. Reprinted in
*Modern Art: Nineteenth and Twentieth Centuries (The Selected Papers of Meyer Schapiro: Vol
II)*. © George Braziller. Reprinted by permission.

Meyer Schapiro was Professor of Art History at Columbia University from 1928 until his
retirement in 1973. A noted scholar of Early Christian, Byzantine, and Romanesque art, as
well as an expert in 19th- and 20th-century European art, Schapiro took an early interest in
Abstract Expressionism.

Frank Getlein, "Schmeerkunst and Politics," 1959

More complex and more interesting than the paintings themselves
are the explications, theologies and cosmogonies occasioned by that
body of painting known as abstract expressionism, action painting,
tachism or the New York school, and which includes among its chief
practitioners the late Jackson Pollock, Mark Rothko, Willem de
Kooning, James Brooks, Franz Kline, Philip Guston and others.

The typical work of each of the above named artists is instantly
recognizable as his own, though it is not so easy to tell one example
from another. The work is also readily describable in simple
English, though not only is this almost never done by its admirers,
but when straightforward description is attempted, this is usually
resented by the admirers. The reaction is curious. To be sure, any
lover understandably resents an objective description of his beloved,
for such a description is bound to miss the whole point of the
exquisite creature's existence. But that traditional resentment is
particularly out of place in connection with an art which has as a
virtue "unapologetic materialism." That phrase of Sam Hunter's
about Pollock I take to refer to the insistence upon paint—or sand
and gravel—as the primary material in a painting.

Positive values in the new painting are all isolated and exaggerated presentations of values that have existed in many previous ways of painting. Texture, space, an awareness of the paint surface and for that matter the supreme contemporary virtue, an awareness of the act of painting visible in the finished product, all these elements of painting may be found in painters from Duccio to Picasso. In most earlier work these specific values were subordinated to larger aims of the painter. Today they have become aims in themselves. Such concentration is a perfectly defensible course for a painter to take. The values themselves, however, get obscured by the metaphysics constructed around the new painting.

The basic metaphysical point about abstract expressionism is also an old insight—a work of art should not mean but be. Having insisted on this truism and applied it with crude literalness, the exegetes of the new painting proceed to write volumes on the meaning of the pure beings of paint and canvas.

One of the more popular meanings found in Pollock and others of the present generation, was found earlier in the Fauves, the Cubists, Dada and the Surrealists. This is the decline and fall of the West. These vital young men, it is held, could not paint so outrageously if the times were not out of joint. The world is going to hell: our artists paint hellish pictures. In Pollock's painting, writes John Berger in the *New Statesman*, "one can see the disintegration of our culture . . . the consequences of his living by and subscribing to all our profound illusions about such things as the role of the individual, the nature of history, the function of morality."

One can; obviously, Mr. Berger can. One can also see simply the disintegration of a painter or a group of painters. I don't know about Mr. Berger, but I never voted for Pollock to be my symbol and representative in my hour of disintegration. I think it was Chesterton who wrote to Eliot, "*You* may end with a whimper, but *I* shall end with a bang."

Then there is the rhetoric of space, whence Levine's derisive "Space cadets" for the whole movement. Parker Tyler, an *Art News* rhetor, writes, "Pollock's extreme style is a model of the astronomic universe as it looks in the eye of a super-telescope. This explains why the principle of a continuously definable abstract space— carried further by him than by anyone else—is at the other pole from that of conventional continuity of space. . . . Pollock's deep feeling for the existence of voids paradoxically accounts for the rich physicality of paint with which he has cemented the Loneliness of the Universe."

Prose structure has superceded paint structure.

Finally, there is the burlesqued existentialism of the sacred *act* (it

has to be italicized) of painting. The only truly free gesture left us is the gesture of the painter in painting and so on for many pages. This shifts the focus from the product to the process as in schoolboy sports: "It's how you play the game." The change of painting to one of the performing arts has been refined by an endless *Art News* series on painters in process and by the French painter Mathieu's more or less public performances. Again noteworthy is the adolescent literalness with which ancient catchwords are applied. The unreasoned act of violence that is the *act* of painting makes its prior appearance in French and Russian novels [which], as works of art, are highly reasoned objects.

No one can object to painters amusing themselves with the chance flow of paint nor to critics acting as tea-leaf readers if they find that amusing. What is objectionable and what is the most interesting aspect of the whole situation is the strident insistence that abstract expressionism is the one permissible manner of painting. As a corollary, it is insisted that the critic's duty is to advance such painters and to ignore or to crush all others.

Behind this lies a laudable patriotism. Abstract expressionism is seen as America's long awaited contribution to art. It is exported as such in the exhibitions of the Museum of Modern Art's International Counsel. The Americanism of the new movement is disputed by European critic Michel Seuphor, who says it is Kandinsky all over again and was born in Munich around 1912. At any rate the patriotic ardor is at the pitch that produces high tariffs and America First. The most recent variant of the patriotic appeal is the liberal appeal addressed by Thomas B. Hess, executive editor of *Art News*, to this journal: if you go for "advanced" political thought, you must go for "advanced" painting.

The *New Republic*'s editors replied that they see no connection between art and politics, at least in terms of interlocking commitments. I disagree. In the exaltation of an undefined Americanism as a supreme value, in the preference for simple existence to any meaning, and in the cherishing of sincerity without regard to results, I find abstract expressionism and its prophets to be a splendid artistic equivalent of Eisenhower Republicanism in politics. Which called the other into being, I can't guess. But they arrived in the public consciousness together and together, I like to think, will softly and suddenly vanish about two years from now.

from *The New Republic*, vol. CXL, no. 6, February 9, 1959, p. 29. Reprinted by permission of *The New Republic*, © 1959, The New Republic, Inc.

Frank Getlein was art critic for *The New Republic* from 1957 until 1967. The attitude evinced is typical of the frustration which many critics and artists felt with the gathering acceptance and critical acclaim gained by the Abstract Expressionists by the end of the 1950s.

John Canaday, "The City and the New York School," 1960

. . . The energetic confusion and the high emotional color of this
city explain why the painters called—so appropriately in this
light—"The New York School" are obsessed with the sweeping,
splashing, lunging, agitated forms typical of the majority of them. It
explains too why this style as adopted wholesale all over the country
has such a hollow ring in the work of imitators who inhabit the
prairies west, the bayous south, and the green hills north, of
Newark. It explains why contemporary American painting fascinates
artists on the other side of the Atlantic, yet repels them even while
they adopt it—the cocktail in the country of subtle wines.

It explains in our country the difference between Mark Tobey and
Jackson Pollock (a philosopher and an athlete) and it explains why
the rigidly controlled school of abstract painting runs such a poor
second to action painting on Manhattan Island, and why even
Mondrian, in his last years here, began to paint jumpy
compositions.

In the ebullience, the vitality, and the exuberance of its first
youth the art of . . . abstract expressionism captured the common
denominator of a city. But it did not begin to capture the common
denominator of a nation; it is New York painting, not American
painting. And even as New York painting, there is plenty of
question as to whether it gives any order or meaning, as art should
do, to the energy it expresses, or whether it has created only
explosive fragments. That is my quarrel with even the best of it.

Perhaps abstract expressionism cannot mean anything because the
vast welter of New York is in itself meaningless, an unhappy
possibility. If so, then the quarrel is not with the artist's limitation
but with our time and our city, of which abstract expressionism
offers a complete and authentic expression. But it seems to me that
the expression is no more complete and authentic than are fireworks
as an expression of what the Fourth of July means.

Fireworks are wonderful to look at but I do not think that they
offer a very profound experience, and I would not want the sky filled
with them all night, year after year. Similarly I enjoy looking at
abstract expressionist painting, but there is a limit to how much of
it one can take, and I am tired of hearing that its skyrockets are
cosmic manifestations.

New York is always called an exciting city, and so it is. But the
things that make it exciting also make it monotonous if they are not
tied to something deeper than surface movement and color. That is
what I look for in abstract expressionist painting, and do not find,

and that is why I find it monotonous. A fine place for a visit, but I wouldn't want to live there (without the sustenance of those inner human values that are universal—even to New Yorkers—yet are non-existent in the painting of the New York School).

excerpted from *The Embattled Critic*, New York: Noonday Press, 1962, pp. 24–29 (First published in *The New York Times*, May 22, 1960) © John Canaday, 1962, Noonday Press. Courtesy of the Estate of John Canaday

John Canaday was art critic for *The New York Times* from 1959 until 1976. He was a highly visible and influential critic with New York City's most important newspaper, and his reluctance to embrace abstract art, and in particular, his steadfast resistance to Abstract Expressionism, placed him in the center of controversy. It is important to note that his reaction to Abstract Expressionist art was very much in line with that of the general public. (See letter to the editor, p. 227).

Robert Rosenblum, "The Abstract Sublime," 1961

How Some of the Most Heretical Concepts of Modern American Abstract Painting Relate to the Visionary Nature-painting of a Century Ago

"It's like a religious experience!" With such words, a pilgrim I met in Buffalo last winter attempted to describe his unfamiliar sensations before the awesome phenomenon created by seventy-two Clyfford Stills at the Albright Art Gallery. A century and a half ago, the Irish Romantic poet, Thomas Moore, also made a pilgrimage to the Buffalo area, except that his goal was Niagara Falls. His experience, as recorded in a letter to his mother, July 24, 1804, similarly beggared prosaic response:

"I felt as if approaching the very residence of the Deity; the tears started into my eyes; and I remained, for moments after we had lost sight of the scene, in that delicious absorption which pious enthusiasm alone can produce. We arrived at the New Ladder and descended to the bottom. Here all its awful sublimities rushed full upon me . . . My whole heart and soul ascended towards the Divinity in a swell of devout admiration, which I never before experienced. Oh! bring the atheist here, and he cannot return an atheist! I pity the man who can coldly sit down to write a description of these ineffable wonders: much more do I pity him who can submit them to the admeasurement of gallons and yards . . . We must have new combinations of language to describe the Fall of Niagara."

Moore's bafflement before a unique spectacle, his need to abandon measurable reason for mystical empathy, are the very

ingredients of the mid-twentieth-century spectator's "religious experience" before the work of Still. During the Romantic Movement, Moore's response to Niagara would have been called an experience of the "Sublime," an aesthetic category that suddenly acquires fresh relevance in the face of the most astonishing summits of pictorial heresy attained in America in the last fifteen years.

Originating with Longinus, the Sublime was fervently explored in the later eighteenth and early nineteenth centuries and recurs constantly in the aesthetics of such writers as Burke, Reynolds, Kant, Diderot, and Delacroix. For them and for their contemporaries, the Sublime provided a flexible semantic container for the murky new Romantic experiences of awe, terror, boundlessness, and divinity that began to rupture the decorous confines of earlier aesthetic systems. As imprecise and irrational as the feelings it tried to name, the Sublime could be extended to art as well as to nature. One of its major expressions, in fact, was the painting of sublime landscapes.

A case in point is the dwarfing immensity of Gordale Scar, a natural wonder of Yorkshire and a goal of many Romantic tourists. Re-created on canvas between 1811 and 1815 by the British painter James Ward (1769–1855), *Gordale Scar* is meant to stun the spectator into an experience of the Sublime that may well be unparalleled in painting until a work like Clyfford Still's *1957-D*. In the words of Edmund Burke, whose *Philosophical Enquiry into the Origin of Our Ideas of the Sublime and the Beautiful* (1757) was the most influential analysis of such feelings, "Greatness of dimension is a powerful cause of the sublime." Indeed, in both the Ward and the Still, the spectator is first awed by the sheer magnitude of the sight before him. (Ward's canvas is 131 by 166 inches; Still's, 113 by 159 inches.) At the same time, his breath is held by the dizzy drop to the pit of an abyss; and then, shuddering like Moore at the bottom of Niagara, he can only look up with what senses are left him and gasp before something akin to divinity.

Lest the dumbfounding size of these paintings prove insufficient to paralyze the spectator's traditional habits of seeing and thinking, both Ward and Still insist on a comparably bewildering structure. In the Ward, the chasms and cascades, whose vertiginous heights transform the ox, deer, and cattle into Lilliputian toys, are spread out into unpredictable patterns of jagged silhouettes. No laws of man or man-made beauty can account for these God-made shapes; their mysterious, dark formations (echoing Burke's belief that obscurity is another cause of the Sublime) lie outside the intelligible boundaries of aesthetic law. In the Still, Ward's limestone cliffs have been translated into an abstract geology, but the effects are substantially

the same. We move physically across such a picture like a visitor touring the Grand Canyon or journeying to the center of the earth. Suddenly, a wall of black rock is split by a searing crevice of light, or a stalactite threatens the approach to a precipice. No less than caverns and waterfalls, Still's paintings seem the product of eons of change; and their flaking surfaces, parched like bark or slate, almost promise that this natural process will continue, as unsusceptible to human order as the immeasurable patterns of ocean, sky, earth, or water. And not the least awesome thing about Still's work is the paradox that the more elemental and monolithic its vocabulary becomes, the more complex and mysterious are its effects. As the Romantics discovered, all the sublimity of God can be found in the simplest natural phenomena, whether a blade of grass or an expanse of sky.

In his *Critique of Judgment* (1790), Kant tells us that whereas "the Beautiful in nature is connected with the form of the object, which consists in having boundaries, the Sublime is to be found in a formless object, so far as in it, or by occasion of it, *boundlessness* is represented" (I, Book 2, 23). Indeed, such a breathtaking confrontation with a boundlessness in which we also experience an equally powerful totality is a motif that continually links the painters of the Romantic Sublime with a group of recent American painters who seek out what might be called the "Abstract Sublime." In the context of two sea meditations by two great Romantic painters, Caspar David Friedrich's *Monk by the Sea* of about 1809 and Joseph Mallord William Turner's *Evening Star*, Mark Rothko's *Light, Earth and Blue* of 1954 reveals affinities of vision and feeling. Replacing the abrasive, ragged fissures of Ward's and Still's real and abstract gorges with a no less numbing phenomenon of light and void, Rothko, like Friedrich and Turner, places us on the threshold of those shapeless infinities discussed by the aestheticians of the Sublime. The tiny monk in the Friedrich and the fisher in the Turner establish, like the cattle in *Gordale Scar*, a poignant contrast between the infinite vastness of a pantheistic God and the infinite smallness of His creatures. In the abstract language of Rothko, such literal detail—a bridge of empathy between the real spectator and the presentation of a transcendental landscape—is no longer necessary; we ourselves are the monk before the sea, standing silently and contemplatively before these huge and soundless pictures as if we were looking at a sunset or a moonlit night. Like the mystic trinity of sky, water, and earth that, in the Friedrich and Turner, appears to emanate from one unseen source, the floating, horizontal tiers of veiled light in the Rothko seem to conceal a total, remote presence that we can only intuit and never fully grasp. These

infinite, glowing voids carry us beyond reason to the Sublime; we can only submit to them in an act of faith and let ourselves be absorbed into their radiant depths.

If the Sublime can be attained by saturating such limitless expanses with a luminous, hushed stillness, it can also be reached inversely by filling this void with a teeming, unleashed power. Turner's art, for one, presents both of these sublime extremes. In his *Snowstorm* of 1842, the infinities are dynamic rather than static, and the most extravagant of nature's phenomena are sought out as metaphors for this experience of cosmic energy. Steam, wind, water, snow, and fire spin wildly around the pitiful work of man—the ghost of a boat—in vortical rhythms that suck one into a sublime whirlpool before reason can intervene. And if the immeasurable spaces and incalculable energies of such a Turner evoke the elemental power of creation, other works of the period grapple even more literally with these primordial forces. Turner's contemporary, John Martin (1779–1854), dedicated his erratic life to the pursuit of an art which, in the words of the *Edinburgh Review* (1829), "awakes a sense of awe and sublimity, beneath which the mind seems overpowered." Of the cataclysmic themes that alone satisfied him, *The Creation*, an engraving of 1831, is characteristically sublime. With Turner, it aims at nothing short of God's full power, upheaving rock, sky, cloud, sun, moon, stars, and sea in the primal act. With its torrential description of molten paths of energy, it locates us once more on a near-hysterical brink of sublime chaos.

That brink is again reached when we stand before a *perpetuum mobile* of Jackson Pollock, whose gyrating labyrinths re-create in the metaphorical language of abstraction the superhuman turbulence depicted more literally, in Turner and Martin. In *Number 1, 1948*, we are as immediately plunged into divine fury as we are drenched in Turner's sea; in neither case can our minds provide systems of navigation. Again, sheer magnitude can help produce the Sublime. Here, the very size of the Pollock—68 by 104 inches—permits no pause before the engulfing; we are almost physically lost in this boundless web of inexhaustible energy. To be sure, Pollock's generally abstract vocabulary allows multiple readings of its mood and imagery, although occasional titles (*Full Fathom Five, Ocean Greyness, The Deep, Greyed Rainbow*) may indicate a more explicit region of nature. But whether achieved by the most blinding of blizzards or the most gentle of winds and rains, Pollock invariably evokes the sublime mysteries of nature's untamable forces. Like the awesome vistas of telescope and microscope, his pictures leave us dazzled before the imponderables of galaxy and atom.

The fourth master of the Abstract Sublime, Barnett Newman,

explores a realm of sublimity so perilous that it defies comparison with even the most adventurous Romantic exploration into sublime nature. Yet it is worth noting that in the 1940s Newman, like Still, Rothko, and Pollock, painted pictures with more literal references to an elemental nature; and that more recently, he has spoken of a strong desire to visit the tundra, so that he might have the sensation of being surrounded by four horizons in a total surrender to spatial infinity. In abstract terms, at least, some of his paintings of the 1950s already approached this sublime goal. In its all-embracing width (114½ inches), Newman's *Vir Heroicus Sublimis* puts us before a void as terrifying, if exhilarating, as the arctic emptiness of the tundra; and in its passionate reduction of pictorial means to a single hue (warm red) and a single kind of structural division (vertical) for some 144 square feet, it likewise achieves a simplicity as heroic and sublime as the protagonist of its title. Yet again, as with Still, Rothko, and Pollock, such a rudimentary vocabulary creates bafflingly complex results. Thus the single hue is varied by an extremely wide range of light values; and these unexpected mutations occur at intervals that thoroughly elude any rational system. Like the other three masters of the Abstract Sublime, Newman bravely abandons the securities of familiar pictorial geometries in favor of the risks of untested pictorial intuitions; and like them, he produces awesomely simple mysteries that evoke the primeval movement of creation. His very titles (*Onement, The Beginning, Pagan Void, Death of Euclid, Adam, Day One*) attest to this sublime intention. Indeed, a quartet of the largest canvases by Newman, Still, Rothko, and Pollock might well be interpreted as a post-World-War-II myth of Genesis. During the Romantic era, the sublimities of nature gave proof of the divine; today, such supernatural experiences are conveyed through the abstract medium of paint alone. What used to be pantheism has now become a kind of "paint-theism."

Much has been written about how these four masters of the Abstract Sublime have rejected the Cubist tradition and replaced its geometric vocabulary and intellectual structure with a new kind of space created by flattened, spreading expanses of light, color, and plane. Yet it should not be overlooked that this denial of the Cubist tradition is not only determined by formal needs, but also by emotional ones that, in the anxieties of the atomic age, suddenly seem to correspond with a Romantic tradition of the irrational and the awesome as well as with a Romantic vocabulary of boundless energies and limitless spaces. The line from the Romantic Sublime to the Abstract Sublime is broken and devious, for its tradition is more one of an erratic, private feeling than submission to objective

disciplines. If certain vestiges of sublime landscape painting linger into the later nineteenth century in the popularized panoramic travelogues of Americans like Bierstadt and Church (with whom Dore Ashton has compared Still), the tradition was generally suppressed by the international domination of the French tradition, with its familiar values of reason, intellect, and objectivity. At times, the countervalues of the Northern Romantic tradition have been partially reasserted (with a strong admixture of French pictorial discipline) by such masters as van Gogh, Ryder, Marc, Klee, Feininger, Mondrian; but its most spectacular manifestations—the sublimities of British and German Romantic landscape—have only been resurrected after 1945 in America, where the authority of Parisian painting has been challenged to an unprecedented degree. In its heroic search for a private myth to embody the sublime power of the supernatural, the art of Still, Rothko, Pollock, and Newman should remind us once more that the disturbing heritage of the Romantics has not yet been exhausted.

from *ARTnews*, vol. 59, no. 10, February, 1961. © ARTnews, LIX, No. 10, February 1961. Reprinted by permission.

From 1956 until 1966 Robert Rosenblum was Associate Professor of Art History at Princeton University. Since then, he has been Professor of Art History at The Institute of Fine Arts, New York University.

Howard Nemerov, "On Certain Wits," 1958

"On Certain Wits"

> who amused themselves over the
> simplicity of Barnett Newman's
> paintings shown at Bennington
> College in May of 1958

When Moses in Horeb struck the rock,
And water came forth out of the rock,
Some of the people were annoyed with Moses
And said he should have used a fancier stick.

And when Elijah on Mount Carmel brought the rain,
Where the prophets of Baal could not bring the rain,
Some of the people said that the rituals of the prophets of Baal
Were aesthetically significant, while Elijah's were very plain.

University of Chicago Press © 1968 Howard Nemerov

Howard Nemerov was named poet laureate of the United States in 1988.

International Reviews

This section contains excerpts from reviews of the exhibition "The New American Painting," organized by The Museum of Modern Art, New York. The show traveled to Basel, Milan, Madrid, Berlin, Amsterdam, Brussels, Paris, London, and New York in 1958–59. The artists included in the show were Baziotes, James Brooks, Sam Francis, Gorky, Gottlieb, Guston, Grace Hartigan, Kline, de Kooning, Motherwell, Newman, Pollock, Rothko, Stamos, Still, Tomlin, and Jack Tworkov.

Helmi Gasser, *Neue Zürcher Zeitung*, Zurich, May 23, 1958

The great reach of American painting becomes apparent when it not only comprises segments of reality dipped into vivid color by Hartigan, but also the severity of Barnett Newman, although the main influence lies in the direction of *Tachisme.** European influences are caught in the occasional appearance of painterly effects, particularly in absorbing surrealist motifs. Of Kandinsky, who means so much to European abstract painting, there is strikingly little, which is interesting because of the central position that the realization of spatial concept takes up in American painting. This in particular is its decisive character: the direct translation of unlimited space into the gesture of painting itself, whether into expanding form or the continual overflow and intermingling of forms; it is creation which tries for the domination of space. This impelling urge toward utter freedom and uninhibited statement frees this style of painting of all symbolic sign language and allows it to reach the most spontaneous manifestation of emotion.

*The European term for Abstract Expressionism.

Marco Valsecchi, *Il Giorno*, Milan, June 10, 1958

One should not forget that while on the Atlantic coast there was close contact with Europe; on the Pacific, in San Francisco, there were more diverse graftings: the totem poles of the Indians and the Mexicans' intricate baroque, the symbolic and ancient scripts of China and Japan. Such important and stimulating facts could not remain dormant in soil so rich. And the difficulties encountered by this new generation of painters in trying to pierce the indifference of the American public, the necessity of surviving as individuals

without being crushed by the conformism of industrialized life, have added that charge of violence and of personal fury which each of these paintings conveys. It is like witnessing a shipwreck and their fight for survival.

The rapidity and vigor of the results are astonishing. To be objective, I must say that American art derives from European art and is still sensitive to its cultural echoes, but nevertheless its character is so well defined, the images are so abundant and so permeated by the fantasy and motivations of Americans ideals, that one must admit it has by now the look of independence, decisively recognizable.

I feel that this process is taking place among these Americans with unexpected tenderness and lightness of touch, with a feeling of happiness, in spite of past anxieties. This recalls Matisse, and, less directly, Impressionism. Their creative talent is more free because they are not bound to traditions, to deep-rooted cultures, as our artists are. Therefore the American artists succeed in reaching a greater freedom, with results more pleasant, vibrant, and cheerful. We had been told that they were wild: we find instead a festive pictorial quality without dramatic shocks; including Pollock, who plunged deepest into the intricate web of pictorial experiments.

Mario Lepore, *La Tribuna*, Milan, June 15, 1958

Examining the works of the artists represented in this exhibition, in spite of the warning made by the sponsors that the personality of these painters developed in America (even the ones of European origin) we did not find any real American characteristic: either aesthetical or storical. The truth is that the 16 painters are abstract artists, even if some of them give titles to their canvases and if the critics succeed in making some very fine differentiation among them. They use the language of the non-figurative pictorial world: language which had its origins and its evolution in Europe. As for the woman painter she is a representational expressionist and, as such, she too is bound to a European artistic experience. The exhibition is called "The New American Painting," but of new, unless by this we simply intend contemporary, there is nothing. As for "American," the language of abstractions, for its own nature, cannot indicate a meaning, as it is implicit in the adjective. This form of painting is not American but international and of European sources.

But there are in the U.S.A., within the great variety of tendencies that animate its artists, some real American painters, and that is painters who are inspired by American life and have an

American poetic world: Hopper, Ben Shahn, Levine, etc. We believe it would have been better to show the above artists who in addition seem to us, as a sportsman would say, of a better class than the Pollocks and others represented here. But today abstractions are the latest fashion and the organizers, without realizing that they were following a fashion of European origin, have preferred the others.

Mercedes Molleda, *Revista*, Barcelona, August 30, 1958

I had resigned myself to not seeing the exhibition. But others did not resign themselves, and thus in rapid, improvised, and exhausting days, it was possible to move eighty-one canvases, packed in more than forty enormous cases, from Milan to Madrid. To judge the size of the transoceanic guests, a detail will suffice: to bring into the Museum two of the canvases, one by Jackson Pollock and one by Grace Hartigan, required sawing the upper part of the metal entrance door of the building the night before the inauguration.

Upon entering the room, a strange sensation like that of magnetic tension surrounds you, as though the expression concentrated in the canvases would spring from them. They are other myths, other gods, other ideas, different from those prevailing in Europe at present, and from that grayish and textured Parisian fog which also in this country of light and color today masks the polychromatic traditions.

Each picture is a confession, an intimate chat with the Divinity, accepting or denying the exterior world but always faithful to the more profound identity of conscience. The present painting is a mystery to many who wish to understand its significance without entering into its state, thereby committing an error as profound as he who wishes to attain the Moradas of Teresa de Avila by means of intelligence and not by means of Grace.

Will Grohmann, *Der Tagesspiegel*, Berlin, September 7, 1958

The New American Painting is an event, and as such was feted in Basel from where the exhibit came. The fact that the large Pollock one-man show came too, is chance; it had not been intended for Berlin. Pollock is without question the genius of the post-war generation of painters, who were born between 1900 and 1923, and correspond in age to our own successful artists from E. W. Nay to Sonderborg. The youngest, Sam Francis, is born in the same year as

Sonderborg (1923), Mark Rothko about the same time as Nay and Jackson Pollock (1912), as most of our "tachistes," whose leader, the unforgettable Wols, like Jackson Pollock, died an all too early death.

The seventeen American painters at the "Steinplatz," though not drawing on the entire present artistic output of the United States, do present a representative section thereof. In view of the large number of great talents, one can speak of an American School; for the first time in the history of art, personalities are emerging that are not influenced by Europe, but, on the contrary, influence Europe, including Paris, through the convincingness of their conceptions. For nearly ten years Pollock has exerted his influence on the avant-garde of all countries. The appearance of his paintings in Paris and in Venice was a sensation; and since the young Sam Francis lives in Paris, he too is in the center of international interest. The unshakable fortress of the French School is shaken. . . .

Pollock is regarded as a tachist, the originator of the movement, but he is more. In front of his giant canvases one does not think of schools or slogans, but only of talent and singularity. His rich inventiveness and his force of movement and organization are admirable. Here is reality, that of today not of yesterday. A Walt Whitman revival, superabundance of the continent, the sea and the moods, the seizing of the undiscovered world, as 300 years ago, when the pioneers arrived. And what a culture of the painterly. How differentiated the single layers of events are gradated one on top of the other, so that in the end it includes the whole of reality, evoked, not represented, because nothing is represented, all is invented in the spirit of a natural and universal happening.

Pollock was a genius, but by European standards, one can easily count half of the other sixteen to be exceptional talents. Someday these painters too will make their mark in Paris; it will, as in the case of Kandinsky, still take two decades. Only the painters already know today what it is all about. They may not be quite equal to the task, because our society does not know any more the jungle nor a society in progress.

There is, for example, Willem de Kooning, who suggests in his "February" part of a season, in composition and in memory. There are dimensions of memory, but fused to painterly inventions or perhaps it is the opposite. For the spectator that is not essential, he is not concerned with the process, but with the result. De Kooning also has influence; Grace Hartigan, the only woman painter of the group, belongs to his way of expression, and Theodoros Stamos, with his "High Snow" and Jack Tworkov with his "Prophets"? They may have the same conception of what art can be today: They are

painters without regard for the ready-made world. What they paint is real; it is the spectator himself who must have a certain amount of imagination in order to comprehend. Without an actual consciousness of the universe this is not possible. Here there is no comfort, but a struggle with the elements, with society, with fate. It is like the American novel; something happens, and what happens is disquieting and at the same time pregnant with the future. Here we do not have a question of aesthetics, not today, but possibly in another twenty years, when we have gotten used to the idea that painting is also this.

Unknown to us were Clyfford Still and James Brooks, who with their enormous dimensions make us sense what goes on within an American painter, faced with the immensity of his continent and his growing history. These are maps that reach from the South Sea all the way to the Atlantic; and when Brooks calls a painting "Doubt" (1954), it is not meant in a psychological sense (what would we care about the psychology of Mr. Brooks) but in the sense of a universal event. Nevertheless the colours are as optimistic as those of our E. W. Nay, the only one who dares to work in larger dimensions. Still, they would seem like miniatures next to these world maps.

Very different are Mark Rothko and Sam Francis. Both see things from a greater distance, the one as a last residue of remembered prairie or desert, the other as rampant growth without limits. Those are dreams as they exist in childhood, mixed with fear but also with palpitating hope. Every great artist keeps within himself part of this state which is as cruel as it is believing. In Europe childhood dreams are different, more hereditary, more archaic. The archaic lacks in this colonial country, memory does not reach back as far as the Sumerians but only to the Indians, which were encountered on the roads toward the West Coast. That is not yet long ago. Possibly more burdened are those painters, who immigrated from the east, as Arshile Gorky, in this case not from Poland or Russia, but from Armenia. Here we have surreal, tragic, metamorphosed through the centuries, entanglement in accidental anxieties as once Hieronymus Bosch communicated them in his way.

Robert Motherwell and Franz Kline stand apart from the rest. They paint gigantic symbols on the wall and call their proclamations *Elegy for the Spanish Republic* or *Accent Grave*. The paintings are hypotheses of that which could come; but poems by Ezra Pound or the Spaniard Guillen are exactly as hypothetical if one starts with the limitations of one's own imagination. What makes these painters artists is the advance into a world which is not prefabricated, but for that reason is also not boarded in; on the contrary, it is so vast that one hardly dares to enter it. What is emphasized here? An event

that starts like a poem by Ezra Pound and ends with a statute for the investigation of the space of the universe. Greece is not a European suburb anymore.

These are examples of the whole, not a sum total of personalities, not a grouping. Nevertheless, there does exist enough common ground. They all use vast dimensions, not from megalomania, but because one cannot say these things in miniature. Klee was able to do just that; his world was not smaller because of it; he was a monk and wrote the psalter of our speculum. Americans are world travellers and conquerors. They possess an enormous daring. . . . One proves oneself in the doing, in the performance, in the act of creation. In the United States one speaks of Action Painting. We speak of Abstract Expressionism. This difference characterizes Americans as well as Europe. We cannot forget, we distill the conceptions of long experience instead of creating new ones. In any case, these young Americans stand beyond heritage and psychology, nearly beyond good and bad. In Europe we are a little bit afraid before such a lack of prejudice. Could it be that we are already in a state of defense?

Unsigned, *Nieuw Rotterdamse Courant,* Rotterdam, November 15, 1958

Pollock must be given credit for creating, by colors and the movement of line, a dynamism which fascinates the eye. One feels that he has painted in a kind of ecstasy, supported, however, by authentic skill and by a highly developed gift as a colorist. Thus was his work created; a "map" of modern life, a map in which areas of chaos are charted. Pictures consisting of angry, confused lines that are gradually acquiring order, the latter eloquently expressed by color. Consequently, the tension in Pollock's paintings contains an element of relaxation.

De Kooning's work is aggressive, filled with wrath and sometimes with repulsion. But it has dynamism and originality; his color as well, which sometimes makes startling contrasts. In this art, conflicts are expressed with a hardness and a temerity which involuntarily remind us of the hard-boiled mentality of modern American literature. Tomlin's work is characterized by a dynamic kind of calligraphy and is therefore an example of the influence of Asian art, which is indeed considerable in America. Franz Kline paints angrily gesticulating signals suggesting danger, hostile barriers, and heads of prehistoric insects.

No matter how subjective their work may be, it has a

communicative power because they live under the spell of their time, which is also our time, and because the projection of their personal tensions represents, to some extent, a projection of the spirit of our time, experienced by all of us.

L. D. H., *La Libre Belgique*, Brussels, December 12, 1958

This is a demonstration of strength in proportion to the size of the United States. *The Biggest in the World.* The show must be seen. Even if you leave this encounter in a state of terrible dejection and of real anxiety as to the solidity of human reason on this planet in 1958. For this strength, displayed in the frenzy of a total freedom, seems a really dangerous tide. Our own abstract painters, all the "informal" European artists, seem pygmies before the disturbing power of these unchained giants. They paint in terms of walls, not of easel-size canvases. Size counts for a great deal in the impression of space they give. . . .

Some years ago, the American painting shown here stood for virtually nothing. Today, whether you oppose or accept it, it exists. It is a fact. And a fact, as the British say, is stronger than a Lord Mayor. . . .

The movement is generally known as "abstract expressionism" or, more accurately, "action painting." This latter, to my mind, corresponds better to the immediate impression received at first contact. Here is an esthetic terrifying for its excess, its chaos. But it certainly seems to represent "action" in its most frenetic and hallucinatory aspects. Whether it is produced and performed by geniuses or intelligent orangutangs, intellectual weaklings or complete humbugs, there is in this work an undeniably "active" quality. Beyond which, there is no spontaneous explanation possible. This is the existential nothingness expressed by various temperaments.

Unsigned, *Le Phare*, Brussels, December 14, 1958

The packing alone of some of these works weighed no less than 800 pounds! The show is, therefore, a substantial one, all the canvases being of imposing dimensions. Now that we have paid this homage to questions of size and transportation, let us say quite bluntly that this enormous sideshow is the most frightening demonstration of impotence that has ever been hawked around the world. Seventeen painters, famous (we are told) in the United States, find themselves

involved in this wretched imposture. An extremely handsome catalogue provides us with their photographs. And these deserve to be closely examined. In the expressions, the postures, the gaze of each of these artists, one can really discover one of the various complexes, which, among our transatlantic colleagues, are the qualifications of nobility of thought. . . .

These artists prove to themselves that they are something or someone by saying: "I paint, therefore I am." Almost the way certain criminals of recent American vintage have projected themselves into reality by saying: "I kill, therefore I am."

The Belgian—and European—public (the exposition will make a European tour, like a wild-west show) should pay attention to this cultural manifestation. It is with great profit that the programmatic remarks of several of the exhibition's artists will be read. Each is the expression of a frustration, of a desire for self-punishment or possession which relate quite distinctly to psychiatry.

As for the paintings themselves, they far exceed the worst excesses imaginable as for indigence, mediocre imitativeness, and intellectual poverty. One can examine here with consternation inkspots measuring 2 yards by 2½; graffiti enlarged 10,000 times, where a crayon stroke becomes as thick as a rafter; vertical stripes 2½ yards wide separate areas 2 yards wide; soft rectangles, formless scribblings, childish collections of signs; enough to make our own abstract painters blush for shame, exposed henceforth to the most humiliating comparisons.

There has been a great deal of crowing about the traditionalism of modern Russian artists. It seems to me that if art needs air and free imagination, it also needs the disciplines that any honestly practiced craft demands.

The seventeen Americans presented to us as the most representative of the new transatlantic painting have neither craft nor imagination. They are free, perhaps, but they are pathetic creatures who make poor use of their freedom.

To those of my readers who find my remarks irritating, I simply extend the request that they pay a visit to the Palais des Beaux-Arts and judge the evidence for themselves. It is essential that certain things be said and understood.

Claude Roger Marx, *Le Figaro Littéraire,* Paris, January 17, 1959

Jackson Pollock . . . born in the Far West, painting on the floor like the Indians drawing in the sand, this troubled artist, after having

undergone many influences, ends up with these batiks, these used
blotters, sometimes measuring several square yards, these winding
streams of whitewash and lamp-black, these threadlike curlicues,
these vermiculations, these lasso-throws, these dancing spots and
stains that confer upon the motionless, the limitless, a refined
agitation.

It seems difficult to distinguish one of the "seventeen" from
another. . . . Almost all are pseudo-literateurs, intoxicated by
words, if only for their extreme naiveté. Why do they think they are
painters? If James Brocks, Still, W. de Kooning, Guston, and the
young lady of the group, Grace Hartigan, have evident qualities as
colorists and permit us to communicate with their dreams, even
Gorky—who is said to exercise a powerful influence on the young
painters—seems only a diminutive of diminutives, and satisfies
himself with childish solutions, like Kline, Baziotes, Motherwell, or
Gottlieb. One smiles to see treated as leaders of a school painters
like Newman, exercising on his parallel bars, and Rothko, brushing
in his oozing squares. They speak, however, only of "passion," of
"spirituality," of "the process of expansion." Stamos declares with
conviction "that one must be true to one's colors, to one's God, to
one's dream." And we would end up by being I won't say
convinced—for the only greatness here is in the size of the
canvases—but disarmed if we did not deplore the terrible danger
which, following the exhibition of the Guggenheim collections, the
publicity given to such examples offers, as well as the imprudence
of the combined national museums in offering official support all too
generously to such contagious heresies.

André Chastel, *Le Monde*, Paris, January 17, 1959

This is a painting of behavior in which the painter commits himself
as one might dive into a waterfall, often with unusual procedures of
brushwork and application—sprinkling, spattering, dripping, etc.;
the result is a trickling, streaming, unpredictable picture that can
vary from nothingness to an expressive whole. . . . with a colossal
proportion of waste, these games of the unconscious, of raw passion
and of chance, have allowed some notable successes, for in them we
find elemental feeling and movement, the ardor and the naivete of
the New World . . .

The seventeen painters clearly define the amplitude of these
experiments, from Barnett Newman's concise stripes, Rothko's

simple contrasts (*Brown and Green, Beige and Black on Red*), and the thick black lines of Franz Kline to Guston's semi-impressionist pink flickerings, Brooks' brilliant nests of color and Sam Francis' rain of petals. . . . We grasp the pleasure that Motherwell, for instance, or Tworkov takes in projecting himself into the formless; Grace Hartigan in producing street scenes of brilliant and clashing patches of color that recall the Fauves, Tomlin in marking out geometrical vibrations that are almost elemental signs. Baziotes, easily the most agreeable member of the group with his rather fragile mauves and greens, stands apart in his lack of frenzy. The two most feverish, and by the same token the most typical, are Willem de Kooning, who does not appear here to his advantage, with his grinning, flayed women, and . . . Gorky, who died in 1948, the hostage of nervous crisis and of drama in this array. He is a sort of obsessed Miró, whose forms occasionally decompose with painful effect, and who can find shrill, strident accents for his grey pictures inhabited by spermatozoas. These canvases have been arranged in a single group and thereby betray something like a secret—the paroxysm of the young generation. But one is inevitably struck by the *gigantism* of these paintings. This disease, often remarked in Paris, is worldwide. Enormous size has the disadvantage of emphasizing the vacuity or the monotony of the image. The forms—rather mannered—of Clyfford Still swell like sun spots. The panels of Gottlieb and Kline proclaim their excess. We are dealing with a kind of painting that seems to refuse any frame, any imprisonment; which no longer takes anything into consideration. And which will have the greatest difficulties growing old.

All of which emphasizes to an extreme degree the originality of the American scene—or more exactly, of the New York milieu. And yet this show enforces certain analogies. The roots of this art are European, and are called fauvism, German expressionism, Klee, Picasso, sometimes Matisse or Andre Masson's inspired surrealism. . . .

In Europe we have returned by more or less brutal stops and starts to the notion of the "object" and to the privileges of the *painting* treated as such; in the United States, ingenuous even in their surrealist revolt against the oppression of a mechanistic civilization and its utilitarian nonsense, men have discovered the facility and the strangeness of the very act of painting. There had to be this somewhat blind generosity to which Pollock bears witness to give this anxiety its whole meaning. Thus develops a difficult and tentative dialogue, which constitutes the value of this century's painting.

Raymond Cogniat, *Le Figaro*, Paris, January 22, 1959

It is certain that P[ollock]'s art, made of spots and paint drips, affirms itself with authority; it emanates a powerful vitality, a type of convincing violence, even when one is irritated in seeing him state his refusal of reality with such ease. But as soon as one accepts it, one feels that this art is more a pathetic debate than a provocation. One can see the violent refusal of all that belongs to the past in trying to discover a completely new vocabulary.

Maybe the American painters of this trend are at the stage of the child who tries his brushes and crayons for the pure physical joy (of it) and at the same time starts to learn his future spiritual pleasures. As long as Abstract art has taken the place we know in contemporary life, it would be childish and vain to deny it, but we must also state that it can correspond to two completely different attitudes: (it can be) a point of departure, a search toward the future as the Americans suggest, or (it can be) a supreme refinement, a form of decadence, as in most European artists.

In both cases this art is satisfied by too elementary results to correspond to a real and deep culture and if one can understand that the critics find justifications, and pretexts to dissertations on the spirit which animates them, it is permissible to be surprised that the creating artist is satisfied with such slim and easily acquired results.

Unsigned, *The Times*, London, February 4, 1959

[The exhibition] provides concrete evidence for anyone interested in the operations of the aesthetic barometer why the United States should so frequently be regarded nowadays as the challenger to, if not actually the inheritor of, the hegemony of Paris in these matters.

What cannot fail to strike any visitor, and strike him forcibly whether he is naturally inclined for or against this development of modern art, is an impression of size; of size, moreover, not merely in an inflatory sense but as a natural assumption of scale which seems for once to fill, in the most acceptable manner, the Edwardian stateliness of the Tate's towering rooms. The paintings fulfill the demands of the galleries' dimensions, which are not proportioned for individual comfort or domestic relaxation but for the expansive scale of the social occasion. The merely large painting of the naturalistic, processional, or "heroic" order cannot usually achieve this effect without incurring a depressing heaviness and

pomposity. The American paintings appear to achieve it because, being essentially essays in the flat rather than in pictorial space, they are perfect mural decorations, and because the boldness, assurance, and rhetoric of their frequently simple forms and unexpected colours manage to animate more architectural space than in fact they occupy.

Though the suggestion may not be readily acceptable in some quarters, it still seems worth remarking that paintings which can function in this manner appear eminently suitable for the public and social role which is so desperately looked for from the art of the present time, a role which can combine the so-called "environmental" demands of architecture with the qualities of a personal statement. It must, however, be admitted that American painting has perhaps only unconsciously begun to satisfy the former requirement, its conscious pursuit being of the latter. But here again the quality of adventure, of individual striving, of hammering out modes of expression with a pioneering sense of independence, lends these personal utterances a forceful, easily communicable, vitality.

Unsigned, *Evening Times*, Glasgow, February 25, 1959

You want to know how to create a real genuine masterpiece? It's easy.

Get a pot of paint—any old kind—and a brush, and then have a "ball" on canvas.

Masterpieces are dead easy this new way, the way the Tate Gallery, London, is showing us.

It's there for all to copy in "The New American Painting," a big, slap-happy show straight from New York.

Be Big

The first rule of success is size. If your canvas is as big as the side of a house you're halfway there.

Next, make what is called your statement of faith. This gives people the idea that you really mean something.

One painter, Jack Tworkov, who really splashes it on, says his hope is to "confront the picture without a ready technique or a prepared attitude." He can say that again.

Another, Adolph Gottlieb, says—"I prefer, innocent impurity to doctrinaire purism, but prefer the no-content of purism to the shoddy content of social realism" . . . what ever that means.

After the statement of faith comes the painting.

Smack at it, whack at it, pour it on if you feel like it, stir it up, muck it about; it's all a question of emotion.

And whatever comes out is IT—your masterpiece.

You can vary the technique. What really jerks up interest is if you paint the canvas nearly all one colour.

The Technique

If you paint another colour that knocks the critics flat, draw a straight line just off centre and give it a fancy title and they'll line up to discover the emotion.

Finally, when you're asked what it's all about, say you don't give reasons, because what's done is done and can't be undone.

I'm pretty sure, after seeing this lot from America, that when you get your masterpiece ready, the Tate will give it a big show.

Frederick Laws, *The Manchester Guardian*, Manchester, February 27, 1959

Once inside the gallery you can't slide politely past this lot of pictures. If our aesthetic reactions are not numb, scenes of enthusiasm or distress, dancing or denunciation are to be expected at the Tate. During my visit the public was quiet, though I have never seen so many young gallery-goers sitting down in a silent daze.

Alan Clutton-Brock, *The Listener*, London, March 19, 1959

To get the feel of this work it is necessary to see a large collection of it, like this, and for the paintings to be of the largest size, as here they certainly are. Given this, the direct effect on the senses is undeniable and even impressive; also the huge and heavy blots, the intricate webs of trickling colour, the violent slashes of black across white exert something like a spell and seem like magical signs which even if they cannot be interpreted still have power over the imagination.

It appears to be all a matter of scale. If such blots and scribbles occurred by accident or in the course of some half-conscious process like automatic writing they could not be of this size and would hardly have any such effect, but great enlargements of them cannot be produced without complete assurance and commanding

gestures. Conceivably, as some of the more abstract designs of Paul Klee might suggest, reduction of size, entailing a fine miniaturist's technique, could have much the same effect, but the point is that there must be a marked change of scale to introduce the necessary element of purpose into the design. At the same time this is likely to encourage a sensitive handling of the paint, and in the work of Motherwell, Sam Francis, Franz Kline, and Philip Guston, in particular, there is an admirable richness and sometimes an extreme refinement of texture. It is not easy to understand why such pictorial qualities, which are usually associated with a long tradition of expert painting, should suddenly appear in America as if released by these completely uninhibited exercises with the brush; but it certainly is so, and most European work in this style would look tame beside the maniacal flourishes of these newly liberated giants.

Hilton Kramer, *The Reporter,* New York City, July 23, 1959

For many artists and intellectuals of the younger generation in Europe, American painting of the abstract expressionist school has recently joined the curious company of jazz, blue jeans, Coca-Cola, Marilyn Monroe, and the plays of Tennessee Williams as one of the more arresting symbols of American life. It is an object worthy of imitation and aspiration. It evokes not only partisanship but an astonishing evangelical zeal. There are critics in London, Basel, and Berlin who write about Jackson Pollock and Willem de Kooning with the kind of passionate conviction that used to be reserved for urgent political questions. The cognoscenti of Amsterdam and Madrid speak the names of Mark Rothko and Clyfford Still with familiarity and enthusiasm. When an enormous exhibition of these and other painters, together with a retrospective showing of Jackson Pollock, was installed at the Musée National d'Art Moderne in Paris earlier this year, Annette Michelson reported in the magazine *Arts:* "The fact that this exhibition remains after five months, the one really lively topic of discussion in any gathering of artists, critics, or dealers speaks for itself." European advocates of this art do not simply "like" it, they *believe* in it. They bring to this commitment some of that terrifying capacity to close out all other values which, again, has more often been identified with political irrationalism than with a response to art. For Europe, American painting of this type is less an aesthetic experience than an ideology.

Just why this should be so tells us more, perhaps, about the

condition of art in Europe than about American painting. There is no denying that a loss of confidence has taken place in European painting. This is especially true of the School of Paris, whose leadership in this sphere is now challenged for the first time in the history of modern art. What is happening is what always happens in a crisis of this kind: there is a search for new sources of vitality. There is the customary assumption, too, that these sources are to be found in forms of expression as far removed as possible from the sophisticated, overrefined styles of Europe itself.

What the European eye looks for in American painting is not something close to its own sensibility. It does not seek out a confirmation of its own traditions. On the contrary, the European response is precisely to qualities that are regarded as distant from inherited values. It is the *otherness* of this art that excites the European imagination, and wins it over to what is said to be a new vitality and power.

The exact nature of Europe's interest in our art has been made much clearer by recent reactions to an exhibition called "The New American Painting." This is the show that went to Paris and toured seven other European cities at the same time the large Pollock show was also on the road. It has now returned from its triumphant tour and is installed for the summer months at The Museum of Modern Art in New York. The museum, whose International Council sponsored the tour, has also issued a special catalogue, complete with clippings from the European press. This volume, called *The New American Painting* (Doubleday, $2.95), is a useful guide to the whole movement, including color plates, biographical resumes, and some gnomic statements from the artists.

In this country, abstract expressionism is now our certified contemporary style so far as the museums, the critics, and the big investors in modern painting are concerned and inevitably its local partisans have felt vindicated by this resounding victory abroad. To enjoy the fruits of this victory, however, they have had to do some fast work in rehabilitating the value of European opinion. For ten years they have been persuading all comers that Europe was a backwater. Yet when the opportunity came, it still seemed to require the word of this "decadent" culture to confer legitimacy on our native efforts.

For myself, I find this victory ambiguous. What Europeans found to admire in our painting may not be at all what we Americans should like to admire in it ourselves. They responded especially to its raw power, its daring, and its scale. They insisted a little too much perhaps on its physical vigor and on its violence. The poet Kenneth Rexroth reported in *Art News:* "Even those [journalists] who

did go [to "The New American Painting" show] got hold of the wrong
catalogue and were under the impression the pictures were painted
by Wyatt Earp and Al Capone and Bix Beiderbecke." Originality,
power, newness—these words are such music to our ears that we
have neglected to observe how seldom either profundity or delight
was attributed to this art by critics who take such matters seriously.
When it came to judging the new American painting, Europe still
withheld its ultimate praise and retreated into the euphemisms that
are used in any polite society to encourage growing boys. The key to
this European attitude came in its reluctance to recognize American
painting in its continuity with European tradition. This was the
crux. In her report to *Arts,* Miss Michelson commented: "The
hospitality [of the Paris critics] was somewhat qualified . . . by the
suggestion of a condescension to a fresh and interesting art
produced by a tribe of noble savages, or by the masochism of the
civilized European, submitting to a rape performed upon his
exquisitely decadent sensibility (Gide rejecting James in favor of
Dashiell Hammett, feeling that a literature which had produced *A la
Recherche du Temps Perdu* could take no interest in *The Golden
Bowl*)."

This was, in effect, a way of saying that American painting could
not be taken to exist on the same level as its European counterpart.
Its interest as ideology was affirmed, but its achievement as art was
left in abeyance. Yet, when I say that Europeans responded to
qualities different from those we ourselves admire, I am probably
not speaking for New York's art circles. There has been in New
York, too, an odd compulsion to place this school of painting—
which spends half its time denying it is a school and the other half
wondering if it is a new academy—outside the confines of art. The
most famous essay on abstract expressionism, Harold Rosenberg's
article on "The American Action Painters" in 1952, specifically
warned against the "fallacy" of regarding such work as mere art:
"The critic who goes on judging in terms of schools, styles, form—
as if the painter were still concerned with producing a certain kind
of object (the work of art), instead of living on the canvas—is bound
to seem a stranger."

Actually, the whole abstract expressionist movement is intimately
bound up with the development of modern painting in Europe. Its
impulses date from the influx of European artists to this country in
the late 1930s and especially during the Second World War. This
was the period when Léger, Masson, Breton, Lipchitz, Mondrian,
Chagall, and other luminaries of the Paris avant-garde settled in
New York. This distinguished wave of emigration was an event
second only to the Armory Show of 1913 in determining the course

of American art. Pollock, Gorky, de Kooning, Rothko, Motherwell, and the other senior members of this group all came of age in the atmosphere created by the presence of these Parisian vanguard artists in New York.

The difference between the Americans and their Parisian elders was a difference in attitude toward the same artistic capital. The Americans, as heirs to a cultural fortune they had never had to earn, were free to squander, take chances, risk everything. At the very worst, they would only end up where they had started. The Europeans were more conservative, admitting and encouraging new possibilities but unwilling to spend recklessly what had been won at such a profound spiritual cost.

This is the real meaning of the abstract expressionist movement in New York: that it has promised a liberation from culture in the name of an art which, whether violent or serene, resigns from all the complexities of mind which Europe still regards as the *sine qua non* of artistic seriousness. It has thus brought modern painting to an end, hastening its demise out of some compulsive curiosity to see what the future of art can be without it.

When I go through the galleries of The Museum of Modern Art now and look at these paintings again, I wonder if they can bear this ideological burden very much longer. André Chastel, the critic for *Le Monde*—incidentally, one of the few who clearly understood the European origins of this painting—commented: "We are dealing with a kind of painting . . . which no longer takes anything into consideration. And which will have great difficulty in growing old." Such a difficulty is plainly evident in the brittle, dry surfaces, the poverty of invention, the inflated scale. Above all, it shows up in the athleticism going to seed in preciosity which confronts the eye at every turn. If this is the future, the future is going to be meager.

The festivities that celebrated the victorious return of "The New American Painting" to New York took place in quite a different atmosphere, of course. The opening-night events at The Museum of Modern Art had the air of a college town on Saturday night after the big game; I've never seen so many happy faces in a museum. But then, nobody goes to opening night at the museum to see pictures. I remember, though, the remark of a painter I happened to run into that evening. "I'm glad to see this work here, set upon the altar this way and everybody worshiping," he said. "That means it's over, and now something else will have a chance."

International reviews reprinted from *The New American Painting* by Alfred H. Barr and The Museum of Modern Arts files by permission of the Museum of Modern Art. © The Museum of Modern Art (1959) with the exception of "The End of Modern Painting," *The Reporter* by Hilton Kramer. © Hilton Kramer.

Chronology

1929 Rothko and Gottlieb meet. (Gottlieb and Newman met at the Arts Students League, New York, in 1923)
 The Museum of Modern Art (MOMA), New York, opens under director Alfred H. Barr, Jr. The first exhibition is of works by Cézanne, Gauguin, Seurat, Van Gogh.

1931 Whitney Museum of American Art, New York, opens under director Juliana Force as the first museum devoted entirely to contemporary American art. The first exhibition is of the Gertrude Vanderbilt Whitney collection, which includes works by Benton, Bellows, Davis, Demuth, Hopper, O'Keeffe, Prendergast, Sloan, Weber.

1932 Rothko and Smith meet.

1933 Hans Hofmann opens his art school in New York.
 Black Mountain College, North Carolina, opens. Josef Albers becomes head of the art department.
 Gottlieb and Smith meet.

1934 Artists' Union formed in New York, with local chapters elsewhere, to agitate for creation of "art projects for unemployed."

1935 The Works Progress Administration (WPA) Federal Art Project is established; Holger Cahill director. This is the most extensive of government-supported art programs during the Depression. It consists of easel, mural, graphic, and sculpture divisions.
 Whitney Museum shows Abstract Painting in America; artists include Davis, Demuth, Dove, Gorky, Graham, Hartley, Matulka, Marin, O'Keeffe, Sheeler, Stella, Weber, Wright.
 American Abstract Artists is formed, an association of artists who paint in the abstract-geometric style influenced by neo-plasticism and de Stijl.
 Rothko and Newman meet.

1936 MOMA shows Cubism and Abstract Art and Fantastic Art, Dada, Surrealism.
 The WPA Federal Art Project employs at this time Baziotes, de Kooning, Gorky, Guston, Pollock, Reinhardt, Rothko, Tworkov.
 Siqueiros, living in New York, founds Experimental Workshop.

1937 John Graham publishes book on aesthetics, *System and Dialectics of Art*, and article "Primitive Art and Picasso" in *Magazine of Art*.
 De Kooning meets Smith and Newman; Smith also meets Pollock.

1939 The Museum of Non-Objective Painting opens in New York; is renamed The Solomon R. Guggenheim Museum in 1952. (Kandinsky paintings have been exhibited since 1936.)
 Europeans who move to U.S. after 1939 include Breton, Chagall, Dali, Duchamp Ernst, Graham, Léger, Lipchitz, Masson, Matta, Mondrian, Ozenfant, Seligman, Tanguy, Tchelitchew, Zadkine.
 De Kooning and Kline meet.

1940 The American Federation of Modern Painters and Sculptors is established in New York; group is concerned with politics as well as culture; includes among its members Avery, Baziotes, Bolotowsky, Gottlieb, Gatch, Morris, Rothko, Smith, Stella, Tomlin, Zadkine.
 First issue of *View*, September, last of magazines oriented to Surrealism, founded by Charles Henri Ford; published until 1947. Special issue devoted to Surrealism, October–November, 1941.

1942 John Graham organizes international exhibition, American and French Painting, at McMillen Gallery, New York; juxtaposes Braque, Bonnard, Matisse, Picasso, Modigliani with Pollock, Lee Krasner, Stuart Davis, de Kooning.
 Samuel Kootz organizes group exhibition at R. H. Macy Department Store, New York; 72 artists include Avery, Gorky, Gottlieb, Graham, Holty, Matulka, Morris, Rothko.
 First solo show in New York of Piet Mondrian.
 Exhibition, Artists in Exile, at Pierre Matisse Gallery, New York; 14 artists include Léger, Masson, Matta, Mondrian, Tanguy.
 Peggy Guggenheim opens Art of This Century gallery in New York. Shows established modern Americans, unknown Americans, and her private collection of European

avant-garde art. Howard Putzel is director, 1942–44. Gallery closes in 1947. Exhibition of collages, spring 1942, includes Pollock, Baziotes, Motherwell, Reinhardt. Gives first solo shows to Pollock, Hofmann, Baziotes, Motherwell, Rothko, Still.
Baziotes, de Kooning, Hofmann, Motherwell, and Pollock all meet.
First issue of *Dyn*, April/May, founded and edited by Wolfgang Paalen. Six issues appear through November 1944.
André Breton organizes First Papers of Surrealism at Reid Mansion, New York. Participants include Duchamp, Max Ernst, Klee, Matta, Miró, Masson, Picasso, Tanguy, together with young Americans including Motherwell, Hare, Baziotes.
First issue of *VVV*, magazine founded and edited by David Hare, with Breton and Ernst as editorial advisers; text in French and English; three issues published until 1944.

1943 Samuel Kootz publishes book, *New Frontiers in American Painting*.
Still and Rothko meet in Oakland, California.

1944 Betty Parsons, a partner in the Wakefield Bookstore since 1940, becomes director of the contemporary section when Mortimer Brandt takes over shop; shows Stamos, Gottlieb, Rothko, Reinhardt, Hedda Sterne.
Sidney Janis organizes group exhibition Abstract and Surrealist Art in America, in conjunction with publication of book of same title; exhibit travels throughout U.S. and shows at Mortimer Brandt Gallery, New York; includes de Kooning, Baziotes, Gottlieb, Motherwell, Rothko.

1945 Kandinsky retrospective at Museum of Non-Objective Painting.
First important solo show of Gorky at Julian Levy Gallery, New York. Mondrian's *Plastic Art and Pure Plastic Art*, edited by Motherwell, is published in New York.
Charles Egan opens gallery; begins by showing older American painters.
Samuel Kootz opens gallery; takes over Baziotes and Motherwell from Peggy Guggenheim.
Group exhibition, A Painting Prophecy—1950, at David Porter Gallery, Washington, D. C.; includes Baziotes, Stuart Davis, Jimmy Ernst, Gorky, Gottlieb, Karl Knaths, de Kooning, Motherwell, Richard Pousette-Dart, Pollock, Rothko, Tomlin.
Howard Putzel organizes group exhibition, A Problem for Critics, at 67 Gallery, New York, to defend recent trends; includes Arp, Gorky, Gottlieb, Hofmann, Krasner, Masson, Miró, Picasso, Pollock, Pousette-Dart, Rothko, Seliger, Tamayo.

1946 Betty Parsons Gallery opens. Takes over Pollock, Rothko, Still from Peggy Guggenheim when she closes her gallery. First show, Northwest Coast Indian Painting, is arranged by Newman.
Robert Coates, reviewing Hofmann show at Mortimer Brandt Gallery, New York, in *The New Yorker*, March issue, uses term "Abstract Expressionism" in discussing New York artists. First use of term. Group exhibition, 14 Americans, at MOMA; includes Motherwell, Gorky, Hare, Noguchi, Steinberg, Tobey.
Group exhibition, Advancing American Art, at The Metropolitan Museum of Art; 47 artists include Avery, Baziotes, Davis, Gottlieb, Guston, Marin, O'Keeffe.
Kandinsky's *Concerning the Spiritual in Art* published in New York.

1947 Group exhibition, The Ideographic Picture, at Betty Parsons Gallery; announcement text by Newman; includes Hofmann, Newman, Reinhardt, Rothko, Stamos, Still.
Samuel Kootz organizes first exhibit of Abstract Expressionism in Europe, *Introduction à la peinture moderne Américaine*, at Galerie Maeght, Paris; includes Baziotes, Gottlieb, Motherwell.
First of nine issues of *Tiger's Eye*; Edited by Ruth and John Stephan, continues through 1949; Newman helps on first few issues. Baziotes, Gottlieb, Gorky, de Kooning, Motherwell, Newman, Pollock, Reinhardt, Rothko, Stamos, Still, Tomlin were among those who contributed texts or whose work was discussed and reproduced.
Single issue published of *Possibilities: An Occasional Review*, founded by Motherwell and Harold Rosenberg; editors were Motherwell, art; Rosenberg, writing; Pierre Chareau, architecture; John Cage, music. This was the first magazine to deal exclusively with contemporary American art. Includes statements by Baziotes, Stanley William Hayter, Pollock, Rothko, Smith, as well as reproductions of their work.
Robert Goldwater becomes editor of *Magazine of Art*, the first art magazine to cover the Abstract Expressionists, especially from 1948 to 1951.

1948 Protest meeting organized by Tomlin held at MOMA; participating artists fault certain
 art critics and, especially, condemn the manifesto issued by the Institute of Modern
 Art, Boston (announcing its change of name to the Institute of Contemporary Art),
 which accused advanced art of "obscurity and negation" and questioned the honesty of
 its practitioners.
 The Subjects of the Artist school opens at 35 East 8th Street, New York, founded by
 Baziotes, Hare, Motherwell, and Rothko. Still helps plan it, but does not teach;
 Newman joins the second semester. It is an art school with "no formal courses," but a
 "spontaneous investigation into the subjects of the modern artist—what his subjects
 are, how they are arrived at, methods of inspiration and transformation, moral
 attitudes, possibilities for further explorations. . . ." Motherwell, with help of
 Newman, organizes Friday evening lectures, which are open to the public and given
 by artists. Financial failure forces school to close end of spring 1949 term.
 Life, October issue, features article, "A *Life* Round Table on Modern Art," with a
 section on "Young American Extremists," which includes discussions of Baziotes,
 Gottlieb, de Kooning, Pollock, Stamos.
 Sidney Janis opens gallery in New York with Léger exhibition; Abstract Expressionists
 are not shown until 1950.
 Death of Arshile Gorky.
 Thomas B. Hess becomes editor of *ARTnews*, and features Abstract Expressionists
 throughout the 1950s.

1949 Samuel Kootz and Harold Rosenberg organize group exhibition, The Intrasubjectives,
 at Samuel Kootz Gallery, New York; title comes from phrase taken from Ortega y
 Gasset's "On the Point of View of the Arts." Includes Baziotes, Gorky, Gottlieb,
 Graves, Hofmann, de Kooning, Motherwell, Pollock, Reinhardt, Rothko, Tobey,
 Tomlin.
 The Club forms as semi-official meeting place at 39 East 8th Street, New York.
 Organized by Philip Pavia. Select admission grows from 20 to 60 by 1950; lasts until
 spring, 1962. Rothko, Pollock, and Still do not join.
 Three New York University professors take over Subjects of the Artist space and open
 Studio 35 at 35 East 8th Street, New York, which continues Friday evening lectures
 until April, 1950. Final activity is a three-day closed conference the proceedings of
 which were published in 1951 in *Modern Artists in America*, a single-issue magazine
 edited by Motherwell, Reinhardt, and Bernard Karpel.
 Robert Goldwater invites 16 critics to assess the state of American art in *Magazine of
 Art*.
 Louis Carré organizes group exhibition, European and American Painters, at Betty
 Parsons Gallery, New York.

1950 Group exhibition, Black or White: Paintings by European and American Artists, at
 Samuel Kootz Gallery, New York; includes Baziotes, Gottlieb, Hofmann, de Kooning,
 Motherwell, Tobey, Tomlin.
 In May, open letter by 18 people to The Metropolitan Museum of Art, protesting
 "regional" jury of national juried exhibition American Painting Today—1950, to be
 held December 1950–February 1951. Reprinted in *ARTnews; The New York Times* ran
 the story on its front page and reports appeared in other papers. The *Herald Tribune*
 ran an editorial entitled "The Irascible 18," and *Life* ran a photo of the group by Nina
 Leen after the opening in January, 1951, with the caption "Irascible Group of
 Advanced Artists Led Fight Against Show."
 The Institute of Contemporary Art, The Museum of Modern Art, and the Whitney
 Museum issue statement in support of Abstract Expressionism.
 Leo Castelli organizes group exhibition, Young Painters in U.S. and France, at Sidney
 Janis Gallery, New York, comparing 15 American and French painters, including
 Gorky and Matta, Kline and Soulages, de Kooning and Dubuffet, Pollock and
 Lanskoy, Rothko and de Staël, Reinhardt and Nejad, Tomlin and Ubac.

1951 Group exhibition, Abstract Painting and Sculpture in America, at MOMA;
 includesBaziotes, Gorky, Guston, Hofmann, de Kooning, Motherwell, Pollock,
 Reinhardt, Rothko, Stamos, Tobey, Tomlin.
 Symposium: "What Abstract Art Means to Me" held in February and published in
 Spring *MOMA Bulletin;* participants include de Kooning and Motherwell.

Michel Tapié organizes exhibition *Véhémences Confrontées*, a "confrontation of the most advanced American, Italian, and Parisian painters for the first time in France," held at Galerie Nina Dausset, Paris; includes de Kooning and Pollock.

Members of The Club, with Leo Castelli, organize 9th Street Show of 61 artists, held in rented empty store at 60 East 9th Street, New York; includes many young New York artists. Baziotes, Gottlieb, Newman, Rothko, and Still do *not* submit work.

Group exhibition, 17 Modern American Painters, at Frank Perls Gallery, Beverly Hills; Motherwell writes catalogue introduction, "The School of New York,"—a term to which many artists included objected. Artists in show are Baziotes, Gatch, Gottlieb, Graves, Hofmann, de Kooning, Matta, Motherwell, Pollock, Pousette-Dart, Reinhardt, Rothko, Stamos, Sterne, Still, Tobey, Tomlin.

Leo Castelli helps organize group exhibition, American Vanguard Art for Paris, at Sidney Janis Gallery, New York, to be shown at Galerie de France, Paris in 1952, under title Regards sur la Peinture Américaine; includes Albers, Baziotes, Brooks, Goodnough, Gorky, Gottlieb, Guston, Hofmann, Kline, de Kooning, Matta, MacIvor, Motherwell, Pollock, Russell, Reinhardt, Tobey, Tomlin, Tworkov, Vicente.

June issue of *Art d'aujourd'hui*, a monthly magazine of art published in Paris and edited by André Bloc, devotes issue to "Painting in the U.S." To date this is the most complete representation of avant-garde American painting to be published abroad.

Thomas B. Hess publishes *Abstract Painting: Background and American Phase;* first book to focus on Abstract Expressionists.

Motherwell and Guston become friends.

1952 Group exhibition, 15 Americans, at The Museum of Modern Art, New York; includes Baziotes, Ferber, Pollock, Rothko, Still, Tomlin.
Harold Rosenberg publishes "The American Action Painters" in *ARTnews*.

1953 Death of Bradley Walker Tomlin.
Group exhibition, Abstract Expressionists, at The Baltimore Museum of Art; includes Guston, de Kooning, Tworkov.

1954 Group exhibition, Younger American Painters, A Selection, at The Solomon R. Guggenheim Museum, New York; 57 artists include Baziotes, Brooks, Diebenkorn, Gottlieb, Guston, Kline, de Kooning, Motherwell, Pollock. Show travels in U.S. through 1956.

1955 Group exhibition, The New Decade: 35 American Painters and Sculptors, at Whitney Museum; includes Baziotes, Brooks, de Kooning, Gottlieb, Hare, Kline, Motherwell, Pollock, Pousette-Dart, Reinhardt, Stamos, Tomlin.
Clement Greenberg publishes article "American-Type Painting" in *Partisan Review*.

1956 Group exhibition, 12 Americans, at MOMA; includes Brooks, Sam Francis, Hartigan, Kline, Guston.
Death of Jackson Pollock.
Black Mountain College closes.
Meyer Schapiro publishes "The Liberating Quality of Avant-Garde Art" in *ARTnews*.

1957 Leo Castelli opens gallery in New York; inaugural exhibition includes Gorky, de Kooning, Smith.

1958 Group exhibition Nature in Abstraction: The Relation of Abstract Painting and Sculpture to Nature in Twentieth-Century American Art at Whitney Museum; 57 artists include Baziotes, Gorky, Gottlieb, Guston, Hofmann, Kline, de Kooning, Pollock; show travels to Washington, D.C., Fort Worth, Los Angeles, San Francisco, Minneapolis, St. Louis, through 1959.
Group exhibition, The New American Painting as Shown in Eight European Countries 1958–59, organized under the auspices of the International Council at MOMA; circulates to Switzerland, Italy, Spain, Germany, Holland, Belgium, France, England,and, finally, to New York; artists are Baziotes, Brooks, Francis, Gorky, Gottlieb, Guston, Hartigan, Kline, de Kooning, Motherwell, Newman, Pollock, Rothko, Stamos, Still, Tomlin, Tworkov.

1959 The Solomon R. Guggenheim Museum, New York, opens in new building designed by Frank Lloyd Wright. The first exhibition, a survey of the collection, includes, among 74 artists, Gottlieb, Kline, de Kooning, Pollock.

1960 Group exhibition, Paths of Abstract Art, at The Cleveland Museum of Art; includes Ferber, Guston, Hoffman, Kline, de Kooning, Motherwell, Pollock, Smith, Rothko, Tobey.

Group exhibition, 60 American Painters 1960: Abstract Expressionist Painting of the Fifties, at Walker Art Center, Minneapolis; includes Baziotes, Brooks, Gorky, Gottlieb, Guston, Hofmann, de Kooning, Motherwell, Pollock, Reinhardt, Rothko, Stamos, Still, Tobey, Tomlin, Tworkov.

Fifty artists, critics, and collectors send letters to the editor of *The New York Times* protesting John Canaday's criticism of Abstract Expressionism.

1961 Group exhibition, American Abstract Expressionists and Imagists, at the Guggenheim Museum; 64 artists include Baziotes, Gorky, Gottlieb, Guston, Hofmann, Kline, de Kooning, Motherwell, Newman, Pollock, Reinhardt, Rothko, Still, Tobey, Tomlin, Tworkov.

Robert Rosenblum writes article "The Abstract Sublime" in *ARTnews*, relating Newman, Pollock, Rothko, and Still to 19th-century visionary painters.

1962 H. H. Arnason organizes group exhibition, Vanguard American Painting, for U.S. Information Service; show travels to Yugoslavia, London, Darmstadt, Salzburg.

Group exhibition, American Art Since 1950, at Fine Arts Pavilion of the Seattle World's Fair; show travels to Boston; 87 artists include Baziotes, Brooks, Davis, Gottlieb, Guston, Hofmann, Kline, de Kooning, Motherwell, Newman, Pollock, Rothko, Stamos, Still, Tobey, Tomlin, Tworkov.

1963 Death of Franz Kline.

Albers's *Interaction of Color* is published in English.

Death of William Baziotes.

Group exhibition, Black and White, at The Jewish Museum, New York; includes Gorky, Hofmann, Kline, de Kooning, Motherwell, Newman, Pollock, Pousette-Dart, Tomlin.

Group exhibition, New Directions in American Painting, organized by The Poses Institute of Fine Arts, now The Rose Art Museum, Brandeis University, circulated in U.S.; 57 artists include Gottlieb, Guston, Hofmann, Kline, de Kooning, Motherwell, Newman, Pollock, Rothko.

1964 Death of Stuart Davis.

1965 Group exhibition, The New York School: The First Generation, Paintings of the 1940s and 1950s, at the Los Angeles County Museum of Art; includes Baziotes, Gorky, Gottlieb, Guston, Hofmann, Kline, de Kooning, Motherwell, Newman, Pollock, Reinhardt, Rothko, Still, Tomlin.

Death of David Smith.

Special issue of *Artforum* on "The New York School."

1966 Samuel Kootz closes gallery in New York.

The Whitney Museum of American Art opens in new building, designed by Marcel Breuer.

The International Council of MOMA organizes group exhibition, Two Decades of American Painting, shown in Japan, India, and Australia; 34 artists include Gorky, Gottlieb, Guston, Hofmann, Kline, de Kooning, Motherwell, Newman, Pollock, Reinhardt, Rothko, Still, Tobey, Tomlin.

Death of Hans Hofmann.

1967 Death of Ad Reinhardt.

1968 MOMA shows Dada, Surrealism, and Their Heritage; includes Gorky, Gottlieb, Hare, Pollock, Rothko, Smith.

Group exhibition, The Art of The Real: U.S.A. 1948–1968, at MOMA New York; includes Newman, Pollock, Reinhardt, Rothko, Smith, Still.

1970 Henry Geldzahler organizes group exhibition, New York Painting and Sculpture: 1940–1970, at The Metropolitan Museum of Art, New York. 47 artists include Gorky, Gottlieb, Guston, Hofmann, Kline, de Kooning, Motherwell, Newman, Pollock, Reinhardt, Rothko, Smith, Still, and Tomlin.

Death of Barnett Newman and Mark Rothko.

Index

7-02 Ded 1-00 C.16